Contesting Feminisms

SUNY series, Genders in the Global South

Debra A. Castillo and Shelley Feldman, editors

Contesting Feminisms

Gender and Islam in Asia

Edited by

Huma Ahmed-Ghosh

SUNY PRESS

Cover image © Huma Ahmed-Ghosh, with development by Shreya Carey

Published by State University of New York Press, Albany

For information, contact State University of New York Press, Albany, NY
www.sunypress.edu

Production, Jenn Bennett
Marketing, Fran Keneston

Library of Congress Cataloging-in-Publication Data

Contesting feminisms : gender and Islam in Asia / edited by Huma Ahmed-Ghosh.
 pages cm. — (SUNY series, genders in the global South)
 Includes bibliographical references and index.
 ISBN 978-1-4384-5793-2 (hc : alk. paper)—978-1-4384-5792-5 (pb : alk. paper)
 ISBN 978-1-4384-5794-9 (e-book : alk. paper)
 1. Muslim women—Asia—Social conditions. 2. Feminism—Asia. 3. Feminism—Religious aspects—Islam. I. Ahmed-Ghosh, Huma.

 HQ1170.C746 2015
 305.48'697095—dc23 2014043286

10 9 8 7 6 5 4 3 2 1

Contents

PART II
FEMINISMS AND MUSLIM WOMEN'S MOVEMENTS
IN CONTESTED SPACES

PART III
TRANSNATIONAL FEMINISMS: LOCATING MUSLIM WOMEN
AT THE CROSSROADS

Acknowledgments

I would like to acknowledge Diana Fox, editor of the *Journal of International Women's Studies,* for inviting me to do a Special Issue on Gender and Islam in Asia five years ago. This book has its genesis in that project. This book would not have been possible without the brilliant contributions by the authors, and their patience. I would also like to express my gratitude to Shelley Feldman, for her faith in me. I greatly appreciate her editorial comments. I am also grateful to my graduate student, Taylor Wondergem, who was always there when I needed technological assistance with formatting the essays and checking the bibliographies. I am extremely appreciative to Danielle Bauer for her skills, patience, and hard work in creating the Index. I am indebted to the external reviewers whose invaluable comments and appreciation of the text encouraged me to finish this task. I would also like to thank Beth Bouloukos, Rafael Chaiken, and Jenn Bennett at SUNY Press for their support and guidance. A big thanks to Teddi Brock for keeping the humor and cups of tea flowing in the office—both were essential to complete this book. I would also like to thank Soumitra Ghosh for his detailed editing of the Introduction, and Helen Lockett for her thorough reading of the proofs. Acknowledgments are due also to Shreya Carey who offered her expertise in the creation of the book cover.

Introduction

Huma Ahmed-Ghosh

While challenging popular contestations of the Muslim woman, Syed Jamil Ahmed states that, "representations of the 'Muslim woman' as the 'Othered' object of the 'Western' gaze and the domesticated 'object' which the Islamist apologists strive hard to defend, are both constructions and false anti-thesis of each other."[1] This book reinforces and elaborates this view by addressing the pressing issues of feminisms and Asian Muslim women's movements in the world. The world post-9/11 has seen a rapid increase in discussions of Muslim women's lives in Islamic states and in states with substantial Muslim populations. Following this event, there is a sense of an Islamic identity that is more commonly shared among Muslim women today than in other historical periods. This identity is framed by a contentious political and ideological dichotomy between the West and Islamic states and other Muslim communities, albeit through the creation of an anti-West identity politics. This period has also witnessed a dramatic increase in research on Muslim women's status in order to better understand their lives and lifestyles, the societies in which they live, and the issues faced by Muslim populations in non-Muslim societies and in the West. Despite this scholarship, we still know far too little about the lives of Muslims in Asia.[2]

This book brings together essays that contend with issues of feminisms and women's movements as they pertain to Muslim women's lives in Asian countries and in the Western diaspora. Each essay in this book speaks to Muslim women's struggles to claim agencies and rights within their countries as dictated by regional historical, political, and social institutions that lead to constantly shifting cultural values and prescriptions. Shifting of cultures is also a result of global embroilment, and thus these essays illuminate how

women's lives are directly influenced by them. This collection offers nuanced insights into scholarly debates that wrestle with the current politicization of Islam, particularly for women who reside in countries with a Muslim majority or have a substantial Muslim minority. These collected essays fill a void in the literature on Muslim women in Asia and bring to the forefront debates that critically engage and expand our understanding of transnational feminisms. By addressing the question of what is gender equality, this book explores ways in which a multifaceted understanding of Islam can contribute to productive dialogue about the future of Muslim women in Islamic and secular states and in the Western diaspora.

Much has been written and debated about women's rights in Muslim countries where women themselves are divided on the "best practices" approach to empower women. Most of these debates, however, have been confined to academia. Bridge building is essential to relate these academic debates to women's realities, and vice versa. In attempting to do so, one might be able to defuse tensions among academics, theologians, and feminists, and importantly, help to influence government, international institutions, and policy makers more effectively.

While there is rightfully a revival of the debate on women in Islam, especially regarding their representation in the Quran, this has, until now, largely intended to address the West's perception of Muslim women. The essays in this book decenter the West-centric framework of feminism and offer an exploration of women's status within their own social, economic, and historical contexts. When Muslim women choose to conform to an Islamic lifestyle, they are viewed by Westerners as symbols of a regressive Islam that is oppressive to all women, whereas Islamists see them as supporters of the perfect Islam that reinforces Islamic patriarchy and "rejects" Westernization. If Muslim women choose not to conform to a "strict" Islamic lifestyle, they are seen as betraying the Islamic cause by their "brothers," and viewed by Westerners as "liberated" women who oppose "oppressive" Islam and conform to Western feminism. Such external constructions and expectations of women's behavior render their own decisions, choices, and life circumstances invisible, and their realities are reduced to simplistic and judgmental interpretations.[3] The essays in this book deconstruct Western hegemonic interpretation of Muslim societies and the everyday lives of Muslim women to reveal the multiple realities of Muslim women in Asia and the diaspora, and contribute to an understanding of women within their local cultures. In so doing, the essays create a dialogue between empowerment and religious spirituality. They also challenge the oft-repeated sentiments that "Muslim women are victims," and that Muslim societies are hyper-patriarchal, thereby

concluding that Muslim women need to be rescued and protected by the West. In challenging these notions, this book speaks to the complexity and diversity of Islamic/Muslim feminisms and to the heterogeneity of the Muslim population, and focus instead on Muslim women's agency. As editor of this set of essays, my objective is to expose the reader to a range of complex discussions on the multiplicity of Muslim women's lives that speak to the diversity and, at times, contradictory consequences of Islamization, secularization, and local politics for Muslim women. This book opens up spaces for future research and understanding of Muslim women's lives and reflects on how Muslim women "build and extend their social knowledge within the larger nexus of nationalism, kinship and religion."[4]

Locating Islamic and Non-Islamic Feminisms in Asia[5]

The word *feminism* continues to be a contested term globally. In the modern era, with the emergence of Islamic states forty years ago, and the rapid spread of the faith and its intensity around the world, "concern" over Muslim women's lives has increased. Scholars studying women in Muslim societies have responded by defining feminism in new and nuanced ways, and challenging what they perceive as "Western feminism." In general, these challenges have led to two broad theorizations of feminisms—Islamic feminism and secular feminism—that are rooted in support of and opposition to Islam and its impact on Muslim women's lives. As explicated in my earlier work on the deconstruction of these two feminisms,[6] many liberal feminists see Islamic feminism as a paradox or oxymoron, while those who conflate feminism with Western feminism see secular feminism as problematic in Islamic states and for Muslim women globally. But there is a contested space between these two theories where the lives of most Muslim women are situated. It is in this space that I engage with the concept of collaborative/hybrid feminism in an attempt to expand the discussion on this evolving trend in studies of feminism. To clarify, "hybrid feminism" does not necessarily refer to a blending of Islamic and secular feminism to create a new form of feminism, but rather implies a compromised agreement reached by the two opposing feminisms and feminists on issues pertaining to women that they deem oppressive. Thus, an example of hybrid feminism would be the Domestic Violence (Prevention and Protection) Act of 2012 in Pakistan. A group of multiparty women formed the Women's Caucus in the Pakistani Parliament and fought together to bring about this Act without compromising on their feminisms (ranging from Islamic fundamentalist to secular).[7] Such feminism

does not challenge patriarchy head-on but is a movement that is issue-based in its approach.

An interesting debate also exists amongst Asian Muslim feminists who are educated in the West and in their home countries. Exposure to Western feminism and to the realities of women's lives in their home countries and in the diaspora has led to ideological positions on feminism grounded in the "politics" of their own location in a globalized world. Most secular feminists base their feminism on a human rights discourse, which they see as fundamental to secularism.[8] Then, there is a category of secular-left intellectuals and feminists[9] "who espouse Islamic feminism as a "strategy" with an emphasis on reinterpretation of the Quran[10] by questioning the Hadith[11] and Shariah[12] in Islamic states."[13] Another set of scholarship on Islamic feminism delves into the Quran and other texts of Islam to claim that the texts do guarantee equal rights to women, and that it is through the false interpretations of these texts that women have been rendered subservient to men.[14]

Based on the lives of women in their local cultures, a group of feminists[15] have focused more on class and theories of patriarchy rather than just religion, in this case Islam, to analyze women's disparate status in society. Thus, for Muslim women whose lives are positioned at the intersection of kinship, local culture, religion, class, ethnicity, nation, and global politics, "hybrid feminism provides a useful analytic tool to address women's issues."[16] One needs to look for coalitions that can emerge in different communities, and which are able to bring together Islamic, secular, and other discourses in a collaborative form that attend better to women's lives and sense of personhood. Muslim women's heterogeneous realities challenge mainstream/ Western feminisms, since these women's lives, as products of local cultures and politics, do not fit into typical Western feminist ideological compartments. Muslim women's lives also do not conform to the rigid parameters of a secular or Islamic nation but are impacted by women's class, region, ethnicity, and local politics. These variables could potentially give women the option to negotiate their status and rights contrary to the dominant ideology. Toward this end, the essays in this book articulate the numerous interpretations of Islamic, secular, and hybrid feminisms that have surfaced in Islamic and non-Islamic democratic and secular states in Asia.

The important question here is: what are the best discourses to bring about progressive policies for equal/better rights for Muslim women in Islamic states and other Muslim communities? The essays in this book address this question from various authors' perspectives and expertise, employing interdisciplinary approaches and methodologies, "yet each essay is infused with the particularity of its context."[17] The book is divided into three parts. Each

part, while focused on the thematics of its specific topic, builds on the previous parts to expand the discussion on Muslim women's lives—from claims for individual agency, to relationships with the nation state, and ultimately to how transnationalism affects their lives and identity. Part I of the book focuses on "conceptually redefining empowerment;" Part II "is anchored in a feminist analysis of Muslim women's discursive and material practices"; and Part III "highlights some of the dilemmas at the heart of the transnational Muslim women's specific realities and histories."[18] Each essay is framed in accordance with the main theme of the relevant Part, with a discussion preceding that abstract. These discussions are substantiated by meticulous analysis of the contestory space in which they are embedded.

Part I. Whose Feminism?
Muslim Women Redefining "Empowerment"[19]

The emergence of contemporary Islamic feminisms in the modern world is the product of the Islamization of particular countries such as Iran, Afghanistan, and Pakistan since the late 1970s and early 1980s, and in response to 9/11 in the United States. The latter event created a renewed awareness of the "us versus them" divide between the Muslim world and the Western world. These historical precedents are important because women in these societies have had to wrestle with their everyday realities, as limited as they may be, and engage in processes to empower themselves. Islamic feminism, while different in its message from secular feminism, may have been an appropriate strategy for women to employ under the watchful and critical eyes of Islamic regimes. While some women choose Islamic feminism for pragmatic reasons, others view it as an appropriate form of feminist dialogue and struggle. For many women, Islam is used strategically to empower women within an Islamic framework.

As noted earlier, "Islamic feminists are seeking Muslim women's emancipation within the rubrics of Islamic patriarchy whether progressive, modernist, traditionalist, pragmatist, neo-Islamist, or fundamentalist."[20] Many Asian feminists distinguish between equity and equality, and argue that gender roles are complementary and assign "equitable" rights to each gender. A phrase such as "separate but equal" is used to define Asian feminism. Rebecca Foley[21] through research in Malaysia "elaborates that equity refers to fairness whereas equality to equal rights with men."[22] Many Islamic women theologians and scholars refer to empowered women in Islamic texts to challenge the subservience of women during the early stages of Islam in Arabia

by pointing to Prophet Muhammad's wife and the first convert to Islam, Khadija, who ran a flourishing trade business. As another notable example, Prophet Muhammad's last wife, Ayesha, led a battle on camelback to fight against Ali, who had laid claim to the caliphate in Arabia.

Islamic feminist theologians base their understanding of gender relations primarily on the Quran rather than the Sharia. Sharia is the prescriptive text of Islamic law that is based on the Quran and Hadith. Though Sharia compilations started shortly after Prophet Muhammad's death, the text solidified its legitimacy almost a hundred years later by incorporating local traditions and politics that were far removed from the early Quranic era. For example, the oft-quoted Islamic theologian Riffat Hassan claims that human rights are not the prerogative of secularism and can be claimed through a proper understanding of Islam. Hassan recognizes the atrocities perpetuated against Muslim women such as honor killings and discrimination against girl children in Pakistan, but is quick to point out that such institutions are not part of the Quran.[23] Politicization of religions legitimizes moral and social codes that lead to gender discrimination, and gender hierarchies exist in the texts of all mainstream religions. Therefore, Islamic theologians do need to deconstruct the religious texts as they are interpreted today to align with social changes and cultures to ensure women's rights.

Since all women, religious or nonreligious, live in patriarchal societies, research reveals that many women are keen to conform to religious ideals in what I term "patriarchy trading,"[24] a negotiation that allows them to claim some agency and access to spiritualism. Through various case studies, the following essays elaborate the notion of agency and "empowerment" for Muslim women within an understanding of Islam that is perceived to be "fair" and "just," and "Islam is shown to be a discourse and form of praxis utilized by Asian Muslim women."[25] The following four essays examine women's agency not only expressed through their decisions to engage actively with their faith, but also through the strategies these women employ as believers. In all four essays, Muslim women tussle with their perception of Islam and how their contribution to their faith as leaders, participants, and enforcers through their class status empowers them.

Svetlana Peshkova, in her essay, asks the basic question, "Can Muslim women lead?" The questions of whether women can be leaders and in what capacity are central in debates about leadership in Muslim communities. Peshkova argues that our understanding of Muslim women's leadership (as otinchalar) should not be reduced to its social manifestation and constitution, but must include an analysis of an important and often ignored dimension of leadership—its emotional nature. Without the human body, mind,

and consciousness, leadership as a concept and a set of actions does not exist. She develops this argument by analyzing leadership provided by some Muslim women in Uzbekistan. By foregrounding the in-bodied existence of an individual as a part of a composite society, Peshkova challenges existing debates about women's leadership to reflect corporal location and emotional constitution.

Similar to otinchalar in Uzbekistan, Alexander Horstmann examines women's empowerment through faith in his research on women in Tablighi Jama'at's Missionary movement in Southern Thailand. Horstmann argues that lower-class women shed their economic, social, and gendered marginality in society by becoming Tablighi missionaries. Such women are encouraged by the leadership of the movement, despite protests by other Muslims and even some within their movement, to step out of their homes and travel to proselytize the faith. These women are also seen as instrumental in developing boundaries between the Muslims and Buddhists in an attempt to foil the dominance of Buddhism in their region. Through their participation in this movement, which continues to be male dominated in its leadership, Muslim women are able to transcend class and ethnic boundaries as they are absorbed within the Tablighi Jama'at Missionary movement.

Another example of claiming empowerment through Islam is the work of Maris Boyd Gillett who, through nearly two decades of ethnographic research in Xi'an, China, describes the lives of three Hui women who express their agency as "empowered" Muslim women in their village. Through their stories, Gillett highlights the rise of Islamic consciousness among the Hui, especially men, who with the aid of their wives become better followers of the faith, and create more peaceful marital lives for themselves. She elaborates on this process by detailing the lives and decisions of three women, and concludes that they do not express agency through decisions pertaining to them as autonomous individuals, but rather as integral members of their collective and larger kinship relations. In so doing, Gillett deconstructs the concept of "women's empowerment" to determine what issues women themselves consider important to their social status and the well-being of their families, thereby contesting "Western feminist" notions of empowerment.

In her essay on conflicting Muslim groups in the Southern Philippines, Birte Brecht-Drouart skillfully delineates the politics of gender discourse as competing perspectives between two opposing Islamic parties and the national government of the Philippines (GRP). Brecht-Drouart points out how the discussion of women's issues and women's rights are confined to these competing patterns of Islamic politics, and thus are not part of discussions independent of political interests. This situation, according to the

author, limits space for any progressive laws to be considered and complicates debates on Islamic feminism. Besides making different claims on women's status through its diversity in the Philippines, Islam is a syncretic faith that has been preserved by the sultans to maintain their power in the community by ascribing women some political power—albeit those with class and clan status.

The essays in Part I speak to the complexity of Muslim women's roles in these regions, thus making it difficult to categorize these essays into neat compartments or distinct theorizations. Islamic feminists use religion as a framework to define gender roles and to structure their family and community and women's inclusion in the nation state. As the above essays reflect, the individual is subsumed by the collective that is presumed to preserve culture, religion, and family better than an individualistic approach. In this collective, Muslim women are able to legitimize and negotiate their status by reclaiming Islam through its various interpretations to augment the status of their communities.

Part II. Contesting Feminisms and Muslim Women's Movements in Contested Spaces[26]

While Part I focused on individual women claiming their stake and status as practitioners of their interpretations of Islam to enhance their communities, essays in Part II engage the State in their questioning of Muslim women's rights. In these essays, feminisms are contested and validated through competing interpretations of secularism and women's rights. The essays in this part show that it is within secular states and human rights discourses that Muslim women fight for their right to follow their faith on their own terms. While cognizant of the space secularism provides for alternative discourses on Muslim women's rights, these essays critique the same space for stifling those rights. All four essays complicate the arguments of secularism and Islamism by critiquing limitations both ideologies place on women's rights.

An example of secularism providing contestory spaces for Muslim women is most visible in the cases of France and Turkey, where secular state policies ban or allow veiling of Muslim women in their respective countries. In France, wearing of headscarves and veils has been a contentious issue for some decades. Reclaiming their century-old laws and secularist philosophies, France banned the use of religious symbols in schools in 2004, following a fifteen-year debate to ban headscarves worn by Muslim

girls in schools. In 2011, the ban was extended to include full-face covering by Muslim women in public spaces, once again in the name of secularism. In Turkey, Kemal Ataturk prohibited the headscarf in his quest for secularism and modernization in 1924. This prohibition led to passionate debates between secularists and more Islamic-minded people in the 1980s. This debate became even more intense and, on the grounds of freedoms and rights, the headscarf ban was lifted in October 2013 with the support of the AKP (Justice and Development Party that is founded on a "liberal" Islamic agenda) that came into power in 2002. One of the strongest arguments proffered by conservative women was that the ban on headscarves prohibited their enrollment in education and participation in the workplace. In these ways, the essays in Part II question the duplicity of the State in order to reclaim religious rights.

Zeynep Akbulut, through ethnographic research, deliberates on the strategies head-scarved women in Turkey engage in to reclaim their Islamic rights in a secular democracy. She elaborates on how these women co-opt women's rights discourses to claim their space in a country generally hostile to veiling because it is seen as a reversion to fundamentalism. Akbulut's aim is to "elaborate on new discourses" such a situation creates among head-scarved women, and she does so by examining the State's right to exclude women from universities. She implicates the State in its denial of human rights to its citizens. Through her discussion of the Women's Rights Association against Discrimination (AKDER) and the Capital City Women's Platform, she explores how such organizations use the human rights discourse to demand rights to wear the headscarf. She concludes that through this process linkages can be created locally and internationally to bridge understandings between the secularists and religious interpretations of women's rights.

The essay by Nadja-Christina Schneider, thematically similar to Akbulut's essay, examines the "new forms of feminist articulations" among Muslim women in the context of secularism that India and the mainstream Indian women's movement have adopted. Through deconstruction of the concepts of "mobility" and "immobility," she relates them to Muslim women's representations, especially through media, to elaborate on the emergence of a "new" feminist movement. By examining the static construction of the Muslim woman, Schneider takes to task the right-wing Hindu movement and the restrictive Muslim Personal Law. In so doing, she considers the Muslim women's movement as located at the crossroads of transnational interpretations of Islamic feminism and the networks they enable, and how such interpretations translate for movement members. Schneider looks to Sisters in Islam in Malaysia to inspire the Muslim women's movement in India.

Yasmin Moll explores the epistemological assumptions of Islamic feminist discourses. Using the Malaysian group Sisters in Islam (SIS) as a case study, Moll argues that the hermeneutical strategies and activist methodologies of SIS partake in the same objectifying rationalities of the Malaysian state when it comes to Islamic jurisprudence. While acknowledging the important political labor performed by SIS in contesting patriarchal norms from within a religious frame, Moll highlights how this labor is made possible by the changing relations of knowledge and power that enable Qur'anic interpretation to be conceptualized as a matter of individual rights. She argues that such Islamic feminist claims and strategies take for granted the interpretive closure introduced by the codification of Islamic law in the modern period. Through her analysis, Moll shows how contemporary Islamic feminism, far from "reclaiming" an "uncorrupted" Islamic tradition, redefines the very epistemological basis of this tradition through advocating new ways of reading and relating to the Qur'anic text.

Following on the heels of Moll's essay, on a contrary note from Moll, Afiya Shehrbano Zia problematizes the wisdom of using Islam as a strategic tool for women's empowerment by secular working-class women and how women's movements in Pakistan occupy conflicting spaces in support or in contestation of state agendas. To quote Zia, her essay addresses "the interplay of the understandings and contradictions of Islamic and secular identity politics in the Pakistani women's movement." She claims that secularism in Pakistan has become a delegitimized space for fundamentalist Islamic groups to not just occupy to enforce Islamic impositions in certain aspects of Pakistani life, but especially to inflict severe restrictions on women's status. Zia helps debunk General Musharraf's regime in Pakistan that promised secularization and a progressive agenda for women's rights by exposing the false promise of "moderate" or "enlightened" Islam which the Islamists exploited to the fullest.

Together, the essays in Part II shed light on how the authors use a human rights discourse made possible through secularism to address contestory feminisms in their countries. As detailed in my work on women's rights in Afghanistan, a rights discourse is culture-specific and is not a universally detailed imposition by the West. In the study, I have posited that "the notion of universal human rights is a powerful ideology and philosophy but not the ideal political strategy when played out on the stage of global politics of the West and the Islamic East."[27] Democracies and secularism endow their people with the ability to claim rights that have been suppressed by states' opposition to these religious ideologies. But to reclaim religious and human rights within a secular democracy and within Islamic states is problematic and contestory, especially when trying to empower women. Part II "situates

faith-based Islamic feminism within the larger Islamic statist discourse to show that religion can be a lobbying force for justice for women"[28]—albeit with limitations in some countries.

Part III. Transnational Feminisms:
Locating Muslim Women at the Crossroads[29]

The essays in Part III address issues and responses to the complexity of transnational feminisms as they pertain to Asian Muslim women expanding the debate beyond the nation state. The essays in this volume could be seen as "case studies" from Asia and the diaspora that in nuanced ways wrestle with Muslim women's status and rights in diverse parts of Asia and the West. Authors in Part III reflect the "changing times" and engage in debates on what Islamic feminism is and its many avatars emerging from modernity and a transnational perspective. Through a deconstruction of the concepts of feminism and empowerment, authors locate Muslim women's lives and their options and choices within locally produced gendered discourses, expanding the meanings of these concepts and creating the space for further discussions and theorizing. In bringing these essays together, this part brings to the forefront debates that critically engage and expand our understanding of transnational feminisms.

In the larger understanding of globalization and feminist advocacy, Elora Halim Chowdhury draws our attention to the importance of transnational feminism in Muslim societies. Through her discussion of the anti-acid violence campaign in Bangladesh, Chowdhury analyzes "transnational feminist praxis" by engaging with the local, national, and international discourses that emerged when "victims" of acid throwing were brought to the United States. Chowdhury critiques existing linguistic/rhetorical frameworks assigned to women as "victims," "subjects," and "agents." In her assessment, she reflects on the complex relationships among women's organizations in the South.

Continuing with the complexity of transnational women's organizations, Cyra Akila Choudhury looks at transnational feminist advocacy by the Feminist Majority in the United States and RAWA (Revolutionary Afghan's Women's Association) in Afghanistan to critique liberal legal feminism. Choudhury's main contention is that liberal feminists co-opt justifications for colonialism and are not sensitive to Muslim women's lives. Using 9/11 as a watershed mark, she claims that there has been a bigger push since to "help" Muslim women by liberal feminists through their discourse on Western-style reform. Choudhury also critiques Governance Feminism as being rooted in a universalism that borders on imperialism. While acknowledging

the repressive strictures some Muslim women must abide to, she calls for a better understanding of the choices Muslim women may make. This essay points to the further damage militarization and appeals to international law and state interventions do to local women.

In a different setting but continuing the debates put forward by Choudhury, Beverly M. Weber's theoretical essay raises very pertinent questions about the validity of European Muslim women's claims regarding perception of women's rights and senses of democracy. Drawing on diverse European Muslim scholars, Weber elaborates on the complexities of such discourses. Her essay focuses on Muslim immigrants, a majority of them Turks living in Germany, to untangle the perceptions of these women and other Muslim immigrant women "in the face of racialized forms of exclusion." Weber attempts to understand the location of Muslim women's agency within the larger debate on Muslim women in Europe and how it complicates feminist thinking in the region. Weber, like Choudhury, questions the validity of Governance Feminism in its interface with state institutions to understand the location of Muslim feminism and its various incarnations.

All the essays in Part III build on previous ones "through selecting the issue of victimization as its subject."[30] Seeing Muslim women "as witnesses rather than as victims" disrupts the common assumptions of Muslim societies as "being static and [overtly] patriarchal." These essays call for a hybrid feminist understanding and solidarity that is crucial for creating an environment for learning and exchange of ideas. This theorizing can lead to examining critical issues that shape understanding feminism, Islam, and the complexities of women's lives transnationally. It is within the hybrid feminist discourse that Muslim women's lives can be negotiated given the struggles of the politics of identity formation by the Islamic and Muslim community and nation post-9/11.

Conclusion

I frequently ask the question: Can there be pragmatic value to developing a standard for feminisms for Muslim women that can be "modern" and holds up to more oppressive local conditions and politics and their particular forms of patriarchal domination? To answer this question, we need a comprehensive understanding of the local and global oppressions that exist in specific countries, and the feminist perspectives that can be brought together in a coalitional and negotiable manner. The essays in this book examine Muslim women's issues, feminisms, and women's movements through a "myriad of strategies and ideologies," and argue for the need to recognize that lived

experiences and political ideologies lead women to negotiate their rights and lives in diverse ways. Recognizing this need can contribute to the creation of new approaches and tools to analyze diverse feminisms and challenge hegemonic national policies. "[F]or example, Western feminists need to challenge their governments' policies and Islamic women need to challenge the religious extremism of their own governments' policies."[31]

As is apparent from all these essays, there is constant turmoil in women's lives and status due to shifting global and internal politics that complicate women's demands for justice and rights in all societies. These essays reflect some of the theoretical dilemmas of feminisms, feminists, and women's movements as they play out for Asian Muslim women in fundamentalist Muslim majority and minority countries in Asia and in the Western diaspora.

> Similarly, for women in Islamic states and in Muslim communities, dilemmas exist as to should they contest internal oppressive religious norms or "support" their communities in their resistance to westernization. These dilemmas mainly exist because of the politicization of not just Islam but also secularism. There needs to be a multi-pronged approach to understanding feminism in Islamic countries and Muslim communities giving prime importance to the multi-causal ground reality of women's lives.[32]

It is essential for feminists to look at women's reality in society in order to grasp an understanding of women's lives, and help craft consequential and implementable policies and build meaningful praxis. Sadly, the gap between theory and practice is glaring in all Muslim communities. The depiction and analysis of Muslim women's lives and agencies in this book are contrary to Western beliefs of constant objectification of Muslim women as oppressed, and diverge from Islamic fundamentalist expectations of Muslim women as being servile and obedient, preferably confined to "four walls." Rather, the essays present themes at the juxtaposition of feminism and activism, and highlight Muslim women as activists who do fight for and create for themselves situations that are liberatory.[33]

What is apparent is that national ideology, cultural hegemonies, international politics, and global dependencies contribute to the heterogeneity of Muslim women's lives. In so doing, various derived feminisms and demands of a range of women's movements lead to contesting feminist beliefs in contestory spaces. The objective of this book is not just to highlight women's lives as shaped by local conditions, but also to step back and look at the bigger/global picture to understand the complexity of issues when one tries to unravel the intricacies of women's lives anywhere, irrespective of culture or religion. The

essays in this book attempt to address the questions raised in this Introduction. I hope in their contestory nature these essays will, while educating readers on the diversity in realities of Muslim women's lives in Asia, also expose them to the complexities and dilemmas to render them curious enough to delve deeper into understanding the gendered politics of identity and religion.

Notes

1. Ahmed-Syed Jamil 2006, 1.

2. This book includes essays on Muslim women from Uzbekistan, Thailand, China, Philippines, Turkey, India, Malaysia, Pakistan, Afghanistan, Germany (Turkish diaspora), and Bangladesh.

3. Ahmed-Ghosh 2004.

4. Comment by anonymous reviewer of manuscript. May 2014.

5. Parts of this section are adapted, with permission, from a previous publication: "Dilemmas of Islamic and Secular Feminisms." *Journal of International Women's Studies* 9, no. 3, 2008.

6. Ahmed-Ghosh 2008.

7. See: Kalhoro, Sanam, 2014. *The Politics of Space and the Creation of the Third a Study of the Women's Parliamentary Caucus in Pakistan.* Unpublished Master's Thesis. Department of Women's Studies, San Diego State University.

8. To name a few, Moghadam 1993, 2002, 2003; Moghissi 1996; Sahidian 1994; Jalal 1991; Jahangir 1990; Khan 1994; Jilani 1998.

9. For example Tohidi 1998 and Najmabadi 1993 among others.

10. The Quran is the divine holy book of the Muslims revealed to the Prophet Mohammad over a period of twenty-three years starting in AD 608.

11. The Hadith is the compilation of the Prophet Mohammad's deeds and sayings as recollected by his Companions, wives, and others during the eighth and ninth century AD that dictate the way of life for Muslims.

12. Shariah is the Islamic religious law derived from the Quran and the Hadith during the seventh to ninth century AD.

13. Ahmed-Ghosh 2008, 102-103.

14. Wadud 1999; Webb 2000; Hassan 2004; Engineer 2001; Ali 1996; Mir-Hosseini 1996; Mernissi 1991; Karmi 1996.

15. Kandiyotti 1996, 1991, 1989; Lateef 1990; Hasan and Menon 2004; Khan and Zia 1995; Zafar 1991.

16. Ahmed-Ghosh 2008, 102.

17. Comment by anonymous reviewer of manuscript. May 2014.

18. Comment by anonymous reviewer of manuscript. May 2014.

19. Parts of this section are adapted, with permission, from a previous publication: "Dilemmas of Islamic and Secular Feminisms." *Journal of International Women's Studies.* Vol. 9, no. 3, May 2008.

20. Badran 2001, Yamani 1996; Najmabadi 1993.

21. Foley 2004.

22. Ahmed-Ghosh 2008, 103.

23. Hassan 2004.

24. Patriarchy trading: Ahmadi women are aware of the patriarchal constraints in their religion but opt for it over what they refer to as Western patriarchy, which is overlaid with resentment toward Islam and is racist. See Ahmed-Ghosh 2004.

25. Comment by anonymous reviewer of manuscript. May 2014.

26. Parts of this section are adapted, with permission, from a previous publication: "Dilemmas of Islamic and Secular Feminisms." *Journal of International Women's Studies* 9, no. 3, 2008.

27. Ahmed-Ghosh 2006, 126.

28. Comment by anonymous reviewer of manuscript. May 2014.

29. Parts of this section are adapted, with permission, from a previous publication: "Dilemmas of Islamic and Secular Feminisms." *Journal of International Women's Studies* 9, no. 3, 2008.

30. Comment by anonymous reviewer of manuscript. May 2014.

31. Ahmed-Ghosh 2008, 113.

32. Ahmed-Ghosh 2008, 112.

33. Idea from anonymous reviewer of manuscript. May 2014.

Bibliography

Afshar, Haleh. *Islam and Feminisms: An Iranian Case-Study.* New York: St. Martin's Press, 1998.

Ahmed, Syed Jamil. "The 'Non-dit' in the Zenana: Representations of Muslim Women in Islamic Canonical Texts, the Neo-colonial Imagination and a Feminist Response from Bangladesh," *Inter-Asia Cultural Studies* 7, no. 3 (2006): 431–455. doi: 10.1080/14649370600849306.

Ahmed-Ghosh, Huma. "Dilemmas of Islamic and Secular Feminisms." *Journal of International Women's Studies* 9, no. 3 (2008): 99–116.

———. "Voices of Afghan Women: Human Rights and Economic Development." *International Feminist Journal of Politics* 8, no. 1 (2006): 110–128.

———. "Portraits of Believers: Ahmadi Performing Faith in the Diaspora." *Journal of International Women's Studies* 6, no. 1 (2004): 73–92.

Ali, Zeenat Shaukat. *The Empowerment of Women in Islam.* Mumbai, India: Vakils, Feffer, and Simons, 1996.

Badran, Margot. "Understanding Islam, Conservative Islam and Islamic Feminism." *Journal of Women's History* 13, no. 1 (2001): 47–53, 2001.

Engineer, Asghar Ali. *Islam, Women and Gender Justice.* New Delhi: Gyan Publishing House, 2001.

———. (Ed.). *The Shah Bano Controversy.* New Delhi, India: Orient Longman, 1987.

Foley, Rebecca. "Muslim Women's Challenges to Islamic Law: The Case of Malaysia." *International Feminist Journal of Politics* 6, no. 1 (2004): 53–84. doi: 10.1080/1461674032000165932.

Hasan, Zoya, and Ritu Menon. *Unequal Citizens: A Study of Muslim Women in India.* New Delhi: Oxford University Press India, 2004.

Hassan, Riffat. "Are Human Rights Compatible with Islam? The Issue of the Rights of Women in Muslim Communities." http://www.religiousconsultation.org/hassan2.htm. Accessed October 1, 2004.

Jahangir, Asma, and Hina Jilani. *The Hudood Ordinances: A Divine Sanction?* Lahore, Pakistan: Rohtas Books, 1990.

Jalal, Ayesha. "The Convenience of Subservience: Women and the State in Pakistan." In *Women, Islam and the State*, edited by Deniz Kandiyotti, 77–114. London: Macmillan, 1991.

Jilani, Hina. *Human Rights and Democratic Development in Pakistan.* Lahore, Pakistan: Human Rights Commission of Pakistan, 1998.

Kalhoro, Sanam. *The Politics of Space and the Creation of the Third: A Study of the Women's Parliamentary Caucus in Pakistan.* Unpublished Master's Thesis. Department of Women's Studies, San Diego State University, San Diego, California, 2014.

Kandiyoti, Deniz. (Ed.). *Gendering the Middle East: Emerging Perspectives.* Syracuse, NY: Syracuse University Press, 1996.

———. (Ed.). *Women, Islam, and the State.* Philadelphia, PA: Temple University Press, 1991.

———"Women and Islam: What Are the Missing Terms?" *Women Living Under Muslim Laws.* Dossier 5/6, 69–86, 1989.

Karmi, Ghada. "Women, Islam and Patriarchalism." In *Feminism and Islam: Legal and Literacy Perspectives*, edited by Mai Yamani, 68–86. New York: New York University Press, 1996.

Khan, Nighat Said, and Afiya Zia. (Ed). *Unveiling the Issues: Pakistani Women's Perspectives on Social, Political and Ideological Issues.* Lahore, Pakistan: ASR Publications, 1995.

Khan, Nighat Said. "Reflections on the Question of Islam and Modernity." In *Locating the Self: Perspectives on Women and Multiple Identities,* edited by Nighat Said Khan, Rubina Saigol, and Afiya Shehrbano Zia, 77–95. Lahore, Pakistan: ASR Publications, 1994.

Lateef, Shahida. *Muslim Women in India: Political and Private Realities, 1890s–1980s.* New Delhi: Kali Press for Women, 1990.

Mernissi, Fatima. *The Veil and the Male Elite.* Cambridge, MA: Perseus Press, 1991.

Mir-Hosseini, Ziba. "Stretching the Limits: A Feminist Reading of the Sharia in Post-Khomeini Iran." In *Feminism and Islam: Legal and Literacy Perspectives,* edited by Mai Yamani, 285–319. New York: New York University Press, 1996.

Moghadam, Valentine. *Modernizing Women: Gender and Social Change in the Middle East.* Boulder, CO: Lynne Rienner, 2003.

———. "Islamic Feminisms and its Discontents: Toward a Resolution of the Debate." *Signs* 27, no. 4 (2002): 1135–1171. http://www.jstor.org/stable/10.1086/339639.

———. *Identity Politics and Women: Cultural Reassertions and Feminisms in International Perspective.* Boulder, Col: Lynne Rienner, 1993.

Moghissi, Haideh. *Populism and Feminism in Iran: Women's Struggle in a Male-Defined Revolutionary Movement.* New York: St. Martin's Press, 1996.

Najmabadi, Afsaneh. "Veiled Discourses—Unveiled Bodies." *Feminist Studies* 19, no. 1 (1993): 487–518. doi: 10.2307/3178098.

Shahidian, Hammed. "The Iranian Left and 'The Woman Question' in the Revolution of 1978–1979." *International Journal of Middle East Studies* 26, no. 2 (1994): 223–247. doi: 10.1017/S0020743800060220.

Tohidi, Nayareh. "The Issues at Hand." In *Women in Muslim Societies: Diversity Within Unity,* edited by Herbert Bodman and Nayereh Tohidi, 277–294. London: Lynne Rienner, 1998.

———. "Gender and Islamic Religious Extremism: Feminist Politics in Iran." In *Third World Women and the Politics of Feminism,* edited by Chandra Mohanty, Ann Russo, and Lourdes Torres, 251–270. Bloomington: Indiana University Press, 1991.

Wadud, Amina. *Quran and Woman: Rereading the Sacred Text from a Woman's Perspective.* New York: Oxford University Press, 1999.

Webb, Gisela. *Windows of Faith: Muslim Women Scholar-Activists in North America.* Syracuse, NY: Syracuse University Press, 2000.

Yamani, Mai. "Introduction." In *Feminism and Islam: Legal and Literacy Perspectives,* edited by Mai Yamani, 69–86. New York: New York University Press, 1996.

Zafar, Fareeha. *Finding our Way: Readings on Women in Pakistan.* Lahore, Pakistan: ASR Publications, 1991.

Part I

Whose Feminism?

Muslim Women Redefining "Empowerment"

Chapter 1

Muslim Women's Leadership in Uzbekistan

Religion and Emotion

Svetlana Peshkova

Leadership and Emotions

Women's ability to provide religious and political leadership in their communities is debated in Muslim and other faith-based communities (see Abugideiri 2001; Mattson 2008; Stowasser 2001; for such debate in Christian communities see Harris 2004). This debate includes perspectives from those who see such leadership as un-Islamic; it manifests a growing Westernization and, therefore, is among the factors leading to Muslims' moral corruption (e.g., Shehab 1986). The proponents of women's leadership include those who insist that women are not only able, but also, as *khalifahs,* God's moral agents on Earth, responsible for leading their communities (Wadud 2007, 14, 33). Although these views differ greatly, they share a focus on the social effects of leadership and its sociohistorical and/or theological, not corporal, constitution. For instance, Amina Wadud (2007), an Islamic feminist and religious and political activist, demonstrates through a personal example the importance of biology in the discussion of leadership. Yet she does not elaborate on the role of the human body in the constitution of individual leadership (e.g., Wadud 2007, 172). In this chapter, I argue that sociohistorical context, theology, and cultural grammar, which includes shared understandings and expressions of individual religiosity, certainly inform but do not entirely determine individual leadership; hence, an analytical approach limited to these factors does not fully explain leadership. By ana-

lyzing in-bodied—located within a physical body—feelings and desires, such as a feeling of being a leader, I argue that an analysis of Muslim women's leadership (or human leadership in general) should include its emotional constitution; being a leader is a part of one's autobiographical self, which is "a real entity in our neuro-cognitive system" (Marranci 2009, 18). Therefore, human leadership has ecological and not social or theological ontology (see also Csordas 1990).[1]

To advance this argument, I utilize Gabriele Marranci's (2006) theory of identity built on a fusion of anthropology and neuroscience. While synthesizing the work of a behavioral neuroscientist, Antonio Damasio (2000), and anthropologists Kay Milton and Gregory Bateson, Marranci, himself an anthropologist, argues that the self and identity are not abstract analytical concepts; the former is "a product of complex neurological systems," while the latter is an "emotional commitment through which people experience [and express] their . . . selves" (2006, 45, 7). This way, the self and identity are determined neither by social processes and cultural expectations, nor by biology and psychology (Marranci 2006, 40). Rather, personal identity is a process that allows the self to make sense of and express emotions and feelings that are activated by interaction with the surrounding environment; it is "what we feel to be [and not how others define us] that determines our personal identity" (Marranci 2009, 18).[2]

Therefore a feeling of being a leader is an outcome of complex neurological processes that involve emotion, consciousness, and the surrounding environment; emotions are "integral to the processes of reasoning and decision-making" (Damasio 2000, 41). If we accept that leadership is, first and foremost, emotional and in-bodied, then the questions of whether one can or cannot be a leader and what kind of leadership one can assume are secondary to ecological emotions, which constitute a human desire to lead; these emotions generate the feeling of being a leader (or make one feel like a leader).

The emotional constitution of Muslim women's leadership by no means makes their leadership less "rational" ("scriptural" or "orthodox") than leadership offered by men. Both men and women feel themselves to be leaders; they articulate and act on their feelings. These feelings, perceptions of emotions, are something intangible, something that cannot really be taken away or reconstituted by the social, as long as individuals perceive their actions as meaningful and their missions as viable. I do not want to diminish the significance of the sociohistorical and ecological context within which these missions acquire meaning and viability. This context is instrumental to being a leader, whereas a human body, consciousness, and emotions are essential for leadership.

In the following paragraphs, I exemplify the emotional constitution of leadership and its expression in acts of identity (e.g., ritual leadership) through an analysis of leadership provided by *otinchalar* or *otins* (Muslim women teachers and leaders) in Uzbekistan, a Central Asian country comprising part of the former Soviet Union.[3] I conclude this chapter by situating otinchalar among other female leaders and demonstrate this argument's significance to debates about Muslim women's leadership. I exemplify its in-bodied origin and emotional constitution by analyzing leadership offered by Amina Wadud, an Islamic feminist, and Zainab al Ghazali (d. 2005), a famous Egyptian Islamist (for a thoughtful criticism of subsuming Muslim women's gender struggles under such categories as "Islamic feminist" or "Islamist" see Seedat 2013). Because one's leadership is essentially emotional and in-bodied, in spite of how others evaluate them, these and other women leaders continue to effect change in themselves and others.

The State, Islam, and Otinchalar in Uzbekistan

In Uzbekistan, there are two clear, historically embedded, tracks of gendered religious authority (Khalid 2007; Sultanova 2011). *Otinchalar* (the singular is *otincha*), female religious teachers and leaders, facilitate ritual life of and provide religious instruction, and sometimes healing, to the members of their communities (Peshkova 2006, 2009a; Fathi 1997; Kamp 2006; Kandiyoti and Azimova 2004). Since Uzbekistan's independence from the Soviet Union in 1991, Islam, as understood by religious, intellectual, and political elites, has become a foundation of the Uzbek state's nationalist ideology, and the number of individuals wanting to reorient life toward "correct" Islam has increased (Adams 2010; Rasanayagam 2010; Peshkova 2013).[4]

In the late 1990s, responding to a political opposition articulated in terms of Islam, the Uzbek government tightened its control over diverse religious sensibilities and behaviors espoused by its citizens. As a result, non-institutionalized religious instruction was prohibited. Missionary activities by Muslim and non-Muslim groups were banned. All religious organizations had to register with the Muslim Board of Uzbekistan, a state institution, while the individuals teaching Islam or providing ritual leadership in their communities had to be certified. In order to prevent circulation of "extremist" ideas and anti-state propaganda, the government tightened its control over the Internet, religious literature, and audio and video recordings featuring Islamic preaching (Kendzior 2010). The government's agencies, such as the National Security Service, continue to routinely penalize Muslims

whose religious sensibilities and behaviors are deemed to be political (e.g., McGlinchey 2011; Human Rights Watch 2007).

Otinchalar are among informal leaders operating in this context. A very small number of them hold a (formal) public office, such as local *imams* (male prayer leaders) (for a discussion of an administrative position of *hokymiat* [city government] *otin* see Peshkova 2014). Even though these women's leadership mainly focuses on ritual performance, they act as both religious and political leaders in their communities (Peshkova 2009a). Otinchalar do not (usually) express their political leadership by engaging the state directly through such actions as public protests. Rather, their political leadership manifests in their efforts to increase individual piety, including providing knowledge about Islam. They negotiate interpersonal conflicts and ease political and economic anxieties accompanying the daily life of local individuals through a ritual mediation between human and divine worlds.

This seemingly apolitical leadership also takes place in "unusual places," such as their homes, the private homes of individual Muslims, and at sacred sites, and not at the mosques (for an example of such leadership in Iran see Friedl 1989; for a description of private ceremonies see Peshkova 2009b; Kandiyoti and Azimova 2004). And yet, the government's criticism and its increasing efforts to monitor otinchalar's activities (e.g., Barrett 2008) point to the potentially subversive, political nature of their leadership, since they provide non-institutionalized religious instruction and officiate at ceremonies that religious authorities often define as nontraditional (for a discussion of "politics of piety" in Egypt see Mahmood 2005; Hafez 2011; for regional religious education see Peshkova 2014). Therefore, otinchalar's leadership exemplifies forms of leadership that are both religious and political, operating in and informed by a particular sociohistorical context, where Islam is both a symbol of national identity and a potential political contender to the government's nationalist ideology (Rasanayagam 2010; Adams 2010; McGlinchey 2011; for contextual nature of such leadership see Peshkova 2009a).

During the second decade of the twenty-first century, Uzbekistan's government agencies continue to control and manage individual religiosity—how religious sensibilities are understood and enacted. Such control includes, among other things, circumscribing individual ability to share religious knowledge, unless this knowledge is received or disseminated at religious institutions or by individuals accredited by the state (Abramson 2010). The police and National Security Service monitor, however successfully, ritual specialists' activities; informal religious leaders continue to be fined, harassed, and sometimes jailed (McGlinchey 2007). Despite the Uzbek state's attempts, informal religious teachers and leaders, like otinchalar, who

in most cases are not accredited by the state, still persevere and thrive (see Kamp 2006; Fathi 2006).

The Uzbek government's ideological emphasis on Islam and popular interest in religious knowledge and practice certainly sustain otinchalar's leadership, which is also historically embedded; as one of two tracks of gendered religious authority in the region, it endures in spite of political repressions. This leadership, in some cases, is also a function of individual resistance to the state's regulation of private religiosity (see Scott 1985; for examples of such resistance in the region see Karagiannis 2006). Economic hardships experienced by local individuals ensure continuity of otinchalar's leadership as well. These women's access to religious and ceremonial knowledge and their ability to skillfully navigate and negotiate a "cultural supermarket," where different understandings and expressions of Muslimness compete and coexist, enables and sustains their leadership (on global cultural supermarket see Mathews 2000; on contesting models of Muslimness in Uzbekistan see McBrien and Pelkmans 2008). In response to the trials of daily life, as intermediaries between human and divine worlds, otinchalar help local individuals tap into a supernatural moral order through their ceremonial leadership and religious knowledge. In return, these women's services are rewarded either monetarily or through goods (e.g., fabrics, scarves, food) (on Muslim women's leadership in Tajikistan see Usmanova 2009; on Muslim women's leadership in Kyrgyzstan see Borbieva 2012). In order to fully understand what propels their leadership, I, however, propose to look beyond its sociohistorical, economic, or ideological constitution, and focus on the human ecological emotions and feelings that constitute an individual's desire to lead. Marranci's (2006) theory of identity, briefly sketched in the following paragraphs, helps frame these women's persistent leadership.

The Self and Identity

Marranci (2006) argues that identity is not a by-product of social history and context, and cannot be fully understood without considering human consciousness and emotions. "The relationship between the individual and its surroundings is 'essentially emotional'" (Milton [2007, 71], quoted in Marranci 2009, 80). Emotions, according to Marranci (2009), are physical (bodily) responses to external stimuli, such as an increased heart rate, sweat, and an elevated blood pressure. Emotions are different from feelings, but both are central to the formation of human identity. Our interactions with human and nonhuman environments cause emotional responses. Since "*a*

state of emotion . . . can be triggered and executed nonconsciously [*sic*]," some of these responses we are conscious of, but not others (Damasio 2000, 37; italics in the original). Thus, following Milton and Svasek (2005), Marranci (2006, 51) concludes that although social interactions "surely" raise emotions, these have an ecological rather than social ontology.

With the help of consciousness, humans become conscious of emotions and articulate them as feelings, such as fear and love. These feelings then become a part of the memory of emotions experienced in different settings, while interacting with human and nonhuman others; this memory helps humans to develop an individual "self" (also see Damasio 2000, 36). This self is not just an analytical concept; it is "real" and "neuro-cognitive" (Marranci 2009, 18). Hence, through emotions we are learning about the world and ourselves, while creating ourselves as a unique historical continuity "beyond the immediate here and now" (Damasio 2000, 37).

Marranci (2006), like Damasio (2000), accepts that human consciousness and the self are not monolithic, but divided into the core and extended consciousness corresponding to the core and autobiographical selves. The core consciousness is a by-product of brain activities retaining information about how external stimuli affect an organism's internal state at a particular time in a particular space; it gives us "the feeling of knowing" (Damasio [2000, 172], quoted in Marranci 2006, 45). Because "we encounter an unending number of objects in our environment," the core self is "continuously generated and time related" (Marranci 2006, 45). The autobiographical self—how we know ourselves historically—"provides a sense of stability" by reactivating selected autobiographical memories (memories of emotions and feelings) and the information retained in the core self (Marranci 2006, 46). These memories enable a human to develop and realize her historical and temporal continuity. Therefore, without the neurocognitive system there would be no self, no "reflecting subject" and no "self-consciousness" (Marranci 2006, 45).

The self is different from identity. Identity is neither a style an individual selects, nor is it determined by others; it is a process allowing "human beings *to make sense* of their autobiographical self [*sic*] and to express it through symbols, which communicate at an inner level feelings that are in other ways directly incommunicable" (Marranci 2006, 48, 51; italics in the original). Symbols, such as language and dress, allow us to communicate what and how we feel deep inside.[5] Thus, identity, too, has an ecological and not social ontology. By enabling communication and feedback mechanisms between brain sites, physical body, and surrounding environment, as part and parcel of a human organism's survival, identity facilitates learning and,

therefore, is responsible for changes and continuities in one's autobiographical self (Marranci 2006, 47).

For example, my statement, "I am a mother," is a symbolic communication of my emotional commitment through which I experience my autobiographical self. (1) When I see my son, a surrounding environment—in this case human (could be nonhuman) and external (could be internal)—induces emotion; (2) his image reactivates particular brain sites containing memories of past experiences, such as his smile and his first words, and how I felt at the time—that is, the ecological emotions I had experienced that my consciousness helped to articulate as feelings (e.g., happy); (3) these emotions, in turn, through a number of signals in brain sites and the body modulate the manner in which I respond to his image—my blood pressure rises, I smile and feel happy; (4) I make sense of these emotions and my past experiences through identity and communicate my feelings through symbols—I make a verbal statement: "I am a mother." I feel like a mother, regardless of how others define me, and express this feeling through language. Therefore, individual identity certainly can, *but does not have to,* change as a result of social interactions because individual feelings (perceived and articulated ecological emotions), not social relations, determine identity. Social relations are part and parcel of my ecological environment; they are instrumental to myself and identity. For example, I might feel happy and complete in the context in which motherhood is glorified; or, as a working mother, I might feel terrible about contextually important virtues that I have failed to live up to, such as a full-time dedication to caring for my children.

To demonstrate how Marrranci's (2006) theory helps to better understand Muslim women's leadership, below I present a case study based on a life history of Bibi Gul', one among thirty local otinchalar, who I spent time with and learned from while conducting ethnographic fieldwork in Uzbekistan during the first decade of the twenty-first century.[6]

Bibi Gul'

In 2002, Jahon, one of the otinchalar I got particularly close to, introduced me to Bibi Gul', a "traditional" otincha, who continued performing customary ceremonies deemed un-Islamic by those Muslims whose understanding of Islam did not include a veneration of saints and local shrines (Jahon, interview, 2002). During our first meeting, Bibi Gul', the first and only woman who, in my experience, self-identified as an otincha and had a nose ring, was wearing a colorful loose dress and a scarf tied at the back of her neck. She

was about fifty years old, neither slim nor heavy. In order to form a unibrow, an attractive feature according to some local women, she connected her eyebrows with a dye made from *us'ma,* a locally grown plant used as a natural dye. Like a distant black bird, the unibrow separated Bibi Gul's forehead from the rest of her face and helped to set out her black, almond-shaped eyes, and the unruly locks of the henna-dyed hair defied the boundaries set by her headscarf.

Bibi Gul' told me that she presided over various ceremonies, including life-cycle ceremonies, such as *sunnat toy* (a feast celebrating a boy's circumcision), and propitiatory ceremonies, such as *Bibi Seshambe* (the Lady Tuesday). This exclusively female ceremony, which honors a popular female saint who communicates women's requests to God and grants blessings, is often criticized by formal religious leadership as un-Islamic (e.g., Kandiyoti and Azimova 2004). Although it was rare to have more than one otincha presiding over a ceremony, Bibi Gul' preferred to be "the only" otincha because otinchalar's understandings of "correct Islam" varied, and "they argued over little things, to show off who is smarter and who knows more" (on diversity and difference of otinchalar's "correct" Islam and the concomitant practices see Fathi 1997; Peshkova 2006).

During such ceremonies in her and other women's homes and at local shrines, Bibi Gul' recited the Qur'an or ceremonial texts pertinent to the occasion, told didactic stories, recited Central Asian classical poetry or performed religious hymns, and offered prayers on others' behalf to God (Peshkova 2014). Like other local otinchalar, Bibi Gul' had her own students; she called them her "followers" or the members of her "team," since the non-institutionalized religious instruction she offered them was prohibited. She also offered advice to the members of her *mohalla* (neighborhood), who consulted with Bibi Gul' on family matters, such as relationships between mothers-in-law and daughters-in-law. In such cases, Bibi Gul' observed gender segregation; she interacted only with women and her male relatives and avoided talking to other men.

Bibi Gul' came from a line of local religious leaders; she was "born an otincha." Her grandmother was "a very learned" local otincha. Her husband's father was an *imam* at a local mosque. Bibi Gul's grandmother taught her daughter, Bibi-Gul's mother, who also became an otincha in their mohalla. Bibi Gul's mother, in turn, taught Bibi Gul' the "proper" recitation of some parts of the Qur'an and "what prayers were appropriate for what occasion" (on importance of biological descent for otinchalar see Fathi 1997). Bibi Gul' has learned from her mother how to officiate at various ceremonies—what texts to use, what stories to tell, and about "proper" comportment. As much

as she could, Bibi Gul's mother taught "correct" Islam to all her female and male relatives, including her daughters in law. "My mother," added Bibi Gul', "taught us about kindness and respectful relationships among human beings, as instructed by the Mighty God."

Born in the 1920s, Bibi Gul's mother was a "*katta* [here means "famous"] *otincha*," who, in addition to Uzbek, "read and spoke *Turki* and *Tajiki* [older dialects of Uzbek and Tajik languages that used the Arabic alphabet]," and Farsi, like Bibi Gul's grandmother, who was born in 1901. Although religious observance "was prohibited" in the Soviet Union, "no one ever bothered" Bibi Gul's mother; she was able to have an uninterrupted career as an otincha throughout her life (on continuity of religious practices under the Soviet state's atheism see Khalid 2007). Bibi Gul' followed her mother's example; in the 1980s, she became a well-known otincha in her mohalla.

Family traditions, the ideological value assigned to religious knowledge and performance, and an economic necessity do not fully explain Bibi Gul's decision to be an otincha. At that time, Uzbekistan was part of the Soviet Union. Unlike independent Uzbekistan, the Soviet state's atheism did not encourage religious sensibilities and behaviors, and Bibi Gul's husband's job at a local *kolkhoz* (collective farm) was, according to her, sufficient to support a family. The Soviet secular education provided Bibi Gul' with knowledge of women's rights, particularly in regard to wage labor. As a result, she could have had some other job. Additionally, national traditions glorified motherhood and the role of women as housekeepers and caretakers, and officiating at ceremonies would have taken Bibi Gul' away from home.[7] Thus, her leadership was not wholly sociohistorically or ideologically determined. Rather, the dynamic of emotions, raised during her interaction with the surrounding environment, including her mother and grandmother, both katta otinchalar, helped Bibi Gul' to form knowledge about relationships between human and divine worlds. More importantly, the knowledge acquired during these interactions about such feelings as kindness and respect raised emotions, which became a part of Bibi Gul's autobiographical self. Her core consciousness, which retained information of how external objects (or information) affected her organism at a particular time and space, helped to create "the feeling of knowing" that she could be an otincha, just like her mother and grandmother were (Marranci 2006, 45). With the help of her autobiographical memory, Bibi Gul' reactivated the feeling (became conscious of it) of being or wanting to be an otincha; she knew it, because she felt like one. Through identity, Bibi Gul' made sense of and expressed her autobiographical self with symbolic statements, such as "I am an otincha," and actions, such as officiating at a ceremony.

As she continued interacting with her surrounding human and non-human environment, after the disintegration of the Soviet Union in the 1990s, Bibi Gul's core self continued changing. Through emotions, physical responses that precede feelings, she was connected to and learning from this environment, which was rapidly changing and included, among other things, since the late 1980s, an economic crisis, and, in the late 1990s, political repressions and religious persecution. Some of these emotions she articulated as feelings of financial insecurity and need and a fear of persecution. These feelings, in turn, became a part of Bibi Gul's autobiographical self, which she expressed through symbols and acts of identity, such as changing vocations—from being an otincha to becoming a businesswoman, and then an otincha again—and completing a two-year Arabic instruction course.

In and Out of Otincha

In her life, Bibi Gul' was in and out of otincha. Her husband worked for twenty-three years at a local kolkhoz. In the early 1990s, this kolkhoz was privatized, and Bibi Gul's husband lost his job. Since then, he drove a taxi-cab. "The 1990s" were a "difficult time" for her family. Although she knew that providing for the family was her husband's "traditional" and Islamic duty, Bibi Gul' felt that she had to help him financially support the family; "now [referring to post-Soviet Uzbekistan]" both spouses "had to" work in order to make both ends meet. As a result, she became a businesswoman. At first she traded locally, but in 1992 she travelled to Poland, where she bought clothes to sell at a local bazaar and to local stores for a profit. In 1996, she travelled four times to Russia. There, in the city of Samara, Bibi Gul' bought food staples, and, on her return, sold them to store owners in her hometown. In order to be a successful businesswoman, Bibi Gul' had to redefine her gendered comportment; she suspended gender segregation and regularly communicated with men unrelated to her.

The mohalla was very important in Bibi Gul's life. This was the place where she was born and raised and married her cousin, who too was born and raised in the same mohalla. Since she was travelling most of the time, Bibi Gul' was not available to her community and could no longer act as an otincha; she "felt bad" about it. "Thankfully," she was not the only otincha in the neighborhood. There was another older woman. But the members of Bibi Gul's mohalla did not want another otincha; they asked Bibi Gul' to "stay home" and be their "neighborhood's otincha." "I had to comply," Bibi Gul' chuckled, and added, "Since they [the members of her mohalla] have raised my salary," meaning that the gratuity she received for organizing and

presiding over ceremonies from those needing her services had increased. This gratuity could be paid as a sum of money, food, or goods, such as different kinds of fabrics (each several meters) or scarves (for more on otincha-lar's practices and forms of gratuity see Fathi 1997; Peshkova 2006). This "relieved" Bibi Gul' from travelling and enhanced her ability to facilitate her mohalla's ceremonial life.

With the help of the members of her mohalla, after several years of being a businesswoman, Bibi Gul's autobiographical self reactivated the memory of religious knowledge and practices retained in the core self and ensured her historical continuity as an otincha. Her mohalla's members certainly informed, but did not determine, her decision; they praised and requested her to "stay home," and rewarded her materially, through an increased gratuity. These factors generated emotions, which, in turn, propelled complex neurological processes that put Bibi Gul' in touch with her environment by reactivating autobiographical memories that modified Bibi Gul's sense of self, making her feel responsible for the ceremonial life in her community—she felt like an otincha again. Through identity she made sense of herself, which she communicated symbolically through the acts of identity, such as officiating at the ceremonies and offering prayers on behalf of her community members to God and her advice. Whereas social relations, ideology, socio-historical context, and economic necessity were instrumental to Bibi Gul's autobiographic self expressed through identity, the perceived and articulated ecological emotions were essential to her self-formation and expression; she was whom she felt herself to be, despite how others defined her.

"I do it"

In the late 1990s, in light of the government's growing interest in and attempts to control its citizens' religiosity, Bibi Gul' attended classes at a local Culture Center, an important social and educational institution in the Soviet Union and post-Soviet Uzbekistan. This Center offered two years of elementary instruction in Arabic, which helped Bibi Gul' to recite the Qur'an "correctly" and "understand some of its parts [better than others]." More importantly, since she was not registered as a religious teacher and leader with the "authorities," such as the Muslim Board of Uzbekistan, local police department, or the hokymiat (city hall), all institutions funded by the state, she felt that attending these classes, in a way, legitimized her activities.

Bibi Gul' was aware that teaching about Islam at home without the government's permission was prohibited. "But, I am an otincha," she said, "I [continue] do[ing] it." This was a symbolic communication of Bibi Gul's

emotional commitment to being an otincha; she experienced and expressed her autobiographical self through this statement. Bibi Gul' added that the local police and the National Security Service were aware of her role as a ceremonial leader and religious instructor in, and sometimes beyond, her mohalla. She smiled and noted, "They [the agents of the National Security Service] keep an eye [on me]. In their notes they keep me [they keep a record of her activities]. They know me. The government allows me. They have my photo." Then Bibi Gul' chuckled and added, "They keep everyone who reads the Qur'an on a blacklist;" she finished this statement by warning me that since I had visited her, I would also be put on the blacklist. Bibi-Gul' made sense of her life, her leadership, and the political situation at the time through the mechanism of identity; she expressed her autobiographical self with a symbolic communication that carried an implicit evaluation of the Uzbek state as politically repressive, where freedoms of religion and expression had clear limits and consequences; even though Bibi Gul' tried not to violate these limits, she was already on the "blacklist."

In light of such understanding of identity, Bibi Gul's leadership cannot be fully explained in terms of Soviet and post-Soviet history and concomitant social dynamics in Uzbekistan, such as the growing importance of Islam as a symbol of national identity or her community's request for her to come back as an otincha. These factors certainly informed but did not determine Bibi Gul's choices and actions and her desire to lead. This desire was really her own; it had an ecological and, since she believed that God was the origin of everything that exists, from her standpoint transcendental, not social, ontology. Despite growing persecution, despite the "blacklist," as long as she felt herself to be an otincha, Bibi Gul' continued being a leader.

Very active during the first decade of the twenty-first century, in 2010 Bibi Gul' became ill. Although there was no particular internal "organ that [was] in pain," she felt as if she could not control her aching and tired body. An ultrasound procedure carried out in a regional hospital "showed changes in [her] liver," and the doctor made her "drink olive oil, and then prescribed injections, right into the liver," which she had to get four times a week, each one of them costing "about 60,000 *soms* [Uzbek currency]."[8] Even though Bibi Gul' felt ill, and, as a result, rarely officiated at religious ceremonies, during *ro'za* (ritual fasting during the holy month of Ramadan) of 2011, she and several older women got together daily to read "*hatma qur'an* [recite parts of the Qur'an]."[9] Under Bibi Gul's supervision and with her assistance, they read the Qur'an "in Arabic with correct *tajweed* [rules of recitation] . . . one of the thirty parts of the Qur'an each day." She assigned homework to each

one of these women and decided which parts of the Qur'an they would read on any given day. "Bibi Gul' and *ejo komanda* [her team]," chuckled Bibi Gul' during our last conversation. Despite her illness, she continued to feel desire to lead and expressed her autobiographical self as an otincha through symbolic acts, such as the Qur'anic recitations. These recitations, in turn, had a physiological effect on her; because of them, Bibi Gul' "felt better."[10]

Otinchalar, by and large, did not represent official religious leadership and were not part of any state's institution. As a result, in the context of the government's promotion of politically correct religious sensibilities and behaviors, and the simultaneous curtailing of "incorrect" religious ethics by juristic and violent means, these women were less vulnerable, but not immune, to the government's social control. If their opinions were interpreted as diverging from those of formal religious leaders, often representing the government's views, otinchalar were still less accessible to formal legal sanctions than the leaders holding an official position. Nonetheless, in order to achieve their goals, such as leading the community's ceremonial life and providing some form of religious instruction, they had to strategize. During our last meeting in 2011, Bibi Gul' did not talk *about* the state of the Uzbek state, but talked *around* it; she expressed herself symbolically and very much metaphorically through a reference to a recent earthquake (July 20, 2011, magnitude of 6.1 M). While talking about the earthquake, Bibi Gul' noted, "If we could read the Qur'an and the roads were all open [for religious education and freedom of religion, expression, and association], we might not have had that earthquake;" a literary mode of religiosity (e.g., Qur'anic recitations) had ecological and environmental effects. According to her, until the "closed roads" were open, God would continue reminding Uzbekistan's people that there was something wrong with the state of the Uzbek state.

Driven by pragmatic considerations, in order to satisfy her and her family's needs and to improve their circumstances, Bibi Gul's life history, including her decision to renegotiate gender boundaries and continue providing ritual leadership, demonstrates that she did not blindly follow prohibitions and permissions issued by others. In the context of increasing religious and political persecution, she was not particularly afraid of political reprisal of her activities, justifying her leadership by references to her descent and a completed two-year Arabic course at the local Culture Center. Her ability to recite and understand the Qur'an better affected her sense of self; she felt like an otincha even more. Whatever her motivations might have been—to make money, criticize the government, pass time, or follow God's call—her desire to lead was a result of her ecological emotions and feelings. Her leadership

was in-bodied and emotional, because without a human body, mind, and consciousness, leadership as a concept and a set of actions would never have existed.

Despite living and aging in a state of prohibition, Bibi Gul' and women like her continue to effect change in themselves and others, while interpreting their actions as God's will. Everything and everyone can change, but, in this dynamic world, they have a static foundation, which, according to them, is God, who is real and does not change. God is God: caring, merciful, and all-knowing—the final judge of all that exists. They know and feel this knowledge through their ecological emotions.

Muslim Women's Leadership: Islamic and Islamist Feminists

Bibi Gul's leadership is one among many examples of Muslim women's leadership. An emphasis on its emotional constitution helps to understand leadership offered by other Muslim women in different countries and times. Several scholarly works discuss women's leadership in Egypt, Lebanon, Indonesia, Iran, China, and Kazakhstan, and demonstrate women's ability to lead, and the kinds of leadership women can assume, while making it clear that women's leadership is debated within Muslim communities (e.g., Mahmood 2005; von Doorn-Harder 2006; Jaschok and Jingjun 2000; Privratsky 2004; Hoodfar 2001; Deeb 2006; Hafez 2011; also see Peshkova 2009a). In some cases, this leadership is performed in public and/or private spaces and is supported by the government; in other cases, women's leadership is limited to domestic space and pilgrimage sites and is critiqued by the government and/or male religious leaders (e.g., Bottcher 2002; Mazumdar and Mazumdar 2002; McBrien 2009; Hamidi 2006; Peshkova 2009b). Some of these leaders advocate gender equality, and others gender equity and complementarity. I refer to the former as Islamic feminists and to the latter as women Islamists.

"Islamic feminism" is ideologically rooted in "the practice of Qur'anically-mandated gender equality and social justice;" it can be understood as a gender and social justice movement informed by the aftermath of the Iranian revolution (1979) and its effects on the Middle Eastern left and diasporas (Badran 2006).[11] Even though this movement is transnational, it is grounded in local contextual dynamics and focuses on local issues. Representatives of Islamic feminism insist on the importance of women's leadership, whether political or religious or both, that, in some cases, is different from, but always equally important to, men's leadership (e.g., Mattson 2008; cooke 2000; Badran 2009; for Islamic feminism as a "gender jihad" see Nomani

2005; Wadud 2007).[12] Reflecting Islam's cosmopolitan locations and aspirations, Islamic feminists engage with each other and non-Muslim feminists, transcending East/West, private/public, and religious/secular dichotomies (Badran 2009, 323; see also Badran 2006).

Islamic feminists, who may or may not claim such an identity (Badran 2002), follow several activist trajectories. Some articulate and promote a women-centered perspective and feminist hermeneutics of the Qur'an and the *Hadith* literature (the stories about and the sayings of the Prophet Muhammad and his companions) in the ways that affirm women's "egalitarian status in relation to family and society" (Moghadam 2002, 1156; e.g., Mernissi 1991; Wadud 1999; Barlas 2002; for a holistic approach to Qur'anic hermeneutics see Bakhtiar 2011; see also El Fadl 2001; Hassan 1999). Others investigate historical contexts of oppressive gender discourses and concomitant practices that expose a tension between the egalitarian message of the Qur'an and gender-based sexual and cultural hierarchies (e.g., Ahmed 1992, cf. Arkoun 1994). Yet others question an androcentric bias of Islamic jurisprudence (e.g., Mir-Hosseini 1996), and/or work on articulating and enacting new relationships between religion and the state, and advocate for social justice through implementing theological re-readings of the sacred sources; they call to challenge existing "laws and policies" based on "misogynist interpretations" (Moghadam 2002, 1160; for societal effects see Muñoz 2012). For example, Amina Wadud put her theological understanding of Islam into practice; by leading co-gendered ritual prayers, among other places, in New York City in 2005, she has challenged a prevalent notion that only males can be imams.

"Islamist feminists" also affirm women's religious and political leadership (for criticism of such feminism see, for example, Moghissi 1999). Active in every Muslim community, including immigrant communities, these women focus on piety (*taqwa*), an active effort to live one's life according to an Islamic ethical paradigm encapsulated in the Qur'an and explicated in the Hadith literature (e.g., Deeb 2006). This effort is inculcated and manifested through spiritual exercises, bodily actions, and religious education, and becomes a locus of female agency. Islamist feminists' religious leadership is also political; it is not necessarily animated by a direct engagement with the state or structures of oppression, but by a support of and solidarity toward men, family, and the community (e.g., Mahmood 2001, 2005; Hafez 2011; Kuumba 2001; Abdellatif and Ottaway 2007; Lewis 2007; cooke 1994; on women's use of Qur'anic resources to articulate gender equity in an inner-city in the United States see Rouse 2004).

Zainab al-Ghazali was a famous Egyptian Islamist and a mentor to male members of the Muslim Brotherhood, an important transnational

Islamic movement, and a leader of the Brotherhood's female part—the Muslim Ladies Association. She argued that women are entitled to *separate but equal* gender struggles and relations; women should not be afraid to take a political stance and argue for an establishment of an Islamic State, and actively engage in Islamization of a society by working on increasing religious observance in all aspects of human life (Lewis 2007).[13] According to al-Ghazali, women's roles in social reproduction were more significant than the men's roles; women were progenitors of "the kind of men that we need to fill the ranks of the Islamic call," and, as mothers and educators, the "building block[s]" of the "entire civilization" (Lewis 2007, 23; Hoffman 1981). In order to be progenitors and educators, women had to educate themselves, be pious and socially active, and engage proactively in a struggle to transform their society into "an uncorrupted Islamic nation" (Lewis 2007, 23). Therefore, in the process of social change, women's roles were *equitable,* if not equal, to men's—if a man was a *mujahid,* a fighter for God, a woman was a *mujahida,* a female fighting for God (Lewis, 2007, 35). Al-Ghazali's own life as a spiritual and political leader served as an example of such efforts (cooke 1994; cf. Marks 2011).

During the second decade of the twenty-first century, women Islamists, like Islamic feminists, continue to challenge not only their societies, but also to confront globally dispersed stereotypes about Muslim women as oppressed (e.g., Beyeler 2012).[14] Unlike Islamic feminists, they also face stereotypes about themselves either as oppressors or as suffering from false consciousness (for a criticism of a liberal discourse on rights see Mahmood 2006). Despite these challenges, they continue challenging a "prescriptive vision of secularized religiosity" and advocate for an alternative Qur'anic and *Sunna*-centered modernity built on a clearly gendered and hierarchical human society (Mahmood 2008, 106; Duval 1998).

In my experience, otinchalar in Uzbekistan did not self-identify either as Islamic feminists or Islamists (on Islamic feminism in post-Soviet Central Asia see Fernea 1998). Some otinchalar, similar to al-Ghazali, advocated for and led their communities, in different ways, toward a Qur'anic and Sunna-centered modernity (see Peshkova 2013). Other otinchalar, like Wadud, led their congregations in worship, except these congregations were limited to women only (Peshkova 2009b). While effecting change in their communities, slowly and carefully, these women's leadership reflected their faith in God and their understanding of a particular relationship between human and divine worlds, as between creatures and the Creator. From this perspective, human beings were not autonomous, not "free from the force of transcendental will, traditions, or custom" (Mahmood 2008, 105, 103). Therefore,

these women's desire to lead was not only contextual (Peshkova 2009a) but also reflected a monotheist theology. But, as I have argued in this chapter, neither context nor theology entirely determined their leadership. This leadership was essentially emotional; ecological emotions, a result of these women's interactions with human and nonhuman environments, articulated as feelings propelled these women's desire to lead.

Despite different historical and sociocultural environments, as humans, our existence depends on bodily reactions to stimuli "that our relationship with surrounding environment provokes" (Marranci 2006, 157). Therefore, not only Uzbek otinchalar's, but also other Muslim women's leadership, is essentially emotional and in-bodied. Below, I briefly illustrate the application of this approach to understanding Muslim women's leadership. The two women, whose leadership's emotional constitution I present in the final part of this chapter, are Amina Wadud and Zainab al-Ghazali. The following analysis does not do justice to the complex and entangled experiences and visions of these leaders but illustrates their leadership's emotional constitution and in-bodied location.

The Two Women: The Two Leaders

To Amina Wadud, sexism, racism, and classism, in the United States and elsewhere, were not abstract analytical concepts, but permeated with emotions, personal experiences, and feelings. Her struggles in the capitalist world, as a single mother, divorcee, African American woman, and a Muslim, were both obstacles and an inspiration for her feminist leadership (Wadud 2007, 60). Experiences of these "isms," and the ecological emotions accompanying them, generated feelings of injustice and personal responsibility to struggle for justice by stimulating ideological and practical changes in the lives of Muslims. These feelings became part and parcel of Wadud's autobiographical self that she made sense of and expressed through identity with symbolic communication and acts of identity, such as her leadership of co-gendered congregational prayers and scholarship, including her theological insistence that agency is a "full moral responsibility to obey the will of Allah" that cannot be restricted "on the basis of race, class, or gender" (Wadud 2007, 37).

According to Wadud, individual moral responsibility is an irreducible part of *taqwa* (piety), which she defines as a "moral consciousness in the trustee of Allah" (Wadud 2007, 40). Through ecological emotions, the feeling of moral responsibility became a part of her core consciousness and a part of her autobiographical self. Through identity she made sense of her

autobiographical self and the memory of emotions (e.g., a feeling of justice or a lack of thereof) propelled Wadud's engagement in "gender jihad"—the struggle against oppression for justice—the struggle that continues despite (or because of) the aforementioned "isms," and "despite experiences of utter dismay and humiliation in the name of Islam" that women like her undergo (Wadud 2007, 3). Thus, an overwhelming feeling of injustice and moral responsibility engendered Wadud's desire to "achieve living experience of justice for as many Muslim women and men as possible" and to lead others in such efforts (Wadud 2007, 16).

Wadud is very much aware of not only her embodied struggle and victimhood, but also of her in-bodied self. Human biology is prominently featured in her discussion and experiences of "gender jihad." The pain of menstruation and symbolic violence experienced by women who are denied a full ritual involvement because of it, the celebration of love as coitus and an absolute orgasm at the moment of giving birth, and the physical violence that can accompany some marriages, continue informing Wadud's "gender jihad." They motivate her to challenge existing "reformist" ideals held by those "whose 'fight' for justice focuses so exclusively on the right to preserve or extend greater privilege to the ones already privileged—Muslim men" (Wadud 2007, 126, 127). Wadud's understanding of the divine is permeated with biology and emotions—womb, mercy, and justice; these are necessary and irreducible elements of "gender jihad," which she defines as a struggle to restore the full human dignity and justice in human society (Wadud 2007, 159). Therefore, the leadership Amina Wadud continues to offer is contextual, theological, and gendered, but it is essentially emotional and in-bodied. She feels, rationalizes, articulates, and enacts leadership through her biological body, mind, emotions, and consciousness.

Zaynab al-Ghazali "had no formal training in religious issues and [probably] never received an education beyond secondary school," but she worked relentlessly toward a moral transformation of Egyptian Muslims though preaching, and was also actively involved in political struggles against the existing regime (Mahmood 2005, 67). As both a religious and political leader, al-Ghazali's struggle was determined not by theological debates and concepts, but, I argue, by ecological emotions that permeated her life experiences.

As a young female, al-Ghazali (1917–2005) felt frustrated with Egyptian feminists' efforts to achieve gender justice through secularization. In 1936, she formed the *Jamiat al-Sayyidat-al-Muslimeen* (the Muslim Ladies Association) with a goal of achieving gender justice through religion as "a means to personal agency and as a source of advancement" (Lewis 2007, 3).

Under the President Gamal Abdul Nasser, the Association was dissolved and al-Ghazali was arrested, tortured, and imprisoned. After six years she was released, but prohibited from speaking in public (Mahmood 2005, 68). She continued her leadership in public places created in private spaces, such as her home and private homes of individual Muslims. Al-Ghazali also wrote articles and essays urging fellow Muslims to greater piety and about her experiences and struggle against oppression. Her latter works recount the torture, anguish, pain, and an unbendable resolve to continue her struggle for justice and dignity as a Muslim woman and a religious and political leader (e.g., al-Ghazali 1989; for a different translation of this book see al-Ghazali 1994).

Although the idea of justice is clearly articulated in some Islamic texts, to al-Ghazali, the feeling of justice was not an abstract notion or divine decree. Through the stories about and experiences of colonialism and post-colonialism, being subjected to an unjust and violent treatment as an indigenous person, a female, and a Muslim, she formed her understanding of justice and dignity as essentially emotional (Marranci 2009, 94). From the interactions with her surrounding human and nonhuman environment that activated emotions (bodily responses) and then feelings (perceptions of emotions), she had learned how to feel dignity and justice or a lack thereof. She, as Marranci (2009, 94) rightly suggests, was "educated" through "personal memories that form[ed] . . . [her] autobiographical-self [sic];" she was educated through her body.

Al-Ghalzali's experiences in prison were fundamental to "educating" her how to, or not to, feel justice and dignity (al-Ghazali 1989). She had endured torture, including being thrown into a cell with hounds that bit into her flesh, "dumped into water cell, hanged, consistently flogged and thus subjected to all kind [sic] of physical and spiritual torture" (al-Ghazali 1989, 127). The torture, and the anguish it ensured, tested not only her physical body but also her emotional commitment to justice and dignity and strengthened the feeling of personal responsibility for bringing about change; she, to borrow Marranci's (2009, 101) words, "was looking for dignity, and so justice, not just with . . . [her] mind, but also with . . . [her] heart and feelings." These feelings became a part of her core consciousness and auto-biographical self that she made sense of and articulated through the acts of identity, such as praying and preaching, and in terms most familiar and dear to her—in terms of Islam: "How indebted I am to Him [sic] for putting me in the company of Muslims and selecting me for fighting in His cause and for testifying to His saying that Muslims have forfeited their lives and wealth in return for heaven to Allah. They fight in His cause and attain Martyrdom.

They are the best Ummah created for enjoying good and forbidding wrong"
(al-Ghazali 1989, 126).

Pain, Marranci (2009, 114) reminds us, is "one of the most powerful
emotions." Not only the pain that Al-Ghazali had endured, but also such
experiences as one guard's "repentance," a moral transformation generating
a desire to be "a Muslim anew," only reinforced her resolve to lead others
"to Allah" (al-Ghazali 1989, 136). Thus, a particular combination and rela-
tionships among the context, emotions, consciousness, and autobiographical
memories "produce bias which changes the links between the emotional
experience of dignity and other 'ideas' such as honor . . . justice, compas-
sion and mercy" (Marranci 2009, 95). In the case of al-Ghazali, these ideas
became ecological; they were now a part of her autobiographical self. Through
a mechanism of identity she made sense of and expressed this self in identity
acts, such as her political and religious activism until the end of her life.

Conclusion

In this chapter I have argued that individual leadership cannot be reduced
to its social manifestation and constitution. It is a part of an individual self.
This self is real; it is a part of the human biological body and its neurological
system. Unless the self is annihilated, or loses its ability to react to external
stimuli and to see life as meaningful, one's feeling of being a leader continues
to be *real* against all odds and despite prohibitions and approvals of others.
Therefore, I have proposed that in order to understand Muslim women's
leadership fully we have to start with an individual—with one's physical body
and neurological system that are essential to leadership.

Experiences of justice and dignity, or a lack thereof, and feelings of
personal responsibility for social change, which includes change within one's
self, are the result of a dynamic of emotions ensured by a human's interac-
tion with surrounding human and nonhuman environments. This dynamic
is central to formation of certain selected feelings, such as a feeling of being
a leader, or of being responsible for others, or as a desire to lead others
toward moral transformation. The women discussed in this chapter felt like
leaders and expressed this feeling through acts of identity, such as preach-
ing, ceremonial leadership, theological arguments, criticism of the existing
social structure and political system, and learning and teaching Islam. What
made them leaders was not only their sociohistorical, political, and economic
context, theology, and culture. A careful analytical consideration of the pro-
cess of forming autobiographical memories and their core selves by learning

through emotions about their surrounding environment, and making sense of their autobiographical selves by performing acts of identity, helps us to understand more fully why they continue leading others despite all odds.[15]

The analysis provided in this chapter leads me to propose that as long as Muslim women—be they Islamic feminists or Islamists—feel being leaders, as long as they see their lives as meaningful, and as long as they believe that leadership is instilled in them by God and is fundamental to their earthly lives, as well as instrumental to their afterlives, they do not (really) have to seek their community's, government's, or male religious leadership's consent to lead and permission to act. Although not without reservations, they act because they believe in God, not abstractly, but physically, through their ecological emotions. They feel that they are meant and have to officiate at ceremonies, as Bibi Gul' and many other otinchalar do; share their religious knowledge with and exhort others to change their lives, as Zainab al-Ghazali did; or lead co-gendered ritual prayers, as Amina Wadud does. Because their leadership is essentially emotional and in-bodied, in Uzbekistan, as in Egypt or the United States, in spite of how others evaluate them, women like Bibi Gul' continue to effect change in themselves and others, interpreting their actions as moral and believing in and insisting on having a "correct" understanding of Islam as a message of kindness, respect, justice, mercy, and dignity. Individual consciousness is fundamental to their leadership: unless these women are conscious of the fact that they are meant to effect change in themselves and others, there is no leadership either as a concept or as an actuality to speak of, and no social component of it. This process cannot happen without ecological emotions created while interacting with a surrounding environment.

Notes

1. This argument is based on an anthropological, not a theological, approach to analyzing leadership. Thomas J. Csordas (1990) presents a thorough review of the theoretical paradigm of "embodiment" and its genealogy in anthropological studies. The analysis I offer in this chapter continues a tradition of theoretical analysis of emotion, body, and its situated existence (see Csordas 1990).

2. Marranci (2009, 19) points out that Damasio (2000) sees identity as a mechanism—"a delicately shaped machinery of our imagination [which] stakes the probabilities of selection toward the same, historically continuous self."

3. In keeping with my previous discussions of Muslim women's leadership (2006, 2009a, 2009b), in this chapter, I continue to use the term "otinchalar" and its singular form "otincha."

4. Uzbekistan's population is about twenty-nine million and includes Uzbeks, Tajiks, Kyrgyz, Koreans, Russians, Roma, Jews, and others, who variously profess Islam, Christianity, Judaism, Buddhism, and atheism. Although statistics show that about eighty percent of the country's inhabitants self-identify as Muslim and seventy-three percent as Uzbek, local people construe and enact their religious and ethnic identity in a variety of ways. For instance, there are Muslim atheists who claim to not believe in God but who identify as Muslim because they were raised in Muslim households.

5. Symbols, such as language, are "filled with references to stimuli capable of provoking emotions which induce certain selected feelings" (Marranci 2006, 48).

6. Bibi Gul' is a pseudonym. The following narrative is based on materials collected through observations and interviews I conducted with Bibi Gul' and her family members during our subsequent meetings in 2002, 2003, and 2011.

7. Although the Soviet ideology equated women's liberation to wage labor, motherhood and childcare continued to be glorified and encouraged through long maternity leaves, free childcare, and so forth (on this and other discourses on women's rights see Peshkova 2013).

8. In the summer of 2011, 60,000 *soms* equaled about $20 to $25; in a week she would have to spend about $100 on this medical treatment.

9. The younger women in the mohalla were busy with house chores and rarely joined Bibi Gul' and older women at these meetings.

10. It would be interesting to explore the relations between her illness and the state of the Uzbek state. Because identity mediates ecological emotions and feelings, sociohistorical context could have affected her physic-biological body and autobiographic self, including the feeling of pain (on a correspondence between one's physical pain and emotional suffering see Damasio 2000).

11. Critical of the terminology, such as "Islamic feminism," and the power dynamic it represents, Seedat (2013, 39) insists on "more than one alternative history of reason in the convergence of feminism and Islam," and argues that Muslim women's discourses on and practice of gender justice draw on "an Islamic history of reason" and not on "Western intellectual histories," such as liberal feminism.

12. For Islamic feminism as a part of global feminism, see information on ICIF's Third International Congress on Islamic Feminism, which took place in Barcelona in October 2008, and its objectives at http://www.wunrn.com/news/2008/09_08/09_08_08/090808_third.htm. Accessed November 13, 2013.

13. This Islamic State should be created under the conditions of subordination of women to men.

14. Like some of their non-Muslim and Muslim-feminist counterparts, but to a greater degree, Islamist women, like al-Ghazali, take an anticolonial, often articulated as an anti-Western, position critical of (what they define as) colonial feminism—a Western feminists' insistence on women's liberation from their cultural baggage and domestic roles and their relocation into a public space and labor market (for a discussion of colonial feminism see Ahmed 1992).

15. Another important question is why people follow such leaders. See Marranci (2009) for an analysis of dispersed "charisma" and "community of emotions."

Bibliography

Abdellatif, Omayma, and Marina Ottaway. *Women in Islamist Movements: Toward an Islamist Model of Women's Activism*. Beirut, Lebanon: Carnegie Middle East Center, 2007.

Abramson, David. *Foreign Religious Education and the Central Asian Islamic Revival: Impact and Prospects for Stability Silk Road Papers*. Washington, D.C.: Central Asia-Caucasus Institute & Silk Road Studies Program, 2010.

Abugideiri, Hibba. "Hagar: A Historical Model for 'Gender Jihad.'" In *Daughters of Abraham: Feminist Thought in Judaism, Christianity, and Islam*, edited by Yvonne Yazbeck Haddad, and John L. Esposito, 81–108. Gainesville: University Press of Florida, 2001.

Adams, Laura L. *The Spectacular State: Culture and National Identity in Uzbekistan, Politics, History, and Culture*. Durham, NC: Duke University Press, 2010.

Ahmed, Leila. *Women and Gender in Islam: Historical Roots of A Modern Debate*. New Haven, CT: Yale University Press, 1992.

al-Ghazali, Zaynab. *Days From My Life*. Translated by A.R. Kidwai. Delhi, India: Hindustan Publications, 1989.

———. *Return of the Pharaoh*. Translated by Mokrane Guezzou. Leicester, UK: Islamic Foundation Press, 1994.

Arkoun, Mohammed. *Rethinking Islam. Common Questions, Uncommon Answers*. Boulder, CO: Westview Press, 1994.

Badran, Margot. *Feminism in Islam: Secular and Religious Convergences*. Oxford, England, Oneworld Publications, 2009.

———. "Islamic Feminism Revisited." *Countercurrents.org*: http://www.countercurrents.org/gen-badran100206.htm. Last modified February 10, 2006.

———. "Islamic Feminism: What's in the name?" *Al-Ahram Weekly Online* 17–23, no. 569 (2002): http://weekly.ahram.org.eg/2002/569/cu1.htm.

Bakhtiar, Laleh. "The Sublime Quran: The misinterpretation of Chapter 4 Verse 34." *European Journal of Women's Studies* 18, no. 4 (2011): 431–439. doi: 10.1177/1350506811415206.

Barlas, Asma. *Believing Women in Islam: Rereading Patriarchal Interpretations of the Qur'an*. Austin: University of Texas Press, 2002.

Barrett, Jennifer. "Gender and Sources of Religious Information in Uzbekistan." *Cognitie Creier Comportament* 11, no. 2 (2008): 417–436.

Beyeler, Sarah. "'Islam Provides for Women a Dignified and Honourable Position': Strategies of Ahmadi Muslims in Differentiating Processes in Switzerland." *Women's Studies: An Interdisciplinary Journal* 41, no. 6 (2012): 660–681. doi:1 0.1080/00497878.2012.691406.

Borbieva, Noor O'Neal. "Empowering Muslim Women: Independent Religious Fellowships in the Kyrgyz Republic." *Slavic Review* 71, no. 2 (2012): 288–307. doi: 10.5612/slavicreview.71.2.0288.

Bottcher, Annabelle. "Islamic Teaching Among Sunni Women in Syria." In *Everyday Life in the Muslim Middle East*, edited by Donna Lee Bowen and Evelyn A. Early, 290–299. Bloomington, IN: Indiana University Press, 2002.

cooke, miriam. "Multiple Critique: Islamic Feminist Rhetorical Strategies." *Napantla: Views from South* 1, no. 1 (2000): 91–110.

———. "An Islamist Activist: Zaynab al-Ghazali." *Die Welt des Islams* 34, no. 1 (1994): 1–20.

Csordas, Thomas J. "Embodiment as a Paradigm for Anthropology." *Ethos* 18, no. 1 (1990): 5–47. doi: 10.1525/eth.1990.18.1.02a00010.

Damasio, Antonio. *The Feeling of What Happens: Body and Emotion in the Making of Consciousness.* New York: Harvest, 2000.

Deeb, Lara. *An Enchanted Modern: Gender and Public Piety in Shi'i Lebanon.* Princeton, NJ: Princeton University Press, 2006.

Duval, Soroya. "New veils and new voices: Islamist women's groups in Egypt." In *Women and Islamization: Contemporary Dimensions of Discourse on Gender Relations,* edited by Karin Ask and Marit Tjomsland. New York: Berg, 1998.

El Fadl, Khaled. *Speaking in God's Name. Islamic Law, Authority and Women.* Oxford, England: Oneworld Publications, 2001.

Fathi, Habiba. "Gender, Islam, and Social Change in Uzbekistan." *Central Asian Survey* 25, no. 3 (2006): 303–317. doi: 10.1080/02634930601022575.

———. "Otines: The Unknown Women Clerics of Central Asian Islam." *Central Asian Survey* 16, no. 1 (1997): 27–43. doi: 10.1080/02634939708400967.

Fernea, Elizabeth Warnock. *In Search of Islamic Feminism: One Woman's Global Journey.* New York: Doubleday, 1998.

Friedl, Erika. *The Women of Deh Koh: Lives in an Iranian Village.* Washington, D.C.: Smithsonian Institution Press, 1989.

Hafez, Sherine. *An Islam of Her Own: Reconsidering Religion and Secularism In Women's Islamic Movements.* New York: New York University Press, 2011.

Hamidi, Ibrahim."The Qubaysi Ladies Take Up Islamic Preaching in Syria with Government Approval." *Al-Hayat,* translated by BBC Monitoring online. 2006. http://faculty-staff.ou.edu/L/Joshua.M.Landis-1/syriablog/2006/05/qubaysi-womens-islamic-movement-by.htm. Accessed November 13, 2013.

Harris, Harriet A. "A theological approach." In *Feminist Philosophy of Religion,* edited by Pamela Sue Anderson and Beverley Clack, 73–86. New York: Routledge, 2004.

Hassan, Riffat. "Feminism in Islam." In *Feminism and World Religions,* edited by Arvind Sharma and Katherine K. Young, 248–279. Albany, NY: State University of New York Press, 1999.

Hoffman, Valerie. "Al Maraa al'Muslima [the Muslim Woman]: An interview with Zaynab al-Ghazzali." *al-Dawah* 57 (1981).

Hoodfar, Homa. "Reproductive Health Counseling in the Islamic Republic of Iran: The Role of Women Mullah." In *Cultural Perspectives on Reproductive Health,* edited by Carla Makhlouf Obermeyer, 154–174. Oxford, England: Oxford University Press, 2001.

Human Rights Watch. "Nowhere to Turn: Torture and Ill-treatment in Uzbekistan." *Human Right Watch Report* 19, no. 6(D) (2007): 1–90. http://www.hrw.org/reports/2007/11/05/nowhere-turn.

Jaschok, Maria, and Shui Jingjun. *The History of Women's Mosques in Chinese Islam: A Mosque of Their Own*. Richmond, Surrey, England: Curzon, 2000.

Kamp, Marianne R. *The New Woman in Uzbekistan: Islam, Modernity, and Unveiling under Communism*. Seattle: University of Washington Press, 2006.

Kandiyoti, Deniz, and Nadira Azimova. "The Communal and the Sacred: Women's Worlds of Ritual in Uzbekistan." *The Journal of the Royal Anthropological Institute* 10, no. 2 (2004): 327–349. doi: 10.1111/j.1467-9655.2004.00192.x.

Karagiannis, Emmanuel. "Political Islam in Uzbekistan: Hizb ut-Tahrir al-Islami." *Europe-Asia Studies* 58, no. 2 (2006): 261–280. doi: 10.1080/09668130500481444.

Kendzior, Sarah. "A Reporter Without Borders: Internet Politics and State Violence in Uzbekistan." *Problems of Post-Communism* 57, no. 1 (2010): 40–50. doi:10.2753/PPC1075-8216570104.

Khalid, Adeeb. *Islam after Communism: Religion and Politics in Central Asia*. Berkeley, CA: University of California Press, 2007.

Kuumba, M. Bahati. *Gender and Social Movements*. Walnut Creek, CA: AltaMira Press, 2001.

Lewis, Pauline. "Zaynab al-Ghazali: Pioneer of Islamist Feminism." *Michigan Journal of History* (2007): 1–47.

Mahmood, Saba. "Feminism, Democracy, and Empire: Islam and the War of Terror." In *Women's Studies on the Edge*, edited by J. W. Scott. Durham, CT: Duke University Press, 2008.

———. "Secularism, Hermeneutics, and Empire: The Politics of Islamic Reformation." *Public Culture* 18, no. 2 (2006): 323–347. doi: 10.1215/08992363-2006-006.

———. *Politics of Piety: The Islamic Revival and the Feminist Subject*. Princeton/Oxford: Princeton University Press, 2005.

———. "Rehearsed Spontaneity and the Conventionality of Ritual: Disciplines of Salat." *American Ethnologist* 28, no. 4 (2001): 827–853. doi: 10.1525/ae.2001.28.4.827.

Marks, Monica. "Can Islamism and Feminism Mix?" *The New York Times: The Opinion Pages*. http://www.nytimes.com/2011/10/27/opinion/can-islamism-and-feminism-mix.html?_r=2&. Accessed October 26, 2011.

Marranci, Gabriele. *Understanding Muslim Identity: Rethinking Fundamentalism*. New York: Palgrave Macmillan, 2009.

———. *The Anthropology of Islam*. New York: Berg, 2008.

———. *Jihad Beyond Islam*. New York: Berg, 2006.

Mathews, Gordon. *Global culture/individual identity: searching for home in the cultural supermarket*. New York: Routledge, 2000.

Mattson, Ingrid. "Debating Form and Function in Muslim Women's Leadership." In *The Columbia Sourcebook of Muslims in the United States*, edited by Edward E. Curtis, 252–263. New York: Columbia University Press, 2008.

Mazumdar, Shampa, and Sanjoy Mazumdar. "In Mosques and Shrines: Women's Agency in Public Sacred Space." *Journal of Ritual Studies* 16, no. 2 (2002): 165–179.

McBrien, Julie. "Mukadas's Struggle: Veils and Modernity in Kyrgyzstan." *Journal of the Royal Anthropological Institute* 15, no. 1 (2009): S127-S144. doi: 10.1111/j.1467-9655.2009.01546.x.

McBrien, Julie, and Mathijs Pelkmans. "Turning Marx on His Head: Missionaries, 'Extremists,' and Archaic Secularists in Post-Soviet Kyrgyzstan." *Critique of Anthropology* 28, no. 1 (2008): 87–103. doi: 10.1177/0308275X07086559.

McGlinchey, Eric. *Chaos, Violence, Dynasty: Politics and Islam in Central Asia.* Pittsburgh, PA: University of Pittsburgh Press, 2011.

———. "Divided Faith: Trapped Between State and Islam in Uzbekistan." In *Everyday Live in Central Asia: Past and Present*, edited by Russell Zanca and Jeff Sahadeo, 305–318. Bloomington: Indiana University Press, 2007.

Mernissi, Fatima. *The Veil and the Male Elite: A Feminist Interpretation of Women's Rights in Islam.* Translated by Mary Jo Lakeland. New York: Basic Books, 1991.

Milton, Kay, and Marushka Svasek. *Mixed Emotions: Anthropological Studies of Feelings.* Oxford, England: Berg, 2005.

Mir-Hosseini, Ziba. "Stretching the Limits: A Feminist Reading of the Shari'a in Post-Khomeni Iran." In *Feminism and Islam: Legal and Literary Perspectives*, edited by Mai Yamani, 285–319. New York: New York University Press, 1996.

Moghadam, Valentine M. "Islamic Feminism and Its Discontents: Toward a Resolution of the Debate." *Signs* 27, no. 4 (2002): 1135–1171.

Moghissi, Haideh. *Feminism and Islamic Fundamentalism: The Limits of the Postmodern Analysis.* New York: St. Martin's Press, 1999.

Muñoz, Gema Martín. 2012. "Feminism in the Arab World: The Silent Revolution Qantara.de." *Qantara.de.* http://en.qantara.de/content/feminism-in-the-arab-world-the-silent-revolution. Accessed November 13, 2013.

Nomani, Asra Q. "A Gender Jihad for Islam's Future." *The Washington Post*, November 6, 2005. http://www.washingtonpost.com/wp-dyn/content/article/2005/11/04/AR2005110402306.html. Accessed November 13, 2013.

Peshkova, Svetlana. "Teaching Islam at a Home School: Muslim Women and Critical Thinking in Uzbekistan." *Central Asian Survey* 33, no. 1 (2014): 80–94. doi:1 0.1080/02634937.2014.889869.

———. "A post-Soviet Subject in Uzbekistan: Islam, Rights, Gender and Other Desires." *Women's Studies: An Interdisciplinary Journal* 42, no. 6 (2013): 1–29. doi:10.1080/00497878.2013.802640.

———. "Muslim Women Leaders in the Ferghana Valley: Whose Leadership is it Anyway?" *Journal of International Women's Studies* 11, no. 1 (2009a): 5–24. Available at http://vc.bridgew.edu/jiws/vol11/iss1/2.

———. "Bringing the Mosque Home and Talking Politics: Women, Space, and Islam in the Ferghana Valley (Uzbekistan)." *Contemporary Islam: Dynamics of Muslim Life* 3, no. 3 (2009b): 251–73. doi:10.1007/s11562-009-0093-z.

———. "Otinchalar in the Ferghana Valley: Islam, Gender, and Power." Doctoral dissertation, Syracuse University, New York, 2006.

Privratsky, Bruce. "'Turkestan Belongs to the Qojas': Local Knowledge of a Muslim Tradition." In *Devout Societies vs. Impious States?*, edited by Stephane Dudoignon, 161–212. Berlin, Germany: Klaus Schwarz Verglag, 2004.

Rasanayagam, Johan. *Islam in Post-Soviet Uzbekistan: The Morality of Experience.* New York: Cambridge University Press, 2010.

Rouse, Carolyn. *Engaged Surrender: African-American Women and Islam.* Berkeley, CA: University of California Press, 2004.

Scott, James. *Weapons of the Weak: Everyday Forms of Peasant Resistance.* New Haven, CT: Yale University Press, 1985.

Seedat, Fatima. "Islam, Feminism, and Islamic Feminism: Between Inadequacy and Inevitability." *Journal of Feminist Studies in Religion* 29, no. 2 (2013): 25–45. Available at http://www.jstor.org/stable/10.2979/jfemistudreli.29.2.25.

Shehab, Rafiullah. *Rights of Women in Islamic Shariah.* Lahore, Pakistan: Indus Publishing House, 1986.

Stowasser, Barbara Freyer. "Old Shaykhs, Young Women, and the Internet: The Rewriting of Women's Political Rights in Islam." *The Muslim World* 91, no. 1/2 (2001): 99–119. doi: 10.1111/j.1478-1913.2001.tb03709.x.

Usmanova, Z. M. "Zhenskie religioznie practiki v kontekste neoficialnogo islama v tadjikistane (Female Religious Practices in the Context of Non-official Islam in Tajikistan)." Izbestiya akademii nauk RT. Seria filisofia i pravo (*News from Academy of Science.*) *Series: Philosophy and Law* 4 (32–38), 2009.

von Doorn-Harder, Pieternella. *Women Shaping Islam: Reading the Qur'an in Indonesia.* Urbana, IL: University of Illinois Press, 2006.

Wadud, Amina. *Insight the Gender Jihad: Women's Reform in Islam.* Oxford, England: One World, 2007.

———. *Qur'an and Woman: Rereading the Sacred Text from a Woman's Perspective.* New York: Oxford University Press, 1999.

Chapter 2

Feminization of Islam?

Agency and Visibility of Women in Southern Thailand's Branch of the Tablighi Jama'at's Missionary Movement

Alexander Horstmann

Introduction

In this essay I discuss the participation of and support for what is probably the largest global Islamic missionary movement in the world today—the *Tablighi Jama'at*. I argue that the Tablighi Jama'at not only provides opportunities for men, but also for women, joining the Mastura Jama'at or female unit of the Tablighi Jama'at. The community building in the Mastura Jama'at provides an unusual space for congregation of Muslim women in a secular society. While veiled women still confront problems in Thai work places and in Thai public colleges, the Mastura Jama'at provides an almost secluded space in which a full Islamic way of life or its imagination can be realized. Although fully veiled, the women are not supposed to be seen by unfamiliar men. At the same time, the veil is also a sign to other women encouraging them to don the veil. The veil thus serves the paradox functions of making women invisible to men and more visible as Muslims to fellow females.

Women in the Mastura Jama'at are included in a common behavioral model on embodied Muslim dispositions of modesty as well as in a shared commitment to the spread of Islam (*tabligh*) (see also Metcalf 2000, 50). Remodeling one's own habitus and daily action after the model set by Fatima, the favorite daughter of the prophet Muhammad, gives purpose and

meaning to everyday life, providing new and exciting transnational social venues and maximizing well-being for a self-chosen identity that prioritizes religion. Thus, participation in the Tablighi Jama'at brings Muslim women in Thailand closer to transnational Islamic networks. They perceive these transnational Muslim spheres as a space of modernity, which they contrast with backward society at home. Second, I argue that in becoming a self-reliant pious Muslim female subject, a Muslim woman's participation in the Tablighi Jama'at affects the relationship of these women with the Buddhist majority. The participation results in the withdrawal of women from multireligious ritual and in the construction of cultural boundaries to Buddhist women who either secularize or espouse Buddhist nationalism.[1]

Scientific studies of the inner life, ideology, or dynamic of either type of Islamic revivalist or reformist movement are still very rare. The gendering of these movements, the specific goods and services they provide for women, certainly a crucial dimension of their development, has hardly been researched. This study on the everyday politics of the Tablighi Jama'at should thus be seen as an initial study without having the ambition to fully explore the subject. It should also be noted that the researcher—a white, male European—had obvious limitations in appearing before veiled female Tablighi preachers. Moreover, the argument of this article is not limited to the position of women, but understands that—similar to the issue of the right to veil in public—the issue of the new presence of female missionaries is not limited to women, but is an issue that concerns the visibility of women in the public sphere. The researcher was welcomed by the Tablighi Jama'at a local unit to stay and travel with a male Jama'at in Tha Sala, Nakhonsrithammarat province, and to visit the Islamic center (Markaz besar) in the border town of Yala.[2]

I am interested in the debates of local society and how Muslims discuss the presence of women in the public sphere and in the da'wa movement in particular. The thesis is as follows: Muslim communities are not just challenged and transformed by the growing impact of transnational movements such as the Tablighi Jama'at, but are increasingly divided between new disciples and opponents who stick to the old ways. In everyday life, the new ideology and the new rituals thus coexist with the old ways and old beliefs. Tensions between the two belief systems grow in case the Jama'at does not tolerate the old ritual, for example if it involves the presence of ancestor spirits. At the same time, the Tablighi Jama'at exercises social pressure as the movement operates in Thai society where shari'a law is applied only in a very limited version or is only present as a discourse and normative order or guideline.

Women are heavily involved in this Islamization process as they con-
struct cultural boundaries to the Buddhists. But the participation of women
in the movement also has important effects on their relations with Muslim
women who stick to the old ways as they exercise pressure on them to join
the new movement. The active participation of women in the outings is also
a subject of debate in local society. Traditionalists criticize the exposure of
women to potentially hostile worlds in which the women are exposed to
danger and gaze of strangers. Even Muslims who are members of the Tablighi
Jama'at sometimes are scared about the visibility of women in public spaces.
But there seems to be a very significant shift in the policy of the Tablighi
Jama'at in recent decades as the movement's leadership seems to realize the
crucial role that women play in the expansion of the movement on the ground
and within families. That is why the leadership has decided to encourage
women to go on female missionary travel tours, called Mastura Khuruj.

The Theoretical Context

Barbara Metcalf argues that the main strategy and ideology of the Tablighi
Jama'at is to put body and mind into the service of God. In order to be
"effective in the world," the body is being shaped in ever new rounds of exer-
cise to become a tool of missionary work (Metcalf 1993, 585ff.). While the
movement takes a quite neo-orthodox position regarding the role of wom-
en, whose place is thought to be in the house, the participation of women
in the Tablighi Jama'at is particularly interesting as women travel and join
preaching tours for several days. This active participation of women beyond
the traditional limitations of women's movement raises a debate inside and
outside of the Tablighi Jama'at about the place and safety of women in the
movement. The new mobility of Malay-Muslim women in Southern Thai-
land should also be seen in the context of the booming civil society and
entrepreneurial activities of increasingly self-confident women, organizing
in religious and nonreligious NGOs and civil society groups.

The "self-productive" aspect of veiling and embodiment of orthodox
Muslim ideologies is emphasized by Brenner (1996). She argues that, for her
informants, donning the veil "was a key moment in producing themselves as
modern Muslim women and in producing a certain historical consciousness
based in Islamist as well as modernist ideologies" (Brenner 1996, 689). In
Thailand, Muslim women and men actively campaigned for Muslim women
to wear the veil in school and in work places against the resistance of the
Thai government. They struggled for the veil not being an issue of contesta-

tion, but a religious obligation and cultural right of Muslim women (Mard-dent 2007). The successful struggle for the veil after the forced removal of a veiled student from Yala Rachapat College was an emblem for the visibility of Muslims in the public sphere. However, Brenner also notes, that through producing themselves through veiling, "women produce certain ideologies and configurations of power that have effects that they have not intended or imagined" (Brenner 1996, 689). I find Brenner's discussion insightful. Women in particular might be caught in the struggle between competing sources of power. Practices that are intended to increase their self-mastery might also unintentionally be drawn against them or limit their agency. Yet it is fairly clear that many of the mosque groups and Qur'an reading groups are women groups (Mahmood 2001, 2005). Women in Egyptian mosque groups or in the Thai Mastura Jama'at thrive to integrate religiosity into their everyday life. They take the decline of religiosity in secular society as a point of departure and aim to discipline their bodies for daily religious exercise and prayer, bringing all aspects of the daily routine under the aegis of religion.

This approach to perfection of the self, spiritual development, and heightened religiosity is also the subject of Sylvia Frisk in her study on Islamic practices and learning processes of pious women within Kuala Lumpur's affluent Malay middle class (Frisk 2009). Frisk describes how Malay middle-class women organize themselves in collective prayer circles to become "true believers." Malay women were creating and maintaining a relationship through disciplining the body and mind in daily rituals and acts of worship such as praying and fasting (Frisk 2009, 137). The daily disciplining of body and mind is akin to the routine and ritual in the Tablighi Jama'at. According to Frisk, striving for the status of true believer in a space dominated by men also creates a space for gender negotiation. Religious studies along with the performance of religious duties and worship were particularly important means through which women came to understand themselves as religious subjects. Frisk argues that the organization, initiation, and participation in Islamic education and worship had personal and structural consequences. Organizing religious classes in the mosque created female spaces in the mosque and brought about changes in the gendered space of the mosque.

Just like women in Kuala Lumpur, women in the Tablighi Jama'at go through various stages in which their human quality created by God, their *akal,* is put to the test, and where they learn to control their desire, their *nafs.* Pious women thus regard it as their responsibility to keep up the akal of their household, their husbands and children. Frisk thus argues that women submit themselves and craft themselves in relation to the idea of a transcendental God, not to the arbitrary will of men (2009, 189–190). Women argue that

women have their akal, that they can control their nafs, that they accumulate merit, and that women and men are equal before God. I agree with Frisk that reducing female Muslim agency as "false consciousness" is not helpful. Instead we should conceptualize the practices as a keen desire to become a perfect believer—a super-Muslim so to speak—and to gain status and prestige through engagement in formal da'wa missionary organizations, and to use this status to contest male privileges and negotiate gendered spaces in the household and in everyday life. The social processes in which the women involve themselves can be conceptualized as transition from one subjectivity to another. By donning the veil, and by visiting Muslim women elsewhere, Tablighi women contribute to the visibility of Muslim women in Thailand, to the presence of women in public spaces, and to the establishment of a particular normative order in Muslim local society in which the moral boundaries and religious duties are more intensively policed, and illicit sex, gambling, and alcohol are perceived as means of the Satan and thus prohibited.

The Tablighi Jama'at

The Tablighi Jama'at al-Da'wa, an Indian Muslim movement that dates from the 1920s, has grown active in more than 150 countries, covering today probably every country where Muslims live (Horstmann 2007; Masud 2000; Metcalf 1998, 2000). It is devoted to the obligation to proselytize in order to win the hearts and minds of Muslims around the globe. Specifically conveying shari'a-based guidance, the conservative movement is nevertheless rooted in Sufism and tries to win the hearts and minds of Muslims by exhorting the spirituality of Islam and by a heavy emphasis on ritual. My argument is that the Tablighi Jama'at combines elements from Salafism as well as from Sufism into an original amalgam without one replacing the other.

The Tablighi Jama'at concentrates on the strengthening of the faith by refocusing peoples' life on bodily dispositions, behavioral rules, and ritual procedures, constantly improving one's inner life and embarking on a journey to discover God and piety. The movement can be described best as a purification movement that emphasizes every aspect of everyday life as an opportunity to please and obey Allah. By organizing a constant circulation of Jama'at in the local context as well as in the world, Tablighis believe that they revive the tradition of the Prophet. The dedicated missionary work of its members and followers in every corner of the world brings millions of members into its fold. It is the grassroots appeal, flexibility, and informal character of the movement that contributes to its strength.

But the missing formal procedures also contribute to the high fluctuation of the movement, with people joining and then leaving the movement again. Formal procedures of control are exercised on the local leadership, and on the followers on tour, but control on the followers in the periods between the outings is loose. Some Muslims might thus find the Tablighi Jama'at fashionable for some time, but might leave it as quickly as they joined it, leaving no roots in the movement. The movement does not lay so much weight on traditional Islamic education such as madrasas, but lays great weight on learning and study sessions, particularly during the missionary outings. At the heart of the learning sessions is the study of the book *Faza'il-e A'maal* (The Merits/Rewards of Good Deeds), or the *Tabligh Curriculum* by Maulana Zakaria, the nephew of Tablighi Jama'at's founder Maulana Mohammad Ilyas. This "weighty and precious volume, originally published in Urdu, was subsequently translated into many foreign languages and is used in the study sessions (called ta'lim) during the outings (called khuruj)" (see Metcalf 1993, 585). The movement is closely associated with the conservative Sufi Deobandi educational network, and its founder was a student of the Dar'ul Ulum in Deoband, India—hence the two transnational networks complement and reinforce each other. The Tablighi Jama'at plays the more activist part, and several Deobandi students join the outings during semester breaks. As its message is simple enough to be accepted by anyone willing to volunteer, it also attracts Muslims with little or no Islamic education. Everybody is welcome to the Jama'at, and every newcomer will receive generous support from all sides for choosing the Tablighi way. Thus, even poor Muslims are entitled to the welfare and protection of the movement, and to the solidarity of their companions. Surely, this warmth of the community greatly contributes to its success.

By participating in the three-day outing, new members are also socialized within the Tablighi ideology. This socialization not only includes adjustment to the uniform and habitus of the Jama'at but also entails a subtle transformation of the member's personality to the rules of the Jama'at. Once the new member takes part, he or she has to follow the directives of the leader (the *amir*). The amir of a small group is selected by its members for his seniority for the period of the outing. One does not need to be a learned scholar to join the movement, nor does one need to have any educational credentials. It is enough to show one's commitment and piety to become a fully respected follower. The main aim of the Jama'at is thus the constant attraction of sympathizers turning into potential missionaries, thus generating a snowball-system.

According to the *Rewards of Good Deeds,* women would get the same kind of reward as men in return for their services to Allah. While the empha-

sis on women's conduct and appearance seems to conceive a fairly passive role for women, "the important weight that women play in Tabligh suggests a different, more active role for women in public spaces" (Metcalf 2000, 46ff.). There is an interesting reconfiguration of status roles in the context of the proselytizing tours. Tabligh as conceived by Ilyas was meant to do nothing less than reverse social hierarchy. His position assumed that any Muslim, by going out to share his sincere feelings about Islam and offer guidance, undertakes what had been the privilege of men distinguished by education, achievement, and birth in colonial British India. The egalization of relations is a radical innovation in the hierarchical societies of Southeast Asia and permits the poor and humble to join the movement at the same status as the rich and powerful.

Among those on tour, decisions are made through a process of consultation known as *mashwara*. The group chooses the amir, who ideally should be distinguished by the quality of piety and experience, not worldly rank. In the mission, different roles are assigned to each member. Key to those roles is the concept of service. The focus on divine reward motivates this service, as it does all else. Journeyers on tour learn to cook, to wash and mend clothes, to nurse the ill, to serve food, and so on—all tasks typically associated with women. However, at least in the case of South Thailand, the gender reversal lasts only as long as the journey.

The Tablighi Jama'at in Southern Thailand

This egalitarian aspect has contributed greatly to the expansion of the Tablighi Jama'at in the marginal Muslim societies of Southern Thailand. As the investment for expensive rituals and communal meals becomes a real problem, da'wa work becomes a very attractive alternative, and the moving through translocal networks becomes a psychological boost. So, it makes a lot of sense to downgrade the worldly life as a life full of decadence and vice, and upgrade the da'wa activities as a preparation and reward for afterlife. Other women who occupied prominent places in ceremonial rites have much more to lose and actually contest the entry of the Tablighi Jama'at. Lower-class women experience a social recognition and presence in public space that they were going to lose in the growing marginalization of Muslims in the imagined mostly Buddhist community of the Thai nation state. While government service becomes an attractive option for Thai Buddhists, Muslims eagerly join the Islamic networks that have become available through the intensification of global networks and social ties in the Islamic world.

So, my observation is that while Theravada Buddhism is nationalizing and is appropriated largely by the Thai Sangha, the Muslim networks are rapidly globalizing, thereby weakening the national representation of Muslims in Thailand.

The Tablighi Jama'at is one part of a much broader phenomenon of the globalization of Islam and the availability of different identity choices in Southeast Asia. Within this context, the Tablighi Jama'at is currently by far the most influential movement. In Thailand, it is able to establish a presence in every Muslim community and a *markaz* in every province where Muslims live. From Thailand, where missionaries can generally speak unharassed by police or the military, small groups of the Jama'at can venture into the neighboring countries, visiting Muslims in Cambodia, Southern China, and, increasingly, Myanmar. Although the Tablighi Jama'at has a strong emphasis on "giving," engaging in tabligh is not an obstacle to more worldly enterprises. Many activists, male or female, use the Tablighi networks as a resource. This is especially true for traders of Indian descent. It is through these traders that the Tablighi Jama'at first entered the Muslim communities. These financial flows and the donations seem to sustain the Tablighi Jama'at, and women are as involved as men in the trading networks.

The markaz symbolizes Islam as a totality of life in which mosque, house, and school are not separated. In Yala, the huge complex of the markaz is a city in itself. More than one hundred families stay here permanently, with children being socialized with the Tabligh from early age. Women staying in the markaz are expected to appear in full purdah. Women in the markaz engage in many pious activities, such as praying, reading Zakaria's book, studying the Qur'an, and listening to the sermons (*bayan*) of Tablighi male preachers who appear behind a curtain.

For Muslims in Thailand, the Tablighi Jama'at offers possibilities to raise status as Muslims. The Tablighi Jama'at, more than any other movement, is able to attract a large diversity of people. Many of the men involved in Tabligh activities were encouraged by their wives to do so. For women, seeing their husbands getting socialized as good Muslims in a pious Muslim environment can be a very attractive option. Tabligh women hope that their husbands shy away from alcohol, sexual promiscuity, and gambling through the movement's influence. There are plenty of famous narratives of conversion careers stating that men have given up vices, such as drug addiction, by joining the Tablighi Jama'at and have become the most dedicated missionaries.

The practice of the Tablighi Jama'at represents a dramatic encroachment on traditions of the community. Intensely biased on invented Islamic ritual, the movement's supporters attempt to stop Muslim's participation in

traditional ritual life. Once a Muslim joins a Jama'at, this person is gradu-
ally socialized within the movement, engendering a process of mutation in
which the rigid regimentation and discipline of everyday life and everyday
propaganda call for youthful commitment and radical militancy. Step by step,
the member adjusts to the Tablighi way, to dressing in the da'wa way, to long
prayer sessions and meetings, and not least to long and regular periods of
traveling. Not only does this intervention question specific rituals, the new
ideology threatens the very premises and reproduction of the community.
The Tablighi Jama'at is an apolitical movement with a radical outlook. Its
disregard for tradition makes it one of the strongest engines of dissolution of
the traditional belief system as well as the logics of ritual exchange between
the living and the dead that are associated with the traditional belief system.
Women used to occupy prominent places in ceremonial ritual and in the
ritual communal meals that followed the ceremonies. However, some of the
communal meals have become a sign of conspicuous consumption, and low-
er-class women could not afford the expensive rituals or would lose face by
providing poor meals. The rituals favored by the Tablighi Jama'at are mostly
free of cost and immediately accessible. They are associated with modernity
and with the devaluation or even diabolization of the traditional rituals.

 This intervention has led to real struggles of religious authority within
mosques. While the majority of mosques are registered under the authority
of the central committee for Islamic affairs headed by the chief Islamic com-
munity leader (*Chularatchamontri*)[3] in the capital, Bangkok, some are virtu-
ally conquered or overrun by Tablighi groups. The resulting polarization of
the neighborhood also affects women, as women joining the Tablighi Jama'at
in full purdah broke their communication with other Muslim women, and
as women contest the space of the mosque as well as men. The debate on
the presence of the Tablighi Jama'at in the mosque went on in the private
sphere of the houses in which women were outspoken. These divisions create
substantial tensions within the community, dividing families.

 The negative discourse on ritual exchange and local knowledge by the
Tablighi Jama'at also affects the relationship between women of different reli-
gions and the management of religious difference in a multireligious setting.
Until thirty years ago, Muslim and Buddhist women in the Songkhla Lake
region in upper Southern Thailand looked very much alike. With Muslim
lifestyles rapidly changing under the influence of da'wa, this is no longer
the case. The formerly common belief in the spiritual force of the ancestors
is the key. It is not unusual in the middle of Southern Thailand for Muslim
women to "convert" to Buddhism after marrying a Buddhist partner. The
Tablighi influence now leads women to break off their communication with

their Buddhist neighbors and kin. Women under the influence of transna-
tional da'wa argue that the spirits are false beliefs. They strongly disapprove
of traditional ritual, as it involves prayers before idols, a practice strictly
prohibited (*shirk*) by the Jama'at. They believe that they have to assist other
Muslim women and men to leave this barbaric world and to escort them
to the civilized world of the Tablighi Jama'at. The questioning of tradition
paves the way for stronger demarcations and sharper boundaries between
Muslims and Buddhists.

The proliferation of Muslim lifestyles in Southern Thailand mirrors the
identities already espoused by the Buddhist nationalisms, especially in the
context of the fresh violence taking place in lower Southern Thailand, on
the border with Malaysia. The withdrawal of women from traditional ritual
and exchange concerns their relationship with Muslim sisters and Buddhist
neighbors alike. Muslim women believe in the presence of ancestor spirits
for whom they are preparing ceremonial meals in April on the Muslim cem-
etery and every evening during Ramadan. These ceremonies are the first to
be condemned by the visiting unit of the Tablighi Jama'at.

Further, Muslim women have kinship relations in the Buddhist neigh-
borhood and are regularly invited to ceremonial functions. While there is no
problem in joining a marriage ceremony after the monks have left the com-
pound, Muslim women in the Tablighi Jama'at don't show up at the Manoo-
ra Rongkruu dance drama ritual and defy invitation by their Buddhist kin,
because the main ritual tradition in Southern Thailand is a spirit possession
performance, in which Buddhist and Muslim ancestor spirits are called upon.
Similarly, Muslim women either withdraw from the ritual of two religions in
Tamot, Patthalung, or do not take part in the exchange of food and gestures.

Muslim women who stick to the old ways do not mind in joining
ceremonial functions of the Buddhists, although they also tend to defy invi-
tations to multireligious ritual, as this ritual becomes increasingly appropri-
ated by Buddhists. Buddhist women and men have at times a very negative
attitude toward the Islamic revival and especially toward the new lifestyles of
Muslim women, which they associate with the new thoughts. They think that
these women have been brainwashed by religious teachers and are exploited
by their husbands. There is a growing feeling of unease on the side of the
Buddhists, who feel that Muslim leaders of the reformist movements estab-
lish strong boundaries and thereby want to dismantle secular society. They
are afraid that Muslims are able to press for special entitlements as Muslim
society is Islamized.

Muslim society in Southern Thailand is changing, part of a "cultural
revolution" in the Muslim world. The Tablighi Jama'at contributes in no

minor way to the visibility of Islam in the form of material culture. The availability of Muslim garments imported from the Middle East and South Asia is one indicator. Another important indicator is the presence of Muslim media, which are eagerly consumed by women and men.[4] The increasing participation in the Hajj has also contributed to the exposure of local Muslims to the global Muslim community. Media include magazines, audiocassettes, and video discs. Members can buy Muslim garments, books, pamphlets, and cassettes readily available in the Muslim shopping market in the markaz. Women and men participate in the Islamic consumer culture in which the markaz in Southern Thailand becomes one enclave of a global culture. As several authors have shown, media technologies have the ability to mediate the sensations and emotions of religious discourse.

Although the Tablighi Jama'at describes most of the media as tools of Satan, the movement has made increasing use of them. Sermons by leading sheikhs are reproduced from the congregations on cassettes and sold at Islamic markets. Blogs in which women and men recount their experiences of their outings in foreign lands are available on the Internet. The point being made here is that women have no restrictions in the use of media. In the secluded spaces of prepared housing, they can also meet their sisters from abroad and make numerous new and exciting friendships. The trip to India on a faithful mission is then both exciting and meaningful.

Women and men find themselves in a borderless world in which local society is only one reference among many. Being with the Tablighi Jama'at is about discovering and mapping the Islamic world, especially the neighboring countries. The radius of movement and perception of the world is opening up quickly. So, withdrawing from multireligious spaces in Southern Thailand, women and men are encapsulated in globalizing Islamic spaces. Muslim women from Southern Thailand keep their home, and the food keeps its Southern Thai flavor, but the orientation is clearly toward a transnational movement. The postmodern shift and the new possibilities of transport and media have accelerated the expansion of the Tablighi Jama'at and their organization in travel teams. How far new security measures following 9/11 have influenced the mobility of the Tablighi Jama'at remains to be studied.

Everyday Politics in Muslim Communities[5]

The demand for total commitment also engenders the most virulent critique against the Jama'at. This criticism holds that men abandon their families for long journeys, leaving their wives and children behind without any income

to sustain the family. These "fanatics" are said to leave behind all worldly aims for the sake of proselytizing among strangers. Even if their wives fell ill, their child was abducted, or their mothers were without a breadwinner, the Tablighi would not notice. More than any other topic, gender relations thus dominate the polemics of polarized villagers. Wives are left behind by husbands who suddenly leave the house and the family in order to travel in the country or even abroad for long periods of time. In Northwestern Thailand, this long absence causes debates and rifts within families, and even divorces in the case that only a wife or husband joins the activities of the Tablighi Jama'at and are not willing to compromise their religious activities with other more mundane responsibilities.

Not only do the Tablighi leave their wives and children behind, they also introduce new forms of gender segregation. They also discourage Muslim women from having friendships with Buddhist neighbors, as they believe that the exposure to any religion other than Islam interferes with the focus of Muslims on Allah. Being a movement of religious purification, the Tablighi Jama'at vehemently forbids and sanctions such ceremonial and ritual practices in the villages because they are dubbed pre-Islamic and heretic. Women used to be dominant in many ceremonies and life-cycle rituals. The Tablighi, who wants to reduce everyday life to the basics, strongly opposes lavish weddings or the display of wealth. The performance of arts, music, and dance is discouraged, including shadow puppet plays (*Nang Talung*) or Manoora dance dramas.

During these Manoora performances, it is possible for present family members to request a boon from powerful ancestor spirits, who are believed to be both Buddhist and Muslim. The Manoora master is able to mediate between the living and the dead, and to entertain, feed, and appease the ancestor spirits. Ancestor spirits are not distinguished according to religion or gender. Ancestor spirits provide a common reference to villagers, Buddhist and Muslim. Given such a radical break with the indigenous traditions, it is no wonder that the Tablighi Jama'at is polarizing villages. For many Muslims in Southern Thailand, it is painful to break with the ancestors, and many believe that the spirits will punish them. Villagers believe the vengeful presence of the ancestors is confirmed when they are losing their appetite or when their children fall ill. Conversion to Tablighi ideology often results in conflicts within the family, and in some cases youths even break up with their parents (see also Janson 2005, 464–466). The older generation has the choice to either support the Tablighi movement (by joining the Jama'at) or resist it, very much depending on the balance of power in a given community. By providing juvenile Muslims with such an opportunity to challenge the prevalent ideology, the Tablighi movement enables young Muslims to boost

their self-confidence by giving them responsibility and mission.

And yet the regime of the Jama'at and the ritualization of everyday life can provide a utopian community, a "surrogate family" (cf. Janson 2005: 466). In this context it is interesting to note that the followers of the movement use kinship terms, addressing each other as "brother" and "sister." By using kinship terms, they create the intimacy of the family within the sharp boundaries between their own group and the other Muslims who are not considered real Muslims. There is an important gender dimension to this generational conflict as young women wearing the burqa drastically distinguish themselves from their mothers and grandmothers, whom they regard as being misguided by the old rituals. This painful antagonism is partly compensated by the solidarity of the "surrogate family" in the form of female Tablighi "sisters" not only from Thailand but also South Asia, and even Europe (see also Janson 2005, 466). The exciting prospect of going on a journey to India as part of a small group significantly adds to the appeal of the movement to women and men. Curiously, while their place ought to be at home, many women reach their widest radius of mobility while on tour with the Tablighi movement.

Women as Participants in the Da'wa Movement

Veiling can have multiple messages. By donning the veil, women can choose the context in which they want to show themselves and in which they want to hide. They can keep their dignity. Veiling is thus more variable and strategic than we think (see also Abu-Lughod 1999). In addition to the preaching sessions, women eagerly participate in special learning sessions organized for women: *talim* (Janson 2005, 471–473; Metcalf 1994, 2000; Sikand 2002). These sermons are delivered by male preachers behind a curtain, but provide a space for women to congregate to "learn about Islam." The talims focus on the moral behavior and religious duties of women. By participating in the talims, women are to be better informed about Islam in everyday life. Women are supposed to arrive at the talim fully covered. The special study sessions certainly provide only a reduced frame of Islamic education and do not replace the syllable in the madrasas, but provide a frame of learning of selected recitations from Qur'an and Hadith. The Tablighi Jama'at does not see themselves as providers of Islamic education, but as openers of an Islamic way of life and complements to formal Islamic education.

In Thailand, women go out on *khuruj* in the company of their husbands or a close male relative. In Southern Thailand women are allowed to accompany men on travelling but have to dress in purdah. A woman supports her

husband while he is on tour. The permission granted to women to participate in khuruj is a turning point in the history and strategy of the Tablighi Jama'at. The leadership seems to have realized the great potential and influence of women in the movement. Metcalf does not put the participation of women in the center of analysis and states that their participation is the exception to the rule (Metcalf 1994, 2000). Sikand also sees the role of women in the domestic sphere of the family (1999, 2002).

The ijtima mass congregations in Yala or Bangkok, where thousands of supporters congregate to listen to the sermons of visiting sheikhs or Islamic scholars (*maulana*), are again mainly for men. While men stay at local mosques, women stay in housing that is prearranged by women for female visitors. There are female Jama'ats at the large annual meetings, but they are secluded in prearranged housing. Women reaching other women fulfill a crucial part of the da'wa, investing in particular within their own sphere of women and family members.

The Tablighi dress code is part and parcel of the transformation of the body and the presentation of the body in public. The donning of the veil, and eventually the burqa, is a crucial transition in the awakening toward becoming "new born" Muslims. The donning of the burqa (which hides the entire body, including the face) in particular is a significant marker of the rising awareness of becoming a true follower of the Tabligh. In Southern Thailand, women cover themselves by wearing batiks and veils in many colors, and full-length body-covering black robes are a fairly recent phenomenon. The Tabligh dress code applies not only to women but also to men. Men must be careful of presenting their bodies in public by donning long white robes and wearing turbans. Like women, men are easily recognizable as orthodox Muslims. Tablighi men and women "on tour" are on constant display when walking the streets. Their presence is not unlike Buddhist monks, who walk the streets as well, begging for alms. Tablighi activists stick out in public and are easily recognized as such by outsiders.

After joining the movement, women activists strengthen their belief in Allah by visiting and living in the Islamic center, by listening to lectures, and by travelling with their husbands as part of a Jama'at. The purpose of proselytizing is to recite the Qur'an and hadith, to perform dhikr (remembrance of God), and to both teach people and learn from them. While men go out to invite people to the mosque, women teach the women in their host compound how they should behave. By going from town to town, village to village, and house to house, the lay missionaries hope to win the hearts and minds of the people they visit, to engage them in a debate on religion and to facilitate a trajectory from a passive Muslim to an active follower

and member. The missionaries believe that Islam in most places is lax or corrupt. When I visited a community in Tha Sala, for example, one senior Tabligh activist made the point that the mosque of the village is neglected and the Muslims living in the village are "pitiful." When the missionaries arrive, the people visited might be very skeptical about the intention of the visitors and their notion of being superior, especially as they are strangers. Slowly, step by step, the missionaries, being trained in communication skills, involve the people in prayer and in meetings of the Tablighi chapter in the mosque. Women play a crucial role in facilitating this process behind the curtain. They operate behind the scene in making the Tablighi movement familiar to the families visited and communicating certain topics (see also Janson 2008, 2011). Even when they do not go on a jama'at, women tend to play crucial roles in tabligh work. By tolerating the husband's absence and by supporting the family, women receive enormous blessing. The points accumulate to a decent sum that is taken into account by God after a woman's death. By encouraging their husbands to perform the prayer in the mosque, women can earn even more points than men.

Concluding Remarks

By joining tabligh work at all levels, women seem to enjoy the social recognition within peer groups that they were going to lose in the transformation of capitalist society. During the khuruj, a radical break allows, in some degree, a temporary class and gender reversal in the construction of an ideal Muslim society. Marloes Janson takes the argument further and argues that the gender reversal during the outings has a long-lasting impact on gender relations. On the other hand, the outings involve the masculinization of women, who become breadwinners and household heads during the travels of their husbands (see Janson 2008, 2011).

In the Gambian case, an interesting detail points to the strength of women in the movement: the women register their husbands for their outings and grant them permission to go. Moreover, the gender reversal is not limited to the tours, as men increasingly take over household chores such as cooking, washing clothes, and caring for children (Janson, 2011). In Southern Thailand, cooking and washing clothes was limited to the outings, and the reason given was that the visitors did not want to be a burden to the visited. Women on missionary outings were supposed to cook for the participating men. Men were not involved in everyday household matters. Men in Southern Thailand chose their outings quite independent of their wives, who had

to cope with the household during the absence of their husbands. Women probably enjoyed their new freedom, but they also had to make up for the salaries that were not given them to sustain the household. This absence of their husbands was a major reason of criticism in the community, as people would complain how men could venture into the wilderness without even thinking about their children. Second, in Southern Thailand, the outings of women were not self-evident, but were a constant topic of controversial debate. Muslim authorities at the local level do not support the outings of women, believing that Muslim women simply like to travel to enjoy the trip. These traditional authorities also did not support the idea that men sleep in the mosque, as they thought that the mosque is a place for prayer, not for sleeping. Thus there was constant tension between the traditional authorities and the Jama'at visiting them, as the Jama'at also contacted the local Imam to gain entry to the community. Hence, I saw the gender reversal taking place in Southern Thailand during the outings as more limited and ambiguous.

I argue that what the organization of women in the Tablighi Jama'at did for themselves, and their visibility in public spaces, provided the main impetus for women to participate in Tablighi activities. The Tablighi Jama'at, while conscribing to a very conservative image of female gender, opens up an important window to women in Tabligh. Women can construct and build their religious piety by regularly participating in the exciting activities of the transnational movement. The adoption of Tabligh ideology means they do not spend their precious resources in rituals as they did before. Most significantly, women can also go on khuruj, although they have to be married, go with their husbands or male relatives, and cannot stay in the mosque. Spaces open up and networks become available as women participate in outings to India.

The tours that form the key of the Tablighi teaching are meant to transform participants in their fundamental relationship to other people. The quiet nature of the Tablighi Jama'at might invariably hide its political character, as the inroads of the Tablighi Jama'at and other Muslim movements are accompanied by rather dramatic transformations in gender relations. These concern the relations between new-born Muslims and other Muslim women who like to stay where they are, as well as the relation of new-born Muslims with non-Muslim women, such as Buddhist women, and the new boundaries between them.

Meanwhile, the meaning of kinship relations changes as well: Muslim women in the Tablighi Jama'at emphasize their religious relations and express them in kinship terms ("sister"), while they de-emphasize their kinship relations with nonmembers or Buddhist women. Likewise, the mean-

ing of friendship is also transformed. While Muslim women formerly could have intimate cross-cutting friendships with Buddhist women (conceptualized in Southern Thailand as "twin" relations), friends are now sought in the increasingly global female Jama'at community from somewhere in the Islamic world. Relations with Buddhists are now viewed as a waste of time, as any contact with non-Muslim women would imply less commitment. By joining the Tablighi Jama'at, people thus cease to participate in a cultural microcosmos in which Muslims and Buddhists are part of a general system. Buddhists also draw boundaries to their Muslim neighbors, as they are too closely drawn into nationalism in Thailand.

In other words, ardent followers of the Tablighi Jama'at believe that Muslims should live in an Islamic society for which the Jama'at provides the model. By turning to the individual improvement of the self, they also influence communal spaces at the societal level. Women are active participants in the shaping of subjectivity; on the other hand, they also become targets of criticism from society. Spaces for women are thus both limited and extended by global opportunities of travel and communication.

Notes

1. Farzana Haniffa (2008) argues in the case of Sri Lanka that the manner in which piety is propagated among Muslims must be understood as located within Sri Lanka's ethnic conflict. By propagating piety, Muslim women actively draw boundaries to the Singhalese Buddhist women whose chauvinist Buddhism has strong anti-Muslim elements. Likewise, in Thailand the new visibility of Muslim women and veiling reflect the growing separation of the Buddhist and Muslim public sphere in Thailand and the growing ultra-nationalism and anti-Muslim feelings in the Thai Buddhist Sangha.

2. Fieldwork on da'wa movements and the Tablighi Jama'at in Southern Thailand and in Northeast Malaysia was done in 1995 to 1996, 2001, and 2004 to 2007 (Horstmann 2007). In 2009 and 2010, fieldwork on the Tablighi Jama'at was also done in Northwestern Thailand.

3. The Chularatchamontri, or Shaikhul-Islam, is appointed by the king from among prominent Muslim scholars of the kingdom. He is responsible for overseeing the administration of Islamic religious life throughout the country.

4. The participation of Muslims in media and patterns of mass consumption is now a topic of lively academic debate (Aydin/ Hammer 2010; Eickelman/ Anderson 2003).

5. The phrase "everyday politics" refers to the political character of establishing normative orders in the mundane activities of everyday life and of course gendered spaces (Eickelman/Piscatori 1996).

Bibliography

Abu-Lughod, Lila. *Veiled Sentiments. Honor and Poetry in a Bedouin Society.* Berkeley: University of California Press, 1999.

Aydin, Cemil, and Juliane Hammer. "Muslims and Media: Perception, Participation and Change." *Contemporary Islam* 4, no. 1 (2009): 1–9. doi: 10.1007/s11562-009-0098-7.

Brenner, Susanne. "'Reconstructing Self and Society': Javanese Muslim Women and 'The Veil.'" *American Ethnologist* 23, no. 4 (1996): 673–697. Available at http://www.jstor.org/stable/646178.

Eickelman, Dale E., and Jon W. Anderson *New Media in the Muslim World: The Emerging Public Sphere.* 2nd ed. Bloomington: Indiana University Press, 2003.

Eickelman, Dale E., and James Piscatori (Eds.). *Muslim Politics.* Princeton, NJ: Princeton University Press, 2004.

Frisk, Sylvia. *Submitting to God. Women and Islam in Urban Malaysia.* Seattle: Washington University Press, 2009.

Haniffa, Farzana. "Piety as Politics amongst Muslim Women in Contemporary Sri Lanka." *Modern Asian Studies* 42, no. 2–3 (2008): 347–375. doi: 10.1017/S0026749X07003137.

Horstmann, Alexander. "The Tablighi Jama'at, Transnational Islam, and the Transformation of the Self between Southern Thailand and South Asia." *Comparative Studies of South Asia, Africa and the Middle East* 27, no. 1 (2007): 26–40. doi: 10.1215/1089201x-2006-041.

Janson, Marloes. "Roaming about for God's sake: The Upsurge of the Tablighi Jama'at in The Gambia." *Journal of Religion in Africa* 35, no. 4 (2005): 450–481. doi: 10.1163/157006605774832199.

———. "Renegotiating Gender; Changing Moral Practice in the Tablighi Jama'at in The Gambia." In Piety, Responsibility Subjectivity—Changing Moral Economies of Gender Relations in Contemporary Muslim Africa, edited by Marloes Janson and Dorothea Schulz. *Journal for Islamic Studies* 28, no. 1 (2008): 9–36.

———. "Guidelines for the Perfect Muslim Woman: The Interplay Between Gender Ideology and Praxis in the Tablighi Jama'at in The Gambia." In *Gender and Islam in Africa: Women's Discourses, Practices, and Empowerment,* edited by Margot Badran. Washington D.C.: Woodrow Wilson Center Press 2011.

Mahmood, Saba. "The Egyptian Islamic Revival." *Cultural Anthropology* 16, no. 2 (2001): 202–236. doi 10.1525/can.2001.16.2.202.

———. *Politics of Piety: The Islamic Revival and the Feminist Subject.* Princeton, NJ: Princeton University Press, 2005.

Marddent, Amporn. "Gendering Piety of Muslim Women of Thailand." *Silapasat-samnuek* 7, no. 19 (2007): 37–43.

Masud, Muhammad Khalid. *Travellers in Faith: Studies of the Tablīghī Jama'at as a Transnational Islamic Movement for Faith Renewal.* Boston: Brill, 2000.

Metcalf, Barbara D. "Living Hadith in the Tablighi Jama'at." *The Journal of Asian Studies* 52, no. 3 (2000): 584–608.

———. " 'Remaking Ourselves": Islamic Self-Fashioning in a Global Movement of Spiritual Renewal." In *Accounting for Fundamentalisms. The Dynamic Character of Movements,* edited by Martin E. Marty and R. Scott Appleby, 706–725. Chicago: University of Chicago Press, 1994.

———. "Women and Men in a Contemporary Pietist Movement: The Case of the Tablīghī Jama'at." In *Appropriating Gender: Women's Activism and Politicized Religion in South Asia,* edited by Patricia Jeffery and Amrita Basu, 107–122. New York: Routledge, 1998.

———. "Tablīghī Jama'at and Women." In *Travellers in faith; Studies of the Tablīghī Jamma'at as a Transnational Islamic Movement for Faith Renewal,* edited by Muhammad Khalid Masud, 44–58. Boston: Brill, 2000.

———. *Traditionalist's Islamic Activism: Deoband, Tablighis, and Talibs.* Leiden, NL: ISIM Paper No. 4, 2002.

Sikand, Yoginder. *The Origins and Development of the Tablighi-Jam'at (1920–2000). A Cross-Country Comparative Study.* New Delhi: Longman, 2002.

Chapter 3

Women's Empowerment
in the Xi'an Muslim District

Maris Boyd Gillette

Introduction

In this essay I explore empowerment among Chinese Muslim women who live in the Xi'an Muslim district. I examine in turn local social structures, three case studies of individual agency, and collective sentiments about gender in the present and past. Xi'an is a large city located in northwest China. As China's early capital, Xi'an is home to Buddhist stupas, temples, monasteries, and museums. It is a jumping-off point for visits to the tomb of the first emperor of China, a Neolithic village (Banpo), a treasure house with a relic of the Buddha (Famensi), and the tomb of China's only female emperor (Wu Zetian). Xi'an also houses one of the oldest Muslim settlements in China, a neighborhood that locals call the *Huiminfang*, "the place where Muslims live."

The first Muslims—Arab and Persian traders—came to Xi'an (then called Chang'an) during the Tang dynasty (618–907). The vast majority of the Huiminfang's residents consider themselves to be descended from these Muslims. They belong to the Hui nationality, one of China's fifty-five officially recognized minority groups. Members of the Hui nationality are often called "Chinese Muslims" in English, to differentiate them from the Turkic-speaking Muslims living in Chinese Central Asia or Xinjiang (Pillsbury 1978; Gillette 2000a). In 2005, the Xi'an Muslim district had eighty thousand Hui residents (Wikipedia 2011). At that time Xi'an's total urban population was eight million, most of whom were Han Chinese.

I have conducted ethnographic research in the Huiminfang for almost two decades. My first research trip was in June 1993, and my most recent was August 2010. In 1994 and 1995, I carried out eighteen months of ethnographic field research in the Xi'an Muslim district. This was the basis of my PhD in anthropology and subsequent ethnography (Gillette 2000a). Over the past fifteen years I have made ten research trips to the Huiminfang, ranging in length from a week to two months. I have longstanding, close relationships with several families there, and in recent years, we've kept in contact through email, Skype, and occasionally Facebook, in addition to my visits to the neighborhood.

Jonathan Lipman, a noted historian of Chinese Muslims, once commented that in my book on the Xi'an Muslim district, my relationships with women, and particularly with women who were approximately my own age, were the most illuminating. While I have close relationships with some men in the Huiminfang—an elderly *ahong* (imam, or Muslim teacher and religious specialist) who died in 1999 was my particular close friend—I have spent more time, and on the whole maintained closer friendships, with women. Even so, this essay is my first effort to analyze women's lives in terms of gender and power, and to compare women in the Huiminfang with Muslim women elsewhere.

Comparative Ethnographies of Muslim Women

As Huma Ahmed-Ghosh writes in her introduction to this volume, the issue of empowerment dominates the literature on Muslim women. Islam is often thought to promote women's subordination. One reason is Surah 4:34, a verse of the Qur'an that has been read as stipulating that women must be submissive to men. For example, Fakhry (2002) translates this passage as: "Men are in charge of women, because Allah has made some of them excel the others, and because they spend some of their wealth . . . And for those [women] that you fear might rebel, admonish them and abandon them in their beds and beat them." However, others have translated this verse as emphasizing men's responsibility to take care of women, and render the final word, *adribuhunna*, as "turn away from them" rather than "beat them" (Aslan 2006, 69–70). As scholar of religion Reza Aslan notes, since the passage can be correctly translated in a number of ways, the issue is whether the reader is looking for a text that justifies women's submission or empowerment (70). Also contributing to Islam's negative reputation when it comes to women are sayings attributed to the Prophet Muhammad that describe stoning women for adultery. Yet here too there is ambiguity, as at least some of these hadith

indicate that stoning is the punishment for all adulterers, regardless of gender (see Aslan 2006, 71). In my work as an anthropologist, I have heard Muslims question the authority of these sayings of the Prophet by pointing out that the Qur'an does not mention stoning for adultery (see also Aslan 2006).

Anthropologists who are interested in Muslim women's empowerment have analyzed the issue by looking at honor and shame, gender segregation and access to public space, and women's dress and veiling (e.g., Abu-Lughod 1987; Brenner 1996; Kaya 2009; Meneley 2007; Newcomb 2006; Wikan 2008). Most of this literature focuses on social structure and agency. For example, Unni Wikan's *In Honor of Fadime* (2008) is a comparative study of honor killing that looks at patriarchal kinship structures and cultural ideologies and the limits of Muslim women's agency in Europe. Fadime Sahindal, the Fadime of the title, was murdered for choosing her own boyfriend and refusing to be separated from her mother and sisters. Wikan argues that Sahindal could adopt European values about personal autonomy in relation to mate choice, but only at the culturally acceptable cost (to her father and brother, anyway) of cutting off all contact with her family. Sahindal could *not* choose personal autonomy *and* close contact with her family; when she tried to do this, her father killed her. Wikan discusses numerous cases of women, and some men, who confront patriarchal kinship structures that inhibit the exercise of personal agency in similar ways. Another example of this focus on structure and agency is Meneley's study of Islamist women in Zabid, Yemen (2007). Meneley describes how young Muslim women who choose to practice reformist Islam can "poach . . . on a traditionally male domain of the dispensing of religious opinions and directives" (2007, 233), and ignore hierarchical kinship practices, which dictate that younger women must serve older ones. Yet the price for this exercise of agency is observing an "uncomfortable level" of modesty, and experiencing a decline in the number of spaces in which women can unveil (2007, 230).

Anthropologists who include sentiment in their analysis of Muslim women's empowerment add a fresh dimension to a field of inquiry focused on structure and agency. Brenner's discussion of veiling in Java (1996), and Rouse's exploration of female African-American converts to Islam (2004), present cases where women feel empowered through choosing more restrictive clothing, taking the home and family as a woman's primary domain, and embracing gender segregation. Their research shows that agency is not only about what you do, but how you feel about what you do. Some Muslim women choose more constraint.

Brenner's and Rouse's attention to sentiment, and their findings, remind me of Elizabeth Fernea's *Guests of the Sheik* (1965), an ethnography of an

Iraqi village and one of the first in-depth anthropological studies of Muslim women ever published. In this book Fernea shows that social structures dictate who Iraqi village women marry, when and how often they go out, what they wear in public space, and whether or not they have an education or a professional career. Yet some of the women who Fernea comes to know find their lives very satisfying. To give one example, the sheikh's favorite wife Selma may not accompany her husband on vacation. Fernea regards this as an unwelcome constraint. Yet when Fernea asks Selma if she wished she could go, Selma is astonished. As she explains to Fernea, why would she want to leave her home, kin, and friends to travel with her husband? Everything Selma wants, everything that makes Selma's life happy and meaningful, is already within her grasp at home.

Scholarship on Hui Women

In the limited ethnographic literature on Chinese Muslims, anthropologists have suggested that Hui women are more empowered than many of their Muslim sisters. Barbara Pillsbury was the first anthropologist to study Hui women (1978). Drawing on historical and contemporary reports from mainland China and her ethnography in Taiwan, Pillsbury describes women's opportunities for religious leadership, women's mosques, women's organizations, female education, and women who work outside the home in the twentieth century. She describes gender separation, and argues that Hui women preferred men to represent the family in public (656). As evidence Pillsbury points to the fact that, once their families achieved a stable income, many Hui women in Taiwan quit working outside the home (666–668). Women took responsibility for maintaining Muslim homes and raising Muslim children. Pillsbury's informants told her that they were more disenfranchised by Han Chinese than by Hui men (659, 665).

Maria Jaschok and Shui Jingjun's monograph *The History of Women's Mosques in Chinese Islam* is the most in-depth anthropological study of Chinese Muslim women available in English (2000). Jaschok and Shui focus their research on the Hui of central China, particularly Henan. This area has a tradition of women's mosques, women ahong, and women providing religious education to other women. While most women's mosques were affiliated with (men's) mosques, some were independent institutions (Chapter 7). The authors represent contemporary Hui women as autonomous agents, choosing their own husbands, initiating divorces, working outside the home for pay, and generally benefiting from the Chinese Communist Party's program of

gender equality. Chinese Muslim women, they argue, have taken advantage of the government's policies "to start reforming Islam, to use Islamic institutions to gain positions of authority, however limited, and in the process help re-define the symbolic map which grounds them in passivity" (306).

My research shows that women's circumstances in the Xi'an Muslim district resemble and diverge from those described for Chinese Muslim women in Taiwan and central China. In Xi'an, I found that Muslim women took pride in maintaining a *qingzhen,* or pure Muslim home. Local Muslims defined *qingzhen* as central to being Hui. By creating and maintaining *qingzhen* homes, women played a key role in maintaining and reproducing local ethnic and religious identity (2000a, Chapter 4). In other words, Xi'an Muslim women, like Taiwanese Muslim women, were proud that they performed an essential role for their family and community. I also saw some women exercising opportunities for agency in collective and public life. For example, when a bride in her early 20s saw that her rented wedding gown was stained, she went to demand a refund (2000b).[1] When a seventy-nine-year-old woman narrated her life history to me, she used government propaganda for her own purposes, turning state discourse into an idiosyncratic self-representation that satisfied her personal values (2006). However, Hui women were largely excluded from a local Muslim social movement to remove alcohol from the neighborhood (2000a, Chapter 6). Several Xi'an Hui women told me that Islam was "men's business." Compared to Muslim women in Henan, Xi'an Hui women had few opportunities to occupy positions of religious authority or reform Islamic practice.

Structure

As of August 2010, gender relations in the Xi'an Muslim district were conservative. Children took their father's family name, not their mother's. Kinship terms were differentiated by whether relations were on the father's or the mother's side, with relatedness on the father's side being privileged. Although daughters were legally entitled to an equal share of their natal family's property, women did not claim their inheritance. Most parents arranged marriages for their adult children, albeit with the potential bride and groom having the right to refuse an engagement. Postmarital residence was typically in the groom's father's home. Divorce was very uncommon. In one extended family I knew very well, the husband had had a mistress for the entire period of our acquaintance, almost twenty years. Although the affair was public knowledge in the neighborhood, the wife tolerated the situation rather than pursue divorce.

Many Hui women in their twenties and thirties stayed at home with their children. Most of the women who worked did so in small family-run private enterprises. Fathers, husbands, sons, or brothers headed the business-es, even when the women who worked there did 80 percent of the labor. I know of no cases where a business was considered to be owned by a woman. If the family enterprise wasn't doing well, adult women worked for free, or married adult daughters or sisters would be laid off. For example, Yan and her sister Xue both continued to work as paid employees in their father's steamed stuffed bun store after they married. But when business slowed in 1999, the two sisters first worked without salaries, and then gave up their jobs. "My brother has a family of five," Xue explained. "Our restaurant is really his. If I work there, I'm depriving him of his livelihood."

Women were more likely to stay within the confines of the Muslim district than men. Locals usually justified this practice by referring to the Chinese saying "men are in charge outside [the home], women are in charge inside [the home]" (*nan zhu wai, nu zhu nei*). I know very few women who had traveled alone; most women who traveled did so with male kin. The three women of my acquaintance who had traveled alone all left the Muslim district for education: one went to Heilongjiang for study in the 1950s, and the others went to Beijing, one in the 1990s and the second in the 2000s. I know many families who refused to allow their daughters to study outside of Xi'an.

Public leadership in the Muslim district was male. Community leaders were successful businessmen and articulate and/or well-connected ahong. The only Muslim woman I know who was a public figure was the female principal of the Hui Middle School. Yet even this woman was not recognized as a leader in the neighborhood in the same way that men were. She came into her position because of her relationship with the local (non-Muslim) government, not from popular support. And after she retired from her job as principal, she ceased to be invited to public events or act as a spokesperson for local Muslims.

While all Hui residents of the Muslim district were Sunni Muslims, the neighborhood had three religious factions, known locally as *Gedimu*, *Sunnaiti*, and *Salafiyya*. The *Gedimu* or "ancient" faction was the oldest, and the other two were reform movements that took root in the first half of the twentieth century. Correct religious practice was the issue at stake in this factionalization. Most families tried to arrange marriages with Muslims who shared their faction. But in cases where the couple came from differ-ent traditions of practice, the woman followed her husband's practices after she married, and her children were raised in that faction. In all three tradi-tions, men occupied all the public positions of authority, led all collective

rituals, and officially represented their families at engagements and funerals. Although some mosques in the Xi'an Muslim district had separate buildings identified as women's mosques, they were always next to and run by (men's) mosques. The women's mosques in this neighborhood had no female leadership or religious specialists. When women came to the woman's mosque, they worshipped individually, not as a collective, as men did.

Many women who lived in the neighborhood wore modest dress. When I first arrived in the Xi'an Muslim district in 1993, older women wore white hats, black caps, or a local Muslim head covering called a *gaitou*, which resembled a hood. Few younger women veiled. By contrast, in August 2010, I saw no women wearing white caps or *gaitou*, but almost all women wearing veils, including most young women. Temperatures were close to 39 degrees Celsius during my visit, yet most women wore long sleeves and long trousers or long skirts. I did not see a single Muslim woman wearing shorts or a short skirt. I also did not see any face veils (*niqab*).

To summarize, Xi'an Hui women faced a range of structural constraints. These Chinese Muslim women had limited or no opportunities to own property, work outside the home for pay, divorce, or head religious organizations. They did not independently choose a form of religious practice or follow a professional career. Most women dressed modestly, covering hair, wrists, and ankles. As Lanying, whose story I detail below, explained to me in the summer of 2010: "That's how it is when we're here [in the Muslim district]. I can take my veil off when I leave, but when I'm in the neighborhood, that's how I have to dress." When Lanying accompanied me to visit a Han Chinese friend who lived across town, she took off her veil as soon as we exited the Huiminfang.

Agency

To investigate individual agency, I compare three cases of Muslim women's decision making. The first story is about Lanying, who was in her early sixties in 2010. The case in question is Lanying's decision to leave her state sector job and work for her father. Like other women of her generation, Lanying was guaranteed a full-time job with benefits under the planned economy. Yet, like the vast majority of Chinese Muslims in Xi'an, she chose to leave her work unit after the government mandated that private enterprise was legal. Lanying gave up state-sector employment as an accountant to work in her father's private noodle stall.

As an eighteen-year-old in 1968, Lanying followed Mao's order that young men and women "go down to the countryside" and work with the

peasants. She and a group of sixteen young men and women from the Hui-minfang went to live in a village about thirty miles away. Lanying was a Young Pioneer and had been a good student before schools closed in 1966 during the Cultural Revolution. She remembered that she was eager to go to the countryside: "Mao told us that the farmers would gladly welcome us, but it wasn't so. We were so innocent, we believed it! But the farmers didn't want us, and the city didn't want us either." Lanying and her compatriots found life in the village very hard. Lanying was often sick, but if she couldn't work, her work team did not give her any food. In 1970, Lanying injured her back, and her former school helped her return to Xi'an. She found a job in a factory set up by her street committee. Lanying worked there as an accountant and supply manager from 1970 to 1980. During those ten years, she married and had three sons, one of whom died young.

Lanying's father began selling cold noodles (*liangpi*) out of the front of his house in 1979 or 1980, with the assistance of Lanying's mother. "My children were small then," Lanying remembered, "and I had a job, so I didn't go work for him." In 1980 she transferred from the street committee's factory to the Hui Middle School, a work unit with higher salaries and better benefits. At that time, the Hui Middle School ran a factory, and Lanying became the accountant. In 1990, the Hui Middle School moved its factory to a suburb, and Lanying quit her accountant job and joined her father full time. When I first met her in 1994, Lanying was the linchpin of her father's business. She made the noodles, prepared the sauces for customers, and took customers' money. Her father paid her a monthly salary (400 yuan per month in 1997) and gave her a bonus at the end of the year if business was good. Lanying kept up this work for almost twenty years, until her son persuaded her to retire in 2009.

When Lanying quit the state sector in 1990, her job was regarded as an "iron rice bowl": guaranteed lifetime employment and benefits. At that time, high school and college graduates depended on the state to allocate work. Work unit jobs were prestigious, even though they could not generate the high incomes that some private enterprises could. The viability of the planned economy depended entirely on the state, and particularly the state banking system, which issued credit to nonprivate enterprises. When, in the mid-1990s, the central government ordered banks to stop providing these loans, the work unit system collapsed. But most Muslims of Lanying's generation had left state and collective sector employment well before anyone had an inkling that the work unit system would go under. They quit about a decade earlier than Lanying did, in the late 1970s and early 1980s.

When I asked local Muslims why they left the planned economy, most talked about problems with eating. Almost all work units in Xi'an had canteens where workers ate lunch, but few if any provided halal food. Muslims complained that they had nowhere to eat. I understand these complaints as being about food, and as a way of expressing unhappiness about being surrounded by Han Chinese. Hui consider Han to be dirty in the same way that pigs are dirty (see Gillette 2000a, Chapter 4). Lanying was more fortunate than most residents of the Muslim district in that her work unit was in the neighborhood and she could easily find halal food.

After Lanying went to work for her father, she had to work harder and longer hours during the spring, summer, and fall, when locals liked to eat cold noodles. During three or four months every winter, when the noodle stall was closed, she was unemployed. Since Lanying worked at her parents' house, where her brothers and their families also lived, she was subject to more intense scrutiny after she left her work unit job. But she and her husband agreed that the potential to earn more cash was a greater benefit for their family than her "iron rice bowl" as they began the multiyear process of saving for their sons' weddings.

The second story is about Yan, who was forty years old in 2010. I examine Yan's decision to remain in the Muslim district rather than pursue study abroad. Yan was the first resident of the Huiminfang who I got to know really well, and the first person there who wanted to have a relationship with me. After I started long-term fieldwork in January of 1994, I had trouble finding anyone who was willing to do more than exchange a couple of sentences with me. One tactic I used to find someone to talk to during my first several weeks living in Xi'an was to patronize repeatedly the same food stalls and small restaurants. I hoped that familiarity might lead to conversation. I selected a dumpling (*baozi*) store on Barley Market Street as one location.

After I had eaten there three times, a middle-aged woman who turned out to be Yan's mother saw me carrying some books about Muslims that I had purchased at a local bookstore and asked me if I were Muslim (literally, Hui). On subsequent visits, she chatted briefly with me when she wasn't busy: in my notes I recorded short conversations about family planning, food, and business. After about a month of this, she approached me and asked if I would teach her daughter English. I first met Yan at the beginning of March 1994. She was twenty-four. She had an unmarried younger sister (Xue) and a married older brother, and she herself was engaged, with the wedding set for October 1994. Yan took cash from customers in her father's restaurant and made dumplings when sales were busy (her father

also hired several employees to prepare food). Yan had also worked in her father's previous business, a cruller and soymilk stall, during the 1980s, when she wasn't in school.

Yan had studied English for three years in junior middle school. She had stopped school when she was fifteen. "People around here aren't too interested in studying," Yan told me. "But I want to learn English. I've been working in my father's shop for nine years and I don't want to do it all my life. I have time every morning to study. If you work with me during your two years in Xi'an, I should just about get it down. My fiancé has agreed that I can keep studying after I'm married, rather than just staying at home and raising kids and looking after him." Our English lessons took place in Yan's home. Yan and her family became key informants, and we developed a close friendship.

Despite the fact that Yan had not passed the exam that would have given her access to high school (let alone college), she soon revealed that she had a burning desire to travel to the United States for study and work. Yan's sister Xue informed me that Yan's fiancé didn't want Yan to go to the United States because he was afraid she'd never come back. But Yan claimed that her fiancé supported her. Initially Yan was diligent at studying English. We met two or three times a week for months. As the date for her wedding grew nearer, though, she lost interest in studying. I still came to her house, but she took these visits as purely social.

After she married, Yan moved out of her father's house and into a set of rooms in her husband's father's house. Local custom was that the groom's parents provided the new couple with living space (this was still true in 2010). Yan invited me to her new home, and she still visited her parents' home every day. She said she wanted to start studying English again, but a pregnancy soon distracted her. Yan bore a son in July 1995. I finished my long-term field research that August.

From 1996 to 1999 I returned to the Huiminfang once a year. Yan was very frustrated during this period. She wanted to work, but her husband wanted her to stay home with their son. In 1997 Yan thought she had persuaded her husband to move the family to Shanghai, to look for new opportunities, but he changed his mind during my visit that summer. In 1998, Yan persuaded her husband to start a small restaurant with her, but when I returned in 1999 they had closed it because they weren't making enough money. Yan complained that she didn't like living in her mother-in-law's house, but her husband didn't earn enough for them to be able to afford to get their own place. Yan's husband also had a junior middle school education. He switched jobs several times during this period. Mostly he

found work as a driver, either a truck or a taxi, and for a while he bought, repaired, and resold old cars.

Each year when I returned to Xi'an, Yan broached the subject of studying English or working in the United States. She asked me to help her apply for a visa by writing a letter of invitation. After I got my job at Haverford College in 1997, I wrote Yan a formal letter inviting her to come stay with me and offering to help her find English as a Second Language classes. When I visited in 1998, Yan told me that her mother had cried when Yan received the letter. Yan's husband also was not enthusiastic. In fact, Yan had no support for her study abroad plans from anyone in her natal or affinal families. Most of her relatives felt that the time when Yan could have studied abroad had passed. She met me "too late," she and her mother said. "You should have come to the Huiminfang a year earlier, before Yan was engaged," her mother told me. Even so, Yan carefully preserved the letter of invitation in the hopes of somehow coming to the United States.

When I visited Yan in 1999, she was preoccupied with her husband. He'd developed a liver infection and been quite ill for a time. "I was so scared when he got sick," Yan told me. "His illness made me think about what life would be like without him, or without our son. You know my father-in-law died recently, too? I still want to go abroad, but not just now." The next time I visited the Muslim district; Yan introduced me to her newborn daughter, and told me that her focus was now on her children. During my visits to Xi'an in 2004, 2006, and 2010, Yan no longer mentioned studying abroad.

The third story is about Xijuan, a young woman who converted to Salafiyya, or *Santai* as it was called in the Muslim district. Xijuan was in her late thirties in 2010. She was Yan's sister-in-law. When I first met her in February 1994, Xijuan, her husband, and her newborn daughter lived on the third floor of Yan's father's house. Xijuan had a son in 1995 and a third (illegal) child in 1998 (a daughter). Unlike the other young married Muslim women I knew, Xijuan rarely returned to her natal home, and she did not have a large extended family in the neighborhood. Her mother was a widow and a migrant from the countryside, living with Xijuan's younger brother. Xijuan rarely visited them; I got the impression that she worried about being an economic burden to her family. During the years that I knew her, Xijuan did not work outside the home for pay, but she sometimes helped out in her father-in-law's, and later her husband's, food business.

Xijuan's mother-in-law had personally selected Xijuan to be her son's bride.[2] Before marriage, Xijuan's husband, Huanmin, did drugs with his friends (I think he smoked crystal methamphetamine). His mother had been eager for her son to marry, thinking that he would settle down if he had

a family. The strategy worked, but unfortunately Xijuan and her mother-in-law fought constantly. Luckily for Xijuan, her husband took her side in arguments with his mother. The conflict between the two, however, soured relations between Xijuan and her husband's natal family. After two and a half years of marriage, Xijuan and her husband and children moved out of her in-laws' home. Xijuan refused to visit her in-laws, although she made sure that her children visited them every day. After Xijuan had her third child, she and her husband moved back into the family home, and her in-laws moved out. When I visited in 2010, Xijuan's in-laws were back in the family home, and Xijuan and her family were renting housing nearby. Xijuan still did not have face-to-face relations with her mother-in-law, father-in-law, or Yan, but she occasionally saw Yan's younger sister Xue.

Xijuan's husband converted to Santai late in 1996. Prior to his conversion, he would sometimes visit his parents, but afterward he quit, and stopped talking to them too. As is the case with Salafiyya adherents worldwide, members of the local Salafiyya faction strictly followed the Qur'an and hadith and refused to engage in any religious practices not explicitly mentioned there. They recited prayers with an Arabic accent, whereas most Chinese Muslims used Chinese sounds to approximate the sound of Arabic. Xijuan's husband grew a beard in emulation of the Prophet Muhammad and adopted a Saudi Arabian-style robe and headdress for prayer. He became very critical of his natal family's religious observance and what he now regarded as his improper Islamic education during his youth. He called his father a Muslim in name only, and believed his entire natal family would go to hell after they died if they did not change their religious observance. When I, rather shocked by the vigor and tone of Huanmin's views, said to him that ultimately I thought it was most important whether or not a person behaved ethically, Huanmin disagreed. "The Qur'an also talks about being a virtuous person," he explained. "It says that you should respect your parents, and not drink or smoke or cheat people. When it comes to respecting my parents, I am not doing very well. But ultimately this is secondary. Virtuous people who know about Islam but don't follow its practices will go to hell. The most important thing is that you recognize God and take Muhammad as his final prophet, and then that you fulfill the five duties of a Muslim. This is the heart of Islam. It is much more important than whether or not you are virtuous, or honest, or how you treat people. Only if you fulfill these conditions will you go to heaven."

Xijuan followed her husband and converted to Santai. For her this meant two things: supporting her husband in his efforts to study the Qur'an by looking after the family business when he was at the mosque, and adopt-

ing hijab. When I visited in June of 1997, Xijuan's conversion was still recent. She fussed constantly with her veil, remarking at one point that she couldn't get it to sit properly on her head. Previously Xijuan had not covered her hair. After her conversion she was careful always to dress in shirts with long sleeves that covered her wrists and long trousers that covered her ankles. She continued to make sure that her family ate halal food, as she had always done. In 2010, Xijuan and her husband still practiced in the Salafiyya tradition and did not have face-to-face relations with his parents.

All three of these cases show Chinese Muslim women's agency, in that they present individual women making choices and taking actions. Yet when considered in relation to local social structure, the degree and nature of their agency is different. When Lanying decided to leave her job with the Hui Middle School and go to work for her father, she chose between two distinctly different and viable alternatives. Lanying quit being an accountant because she did not want to work outside of the Muslim district, and she wanted the higher salary that working in private enterprise promised. Lanying's decision was certainly influenced by what she thought was best for her family, in particular her sons. It was also true that most of Lanying's neighbors had already quit their work unit jobs. Even so, Lanying's husband and her sister-in-law both stuck with their work unit jobs. Lanying could have done the same. She went to work for her father because she wanted to, not because she had to.

When I visited Yan in August of 2010, she was completely reconciled with her decision not to study or live abroad in the United States. Yan lived with her husband and children in a beautiful, big house located around the corner from her parents. She enjoyed the free time that staying at home gave her, especially during the school year when both of her children attended school. Yan had just returned from a visit to Xinjiang with her mother, daughter, and a couple of friends. As she excitedly showed me photographs and purchases from her trip, she informed me that she planned to take a vacation away from Xi'an every year from now on. Yan was content with her life. But when she gave up on studying in the United States, did she really choose between equally viable alternatives? Yan had no support from anyone in her family, and few if any resources to devote to studying abroad. No doubt reconciling to her decision to stay in the Huiminfang was a form of agency. But Yan's options were weighted in a way that Lanying's were not.

Xijuan's conversion to Santai was good for her. By supporting her husband's conversion, Xijuan strengthened her marriage and legitimated her own refusal to engage with her in-laws. Becoming Salafiyya was not burdensome to Xijuan: it meant getting used to a new style of dress, listening to

her husband explain proper Muslim observance, and doing what she could to enable him to study the Qur'an. Nevertheless, Xijuan could hardly have chosen not to convert. This was not merely because women in the Huiminfang customarily followed their husband's form of religious practice after marriage. As the daughter of a migrant whose father was dead and whose natal family had few resources, Xijuan was particularly isolated. Her quality of life depended almost entirely on her husband and children. Xijuan never objected to her husband's decision, and I think she saw her conversion as natural and proper. But she would have had to overcome enormous obstacles to remain Gedimu. She had limited scope for choice.

Collective Sentiment

I asked several residents what they thought about local gender relations during my visit to the Huiminfang in 2010. They assured me that families were much happier at the birth of a girl now than they had been in the past. "Nowadays, families are happy to have a daughter," Lanying's son explained. He and his wife doted on their daughter, giving her piano lessons, an English name, and every advantage they could think of.

"When I was young, things were different," Yan's mother-in-law explained. "Women weren't treated like people. Men really were not good to women. Folks used to believe that daughters were like the water that you poured out over your doorstep." Yan's mother-in-law was convinced that women like her daughter-in-law had much more freedom than she had had. "Nowadays the tide has swept the other way," she went on, in a not-so-subtle critique of Yan. "Sometimes women are treated too well, so that they become selfish, think only of their own wants, and don't respect their parents or the elderly."

In the 1990s, several elderly women I knew (all since deceased) told me how they had been confined in their youth. Older men and women had a saying that women used to see the world through *menfen*, the crack between the two front doors (traditional Chinese houses in this area have a double front door). If a non-kin guest arrived at the home, females were expected to retreat behind a "second door" (*ermenzi*) or barrier that demarcated the family's more domestic space from areas where visitors were hosted. Through the 1940s, Muslim females older than the age of nine or ten were not allowed on public streets. One elderly man told me a story about the older sister of a local Hui leader named Ma Fuping. Cloistered since she was a small child, this woman left her home for the first time in decades in 1958. "They carried her on a sedan chair down to see West Avenue (*Xi Da Jie*), one of the

main streets in Xi'an. She had never seen a paved road before. She marveled at how wide the street was."

Yan's grandmother, who was in her early eighties in 1994, explained to me how, as a young woman, she never left the house. "When I wanted to buy something, I stood by the courtyard door and yelled," she remembered. "A peddler would come over and pass me what I wanted under the door. I slipped the money back through the other way. I never went to school and I never learned to read. Only after the Communists came were women in this area allowed to leave the house. Before that they never went out."

Education was a major area of improvement for local women. In this neighborhood, Muslim females did not receive any secular education, and very little religious instruction, until the 1950s. By contrast, in 2010 all girls at least attended primary school, and most also completed junior middle school. A small number of females who had high test scores went to high school, and an even smaller number went to college. Although by American standards, general levels of education for Xi'an Hui females were low, they were dramatically higher than they had been fifty years earlier, and on par with the general levels of education for Xi'an Hui males.

As an example of women's empowerment, Lanying's son pointed out that wives commonly managed household incomes. This was the case for him and his father. By contrast, in the past men were in charge of family incomes. One elderly man described how budgeting worked when he was a child. "Let's say you had a man who sold *jinggao* (a local food made with sticky rice, dates, and adzuki beans)," Feng said. "When he came home for the day, he'd lay out all the money he'd earned for the day on the bed (*kang*). He would drink tea while his wife and daughter would sort the cash, separating the yuan from mao and fen.[3] Then he would count it. If the day's total was 52.34 yuan, he would put 30 yuan aside for the cost of dates, rice, and chopsticks. Then he'd give his wife 8 yuan for food, and his wife and daughter 2 yuan each for their private use. The daughter would use this money as the basis for her dowry." The man kept the remaining 18.34 yuan for himself.

Still another area of women's empowerment was arranging marriages. While men represented the family in the public rituals that were part of engagements and weddings during the 1990s and 2000s, mothers were in charge of actually arranging marriages. Mothers who had adult sons met with go-betweens and mothers who had adult daughters to discuss possible matches. Women developed opinions about who would be suitable matches, and then brought their ideas home to present to their sons and husbands. Lanying's and Yan's mothers both arranged their children's marriages this

way. During the summer of 2010, Lanying was actively pursuing potential marriage partners for her youngest son.

Over the years that I have been visiting the Xi'an Muslim district, not once has any woman who knows me well ever expressed any desire to have my job or to work the hours I do. Several have said that they feel sorry for me because I live separated from my parents and extended family and have no children. All of my women friends in the Huiminfang strongly encouraged me to bear children. On my last visit, one or two women still hadn't entirely given up the hope that I somehow might, even though in local terms I am closer to the age of a grandmother than a mother.

Several months after my August 2010 visit, I emailed a draft of this chapter to Lanying. The draft had sections on structure and agency but only a paragraph or two on sentiment. Lanying responded by telling me that I should talk about how much better life was for Muslim women now than it had been in the past. She pointed out that her son's wife had gotten a good education (high school degree) and had a good job and a comfortable life. And her granddaughter had opportunities to do things that neither her grandmother nor her mother did, such as learning to play the piano. Lanying's message to me was loud and clear: maybe *I* looked at Xi'an Muslim women's lives and saw constraints, but *she* looked at Xi'an Muslim women's lives and saw opportunities. Obviously, I needed to think more about Hui women's empowerment.

Conclusion

Lanying's comments on my draft were a sharp reminder that a person's social context, historical moment, and cultural values shape how she sees things—and I don't mean merely how *others* see things, but how *I* do, and how *you*, the reader, do. If I stopped writing this chapter after a discussion of property relations, marriage, work, and leadership in the Xi'an Muslim district, many North Americans would see Hui women as unempowered. If my chapter focused only on agency, Yan and Xijuan would seem lacking, and some might see Lanying as retrograde. But when we attend to how Hui women *felt* about their lives and the lives of women around them, how they understood and articulated their own desires, we are forced to question the project of analyzing women's empowerment. To what extent does the very idea of "women's empowerment" rest on European and North American social orders and conceptions of the person?

Anthropologist Hill Gates has argued that late imperial Chinese society combined petty capitalism with a tribute mode of production (1996). To support this economic system, the Chinese state prioritized stability over growth and promoted a cultural ideology and social formation that privileged the rights of men, and male-focused kin groups, over women and individuals. The demands of family took precedence over individual demands; seniors were privileged over juniors, and men over women (see also Watson 1986). Although women were not at the top of the hierarchy, they nevertheless played an important role in sustaining it, not in the least because their power and authority increased as they became more senior (see Wolf 1972).

Not surprisingly, the ideology of the person that arose in this context was not one of individual free agents who realized their desires through autonomous action. Instead we find a notion of the person that is strongly embedded in kinship and other social relations. While contemporary Chinese society differs from that of late imperial China, Gates and others have argued that key aspects of the social and economic order remain the same (e.g., Gates 1996, Chapter 11). As you would expect, contemporary Chinese notions of self and society are influenced by this social and economic context and differ from what we find in Europe or North America (see Gillette 2010).

Perhaps most analyses of women's empowerment are linked to a social order, an ideology of the individual and collective sentiments that are grounded in European and North American societies and histories. Anthropologist Lauren Leve has argued that "women's empowerment," as promoted by the United Nations and other international groups concerned with women's rights, is linked to a transnational market economy (2001). Women's empowerment emerges as a strategy of governance under neoliberalism to promote economic growth (108, 119–120). Empowerment is based on a notion of the person as an autonomous agent who chooses between options. This cultural ideology of the person emerged in Europe and America with the development of capitalism, and is even more central to today's post-Fordist, neoliberal capitalism. Capitalist economic growth, on both the producer and the consumer side, depends on people who view themselves as autonomous agents exercising their independence and individualism through choice. On the producer side, we have the savvy private entrepreneur who quickly and "flexibly" switches production to take advantage of ephemeral market demand. On the consumer side, we have self-actualized agents who (putatively) realize their individual desires through specialized consumption.

Thinking about my efforts to study women's empowerment in the Xi'an Muslim district, I am struck by the thought that scholarly arguments about

women's agency may relate to a European and North American notion of the self as an autonomous free agent. In the anthropological literature, at least, agency is defined primarily as action *against* structure, as resistance or conflict. A person's action that conforms to structure is rarely labeled as agency unless we see some countervailing social trend (as in the ethnographic situations analyzed by Rouse, Brenner, and Menely). Looked at from this angle, Xi'an Hui women who act in ways that conform to the desires of husbands, fathers, and families cannot be perceived as empowered. In other words, if Yan chooses to stay in the Xi'an Muslim district with her family, after her husband's illness causes her to re-evaluate what matters in her life, must we regard her as a victim of patriarchal hegemony? Must Xi'an Hui women act *against* for us to regard them as empowered?

Anthropologist Lila Abu-Lughod points to other problems with the framework of women's empowerment (2002). These problems also derive from specifically European and North American histories. Abu-Lughod links the contemporary language of women's empowerment to an older colonial and missionary discourse that used women's oppression as a justification for political imperialism (784). She points out how ideas of women's empowerment or women's rights have often provided ideological support to efforts to "save" or "free" Muslim women. In recent years, the project of advocating for Muslim women's empowerment has not only upheld a North American sense of superiority and arrogance, it has legitimated American political interventions, such as war in Afghanistan and Iraq, that have clear imperialist goals (788–789).

Perhaps we do indeed need to do more of what Abu-Lughod calls "the hard work involved in recognizing and respecting differences" (787). Not all differences are equally consequential, and not all differences come down to gender. For example, I don't see high degrees of inequality in the structural impediments that Chinese Muslim women and men face with regard to education. Indeed, the differences between Xi'an Hui men and women in this regard are much less significant than the differences between them and me.

When I look at Lanying, Yan, and Xijuan, I see women who faced irritations, difficulties, and disappointments—and who by and large feel fulfilled and content. All three women saw their lives as better than their mothers' lives, even though none of them inherited property from their fathers or were religious leaders. In exercising agency, each woman made choices that were acceptable to her family and community. They exemplify visions of the person, the social order, and "the good life" that are different from my own.

Is women's empowerment an analytic framework that we want to keep? There is something problematic about an analytic lens that has difficulty

locating agency in the choice to conform. There is something problematic about a lens that would have us dismiss collective sentiments when such sentiments do not align with the ones we ourselves feel. There is something problematic about a lens that legitimates the politics of imperialism, a lens that suggests that the most felicitous social and cultural arrangements for the individual, for women, and for Muslim women must be based on a European or North American model of the person, social formation, and the collective sentiments that are informed by them.

Notes

1. Renting wedding gowns was typical in this neighborhood.
2. As was typical in this neighborhood, Lanying's, Yan's, and Xijuan's marriages were all arranged.
3. Dollars from dimes and pennies.

Bibliography

Abu-Lughod, Lila. *Veiled Sentiments: Honor and Poetry in a Bedouin Society*. Berkeley: University of California Press, 1987.

Abu-Lughod, Lila. "Do Muslim Women Really Need Saving? Anthropological Reflections on Cultural Relativism and Its Others." *American Anthropologist* 104, no. 3 (2002): 783–790. Available at http://www.jstor.org/stable/3567256.

Arebi, Saddeka. "Gender Anthropology in the Middle East: The Politics of Muslim Women's Misrepresentation." *The American Journal of Islamic Social Sciences* 8, no. 1 (1991): 99–108.

Aslan, Reza. *There Is No God But God: The Origins, Evolution, and Future of Islam*. New York: Random House, 2006.

Brenner, Suzanne. "Reconstructing Self and Society: Javanese Muslim Women and "the Veil." *American Ethnologist* 23, no. 4 (1996): 673–697. doi: 10.1525/ae.1996.23.4.02a00010.

Fakhry, Majid. *An Interpretation of the Qur'an: English Translation of the Meanings*. New York: New York University Press, 2002.

Fernea, Elizabeth. *Guests of the Sheik: An Ethnography of an Iraqi Village*. Garden City, NY: Doubleday, 1965.

Gates, Hill. *China's Motor: A Thousand Years of Petty Capitalism*. Ithaca, NY: Cornell University Press, 1996.

Gillette, Maris. *Between Mecca and Beijing: Modernization and Consumption Among Urban Chinese Muslims*. Stanford: Stanford University Press, 2000a.

———. "What's in a Dress? Brides in the Xi'an Hui Quarter." *The Consumer Revolution in Urban China*, ed. Deborah Davis. Berkeley: University of California Press. 80–106, 2000b.

————. "Women's Stories, Discourse, and "the Power of Feelings" in China: a Case from a Muslim Neighborhood." *Asian Anthropology* 5, no. 1 (2006): 1–29.

————. "Copying, Counterfeiting, and Capitalism in Contemporary China: Jingdezhen's Porcelain Industry." *Modern China* 36, no. 4 (2010): 367–403. doi:10.1177/0097700410369880.

Jaschok, Maria, and Shui Jingjun. *The History of Women's Mosques in Chinese Islam: A Mosque of Their Own.* Richmond, VA: Curzon Press, 2000.

Kaya, Laura Pearl. "Dating in a Sexually Segregated Society: Embodied Practices of Online Romance in Irbid, Jordan." *Anthropological Quarterly* 82, no. 1 (2009): 251–278. Available at http://www.jstor.org/stable/25488265.

Leve, Lauren. "Between Jesse Helms and Ram Bahadur: Participation and Empowerment in Women's Literacy Programming in Nepal." *Political and Legal Anthropology Review* 24, no. 1 (2001): 108–128. doi: 10.1525/pol.2001.24.1.108.

Meneley, Anne. "Fashions and Fundamentalisms in Fin-De-Siecle Yemen: Chador Barbie and Islamic Socks." *Cultural Anthropology* 22, no. 1 (2007): 214–243. doi:10.1525/can.2007.22.2.214.

Newcomb, Rachel. "Gendering the City, Gendering the Nation: Contesting Urban Space in Fes, Morocco." *City and Society* 18, no. 2 (2006): 288–311. doi: 10.1525/city.2006.18.2.288.

Pillsbury, Barbara. "Being Female in a Muslim minority in China." In *Women in the Muslim world*, edited by Lois Beck and Nikki Keddie, 651–673. Cambridge, MA: Harvard University Press, 1978.

Rouse, Carolyn. *Engaged Surrender: African-American Women and Islam.* Berkeley: University of California Press, 2004.

Wikan, Unni. *In Honor of Fadime: Murder and Shame.* Translated by Anna Paterson. Chicago: University of Chicago Press, 2008.

Wikipedia. "Xi'an." http://en.wikipedia.org/wiki/Xi%27an#Demographics. Accessed January 12, 2011.

Wolf, Margery. *Women and the Family in Rural Taiwan.* Stanford, CA: Stanford University Press, 1972.

Chapter 4

The Influence of the National Question on Gender Issues in the Muslim Areas of the Southern Philippines

Maranao Muslim Women between Retraditionalization and Islamic Resurgence

Birte Brecht-Drouart

Introduction

The Moro[1] rebellion[2] for more self-determination on the southern Philippine Island Mindanao has lasted over forty years now. However, along with times of war there are long periods of peace talks and ceasefires. These "in-between" times amidst the violent conflicts between rebels and the Armed Forces of the Philippines (AFP) can be defined as periods of "no war, no peace." The environment thus termed has characteristics of war, such as mistrust between the conflicting parties, the presence of the military, or markers of violence, but also of peace efforts, such as the creation of peace zones, weeks of peace, or peace institutions (Elwert 1999; MacGinty 2006; Neumann 2009). Furthermore, this period contains the permanent threat of another outbreak of violent conflict (Dijkzeul 2008). War and peace are the consequence of decisions made in this period. Daily life, especially when bearing in mind the length of the conflict, thus becomes influenced by the unsolved national question of which one main point is the consideration of an Islamic state. In this essay the consequences of this situation on local debates on Muslim women's rights are discussed.

In the framework of the unsolved national question, the issue of religious identity becomes one of importance, not only in demanding an independent state but also in ruling the already existing Autonomous Region in Muslim Mindanao (ARMM). The ARMM is the only region in the Philippines that consists of a majority of Muslim inhabitants (90 percent of the population is Muslim), and it contains the majority of the Muslims in the Philippines. In this essay I argue that the ARMM is politically dominated by Muslims, which were supported by the Philippine Government in order to undermine the rebellion. One of the five provinces belonging to the ARMM, Lanao del Sur, is mainly inhabited by the Muslim ethno-linguistic group of the Maranaos.[3] In this area the support by the national government switched in the 2000s from the very successful Islamic Party OMPIA back to members of the royalties. The outcome was not a decline in Islamic narratives of justification but the empowerment of an argumentative framework of retraditionalization *and* Islamic resurgence. Supposing that everyday life cannot be separated from politics (Foucault 1998), this essay demonstrates how this specific political framework developed and how it affects debates on gender.

Retraditionalization

Tradition, according to Shils (1981), preserves and conveys the great bodies "of knowledge and skill" that have been developed over time (p. 8). It further constitutes a mechanism of transmission (Armstrong 1982, 71; see also Jacobs 2007). This transmission is not static because traditions change by adapting to social developments. This perception of tradition can be found within the concept of multiple modernities, which "guarantee the continuity of tradition but not necessarily in its original form" (Lee 2006, 363).

The sultanate system in the Mindanao Province Lanao del Sur (*Pat a Pangampong sa Ranao*, the four principalities of Lanao) may be defined as traditional in the sense of Shils, but it has also to be seen in the context of the modernity project and thus fluent and changeable in its development. Retraditionalization thus is not the return of a fixed set of certain traditions but the revival of what is perceived to be traditional.

The sultanate system dominated Maranao social organization until the increased impact of American colonizers in the beginning of the twentieth century. Even though it was discouraged by the colonial powers and later on by the Philippine national government, it never vanished even though it declined in (state) authority. In fact, it is almost impossible to find a Maranao who would not claim to be of royalty. The reasons it remained are manifold,

but one of them is that it is functional in solving local family feuds (*ridos*). The society is dominated by a clan and family system that is in large parts organized through the sultanate system and its system of *maratabat* (status honor); a "blow of *maratabat*" can easily lead to a family conflict.

Whereas initially the independent Filipino government discouraged the sultanate system, its representatives were symbolically recognized as a countermovement to the rebellion in the 1970s and 1980s. Recently, members of the sultanates have become official advisers of the government, which has recognized their role as peacekeepers in the area. This development can be seen as the national government's strategic-political reaction to the rebellion as well as a participation in a global movement of the revival of traditions since the 1990s and the end of the Cold War.

Women in the Sultanate System

The position of women in the sultanate system is based on its bilateral and thus symmetrical character; a general male hegemony (Ortner 1996) can, however, still be regarded as predominant. The symmetrical character is best demonstrated by male and female counterpart titles, which are not given to married couples but to a female and male representative of the lineage system. Thus, each sultanate, and lineage, has, besides other male and female counterpart titles, a sultan and a *bai a labi*[4] of the place. They are both legitimate representatives of the sultanate. Initially the *bai a labi* had been the sister or daughter of the sultan, but since titles are inherited bilaterally and rotationally among several families, the sultan and the *bai a labi* can meanwhile be relatives of any degree.

Whereas regarding the distribution of titles a gender-symmetrical structure is prevalent, the distribution of public decision making is not symmetrical and gives priority to men. Female elders may be included and can take part more easily in the decision-making process. Maranao women and men, particularly younger women, are restricted regarding their contacts with the other sex. However, Maranao women in their fifties are considered "morally trustworthy" and are therefore allowed to attend conferences, social gatherings, political rallies, meetings, and so forth on their own without escorts to look after them. Women in their thirties also attend gatherings without escorts; they, however, appear in groups. In mixed-gendered groupings it is usually the men who dominate the proceedings (see Bamgbose 2003, 55). Women in this framework rather influence the community decisions by making "informal suggestions to their husbands or other male relatives

about community issues" (Bamgbose 2003, 64). In many cases, women do not want to change this arrangement since an "elevated role of women in decision making embarrasses the women as they judge that this undermines the role of men" (Bamgbose 2003, 66). Women thus prefer to have an indirect and inconspicuous influence. However, this does not mean that they are not involved in community affairs or that they do not have the means to put their husbands under pressure in case they feel neglected or not informed. In the ideal case, this may trigger the *maratabat* (status-honor)[5] of the man, who has to show that he treats her well.

The gender distribution involving a limited female public participation in the decision-making process is not always stringent, and there are possibilities for women to take part when insisting on their traditional rights as representatives of the lineage. Those women who are more actively involved in such processes explain that they experienced appreciation from the community when doing so. Influence on public activities is usually connected to age, social standing, illustrious family background, personal achievements, education, or profession/position. If based on these characteristics, a woman could also take part in public policymaking. She, however, has to be adamant, as the Bai a Labi of Bayasungan and professor at MSU Marawi explained when describing ad hoc meetings in her community. In the *agamas* of Bayasungan, Lumbatan, and Unayan, the *bais* and *datus* with responsibility (who may or may not be titleholders) meet on occasion, such as when a conflict erupts (mainly family feuds, locally called *rido*). The meeting can be called, mainly through text messages, by any person of responsibility. It usually takes place wherever is convenient, such as at a fast-food restaurant. The person who called the meeting explains the situation, ideas are exchanged, and suggestions made. In the case of the Bai a Labi of Bayasungan, she was the only woman who participated. She explained that most of the time men take women "for granted," meaning to say that they do not necessarily expect that a woman would want to take part in public decision-making, since usually this is a man's domain. Thus, a woman who would like to be consulted has to assert herself and "fight for her rights." The *bai a labi*, hence, insisted on being invited; if she had not been invited, she would have investigated the reasons for the neglect. She frequently also mentioned a male relative who promised to protect her against any harm.

It is easier for female titleholders or elders to press a point in traditional mixed-gendered groupings than it is for younger Maranaos. Today's educated married youth, however, transgress these barriers in order to participate in community decision making. Among them is Samira Ali Gutoc-Tomawis, a young journalist for the *Manila Times*, daughter of late Ambassador to

Saudi Arabia Datu Candidato Gutoc and granddaughter of Vice-Governor Sheikh Ibrahim Miro-Ato Ali, the Sultan Dimasangkay of Dansalan. Gutoc-Tomawis is the membership convener of the Young Moro Professional Network (YMPN). This group was founded in 2000 and consists of about two hundred highly educated young Muslims who have spent years in the country's best schools or overseas. The YMPN is a mixed-gendered organization where women as well as men speak out equally. Its goal is to improve the socioeconomic situation of Mindanao through peaceful means. The members are well connected to other Moro organizations such as the Philippine Council for Islam and Democracy (PCID) with its Tausug director Amina Rasul, and to international organizations such as the Friedrich-Ebert-Stiftung (Friedrich Ebert Foundation). Local elders and the MILF also recognize the YMPN members as youth representatives.

Whereas the young professionals found a way to break with traditional conventions by establishing their own group, other Maranao women leaders remain within the traditional framework, following the retraditionalization movement. One young professional from a major descent line who was granted a royal title some months after the interview explained how education helped her to overcome traditional role models and to participate more actively in public decision making despite her youth and gender:

> One of the indicators of education is being able to express yourself. This is very Maranao, that if you are able to express yourself you are easily noticed. So: "Why do not we choose him, why do not we choose her?" And it is very rare for the ladies to be talking that much. To say: "Excuse me, I have a point here!"
>
> It's usually male dominated . . . they have the monopoly. It is not to prevent women but there is a tendency for women to just agree with what men say. Because it is like saying, anyway they will be the one[s] to implement whatever it is being planned, so just let them talk. It is not because you are being prevented to do so. Because for me I do not really feel that I am prevented to do so. It is probably because of the national order of Filipino patriarchal society. And it is added to the Maranao culture [we have], where it is not actually preventing the women, it is dignifying the women, but it becomes over-dignifying the women to the point of preventing them. (Interview, Iligan City, 2007)

Men are obligated by Islam and *adat* (customary law) to protect their women and to treat them like a treasure. Young and, especially, unmarried

women before the introduction of general and mixed-gendered education were very much secluded from public life and were only seldom seen by men. This is judged as one reason why they were highly regarded by men and sometimes referred to as a *montiya*, a precious stone (Tawano 1979, 119). Some *bai a labis* are saying that since women can be seen everywhere today, they have lost some of this regard. Muslim activists, however, criticize this seclusion as a way of controlling "women's freedom of movement under the smokescreen of admiration" (Bamgbose 2003, 60). According to traditional conceptions of gender, a woman should feel appreciated as long as she does not violate the limitations set by the society. A *datu* explains: "She might virtually be carried on hands. Everything she wishes to purchase, as long as the budget is there, will be bought: diamonds, cloth, furniture, cars, etc." These are things a woman may also demand from her husband in order to be able to participate in the acquisition of status symbols, which are crucial in this status-oriented society. Then again, her freedom of movement may be restricted with the argument of protecting her morality and dignity, a protection that young educated women sometimes regard as "over-dignification."

Islam and the Sultanate System

Even though women can claim rights based on *adat*, and there is a retra-ditionalization movement, there is no women's rights movement based on it. Instead Islam is taken as the main legal basis, not only because of its political importance in the "no war, no peace" environment but also because *adat* is seen as based on the *sharia,* and the sultanate system is, although syncretistic, a Muslim system. This can pose problems to royal women since those that have a monopoly on how to define Islamic narratives, such as Islamic feminists who are also conservatives or extremists, often position themselves outside of the sultanate system. They do not take traditional religious titles and are often opposed to the sultanate system. Their reasons are that this system is hierarchical and connected to family feuds (*ridos*) and status-honor (*maratabat*), which bring injustice and great suffering to society. Some consider the sultanate system as un-Islamic. An *alima*, being educated at Al-Azhar University in Cairo, Egypt, and a former member of the MNLF, now leading a *toril* school,[6] stated that:

> We have a lot of problems with the *bai a labis*, because sometimes
> we have a relative who is . . . it is a big problem in the family
> [referring to a conflict among two women aspiring to become the

bai a labi of the place, which led to a *rido*]. This happens only because they really do not know what Islam is. And that is why they fight even for small titles and that creates so much trouble for the family; we know that because many of our relatives are not on speaking terms because of the *bai a labi* . . . So it is not good. Those who believe in Islam should not participate in *bai a labis*. As long as they believe in Islam, they know their role in society, they know what should be done, that is good enough, because the *bai a labi*, the title *bai a labi* is for culture and social affliction only, it has nothing to do with Islam. (Interview translated from Maranao by Norodin Alonto Lucman, Marawi City, 2008; translation modified)

Similar statements were made by another *alima*, also educated in Egypt and Saudi Arabia. She preferred to stay isolated from the community because she feared getting involved in things that might violate her beliefs. A visiting scholar from Saudi Arabia who sponsored a *madari* for orphans in Marawi City argued similarly, saying that it will be a long time before Maranaos are religiously enlightened. McKenna (2002) described the potential conflict between religious functionaries and traditional Moros from the viewpoint of traditionalists from the Maguindanao ethnic group. In Lanao, however, open critiques of traditionalists against religious functionaries, and in particular Islam itself, are rare. A sultan emphasized that the religious sphere is separated from the sultanate, and female titleholders would rather humbly state that they are not religious enough. Even though a new concept of Islam and its importance is generally accepted, the sultanate system itself and its functions were not questioned but seen as corresponding with Islam, or, in other words, corresponding with Maranao identity (which is Muslim). In any case, traditionalists dominate the area in numbers. This means that there is an internal debate between traditionalists and Islamists, but, especially since the decline of Islamic political parties in the 2000s, that politically traditionalists are stronger.

Islamic Feminism

The unsolved national question and thus the importance of defining oneself as a Muslim nation but also the general Islamic resurgence movement increased a sensitivity about gender conceptions in an Islamic framework and has thus to be considered when debating current local women's movements

in Muslim Mindanao.[7] For local Muslim women's NGOs it is thus of impor-
tance to be Muslim in order to implement their concepts, because mistrust
against a cultural domination of non-Muslims is high in the conflict-ridden
area. However, what kind of Islam is implemented varies, as diverse move-
ments are currently influential in Lanao. Apart from a large number of tra-
ditionalists who follow a syncretistic form of Islam, extremists,[8] such as the
MILF, MNLF or Abu Sayaf, or conservatives,[9] such as the OMPIA, there is
also a minority of women who can be called modernists or Islamic feminists,
demanding gender equality on the basis of the Qur'an. In the following
section, this small movement in Lanao is introduced as strong, since it is
sponsored by international development organizations, as well as influential
in regards to current politics on gender in the ARMM (see below).

After the downfall of Marcos, a "democratic wave" overran the Philip-
pines, and in 1991 the government recognized the important role of NGOs
in the Philippines (RA No. 7160) (Cagoco-Guiam 2002). Not all NGOs reg-
istered, especially not those occupied with *da'wah*, which constituted the
majority in Lanao in 2002 (Cagoco-Guiam 2002). Those that registered in
Lanao del Sur were mainly funded by international Western sources and led
by members of the *datu* class. One main point of the sponsored activities at
the time of the study was gender programs, which according to Alojamien-
to had been popularized in Mindanao mainly through international donor
agencies since the early 1990s (2004, 2007), as was also Islamic feminism,
which campaigned for the empowerment of women by turning to Islam as
a reference point.

To Badran (2008), gendered Islamism or Muslim secular feminism
both seem to be Muslim women's movements arguing for a complemen-
tary empowerment of women. The latter is defined by Badran as the heir
of early Muslim feminist movements, such as those in Egypt in the late
twentieth century. In Egypt before the 1970s such movements developed in
relation with women's movements based in other religious groupings during
a time when secularism was not yet defined by Islamists as "Western" or
anti-Islamic (p. 29). Instead, it was predominantly connected with national-
ist movements for equality, no matter the race, gender, or religion. Secular-
ism in this context is not the absence of religion from public space but the
freedom of religions within a national collective space (Badran 2009, 328).
Unlike gendered Islamism, secular feminism goes one step further and insists
on full equality of the sexes in the public sphere, while maintaining accep-
tance of gender complementarity in the private sphere. It was only second-
wave Muslim secular feminists,[10] feminists active at a time when Islamists
defined secularism as anti-Islamic, who started questioning the notion of

the patriarchal family (Badran 2008, 33; 2009, 308). This movement went along and merged with the development of what Badran defines as Islamic feminism. Among Islamic feminists,[11] the concept of equality between men and women—in both the private and public spheres—is paramount. To justify this claim, these groups are particularly involved in the re-reading of the Qur'an from a woman's perspective and in basing their arguments on Islamic sources (Badran 2009, 234).[12]

In Mindanao, all three concepts (gendered Islamism, Muslim secular feminism, and Islamic feminism) can be found; sometimes they merge or are not clearly developed. Whereas in most cases gender programs follow the conception of equity, such as in gendered Islamism and Muslim secular feminism, the issue of gender equality in public and private spaces, such as in Islamic feminism, is also debated.

One of the Muslim women's groups that is most debated is the Al-Mujadilah Development Foundation, Inc. (AMDF). It was cofounded by Yasmin Busran-Lao, who comes from a prominent clan. She ran for senator in the 2010 elections under the Liberal Party, but lost. Formerly, she was a member of the national women's group PILIPINA. Motivated by the Fourth World Conference on Women held in Beijing in 1995 (Cruz 2005), Busran-Lao established her own women's group within the context of Islam in 1997. Busran-Lao realized the main barrier with which women in Mindanao have to struggle is not Islam as such, but rather its cultural interpretation. Thus, she founded a women's organization within the Islamic framework in order to empower women. Its founding was also a "response to allegations that gender issues are Western issues that have no resonance in Muslim Moro communities" (Cruz 2005). The vision of the organization follows common concepts being used by Muslim feminists worldwide since the 1990s: "an Islamized society operating within the principles of Tawhid [one-ness of God] where women and men are accorded the status of Khilafah (God's vice-regents) to serve as moral agents towards the attainment of Sakeena (Tranquility or enduring peace) and human development." *Khilafah* is the trusteeship of God on Earth, given to men and women alike, which cannot be "de-equalized." *Tawhid* states the uniqueness of God, who is the only one a human being has to obey. In a patriarchal society, women have to obey men; this is thus against the principle of *tawhid* (Badran 2007, 38).[13]

Besides the establishment of community-based health clinics and pharmacies and the construction of shelters for IDPs from the 2000 all-out-war, one project of AMDF, sponsored by USAID and the Asia Foundation, was to translate extracts from the Code of Muslim Personal Laws (CMPL)[14] in 2005. It was made more public because it contains the rights and duties of Muslim

women, which are not known by many Muslim Filipinos. Comprising family and civil laws on topics including personal status, marriage and divorce, paternity and filiations, paternal authority, succession and inheritance, support and maintenance, rights and obligations and property relations between husband and wife, CPML is enforced by *sharia* courts.

The fact that the Code includes regulations that, when compared to *adat* law or the Civil Code of the Philippines, partly weaken women's position, led to discussions among Moro women activists (Fianza 2004, 34–35), and the most progressive of them called for a revision of the CMPL (Rasul 2003)[15] on legal succession. Article 112 of the CMPL states that the surviving wife together with a legitimate child or a child of the decedent's son shall be entitled to one-eighth of the hereditary estate. A husband who inherits from his deceased wife, according to Article 117, is entitled to one-fourth. In case there are no such descendants, he inherits one-half of the estate while the woman gets only one-fourth. According to *adat* law, men as well as women have a right to equal shares (Fianza 2004, 32). AMDF handled the situation by ignoring articles that state gender inequalities in relation to inheritance and only popularized Article 110, concerning legal succession, which lists the sharers without stating their particular share. However, other articles under critique, notably by the Pilipina Legal Resources Center (PLRC), were published in their original version without reservations.

The broadcasting of an unrevised version of the CMPL by the AMDF shows the balancing act of the organization between local demands in a "no war, no peace" environment, in which the CMPL became a symbol of the success of a Muslim minority in the face of the state (see Barra 1993, 88) and their will to change certain rights. AMDF solved the conflict by joining the Nisa Ul-Haqq fi Bangsamoro confederation,[16] which is part of a transnational Muslim women's movement. Founded in 2007 by the Sisters in Islam, the Musawah group is composed of individuals and NGOs from about fifty countries around the world, advocating women's rights in the context of Islam. Its specific goal is to advance equality in the family. Nisa Ul-Haqq fi Bangsamoro reports that amendments to the CMPL were already drafted by Muslim women and submitted to the Lower House of Congress in 2000, though the endeavor was not successful. Recently, Nisa Ul-Haqq fi Bangsamoro demanded that polygyny be discouraged, if not forbidden, on the basis of the Qur'anic verse An-Nisa 4:3, where it is written that a man should marry more than one woman only in cases that he can treat them justly, which should be read together with the verse An-Nisa 4:129, stating that it is impossible for a man to do perfect justice to several wives. Both should be understood within the context in which the Qur'an was revealed (historical

understanding) and not taken in general terms, providing room for modern reinterpretations. By using this approach Nisa Ul-Haqq fi Bangsamoro applied international discourses, which are used by Islamic feminists. The proponents of the amendment of the CMPL continue their work by using different disciplines and approaches, including religious, rights-based, scientific, and even evidence-based research: "A research on early marriage is part of the building up of evidence-based advocacy, using lived realities of women in the ARMM" (Musawah, the Philippine Report 2010). The CMPL should further be amended on the basis of the Convention on the Elimination of all Forms of Discrimination against Women (CEDAW). Generally the group's conclusion on the implementation of women's rights in the ARMM is that some programs "have tapped Muslim religious leaders . . . as a sector for advocacy, including that of women's rights. There is still a lot of resistance in this area, but some progressive interpretations of Islamic teachings have gained some headway, with the help of women's rights advocates" (Homepage of Musawah, the Philippine Report 2010).

Islamic Parties and the Return of the Traditional Political Elites

One outcome of the increasing Islamic resurgence movement—since the 1950s but especially as a result of the democratic wave after the downfall of the Marcos government—was the emergence of Islamic parties in Mindanao (McKenna 1990; Maruhom and Allian 2005, 143).[17] The involvement of *ulama* in politics was, according to Maruhom and Allian, a new phenomenon, since the religious sector had previously been separated from the worldly sector. *Ulama,* beside their religious functions, operated as advisors of political leaders, but not as leaders themselves (p. 143). Founded in 1986 by Mahid Mutilan, the OMPIA Party reached its height in the 1990s.[18] Mutilan was supported by the government to curb the MILF and the threat of an *ulama* unification under its authority and thus a unification of the religious sector outside the state. Thus, Mutilan founded the Ulama League in 1996, which was open to dialogues with the Catholic Bishops' Conference of the Philippines (CBCP) (Vitug and Gloria 2000, 151).

The formation of the Kuwaiti-sponsored Ummah Party, headed by Abu Mohammad Sarangani, followed that of Mutilan's OMPIA Party in 1998. The party was founded by the conservative *da'wah* (call to faith) movement Sabaab, which spread in Marawi City under the leadership of the *ulama* who had studied in Kuwait. This movement is involved in socioeconomic community activities and gives seminars on Islam for men and women. It

favors plural marriages but is less strict on *purdah* (segregation of the sexes and seclusion of women) than the Tabligh (Madale 1997, 110; Maruhom and Allian 2005, 141). A coalition of Islamic political parties and organizations earned the OMPIA and Ummah parties a number of political victories in municipal elections. Mayor of the Islamic City of Marawi from 1988 to 1992, Mutilan then ran on a platform of reform and honest government in the provincial elections and won overwhelmingly against the incumbent governor despite meager campaign funds. The OMPIA Party governed the province of Lanao del Sur for the next nine years, until 2001.

The political experiment of a religious party in power did not turn out to change much, and by the end of his nine-year stint as Lanao del Sur governor, Mutilan was said to have been caught in the familiar Filipino maelstrom of money politics.[19] The internal and external political power struggles finally led to a loss of power of religious parties and the return of traditional political family dynasties. Thus, power reverted to clans and traditional politics, under the influence of Filipino government officials in Manila. That is the return of those families that are descendants of mayor sultanates and that have a long history of political leadership, in the instance of the Alonto-Adiong families. Since 2007, the religious OMPIA Party lost contests for every major political position available in the ARMM regional elections.

After the death of its founding leader, the new OMPIA Party direction decided in June 2008 to enter the Lakas-Christian Muslim Democrats (CMD) while remaining an autonomous entity. By doing so, it announced its support for President Arroyo in the August elections in the ARMM, and thus for the candidates of the Lakas-CMD party, Governor Zaldy Ampatuan and Vice-Governor Adiong.[20]

An electoral failure of Islamic parties in Lanao does not mean the failure of Islamic philosophy *per se*, or the lack of influence of Islamic morals in society. During the time of the religious parties, Marawi City was increasingly influenced by Islam, and those who were successful in politics were often *ulama*. Taking the case of Mutilan, it is said that he was not rich and did not even have his own car. His political success was due to his status as an *alim*. As Marawi City mayor, he and his supporting *ulama* passed laws to prohibit drinking and gambling and to make the wearing of the veil in public obligatory. The suggestion to introduce the *abaya* as dress for women was, however, refused because women complained that it would be too expensive. Whereas no public police was founded to enforce the Islamic laws, some used them as a basis to act against women. Before Mutilan's election, this violence reached its climax:

In 1987, several bodies of women were found floating in a river in Marawi City. The police retrieved the bodies but there are no claimants. Days later, the bodies were identified by people but their families did not claim them. It was found out that these women were snatched in Cagayan de Oro City by their relatives and executed in Marawi City. They were accused of engaging in prostitution in Cagayan de Oro City. Thereupon the Imams made pleas during Friday prayers that wayward Maranao women committing acts of lasciviousness will be dealt with harshly by their irate families. The police did not charge anyone but nevertheless filed the cases under "unsolved murders" file. (Written statement by a *datu*, Marawi City, 2008)

In 2002, under the governorship of Mamintal "Mike" Adiong, women were again harassed by some Islamic preachers, who sprayed liquid paint on their faces because of their allegedly improper attires. The ULP confirmed these incidents by stating that the women had been punished. The *Philippine Star* (Unson 2002) wrote that "[t]wo alimas [*sic*] or women preachers, who belong to the ULP, said the ulamas [*sic*] (Muslim religious leaders) are also 'punishing' women who wear tight jeans." Facing a public outcry against those practices, physical violence changed into symbolic violence. In 2008, for example, the faces of women on streamers were painted black. The aim remains the same: an attempt to enforce the Islamic dress code on women.

It is interesting to notice that violence against women in Lanao del Sur on the basis of Islamic laws has been mostly reported in times when Islamic parties did not govern the province and the city.[21] Hence, it might be understood as opposition by extremists (not necessarily members of the Islamic parties) against traditionalists. Local *datus*, maybe out of politically strategic reasons, accuse not the OMPIA Party of such extreme actions but members of the MILF:

In fact, the MILF ordered such defamation against women [painting the faces of women on streamers black] to be carried out . . . Commander Bravo made the operation as part of MILF's effort to force Muslim women to dress modestly or the like. Muslim women being displayed in public is frowned upon by their clans. He explained to me that women should not be displayed in public wearing thick make up and extravagant clothing. (Email correspondence, 2009)

These forms of symbolic violence, however, find only minor appreciation among inhabitants of Marawi City. It is more striking that normally the faces of women and men are shown proudly and that their kin appreciate them.

Gender Blind Reward System

The lineage system of the *Pat a Pangampong* provides a gender-blind reward system, which means that whoever brings increased power to the lineage, clan, and especially family will be supported by the family, clan, and lineage, whether this is a woman or a man. There are thus women who are the silent king-makers of a clan, since they have the family background, the money, and the political clout—maybe because a powerful husband has already died—and there are also those women who are pushed by the clan to run for a specific political position because they are thought to be the best representatives of the clan. Especially powerful clans pay no attention to conservative Islamic critiques of women in leadership, and these clans campaign defiantly for their wives, sisters, and cousins to keep the political office within the family. Lacar (1997, 202) writes that such women simply ignore the animosity of some *ulama* toward female claims to leadership. But it is more than that—they also seek and get the support of *ulama* from the clan. Thus a board member of the ARMM, coming from a political family, reports that her relatives always wanted her to join politics, "although I am a bit limited because I am a woman." Islam itself, she explains, does not prohibit women from participating in politics. Women, however, "shy away," because "a woman is not to be exposed." She concludes by referring to a *hadith* to justify her political activities: "If there is one woman who can do better than a thousand men then it is better to appoint that woman who is working better than the other men."

The board member justifies her position through an Islamic narrative of justification, referring not only to religious authorities but also to a *hadith*. This position thus derives not only from ignorance of the arguments of Muslim extremists and conservatives, as Lacar argued, but from a counterargument based on Islam. The example thus highlights an intra-Islamic debate on the issue, which can also be found in other Muslim countries, such as Indonesia and Pakistan (Brecht 2008). A similar argument was used by Princess Tarhata Alonto Lucman, the only female governor in the history of Lanao del Sur. This leadership shift was largely due to the influence and power of the political clans that supported her candidacy since no male candidate was seen as fit for the position. Tarhata, nonetheless, justifies her

position through an Islamic narrative of justification, referring not only to religious authorities but also to a *hadith*:

> In Islam, women are not so much allowed to participate in politics. But if a woman is 100 times better than man, she is accepted in politics. Like me, firstly I said I am a Muslim, I said I do not want to run because I might violate the rule of God. My brother ["Domocao" Alonto] said: "No, women are better than men if they are stronger and trusted, women are better than men." . . . The *ulama* want women to be kept at home, but I said: "If women cannot do something for the community and to the people, they are right, keep them at home. But if she is better than anyone of you, she has to go!" I fight for the women. For their rights! (Interview, Manila, 2008)

Tarhata is referring to Islam in order to elevate the condition of women in society in general and in politics in particular. She, however, speaks on the basis of a traditional field of power, her descent lines status and family backing. This means that tradition, and thus retraditionalization, has the potential, notwithstanding the political motivations, to reinforce the position of (certain) women—within and despite Islam.

Maranao women who had been successful in politics, in most cases, had a royal background and were from prominent clans and political dynasties. The 2010 election results showed that political dynasties have been rampant in the Philippines: "[i]n at least 34 of the country's 80 provinces, political families won tandem posts—one family member winning as governor and another as representative—in a new configuration that will give them a lock on power for years to come" (*VERA Files,* 14 May 2010). Lanao is thus no exception. The Adiongs, Alontos, Balindongs, and Dimaporos are especially important in the area because they have dynasties that have been established for several decades. All of them belong to the traditional political elite and have royal ancestry. Their dynasties, especially since the introduction of limited terms (three terms at the mayoral level), also include women taking turns in exercising power with their husbands, fathers, or sons. These forms of dynasty can be found particularly at the mayoral level. The Disomimbas in Tamparan are one example where husband and wife take turns as mayor. Bamgbose writes in 2003 that there are "increasing numbers of Maranao women in politics from the *barangay* to the congress level" (2003, 67). This evolution is not reflected at the mayoral level. In 2001, nine cities were directed by women; in 2004 there were four, and four in 2007. In the

2010 elections, five women were (re-)elected. No Maranao congresswoman, or female provincial board member, senator, governor, or vice-governor was elected in 2010 in Lanao del Sur. However, a steady increase of female vice-mayors from 2001 (two) to 2013 (seven) can be observed, and after the 2008 ARMM elections there were two female Maranao assemblywomen, as there had been from 2005 to 2008. However, despite this relative success, most of the women being elected were part of family dynasties. The majority of women who were elected followed their male relatives, who concluded their third term as mayor before them,[22] or replaced them, in cases of political violence (one woman became mayor after opponents shot her brother). Since 1998, no local elective official can serve more than three consecutive terms in the same position, which explains the increase of women in political offices. To keep the position within the family, the wife, daughter, or son will follow—whoever is considered an effective leader of the clan or family. This situation is known all over the Philippines; Hega (2003) from Friedrich-Ebert Stiftung calls these family members "benchwarmers." Whereas men are preferred as leaders, women get their turn when there is no man available to keep the position within the family.

The rather lax restrictions on women becoming clan leaders or politicians—in cases when there is no male candidate—can partly be traced back to the bilateral lineage arrangement. Dube (1997) described the possible positive effects of this system on gender relations in Southeast Asia. Likewise, in Lanao, clan membership and rights are transferred via both the male and female lines. These gender-blind pre-Islamic and pre-Western family arrangements become, to a certain degree, more important than restrictions on women's leadership. In general, however, women are seen as the counterparts of men, establishing their own social networks, which might also include political clout through the female relatives of leading politicians. These unofficial connections, as Roces (1998) demonstrates in her work on female power in the Philippines, are in many cases, even more effective than the power of women occupying political positions. When inhabiting a political post, women have to abide by the rules of the male-dominated public environment (see Brecht-Drouart 2013). In the unofficial space, relatives of politicians can act more freely to a certain degree.

In the end, traditional elites and the *datu*-ship system remain predominant alongside the Islamic influence. The two ideologies cannot, however, be separated. It does not seem that with the return of the traditional elites Islamic laws in Marawi City were abandoned. For instance, Islamic rhetoric remains important in justifying the leadership of men and women,

and a certain dress code (at least to cover their head), whether obligatory or not, remains the usual practice among female politicians. Conversely, as Gonzales noted in 1997, like "the *datus* and the sultans, the *alims* [*sic*], *ustads* [teachers], and *imams* tell believers whom to vote for. They exploit the culture of patronage and the clan system that reinforce Islam and partisan politics" (2000, 132). Both camps do not hesitate to enter into strategic relationships. Thus, "Bombit," the governor of Lanao del Sur, financially supports the *ulama* group, which was founded by Mutilan, though he does not enforce Islamic laws in Lanao del Sur. A certain form of Islamization remains ongoing, although marginalized. This can also be seen in the politics of the ARMM where, after the Maguindanao Massacre,[23] Ansaruddin-Abdulmalik "Hooky" Alonto Adiong became the governor in 2009. On April 7–8, 2010, the Technical Working Group of the Regional Sub-committee on Gender and Development (GAD) in the ARMM met to work on a draft on GAD (Muslim Mindanao Autonomy Act No. 280). The task was to develop a regional translation of Republic Act (RA) No. 9710 (Magna Carta of Women, MCW), which was signed into law on August 14, 2009. The MCW is considered by Filipino women's groups such as the Gabriela Women's Party (GWP) and Isis as a national framework for the implementation of the provisions of the United Nations CEDAW. However, like many other very progressive laws in the Philippines,[24] the law often lacks enforcement regarding "the rich and powerful, including political cronies and state functionaries, who commit crimes" (homepage of Gabriela Women's Party). Further, members of the Gabriela Women's Party criticized certain loopholes, including the Code of Muslim Personal Laws, which permits marriage of girls under eighteen (men can marry at fifteen and women with the consent of the *wali* at twelve), polygamy, and arranged marriages.

The main goal of the Technical Working Group in the ARMM was to bring the MCW into alignment with the official position of the Muslim religious leaders in the ARMM. Like the MCW, the ARMM GAD Code affirms the role of women in nation building, and guarantees the substantive equality of gender, for young and old alike. It also promotes the empowerment of women, pursues equal opportunities for women and men and for boys and girls alike, and ensures equal access to resources, development results, and outcomes in the region. However, as observed by Tarhata Maglangit, Commissioner of the ARMM Regional Commission on Bangsamoro Women for Maguindanao province, the meeting of the Technical Working Group was held with the goal of reinventing initiatives and policies that are "suitable to our 'Muslimness' and to our region's geographical configuration" (ARMM

official homepage). Considering that the MCW left the CPML untouched, it has yet to be seen what impact the GAD Code will have on gender relations and discrimination according to age in the area.

Conclusion

The rebellion brought about an unsolved national question and an environment between war and peace. Islam, as one of the main unifying characteristics of the Moro rebellion, became an important issue, and thus gender questions are discussed within this framework. Supported by the national government as a countermovement to the rebellion, a revival of the traditional system took place. In this bilateral system, each male title has a female counterpart, but women remain predominantly in the unofficial space. Influence on public activities is usually connected to age, social standing, illustrious family background, personal achievement, education, or profession/position. If based on these characteristics, and if she is adamant, a woman can get granted a title and/or take part in public policymaking. Even though royal women would refer to the rights the traditional system grants them, there is no women's movement based on it. On the contrary, women's rights are publicly based on Islam. The definition of Islam, however, varies. This means that female leadership, for instance, provided by the traditional system, can be justified via Islam and not against it. However, one will find no woman being a public political leader based only on Islamic premise. Additionally, debates in the context of Islamic feminism are mainly carried out by members of influential families; their authority is thus based on the traditional background, even though their arguments are derived from Islam.

Because of the "no war, no peace" environment, it is almost impossible for Muslim women who campaign for women's rights, as well as for Muslim women who would like to have more participation and authority in public space, to position themselves outside an Islamic framework. Thus, traditionalists rarely argue against Islam; Islamists, including Islamic Feminists, however, argue against the traditional system. However, it is the traditional system that provides Islamic Feminists, who are mainly from the traditional elite, with the space of power to negotiate about society. The reference to the Qur'an gives them additional authority to criticize so-called cultural misconceptions about Islam. Their special interpretation of the Islamic law enables them also to criticize orthodox interpretations of the Islamic law, such as the right to polygamy. It remains to be seen what influence progressive women's rights advocates will have on future laws in the ARMM, specifically the GAD and the rereading of the CMPL. Because of the political pact between

traditionalists with the conservative Islamic parties and the pressure of being defined as "Muslim" as an outcome of the unsolved national question, it seems unlikely that progressive laws will gain much space in the area.

Notes

1. The Mindanao rebellion unified different Muslim ethnic groups in the southern Philippines under the general term "Moros." Spanish colonial forces originally used this term to denote Filipino Muslims. It is derived from the Spanish term *Moro*, for Muslim Moors from northern Africa who took part in conquering the Iberian Peninsula in the eighth century. Most Moros of the thirteen different Muslim ethnic groups usually referred to as Moros would define themselves as Muslims, which, among the ethnic group of the Maranaos in Lanao del Sur is often connected with their ethnicity, thus being Maranao.

2. For more information on the Moro rebellion, see Yegar 2003, among others.

3. Maranao derives from the expression *taw sa ranaw*, which means "people of the lake."

4. *Bai a Labi* literally means highest woman, also translated as queen; the title is the female counterpart to sultan and is usually reserved to Muslims, and specifically Maranaos; non-Muslims are usually enthroned as *bais* or *datus*.

5. *Maratabat* can be defined as the honor one has in the status of his or her own lineage. It is closely connected to *taritib*, the order or arrangement of the sultanate system. The fact that almost every Maranao claims to be royal should be considered as a sign of a system characterized by "competitive equality" (Toren 1990), meaning that "hierarchy is not a status quo but must be constantly achieved" (Keating 2000, 306). In fact, hierarchy is widely defined through status. The result is that *maratabat* can easily be triggered when lineage is questioned in its status, leading to positive competition but also to bloody clan wars (Disoma 1999a).

6. A *toril* school is a residential school where children aged three and above would be confined in one place and taught Islamic religion and the Qur'an.

7. For the connection between gender issues and nationalism see Moghadam 1994.

8. Maruhom and Allian (2005) define Muslim extremists in the southern Philippines as those who favor or use violence "or force to attain goals including, among others, the establishment of an Islamic state where the Shari'ah or Islamic Law shall be strictly observed" (p.134).

9. According to a publication of local women's activists, conservatives are defined as those who campaign "for the return to the ways and practices of early Muslims during the time of the Prophet Mohammad and often assert . . . the liberal and textual interpretations of the Islamic teachings as enshrined in the Qur'an and the Prophetic Sunnah" (Maruhom and Allian 2005).

10. The first wave of Muslim secular feminists followed the understanding of secularism as involving not the absence of religion but freedom of religion in the

public sphere, including for patriarchal conceptions of Islam. The second wave of Muslim secular feminists started questioning the utility of these conceptions in the public sphere, demanding equality of the sexes.

11. The label of Islamic feminism is one given from the outside; women being defined as such would partly not agree to this, preferring, for example, to be called "believing woman." The reasons for such a rejection are manifold; as one of the main reasons, the avoidance of a connection to "Western" feminism has to be mentioned (Barlas 2008).

12. For Muslim secular feminism, see Badran 2007, 36, 167; 2009, 308; 2008, 28.

13. For a further debate on the differences between an Islamic feminist and a patriarchal interpretation of the Qur'an, see Badran (2007, 39 *et seq.*) and Wadud (1999).

14. The CMPL was enacted under President Marcos in 1977 as one major concession to the rebels. It is *sharia*-based, and is enforced in *sharia* courts, which handle matters concerning family law. National law deals with cases involving criminal law. The MILF labeled these courts "fake Islamic Courts" (McKenna 1990, 476).

15. For a revision proposed by the PLRC, see Solamo-Antonio (2003, 63–65, appendix).

16. Nisa Ul-Haqq fi Bangsamoro includes the following organizations: Alternative Legal Assistance Center, Bangsamoro Lawyers' Network, Neighbors PopDev, Al-Mujadilah Development Foundation, Inc., Tarbilang Foundation, Inc., and Basilan Muslim Women's Association.

17. In 1987, at a meeting of *ulama* of Cotabato called by Zacaria Candao, the Islamic Party of the Philippines (IPP) was founded, a "regional party without connection to the national party apparatus" (McKenna 1990, 503). The main points of the party program were to establish a meaningful autonomy of the Bangsamoro homeland and the equal distribution of wealth. In the 1988 provincial elections, the local *datus* united to defeat the IPP, which had become a strong competitor, placing second in the district including Cotabato City in the congressional elections in 1987. The IPP shifted from puritanism to populism "as the result of steady resistance by ordinary Muslims to the ulama's program for Islamic renewal" (McKenna 1990, 573). This election was the "first ever provincial campaign in which Islamic discourse figured prominently in political appeals" but also the "most genuinely democratic election ever held in Muslim Cotabato . . . because of the new national political atmosphere and the control of the province by non-*datus*" (McKenna 1990, 506).

18. Its members are mostly Maranao preachers trained at Al-Azhar University in Egypt, the World Islamic Call University in Libya, and Islamic schools in Pakistan. It started as a protest movement against a hydroelectric project on Lake Lanao. Vitug and Gloria (2000) describe Mutilan as representing a moderate form of Islam.

19. Nonetheless, in 2001 Mutilan became ARMM vice-governor for one term. Four years later, "Hooky" Alonto Adiong (Lakas-CMD) replaced him.

20. A majority of the traditional elites during the Arroyo administration who occupied a leading position in the ARMM or in the provincial government of Lanao

del Sur were members of the Lakas-CMD. However, during the 2010 national elections the Adiong-Alontos supported Benigno "Noynoy" Aquino of the Liberal Party, showing the importance of "patron-client" relationships that surpass party politics.

21. The mayor of Marawi in 2008 was not an *alim* but a sultan, Sultan Fahad Salic, who has two wives, of which the second is Parañaque City councilor Alma Moreno, a Christian and former actress.

22. The most popular example is Topaan "Toni" Disomimba and his wife "Jan" Alangadi Pundato Disomimba, who both occupied the mayorship of Tamparan for a number of years. "Toni" Disomimba was elected in the 2010 elections after his wife finished her third term.

23. The Maguindanao or Ampatuan Massacre on 23 November 2009 involved the murder of about fifty-eight people, among them female relatives of a political rival of the Ampatuans who were on their way to file the candidacy of Esmael "Toto" Magundadatu for Maguindanao governor in the May 2010 elections, and several journalists.

24. See the debate on the implementation of human rights in Castellino and Redondo (2006, 32).

Bibliography

Alojamiento, S. B. "The Place of Feminism in Philippine Activist Politics: The Case of Mindanao." *Université de Lausanne Website*. http://www2.unil.ch/liege/actus/pdf/GMAlojamiento.pdf. Accessed October 14, 2007.

———. "The Place of Feminism in Philippine Activist Politics: The Case of Mindanao." *Tambara* 19 (2004): 161–174.

Armstrong, David. "Tradition." *Quadrant* 26 (1982): 71–73.

Badran, Margot. *Feminism in Islam: Secular and Religious Convergences*. Oxford, UK: Oneworld, 2009.

———. "Engaging Islamic Feminism." In *Islamic Feminism: Current Perspectives*, edited by Anitta Kynsilehto, 25–36. Tampere Peace Research Institute Occasional Paper No. 96. Tampere, FI: Tampere Peace Research Institute, 2008.

———. *Feminism Beyond East and West: New Gender Talk and Practice in Global Islam*. New Delhi: Global Media Publications, 2007.

Bamgbose, Angie. *Women in Conflicts: Gender Dynamics in Maranao Communities, Southern Philippines. Participatory Rural Appraisal (PRA) and Gender Profiling in Rural Maranao Communities in Lanao del Sur, November 2002–October 2003*. Iligan City, PH: VSO, 2003.

Barlas, Asma. "Engaging Islamic Feminism: Provincializing Feminism as a Matter Narrative." In *Islamic Feminism: Current Perspectives*, edited by Anitta Kynsilehto, 15–24. Tampere Peace Research Institute Occasional Paper No. 96. Tampere, FI: Tampere Peace Research Institute, 2008.

Barra, Hamid Aminoddin. "The Sharia Law in the Philippines: An Introduction." *Dansalan Quarterly* 13/1–4 (1993): 1–107.

Brecht-Drouart, Birte. "Muslim Woman Political Leaders in the Philippines: Tradition Rules." In *Gender and Islam in Southeast Asia*, edited by Susanne Schröter. Leiden, NL: Brill, 2013.

————. "Transformation durch globalen Diskurs: Islam als Referenzquelle für weibliche Identität bei den Maranao auf Mindanao. "In *Islam, Identität und Nicht-Muslime in Südostasien: Frankfurter Forschungen zu Südostasien* 4, edited by Holger Warnk and Fritz Schule, 205–218. Wiesbaden, DE: Harrassowitz, 2008.

Cagoco-Guiam, Rufa. *An Exploratory Study of Civil Society Organizations among Muslim Communities in Two Provinces in the Autonomous Region in Muslim Mindanao*. Ateneo Center for Social Policy and Public Affairs, 2002.

Castellino, Joshua, and Elvira Dominguez Redondo. *Minority Rights in Asia: A Comparative Legal Analysis*. Oxford, UK: Oxford University Press, 2006.

Cruz, Pennie Azarcon-dela. "Yasmin Busran-Lao: She Who Seeks Justice." *The Philippine Daily Inquirer*, March 13, 2005. http://www.truthforce.info/?q=node/view/849. Accessed May 13, 2007.

Dijkzeul, Dennis. "Towards a Framework for the Study of 'No War, No Peace' Societies." *Swisspeace Working Paper* 2/2008.

Disoma, Esmail R. *The Role of Violence in Social Organization: The Case of the Meranao and their Maratabat*. Marawi City, PH: The Office of the Vice Chancellor for Research and Extension, Mindanao State University Main Campus, 1999a.

Dube, Leela. *Women and Kinship: Comparative Perspectives on Gender in South and South-East Asia*. Tokyo: United Nations University Press, 1997.

Elwert, Georg. "Markets of Violence." In *Dynamics of Violence. Processes of Escalation and De-escalation in Violent Group Conflicts*, edited by Georg Elwert, Stephan Feuchtwang, and Dieter Neubert, 85–102. Sociologus: Zeitschrift für empirische Ethnosoziologie und Ethnopsychologie, Beiheft 1. Berlin: Duncker und Humbolt, 1999.

Fianza, Myrthena L. "Land, Ethnicity and Gender in Muslim Mindanao. Focus on Maranao Moro Women." *Mindanao Focus* 3 (2004): 3–43.

Foucault, Michel. *The History of Sexuality: The Will to Knowledge*. Vol. 1. Reprinted. London: Penguin Books, 1998.

Gonzales, L. Francisco. "Sultans of a Violent Land." In *Rebels, Warlords and Ulama: A Reader on Muslim Separatism and the War in the Southern Philippines*, edited by Eric Gutierrez et al., 85–144. Quezon City, PH: Institute for Popular Democracy, 2000.

Hega, Mylene. *Participation of Women in Philippine Politics and Society: A Situationer*. Quezon City, PH: Friedrich-Ebert-Stiftung, 2003. http://library.fes.de/pdf-files/bueros/philippinen/50067.pdf. Accessed August 5, 2010.

Jacobs, Struan. "Edward Shils' Theory of Tradition." *Philosophy of the Social Sciences* 37, no. 2 (2007): 139–162. doi: 10.1177/0048393107299685.

Keating, Elizabeth. "Moments of Hierarchy: Constructing Social Stratification by means of Language, Food, Space, and the Body in Pohnpei, Micronesia." *American Anthropologist* 102, no. 2 (2000): 303–320. doi: 10.1525/aa.2000.102.2.303.

Lacar, Carmelita S. "Maranao Muslim Women Educational Administrators: An Initial Study on the Emerging Muslim Women Leaders in The Philippines." PhD dissertation, University of Michigan, Ann Arbor: UMI Dissertation Services, 1997.

Lee, Raymond L. M. "Reinventing Modernity: Reflexive Modernization vs. Liquid Modernity vs. Multiple Modernities." *European Journal of Social Theory* 9, no. 3 (2006): 355–368.

Li, Tania. *Malays in Singapore: Culture, Economy, and Ideology.* New York: Oxford University Press, 1989.

MacGinty, Roger. *No War, no Peace: Rejuvenating Stalled Peace Processes and Peace Accords.* Basingstoke, UK: Palgrave, 2006.

Madale, Abdullah T. *The Maranaws, Dwellers of the Lake.* Quezon City, PH: Book Store, Inc., 1997.

———. *The Maranaw Torogan.* Marawi City, PH: Mindanao State University, 1996.

Maruhom, Norma A., and Fatima Pir T. Allian. "Religious Extremism and its Impact. The Case of the Southern Philippines." In *Muslim Women and the Challenge of Islamic Extremism*, edited by Norani Othman, 134–156. Kuala Lumpur, MY: Sisters in Islam, 2005.

McKenna, Thomas Michael. "Saints, Scholars and the Idealized Past in Philippine Muslim Separatism." *The Pacific Review* 15, no. 4 (2002): 539–553. doi: 10.1080/0951274021000029422.

———. *Islam, Elite Competition, and Ethnic Mobilization. Forms of Domination and Dissent in Cotabato, Southern Philippines.* Ann Arbor, MI: Univ. Microfilms International, 1990.

Moghadam, Valentine M. *Globalizing Women. Transnational Feminist Networks.* Baltimore, MD: John Hopkins University Press, 2005.

———. *Gender and National Identity: Women and Politics in Muslim Societies.* London: Zed Books Ltd, 1994.

Neumann, Hannah. *Friedenskommunikation. Möglichkeiten und Grenzen von Kommunikation in der Konflikttransformation.* Studien zur Friedensforschung 17. Münster, DE: LIT, 2009.

Ortner, Sherry B. *Making Gender: The Politics and Erotics of Culture.* Boston, MA: Beacon Press, 1996.

Rasul, Amina. "The Moro Woman: History and Role." In *The Road to Peace and Reconciliation. Muslim Perspectives on the Mindanao Conflict,* edited by Amina Rasul, 185–207. Makati City, PH: Asian Institute of Management, 2003.

Roces, Mina. *Women, Power, and Kinship Politics. Female Power in Post-War Philippines.* Westport, CT: Praeger, 1998.

Shils, E. *Tradition.* Chicago: University of Chicago Press, 1981.

Solamo-Antonio, Isabelita. *The Shari'a Courts in the Philippines. Women, Men and Muslim Personal Laws.* Davao City, PH: Pilipina Legal Resources Center, Inc. (PLRC), 2003.

Tawano, Hajda Mo'fida Binolawan, M. "Rights of Women on Marriage According to Adat Laws." *Mindanao Art and Culture: The Maranao Woman* 2 (1979b): 119–126.

———. "The Torogan." *Mindanao Art and Culture: The Maranao Woman* 2 (1979): 56–63.

Toren, Christina. "Making Sense of Hierarchy." *London School of Economics Monographs on Social Anthropology*, vol. 61. London: The Athlone Press, 1990.

Unson, John. "Ulamas in Marawi City 'Punish' Women who Violate Dress Code." *The Philippine Star*, July 27, 2002. http://www.philstar.com/Article.aspx?articleId=169730. Accessed September 3, 2010.

VERA Files. "Poll Results Show Dynasties Stronger than Ever." *VERA Files*, May 14, 2010. http://verafiles.org/front/poll-results-show-dynasties-stronger. Accessed August 5, 2010.

Vitug, Marites Danguilan, and Glenda M. Gloria. *Under the Crescent Moon: Rebellion in Mindanao*. Quezon City, PH: Ateneo Center for Social Policy and Public Affairs, 2000.

Wadud, Amina. *Qur'an and Woman: Rereading the Sacred Text from a Woman's Perspective*. New York: Oxford University Press, 1999.

Yegar, Moshe. *Between Integration and Secession: The Muslim Communities of the Southern Philippines, Southern Thailand, and Western Burma/Myanmar*. New York: Lexington Books, 2003.

Part II

Feminisms and Muslim Women's
Movements in Contested Spaces

Chapter 5

The Headscarf Ban and
Muslim Women's Rights Discourse in Turkey

Zeynep Akbulut

Introduction

In recent years, some European states have imposed restrictions over the use of headscarves by Muslim female students or teachers.[1] In Muslim-majority Turkey, however, the state's prohibition on wearing headscarves has a much longer history and larger scope. About two-thirds of all women wear a kind of head covering in this country,[2] and until very recently, they have not been allowed to become elected politicians, civil servants, or even university students. This essay, instead of examining the headscarf ban itself, explores Muslim women's reactions to it. It particularly analyzes how certain women wearing headscarves in Turkey employed women's rights discourses during their struggle with the ban.[3] Many women who faced the headscarf ban from 1997 to 2013 have appropriated rights-based discourses against it. Rather than simply arguing that the headscarf ban is a restriction of their right to practice Islam, these women have often elaborated their oppression using the language of women's rights and human rights—defining the headscarf ban as a form of discrimination and a restriction of their civic rights and individual freedoms. These women have also often expressed that they have been objectified by the ban as women because their male counterparts, who have practiced Islam in a similar way, have not been affected by this kind of restriction.

 With the imposition of the ban, the Turkish state has forced thousands of women to choose between their headscarves and their education. Most of

them refused to decide based on these state-imposed dichotomous options. Instead of taking off their headscarves permanently or quitting their education, many have tried to find ways to go around the ban. To be able to attend classes, these women have developed different tactics, such as taking off their headscarves only in university buildings, or wearing other head coverings such as wigs, berets, and shawls when they are permitted.

While the visibility of women with headscarves in the public sphere has been problematic since the foundation of the Republic, the most recent and rigid imposition of the headscarf ban took place following the 1997 military intervention, which is known as the February 28 process.[4] This reinitiation of the headscarf ban by a semimilitary government following the 1997 military intervention was not a novel attempt,[5] however it led to the formation of new kinds of subjectivities and discourses among women wearing headscarves. Facing the headscarf ban, women wearing headscarves were not only forced to embrace new acts (removing headscarves in classes, wearing berets, etc.), but were also challenged to produce new discourses and understandings about their situation.

Judith Butler stresses the paradoxes of subjectivation, noting that the very process and conditions that secure a subject's subordination are also the means by which she becomes a self-conscious identity (14). In Turkey, women who were challenged by the headscarf ban largely became more conscious about their subjectivity as women wearing headscarves, which led to an appropriation of women's rights discourses.

This essay is based on about fifty in-depth interviews I conducted with women wearing headscarves in terms of their personal experiences and associational activities. The interviews were conducted between 2008 to 2010 in Istanbul and Ankara. I conducted the interviews in Turkish and translated them into English. I did not use my interlocutors' real names in order to protect their privacy. I employed a snowball recruitment method to find my interviewees, and I chose them among women who experienced the headscarf ban in several universities or public offices. My interviewees are diverse in terms of age, economic status, and ethnic identity. My interviews were conducted both one-on-one and in group settings and took between 1.5 to 3.5 hours. Most of the interviews were semistructured. I allowed interviewees to carry the conversation and asked my pre-prepared questions when appropriate contexts arose.

The first part of this essay explores the individual experiences of discrimination these women faced both from the Kemalist[6] establishment and the Islamic circles, which led to their appropriation of women's rights language. The second part focuses specifically on two women's rights associa-

tions that have actively worked to support women wearing headscarves—the Capital City Women's Platform (Başkent Kadın Platformu) in Ankara, and the Women's Rights Association Against Discrimination (Ayrımcılığa Karşı Kadın Hakları Derneği [AKDER]) in Istanbul. In the third part, I focus on criticisms that are brought to the language of women activists by other Muslim individuals and groups. Although the critics have various backgrounds, such as Islamist and postmodern, they have a common criticism of the usage of liberal rights discourse.

Personal Elaborations on the Women's Rights Discourse

Emergence of Women's Rights Language

During my interviews, many women who experienced the headscarf ban pointed out how the ban had a central role in their life and shaped who they were at the moment. They felt especially resentful toward the Kemalist establishment, which considered the ban as a way of keeping Turkey as a modern nation. Şenkan, one of my interviewees who experienced the ban in her college years, related to me that she could not understand the Kemalist notion of women's rights, which found it plausible to restrict her way of life and beliefs. She continued,

> I don't think that there is anything I cannot do as a woman if I work enough; I don't feel myself inferior to men in any sense. I am an electrical engineer, my field is full of men but I feel myself competent enough. I even feel myself a feminist [smiling] since I get very aggressive when I am discriminated against because of my gender, which sometimes happens. (July 2008)

Şenkan also told me that she was not only the only woman but also the valedictorian in her undergraduate class. Şenkan did not consider herself a women's rights activist, but there was a strong feminist tone in her way of defining her competitiveness and success in an area of study that is predominately male. She also found it odd that many feminists were not on her side in her resistance against the ban, since her understanding of equality between men and women in social life is very similar to what feminists of Turkey also thought of them. Aliye, another interviewee, also articulated her disapproval of the headscarf ban by using similar language. Her objection to the ban was not only because it restricts her right to an education and job

but also because the ban questions the capacity of women with headscarves to decide for themselves. "I don't feel stuck to my headscarf," Aliye said,

> If I want to take it off, I can do it. I am not a child; I am old enough to decide for myself. I think I have a right to expect respect from other people as to who I am. While I respect every-body's decision about what to wear or think, I cannot understand why I am not getting any respect. It hurts me. (August 2008)

Aliye explained to me what she meant with an example:

> As a parent I will teach my child what is right and what is wrong according to my Islamic understanding. Yet, after his adolescence, my son has to decide if he wants to live according to these prin-ciples or not. It is going to be his decision and he will bear the consequences. I will surely be hurt and unhappy if he decides not to live by my teaching. However, it is his life and God gives him the mental capacity to decide what is good and what is bad. (August 2008)

Aliye's articulation of her freedom of choice was a result not only of a liberal perception of freedom but was also rooted in her Islamic under-standing of individual responsibility and accountability toward God. While Aliye finds it unacceptable to force her ideas and lifestyles on even her own child, she could not understand how some people (Kemalists) find it fair to intervene in the way she dresses.

Sevda, who gave up her education because of the headscarf ban, also defined the ban as a government intrusion into women's personal lives. To Sevda, even if a woman wears a headscarf because of her family's initial pressure, she can choose to take it off when her character and identity are settled, or when she becomes an independent adult. However, by not per-mitting her to attend university, the state takes away her chance to become economically independent. Sevda found it perplexing that, while not even families have the power to force their children to do something, the state is powerful enough to force her and other adult women—by any means, including police action—to take off their headscarves.

Most of the women I talked to, regardless of their choices in the face of the ban (giving up their jobs/schools or continuing their careers/education by taking off their headscarves or by wearing wigs), resent the state's oppres-sion of their choices and bodies. They readily compare their experience with

their pious male counterparts, who are not restricted by any formal ban in universities or public offices.[7] The gendered nature of the headscarf ban led these women to develop a specific women's rights discourse in order to articulate the discrimination they experience.

Beyond being an ideological policy, the headscarf ban in Turkey has also become an instrument of economic discrimination for women wearing them. Having been officially excluded from the public sector, these women could not find decent jobs even in the private sector, despite their qualifications and experience. Because of the official discourse against headscarves, companies were not willing to be associated with women with headscarves. According to a study by Dilek Cindioğlu about the work experience of these women, the ban on headscarves in public offices has had a contingency effect on the private sector. Since the public and private sector are closely related to one another in several ways, Cindioğlu concludes that women wearing headscarves in the private sector have had a harder time finding jobs, and even if they have found a job, these women have had much less chance of having an equal opportunity of payment and promotion (8).

My interlocutors experience with so-called Islamic companies also confirms Cindioğlu's findings. Some of these companies did not hire women wearing headscarves because they did not want to be labeled as Islamist,[8] and the ones that employed women with headscarves paid them very little or wanted them to work in back offices and be unseen. Rüveyda was one of my interviewees who gave up her job as a teacher because of the headscarf ban. After she resigned, Rüveyda looked for a job in the private sector and thought that she would have a better chance of finding a job in an Islamic company. However, some potential employers advised her to stay at home, and others questioned how she could possibly want to work with men while she gave up her former job for wearing a headscarf. After a month, she was stressed and gave up her quest to look for a job because of what was happening:

> It was painful, these so-called Islamic companies thought we did not have any other choice and they exploited women with headscarves by paying them less. When I resigned [from the governmental job], I acknowledged that I would be treated as a second-class citizen and would have little chance of finding another job. If I had not thought about that fact, I would be really sorry and regretful for giving up my teaching career. In my quest of looking for a new job, I even met some conservative people who enjoyed the ban, since they thought that it was the right thing for women to stay at home. (August 2008)

According to Ruveyda, the ban was widely politicized by men, while Muslim women paid the price and lived through the consequences of this unfair policy. Hidayet Tuksal, a theologian and then-president of Capital City Women's Platform, also thought that women who wear headscarves have suffered most as a result of the February 28 process. According to Tuksal, because of the strong Kemalist discourse against headscarves, even some Islamist or conservative Muslim men did not consider women wearing headscarves presentable in their Islamic institutions. Once, Tuksal was invited to a meeting of a National Outlook movement, (Milli Görüş hareketi), which was a known Islamic organization. The woman who greeted attendants at the entrance was a blond, beautiful young woman without a headscarf, while the auditorium was full of women wearing headscarves. Tuksal explains that Muslim men, Islamic communities, and Islamist parties are now accustomed to this phenomenon. Muslim men have abandoned their Islamic symbols and take full part in the public sphere. Only women wearing headscarves have faced the discriminatory consequences of state policies.

Like Rüveyda and Hidayet, Ece also defined the headscarf ban as a women's issue. Ece is a medical doctor who studied in Vienna, Austria— a popular destination for students wearing headscarves who escaped the ban in Turkey. Ece also belonged to the first generation of the Imam-Hatip high school students who were disadvantaged in the university entrance examination. Since Ece's family did not have the means, she received financial aid from a pro-Islamic foundation in order to continue her studies in Vienna. However, Ece came to understand that she and some of her friends who found funding were lucky exceptions. When she secured financial aid for herself, she tried to find funding for her friends who wanted to study abroad; however, the foundations that she talked to did not want to sponsor a woman:

> My experience makes me realize that it is hard to be pious in Turkey and it is much harder if you are a woman. They told me, since women wearing headscarves had lower chances of finding a job and mostly ended up being housewives, financing a woman's education was not a profitable investment. When I saw most of my friends unemployed, I could not argue back, but I was very much offended. I remember that some of my female friends who were much more successful than their male counterparts could not find sponsors. I later learned that some sponsors were giving money to these foundations on the condition of supporting only male students. (August 2010)

Hidayet's, Rüveyda's and Ece's anecdotes reveal that women wearing headscarves began to see the ban as a "women's rights issue" not only with state's imposition of the ban, but also when they faced discrimination in their Islamic circles. Headscarf-wearing women who lost their access to state institutions were also considered not presentable enough or not fit for financial aid by pro-Islamic institutions. As Tuksal suggested, pious men who eliminated all outer Islamic markers did not experience the kind of discrimination women wearing headscarves went through. These men continued to be part of public and political life—even becoming the prime minister and president of Turkey. Many women wearing headscarves that I talked with expressed how they became disappointed by pro-Islamic corporations or foundations run mostly by men. In a sense, they had expected some kind of conciliation from "Islamic" circles and thought of them as different from their Kemalist or other secular counterparts because of their "Islamic characteristics." However, when they were either denied funding because "financing women is not profitable" or employed for less because they did not have many options with their headscarves, women wearing headscarves realized that many pro-Islamic institutions had already become part of the capitalist system. These women's personal experiences of discrimination in their own circles contributed to the appropriation of women's rights language by a greater number of women wearing headscarves. The discussion below before the parliamentary elections of 2011 illustrates to what extent Muslim women have adopted the language of women's rights.

A Campaign During Elections

Before the June 12, 2011, parliamentary elections, several women wearing headscarves organized a campaign to encourage all political parties to nominate candidates wearing headscarves. Despite the campaign, most of the political parties and especially the ruling pro-Islamic Justice and Development Party did not include women wearing headscarves in their lists of candidates. Prime Minister Tayyip Erdoğan addressed the campaign as "inappropriate," since the campaign organizers claimed that they would not vote for parties that do not nominate women wearing headscarves. The campaign also found little publicity and support in Islamic oriented newspapers and magazines and was even harshly criticized by a well-known Islamist columnist—Ali Bulaç. Bulaç accused women who initiated the campaign of using their headscarves as a means to gain status and profit over their victimization. He also wrote that these women (who were also part of different platforms or NGOs) separated the headscarf from its religious meaning

and emptied it as a concept by using simplistic feminist and women's rights language and representing it as a simple personal choice. Bulaç also implied that this campaign, in fact, was masterminded not by these women but by other "forces" that were in fact against the Islamic presence in Turkey.[9]

Two of the organizers, Nihal Bengisu Karaca and Havva Kaplan, responded to Bulaç in their columns. Karaca defined Bulaç's analysis as Orientalistic and responded in an ironic manner:[10]

> When pious women become successful businesspeople, as pious men do, it means they use their victimization over headscarves; is this not it? When pious women become part of public life by getting involved in intellectual life, as pious men do, it shows their greed, is this not it? . . . If someone has a right to criticize the Muslim community in Turkey, it is pious men; is this not it? We, headscarf-wearing women have only one right: to acknowledge the power you [Muslim men] represent, to serve and praise it.

Hilal Kaplan also criticizes Bulaç's opposition to the campaign:[11]

> In his piece [Bulaç] named the women who took an active part in this campaign as "bad headscarved women" who are in control of different "forces." He also considered the rest of women wearing headscarves naïve enough to be deceived by these "bad headscarved women." At the end, women wearing headscarves do not have any choice; they are either steered by certain "forces" or deceived. . . . Kemalist men glorified enlightened Turkish women as long as they were not meddling with men's jobs [in the early Republican years]. This was a kind of glorification that objectified women and forced them to stay within borders that are drawn by men. It seems that some conservative Muslim men will also glorify women wearing headscarves as long as they do what their husbands/imams tell them to do and as long as we do not meddle in the men's sphere.

The correspondences between Bulaç and women columnists[12] show us deep divergences in Islamic circles regarding the use of women's rights discourse. The use of rights-based discourses by Muslim women activists regarding their headscarves was criticized by some of their male colleagues in Islamic circles. However, women wearing headscarves did not shy away from responding to these accusations with a strong feminist tone.

In the aftermath of the headscarf ban, women wearing headscarves not only developed discourses on women's rights and human rights at a personal level, but they also started to focus on defending these rights by founding associations. I will examine below two of the most well-known of these associations.

Two Women's Rights Associations

Besides the individual articulations about the headscarf ban as a form of discrimination, the language of rights and discrimination has also been adopted by several organizations that are founded by women who wear headscarves. These organizations were either newly founded or re-oriented against the strict enforcement of the headscarf ban in 1997. I will analyze two of these associations—the Capital City Women's Platform and AKDER.[13]

The Capital City Women's Platform

The Capital City Women's Platform was established in 1995 after the Beijing World Conference on Women. The organization's initial aim was to create space for Muslim women who wanted to be active in public life. According to its president, Tuksal, while the Platform does not explicitly define itself as a feminist organization, all of its members and volunteers are very sensitive about the issues of women's rights. The Platform's website defines its vision to "solve problems of women that have resulted from some religious interpretations and perceptions that enforce the image of 'traditional' women, as well as the practices of modern society that lead to discrimination against pious women."[14] According to Tuksal, the increasing awareness of domestic violence and the active participation of women in political life are among some practical objectives of the Platform.

However, with the strict imposition of the headscarf ban in Turkish universities and public offices in the February 28 process, the Platform started to focus heavily on the headscarf issue. Rather than using a religious rhetoric, it has used the language of rights and discrimination to address the headscarf ban, and has found this discourse productive, especially in cooperation with other associations and organizations.

The Platform has cooperated closely with some women's rights associations, most of which are not religiously oriented, and also was part of the umbrella women's rights organization in Turkey (Permanent Women's Platform for Peace). Tuksal noted that the Platform has reached out to feminists

and other groups as part of a general trend in Turkey. For her, most of the human rights organizations in Turkey share an agenda that ranges from defending rights regardless of ideological differences to supporting Turkey's membership in the European Union. Tuksal and other Platform members have mentioned that they have become accustomed to a diverse and pluralistic social structure in Turkey in which Kemalists, feminists, Alevis, Kurds, and LGBT people have come together in meetings for common causes. "It has been a learning process for us," Tuksal said. She continued:

> As a women's rights organization, we have been working together with other human rights organizations. In time, we learned from them and they also got used to us and learned from us. In order to live together we learned to be respectful of one another. For example, in our communication with gay and lesbian organizations, we are very honest; we never lie to each other. As citizens of Turkey we have to have the same rights. If discrimination against us is bad, discrimination against other groups such as Kurds, gays, and lesbians is bad too. It does not mean that I support PKK [the Kurdish separatist organization] or homosexuality. I am supporting others' right of choice and they are supporting mine. I think through dialogue, we can create a space to live together. We are learning to be patient and tolerant; we are internalizing it through our dialogues. (August 2008)

While Tuksal is optimistic about their relationship with other organizations, the Platform's interaction with other women's rights organizations was not always smooth. In 2005, the Platform worked actively to put the headscarf ban on the agenda of the Committee on the Elimination of Discrimination Against Women (CEDAW)—an international organization. When the report for CEDAW was prepared about Turkey, some Turkish secular feminist groups were reluctant to put the headscarf ban into the report, and agreed to mention it in only one sentence. Consequently, the Capital Women's Platform prepared a shadow report for the CEDAW committee. According to Hidayet Tuksal, other Turkish feminists did not think that the ban could come to the attention of CEDAW. It was because of the Platform's report that the CEDAW committee took the problem seriously, put it on its final report, and demanded a response from the Turkish state.

For Tuksal, the headscarf ban and other limitations that practicing Muslim women have experienced raised their awareness about other acts of discrimination and human rights violations, including the problems of

Alevis, Kurds, and homosexuals in Turkey. The headscarf ban, therefore, was an eye-opening experience for Muslims:

> I think that the oppressions of the February 28 process contributed to our understanding of civic rights. Today, there are several Muslim human rights movements and most of them were established or became active after the February 28 process. I believe that if there had not been a headscarf ban, which put religious people face-to-face with the state authority, pious people would not have been so attentive to their civic rights. The headscarf ban became a turning point that made pious Muslims question state authority. Discrimination against us made us active participants of rights discussions in general. God forbid, I don't want to live in a religious state or think about it. I want a system that is based on freedom and lets everyone live, speak, and teach, as they desire. It has its downsides, but it is the best choice we have. (August 2008)

Ceyda, a member of the Platform, agreed with what Tuksal said and stressed how her experience of the headscarf ban made her aware of other discriminations in Turkey and changed her understanding about the nature of being a rights advocate:

> Now, I don't think one has to believe in a cause in order to support its right to exist and express itself. Does everybody have to believe that a headscarf is obligatory for women in order to support some women's right to wear it at universities? If so, then how could an atheist support our cause? I don't think so; we don't have to believe in something in order to support others' right to do that thing. In this regard, we now have a very respectful and good relationship with other organizations, since we all believe in creating a common space for everybody to live freely and happily. (August 2008)

My interviews with the Platform's members revealed that Muslim women's adoption of rights discourses as a consequence of the headscarf ban made these women more conscious about other rights violations in Turkey. Moreover, while the Platform does not define itself as a feminist organization officially, the language used by members of the Platform was clearly feminist. Hidayet Tuksal, for example, found it insincere not to define herself as feminist after talking about women's rights so much. "Even if we say, we

are not; it is what we do," she said. According to Tuksal, many women in Turkey were not aware of the historical role that women's rights movement plays globally and locally; they assume that women's rights are bestowed upon Turkish women by the Republic and Ataturk. Muslim women, such as Tuksal, are critical of this official discourse that tries to confine women's rights movement to state feminism. Thus, they are becoming part of the larger women's rights movement in Turkey.

The Women's Rights Association Against Discrimination (AKDER)

Students and professional women who were subjected to the headscarf ban officially established AKDER in 1999. Like the Platform, AKDER[15] does not limit itself to the headscarf ban; it has articulated a rights discourse against all kinds of discrimination against women. According to its website, the primary goals of AKDER are to improve women's rights and human rights in general, and to end discrimination; educate its members on women's rights; and provide legal, material, and moral help to individuals whose rights are violated.[16] AKDER also earned Special Consultative Status with the Economic and Social Council of the United Nations. AKDER has played a proactive role in creating alliances with different NGOs to resist state discrimination in Turkey.

AKDER formulates its argument about the headscarf ban as a violation of women's rights to education and as a restriction of personal freedom, rather than as an articulation of religious freedom. According to its vice president, Neslihan Akbulut, the organization first became a center for legal help, and still offers free legal assistance to women with headscarves who are victims of discrimination. They have offered legal help and support in more than a thousand cases, providing lawyers, who have worked as volunteers.

According to Akbulut, women who were expelled from their universities tried to utilize legal procedures first, but they were unsuccessful, and almost all of the court cases that concerned headscarves have been lost. Some university administrations used disciplinary processes very abruptly and often did not follow legal procedures for expelling women wearing headscarves. Akbulut related to me that there were cases in which students were expelled in a single semester with no proper warning. The courts disregarded these legal violations. She also added that the few judges who regarded the ban as a violation of the right to education protected by the constitution, and who decided in favor of headscarf wearers, were warned or sometimes exiled as an example to other judges. Thus Muslim women with headscarves also lost faith in the legal system.

AKDER has tried to record rights violations against women not only at universities, but also in other public and private institutions. According to Akbulut, "if a state, which has to be impartial to its citizens, could enforce this kind of ban, it is predictable that this policy would have consequences in the private sector." Akbulut related incidents in which women with headscarves were not admitted to driver's license testing or not given medical help. AKDER has encouraged and helped women file suit, and pursued these cases against the state and private corporations. Even though most of the legal cases have been lost, pursuing them is still important in order to officially record the violations of rights and discriminations against women with headscarves. In the words of Akbulut, the cases constitute a "history to remember what happened."

With this rationale, AKDER also supported Leyla Şahin's case that was tried in the European Court of Human Rights (ECtHR) in 2005. Fatma Benli, attorney of law and member of AKDER, prepared a report to assess the effects of the ECtHR's decision that found the Turkish state's headscarf ban legitimate. Benli argues that instead of relying on its own precedents, the ECtHR quoted and referred to the Turkish Constitutional Court's decisions that justified the headscarf ban. However, the Turkish constitution explicitly states that "the Constitutional Court shall not act as a law-maker" (article 153, section 2), and fundamental rights cannot be restricted without direct provision in the Turkish legal system (article 13). Despite these principles and the legislature's several attempts to lift the headscarf ban at universities, the Constitutional Court has enforced the ban (Benli, 9). Benli and other AKDER members emphasized that the ECtHR's decision has provided an incentive to the Kemalists to widen the scope of the headscarf ban. For example, in 2006, after the ECtHR's decision, the Turkish Council of State decided against a teacher wearing a headscarf on the street, and approved the governmental decision not to assign a successful teacher to a position because his wife wore a headscarf.

AKDER, like the Platform, attaches importance to working with other associations, many of which are secular.[17] Akbulut pointed out that throughout their interaction with different rights organizations, both AKDER and secular associations have learned from each other and "have changed together." Akbulut and other AKDER members acknowledge that even if the headscarf ban is lifted, most of their problems and other marginalized people's problems will not be solved overnight. In this regard, Akbulut and two other leading AKDER members published an open letter in 2008, "We Are Not Free Yet," in order to point out their commitment to freedom for everyone in Turkey who faces discrimination from the state:

As women exposed to discrimination for veiling ourselves, we
frankly make public that we will not be happy entering the uni-
versity campuses wearing headscarves, unless we achieve the legal
and psychological environment that is required for the Kurds and
others to feel themselves as essential components of this coun-
try . . . unless the ones who shamelessly seized the foundations
of religious minorities are prosecuted, unless it is acknowledged
that the worship of Alevis is not just a cultural activity and their
houses of worship are not only cultural centers. . . . As women
well aware of what it means to be deprived of essential liberties,
we will now and in the future oppose and resist any kind of
discrimination, any violation of rights, and any kind of pressure
and constraint (Declaration by Neslihan Akbulut, Hilal Kaplan,
and Havva Yılmaz, February 2008).

This was a very timely letter, published when Parliament amended
the constitution to lift the headscarf ban (the Constitutional Court later
struck that amendment down). Many liberal and some secular intellectuals
supported the letter.[18] However, the women's rights language appropriated
by these associations and Muslim women has been also criticized by some
Muslim intellectuals and activists. The next section analyzes these critics.

Criticisms of the Employment of Women's Rights Discourses

Some Muslim intellectuals have criticized the use of a new secular language
of rights to defend the right to wear headscarves. These criticisms are also
important to understand diversity of newly emerging Muslim women's dis-
courses in Turkey. For example, Nazife Şişman, sociologist and writer, who
also wears a headscarf, depicted this liberal language as "non-productive and
compromised by concepts of another worldview rather than an Islamic one"
("Başörtüsüne Özgürlük!"). According to her, the idioms and concepts that
have been used and brought to the center of the discussion give us clues
about the priorities of a certain worldview. The liberal conception of freedom
was promoted through a series of European historical experiences, such as
the Renaissance and Reformation, and therefore carries a certain cultural and
secularist baggage. For Şişman, the use of the rights-based discourses is not
an intellectual endeavor but a practical discourse formed by some activists.
She thinks that this pragmatic discourse could be successful in the short run
to create a space to discuss the headscarf ban, and is therefore understand-

able; however, in the long run, it could create a disruption in the hierarchy of the Muslim value system (Başörtüsü 169).

Beyond Şişman's theoretical concerns, there were other practical reasons for some Muslim NGOS's indirect criticisms of the Capital City Women's Platform and AKDER, such as their close communications with homosexual groups.[19] Both the Platform and AKDER were not shy about their meetings with LGBT associations and had a similar discourse in explaining their tolerant understanding of homosexuality. According to Tuksal, the Platform was not legitimizing homosexuality from an Islamic point of view, but they were also not homophobic. Tuksal thought that since "sexuality is mechanical," human beings are capable of desiring both sexes. Humans have the potential to like their own sex but are not supposed to act on that desire. Tuksal sees homosexuality as a human condition; she does not define it as a perverse act but does not support it either. According to her understanding, it is a choice, but not a correct one. Akbulut also elaborated that Islam did not see homosexuality as a pathological disease. For her, Islam considers homosexual relationships as it does adultery or fornication, which are also forbidden in Islam.

Akbulut also told me that they discussed these issues openly with friends from homosexual associations such as LGBT Solidarity Foundations, MOREL, and KAOS-GL in Turkey, however they could not discuss it with many Islamic activists and groups:

> We have talked about Islam, being Muslim, and how Islam understands homosexuality with queer groups. When we look at the twelfth century, we see an intellectual tradition among Muslims that even discussed the existence of God. They did not become apostates by discussing this. However, today Islamic groups are very conservative on various issues and unfortunately, I can readily say most Muslims are homophobic. Islam is not a homophobic religion. Islam talked about it. But today, Muslims who are judgmental about AKDER's politics about homosexuality don't do anything. They don't talk about homosexuality; they don't discuss and engage with this issue. But homosexuals are part of society and we cannot just ignore them. (August 2008)

While AKDER is open about its communication with the LGBT movement, it does not define itself as a multicultural or liberal association, but as an association with Islamic sensibilities and formed by pious women. In that regard, as AKDER, they do not enter into any institutional cooperation

with gay and lesbian associations on homosexuality, but rather maintain their dialogue as good friends, and sometimes work for other causes of shared interest.

During my interviews, members of AKDER and the Platform stressed that while they were using similar rights-based languages, they consider their mode of action different from other homosexual and feminist NGOs in Turkey. According to Akbulut, biopolitics in these organizations calls for addressing the issue of state oppression over their sexualities and bodies. The groups that pursue identity politics want the state to recognize them with their identities, such as homosexuals or women. However, AKDER does not want the state to acknowledge them as "women with headscarves"; they want to be acknowledged as equal citizens.

In this regard, these women's associations do not agree with the theoretical criticisms which assert that the liberal rights discourse does not well serve groups based on Islamic values. These women have appropriated the rights discourse through their practice against discrimination, but have also linked their Islamic understanding to their discourses about rights. For example, in the issue of homosexuality, rather than closing themselves off to discussions, they tried to bring a fresh approach to the Muslim understanding about how to communicate with homosexuals and how to frame it in modern life within an Islamic understanding.

Conclusion

Following the 1997 military intervention, many pro-Islamic actors in Turkey started to employ liberal rights discourses. Women wearing headscarves who were excluded from universities and many other public places also appropriated the rights discourses in their resistance to the headscarf ban. The gendered nature of the ban and the fact that women wearing headscarves were disappointed by patriarchal attitudes of "Islamic" foundations and corporations strengthened these women's formulation of their condition within the framework of women's rights.

Facing the headscarf ban, women from diverse social and economic backgrounds came together in associations such as AKDER and the Platform. The associations carved themselves a space among civil society organizations by using the language of rights. Their use of rights language is not simply instrumental but represents an understanding and deepening empathy. Many women I interviewed elaborated their increasing consciousness regarding other types of discrimination and human rights violations

in Turkey after they experienced the implementation of the headscarf ban. Among my interviewees, there was a strong consensus that the problem of the headscarf ban could be solved only by the democratization of Turkey and extension of freedoms to everyone. In this regard, these Muslim women's rights groups seem to have a more sound understanding of the situation in Turkey than do many conservative politicians, who have tried to solve the headscarf problem, per se, without dealing with the broader problems of democratization in Turkey.

Arzoo Osanloo explores the hybrid environment that feeds the women's rights movement in Iran, where the Islamico-civil legal system led to the rise of a legal consciousness among women (110). I find a parallel example in Turkey, in the sense that another kind of hybrid environment creates a fertile ground for women's rights movements. Similar to women in Iran, who were challenged by Islamic law and thus educated themselves about this legal system, the headscarf ban in Turkey led women wearing headscarves to be more conscious about their rights in a secular democracy.

These women began to employ a language of human rights, defining the headscarf ban in Turkey as discrimination, a restriction of their civic rights, and a violation of their individual freedoms. Women wearing headscarves also articulated themselves in a women's rights framework, and formed women's rights associations because the ban objectified women. Meanwhile, these women's interactions with other rights associations and increasing awareness about other kinds of discriminations in Turkey helped them develop a new consciousness about human rights in general. This consciousness led them to form coalitions with different rights groups such as feminist and queer associations. In doing so, they define commonality in terms of the shared experience of being oppressed and their common interest in challenging that oppression, rather than in terms of a shared identity.

Notes

1. See Bowen 2007 and Chahrokh 2009 for detailed information about headscarf bans in French and German schools.

2. According to the Survey of A&G and Milliyet in 2003, 62 percent, and according to the survey of Ali Çarkoğlu and Binnaz Toprak in 2006, 64 percent of women wear some kind of head covering in Turkey (Milliyet, May 31, 2003; Çarkoğlu and Toprak, 2006, 58).

3. My dissertation examines the headscarf ban and various other reactions of Muslim women to the headscarf ban, such as their development of new Islamic discourses (Akbulut 2011).

4. In the 1997 coup d'état the military did not take over the government literally, as it did in 1960 and 1980; rather, it preferred to stay relatively behind the scenes. President Süleyman Demirel, the judiciary, Kemalist NGOs, and media and business associations—referred as the Kemalist establishment—all supported the military. They pushed the coalition government out of power (Cizre and Çınar 2003, 310). This joint venture led to the February 28 process, during which the military and its civilian collaborators implemented several policies for the eradication of publicly visible signs of Islam and the revitalization of the Kemalist understanding in state institutions and public life. During the February 28 process, around nine hundred military officers were discharged on the accusation of "engaging in acts of irtica (reactionism)," hundreds of Qur'an courses and all secondary sections of Imam-Hatip schools were closed down, and the university admission system was changed to discriminate against Imam-Hatip graduates (Kuru 2009, 162).

5. The first official ban on headscarves for public employees was instituted in 1978 and was followed by the 1982 headscarf ban in universities after the 1980 military coup d'état.

6. Kemalism is the foundational ideology of the modern Turkish state and named after Turkey's first president, Mustafa Kemal Atatürk (1881–1938). Kemalist ideology has six fundamental pillars: Republicanism, Nationalism, Populism, Secularism, Statism, and Revolutionism. Kemalist ideas, including those on modernity and headscarves, have been shaped within a framework of Atatürk's understanding of Westernization.

7. As noted earlier, the February 28 process also resulted in discriminations against pious men who were students of the Imam-Hatip high schools or army officers. However, discriminatory practices primarily targeted women wearing headscarves because of their visibility.

8. In the aftermath of the February 28, 1997, intervention, the military listed companies owned by pious or pro-Islamic businesspeople as "green capital." These lists were used by the military and its Kemalist allies to discriminate against allegedly pro-Islamic companies.

9. Ali Bulaç, "Başörtülü Aday," Zaman, April 2, 2011.

10. Nihal Bengisu Karaca, "Islamcı Aydın Oryantalizmi," Habertürk, April 3, 2011.

11. Hilal Kaplan, "Üstü Kalsın," Yeni Şafak, April 4, 2011.

12. In fact, newspapers are one of the rare venues in which women wearing headscarves have become professionally visible. Nihal Karaca in Habertürk, Cihan Aktaş in Taraf, Hilal Kaplan and Özlem Albayrak in Yeni Şafak, and Sibel Eraslan in Star frequently write columns on a broad range of political and social issues, including topics dealing with women wearing headscarves.

13. There are other women's NGOs in Turkey working on the headscarf issue, which try to solve the problems that the ban has produced. One example is the Education, Culture, and Solidarity Foundation (Hazar). The Hazar Foundation was formed in 1993 and became an official association in 2006. It was formed as a support group for women to help them in education and personal development. The asso-

ciation has focused on the headscarf problem because it has been one of the major barriers for pious women in their participation to social life. Hazar initiated a field study in order to assess the effects of the ban on women wearing headscarves. The study included 1,112 interviews conducted in different regions and cities of Turkey. The results were compiled in the report entitled "The Covered Reality of Turkey" (2006). I chose not to include Hazar in my analysis because it has mainly focused on education and creating alternative environments for women, rather than being part of the active resistance to the ban.

14. Capital City Women's Platform, "Dernek Tüzüğü," accessed at http://www.baskentkadin.org/tr/?cat=6 on November 1, 2009.

15. Both Platform and AKDER are funded by donations and member dues.

16. AKDER, "Our Objective," accessed at http://www.ak-der.org/en/about-us/our-objective.html on January 1, 2010.

17. Both AKDER and the Platform worked together with other women's rights organizations in changing and reforming the Turkish civil code in 2004.

18. Hasan Cemal, "Herkes Özgür Olmadan Asla!" Milliyet, February 20, 2008.

19. In 2010 March, Araştırma Kültür Vakfı, İnsani Yardım Vakfı, Özgür-Der, Mazlumder, and other pious organizations have also made their stands clear against homosexuality by supporting the statement of Selma Kavaf, a minister in charge of family affairs, who defined homosexuality as an illness.

Bibliography

Akbulut, Neslihan, et al. *Henüz Özgür Olmadık.* Istanbul: Hayy Kitap, 2008.

Akbulut, Zeynep. "Banning Headscarves and Muslim Women's Subjectivity in Turkey." Unpublished Doctoral dissertation, University of Washington, 2011.

Benli, Fatma. "Hukuki ve Siyasal Boyutlarıyla Türkiye'de Başörtülü Kadınlara Yönelik Ayrımcılık Sorunu." In *Örtülemeyen Sorun Başörtüsü,* edited by Neslihan Akbulut. Istanbul: Akder Yayınları, 2008.

Bowen, John R. *Why the French Don't Like Headscarves.* Princeton, NJ: Princeton University Press, 2007.

Butler, Judith. *The Psychic Life of Power.* Stanford, CA: Stanford University Press, 1997.

Chahrokh, Haleh. *Discrimination in the Name of Neutrality: Headscarf Bans for Teachers and Civil Servants in Germany.* New York: Human Rights Watch, 2009.

Cindoğlu, Dilek. *Başörtüsü Yasağı ve Ayrımcılık: Uzman Meslek Sahibi Başörtülü Kadınlar.* Istanbul: TESEV Yayınları, 2010.

Cizre, Ümit, and Menderes Çınar. "Turkey 2002: Kemalism, Islamism, and Politics in the Light of the February 28 Process." *South Atlantic Quarterly* 102, no. 2/3 (2003): 309–32. doi: 10.1215/00382876-102-2-3-309.

Kuru, Ahmet T. *Secularism and State Policies toward Religion.* New York: Cambridge University Press, 2009.

Osanloo, Arzoo. *The Politics of Women's Rights in Iran.* Princeton, NJ: Princeton University Press, 2009.

Şişman, Nazife. "Başörtüsüne Özgürlük! Freedom for the Headscarf, Kopftuch, Foulard, and Voile." *Nazife Şişman ile e-soyleşi.* http://www.facebook.com/topic.php?uid=6541501319&topic=4984. Accessed October 5, 2008.

———. *Başörtüsü: Sınırsız Dünyanın Yeni Sınırı.* Istanbul: Timaş Yayınları, 2009.

Chapter 6

Intersecting Dynamics

Representational Activism and New Mobilities among "Muslim Women" in India

Nadja-Christina Schneider

Introduction

Today, more Muslims of different congregations and distinct communities live in South and Southeast Asia than in the Arab-speaking region, which is nevertheless still regarded by many as the core region of the "Islamic world." Against this background, it is frequently overlooked that India has one of the largest Muslim populations worldwide. More than 145 million Muslims live in India, roughly 14 percent of the total population, and thus constitute not only one of the largest Muslim minorities but in fact one of the largest religious minorities in the world. Over the last three decades, the massive discrimination against Muslims in almost every sphere of society, politics, and the economy, has been downplayed or flatly denied, especially by supporters of Hindu nationalism, which emerged as a very powerful political force in post-Emergency India.[1] During their election campaigns, the Hindu nationalist Bharatiya Janata Party (BJP) repeatedly made use of the polemical reproach that Indian Muslims were constantly being "pampered" by the ruling Congress party. In view of this increased polarization, the publication of the Sachar Committee[2] Report in 2006 marked a significant turning point with regard to the public discourse about the Muslim minority in India. Arguably for the first time in post-independence history, this report clearly and officially stated that Muslim Indians were severely

underrepresented in the public sector and civil service. It was especially the fact that the Indian Army was mentioned in this context that triggered a controversy in the country, but this was by far not the only subject to debate with regard to the Sachar report. In order to introduce adequate measures and mechanisms that would help to improve the situation of Muslims and, above all, to achieve an equality of opportunity in the field of education, the National Minorities Development and Finance Corporation (NMDFC) was created shortly afterward.

As far as the central problem of identity and representation of Indian Muslims is concerned, it remains strongly linked to the unsolved question of civil law, a question that has been a focus of discussion ever since India gained independence in 1947.[3] Down to the present day, Muslim Personal Law can be considered a core element of "Muslim identity politics" in India. It is especially the Hindu nationalists who routinely allege that the adherence to a separate, religion-based family demonstrates that Muslims were "backward-oriented" and "not willing to integrate" into the national community. Accordingly, they argue that only a (more or less) secular uniform civil code—in lieu of the religion-based personal or family laws—would bring about the desired integration of Indian society. It is interesting to note that this modernist or, more precisely, Kemalist notion of the transformative power of a secular and national civil law was clearly "borrowed" from the national feminist movement and other secular forces in Indian society. In contrast to this, a new Muslim women's movement has emerged in the last three decades as the central advocate for the reformability of Muslim Personal Law, in accordance with their quest for greater gender equality.

The main focus of this essay is the dynamics that have led to the emergence of new forms of feminist articulations and to what I would like to refer to as "new mobilities" among Muslim women in India. The essay takes special interest in those dynamics that are directly or indirectly linked with the discursive practices and strategies of what is currently labelled "Islamic feminism"—that is, a religion-based gender critique. In order to illustrate the dimension and symbolic significance of these new social dynamics, it is necessary to expand on the context of representation in India or, rather, the politics of representation of the "Indian Muslim woman" that was hitherto firmly based on the notion of "immobility," as I would like to argue in this article. But as writings on Muslim women in India—as elsewhere in the world—"often make broad generalizations about what is, in fact, a highly differentiated category" (Searle-Chatterjee 2000, 147), I should begin with a contextualization, or rather, problematization of this category and of the situatedness of my own research perspective.

Problematizing an Essentialized Category—the "Muslim Woman"

Starting from the Orientalist production of knowledge until the present day, the category "Muslim woman" was constructed and perpetuated through very diverse discursive streams and channels, on local, national, regional and also on a translocal level—and these discursive channels include, among others, media, states, science, and fine arts as well as the discourses of religious agents and transnational women's organizations. Considering the politics of visual representation, the deep polarization, competing agendas, and specific constellations and contexts in which recurring conversations about "women in Islam/women and Islam" take place, there can be no doubt that the category "Muslim woman" is a particularly essentialized category (Sharify-Funk 2008; Kirmani 2009a; see also Wenk 2005; von Braun and Mathes 2007). With regard to the visual representations of "Muslim women" that prevailed until well into the 2000s in Western media, it was especially the veil that was either used as a symbol for the suppression for women in Islam or as an efficacious metaphor for anything that was perceived as hidden, opaque, and potentially dangerous with regard to Islam or predominantly Muslim societies. Visual images referred primarily to an imagined external danger or enemy, but as Christina von Braun and Bettina Mathes argue, an increased blending of veiled female images and the notion of an "internal enemy"—or "sleeper"—became more noticeable in the aftermath of 9/11, and they became even more prominent after the appearance of female suicide bombers (von Braun and Mathes 2007, 82).

And yet, it could well be argued that things are not exactly the same after the so-called "Arab spring" in 2011, when all of a sudden a large proportion of the visual and textual representations of "Muslim women" would differ quite markedly from the otherwise predominant depiction of "veiled femininity" and "oppression of women in Islam." And the reason for this was, of course, the impact of the revolutionary wave of protests in North Africa and the Middle East. Looking at headlines published in international media about the participation of women in the protest movement in Egypt, it almost feels as if journalists and news editors had long waited for an occasion to write about the "New" and "Unexpected" with regard to the "Muslim woman" or "Arab woman" (which was often used synonymously). Some of the most popular headlines that one would find anywhere on the web and in printed newspapers in slightly different versions between February and March 2011 included "A spring for Arab women," "Against Stereotypes: Women are pushing the Arab revolution forward," and "The Revolution of Women." And probably two of the most common headlines

were "The daughters of the revolution" and "Egypt's angry women and the revolution." Under these headlines, one would find a very new kind of visual imagery, which added to a new perception of "Muslim women" as agents or actors, as very active and courageous citizens whose activism was crucial in bringing forth the revolutionary movement in Tunisia and Egypt. At least for a brief moment in history, it seemed as if the visual images and representations of the movement in Egypt, and especially of the demonstrations in Tahrir Square in Cairo, would succeed in doing what so many researchers, activists, authors, and artists have tried to do for years—that is, to make clear, first, that there certainly is not and cannot be one coherent group of "Muslim women," neither in Europe nor anywhere else in the world. And, second, that the diverse ways in which women react to and deal with this overdetermined category of "Muslim woman"—through their own articulations, personal appearance, or performative actions, and in the way they interpret, reinterpret, and reappropriate this category—does not necessarily have to be a problem or to be seen as problematic in themselves. Quite on the contrary, as there is a growing number of young women who actively seek the opportunity to position themselves vis-à-vis the hitherto dominant discourse about "Muslim women" and to express their individuality, self-determination, and agency.

Notwithstanding this rather optimistic assessment, one has to bear in mind the fact that the older stereotypes are still around and have not simply vanished into thin air. Thus, it seems quite possible that the impact of those new images may not last long or actually possess the capacity to profoundly change the long-prevailing perceptions of Muslim women. And yet, in the context of heated ongoing debates about the "integration of Muslim immigrants" in countries like Germany, where a notorious German politician and former banker has coined the much-cited racist metaphor of the "headscarf girl" ("Kopftuchmädchen") as the central symbol of a "failed integration," this completely new visual and textual representation of Muslim women is an unexpected and exciting development that surely requires more in-depth analysis.

Arguably, at least the alleged incompatibility between "Islam and modernity" or "Islam and democracy" seems to have been profoundly challenged, especially in view of the renewed social media euphoria. This certainly resonates with the media coverage of the so-called Green movement in Iran in 2009 (see Michaelsen 2011), and a new symbol for the compatibility of everything that earlier used to be seen as incompatible and deeply problematic was subsequently found in the new figure of the "young, female Muslim blogger." Against the background of what media themselves like to

depict as a media or Facebook revolution, numerous reports and interviews focused on the young female blogger and brought up the question if the new liberty that came with the Internet would also involve Muslim women in countries like Germany. And since there is indeed a growing number of young Muslim bloggers in Germany, both male and female, it didn't take long for journalists to find their new prototype and counterpart to female bloggers in Egypt over here.[4]

At least to a certain degree, similar discursive shifts can be presently observed with regard to the perception and self-perceptions of Muslim women in India, and it can be argued that it is, above all, Indian Muslim women themselves who have recently started the process of redefining, reinterpreting, and also reappropriating this category, and they do so in various ways and through very diverse actions, articulations, and performative practices. At present, the poetic voices (and sociopolitical actions) of Tamil author and poet, Salma,[5] Telugu poet, Shajahana,[6] and Urdu poet and social activist, Jamila Nishat,[7] among others, are getting some attention not only in India or South Asia but at an international level.[8] But while poetry and literature remain two very important media of expression, they are by no means the only ones available, especially for a "postliberalization" generation of Muslim women that has grown up with the rapidly increasing mediatization or densification of mediated communication in India, just as elsewhere in the world. Fathima Nizaruddin, for example, is a documentary filmmaker from Kerala, now based in New Delhi, who explores issues of religion, gender, and identity in her work—including her own identity as a young Muslim woman from South India. In 2010, she finished a documentary titled "Talking Heads—Muslim Women," and this is her second film dealing with the highly problematic construction and/or perception of the "Muslim woman." In her latest documentary, titled "My Mother's Daughter" (2011), Nizaruddin explores the choices made by different generations of women in her community in Kerala (for a detailed discussion of Nizaruddin's work see Schneider 2013). Another very interesting young filmmaker is Ambarien Alqadar, also from Delhi. In 2011, she finished her documentary "The Ghetto Girl," a film about a girl who obsessively walks the streets in a predominantly Muslim neighborhood in South Delhi, which is often referred to as one of India's new "mini-Pakistans." The list could be continued, not only with documentary films but with a number of other forms of creative expression. As can be observed in the Indian media, a growing interest in these new articulations and critical reflections on the prevailing discourses and visual regimes on Muslim women is discernible and likely to expand over the next couple of years.[9] I suggest that the increasing media-communicative mobility as well as

the ability to express and articulate one's own position and reflections about the debate about "Muslim women" should be contextualized in the larger field of entangled (im)mobilities that will be briefly introduced and applied to the Indian context in the following section.

The Politics of Representation of "Mobility" and "Immobility"

For some time now, "mobility" has been seen as a new paradigm in the social sciences and humanities, even though it may not refer to a clear-cut or self-explanatory concept, since we have to deal with multiple levels of meaning, such as spatial, physical, and social mobility, and also communicative or digital mobility, that are becoming increasingly important. Even though we have to deal with this diversity of forms and ideas about mobility, they are nevertheless connected and entwined in many complex ways. Historically speaking, this is certainly not a new phenomenon, but what is new, indeed, according to Mimi Sheller and John Urry, is the fundamentally new dimension and densification of mobility; in order to illustrate this, they list all the kinds of mobile groups of people one can possibly think of today (Sheller and Urry 2006). In addition, there are a number of new places and technologies that serve to enhance the mobility of some people while reducing the mobility of others—if you think, for example, of borders or the so-called digital divide. Questions of mobility, either of too much or too little or the wrong timing or place, are decisive for many individual lives as well as for organizations or institutions. Accordingly, the different forms of mobility and the control over mobility reflect and reinforce current power relations. In this sense, mobility is a resource that not everyone has the same relation and access to. The mobility paradigm, according to Sheller and Urry, can be helpful in highlighting the nexuses that provide some people and groups with new forms of connectivity or connectedness and "empowerment," while engendering isolation and processes of exclusion for others. Research on human mobility on a global level thus needs to pay more attention to "local" questions and problems of mobility, such as transport, material culture, and spatial relations of mobility and immobility, and also to technological questions such as mobile communication technologies and the—not least important—surveillance and security infrastructures. At every turn, these multiple and deeply entangled (im)mobilities also include circulations of images, motion of perceptions, and information in local, national, and global media. Accordingly, the politics of mobility as well as the representation of immobility should form a central focus of analysis.

In India, the idea of "mobility," invoked in innumerable advertising messages, has, in the course of the economic liberalization of the country become a central—if not indeed the most powerful—metaphor in Indian society (Chakravarty and Gooptu 2000; Schneider 2005). Mobility can, in this context, refer to the creation of possibilities to increase one's social standing or to one's personal freedom of movement, and last but not least, in the context of an increasingly media-supported communication both inside and outside of India, also to a "mediatized" or media-related form of mobility. Right from the beginning, however, the concept of an increasing "mobility" on the individual level had been closely tied to the general "progress or rise of the Indian Nation." In contrast to this, Indian Muslims in particular have since the 1980s been increasingly blanked out of the media-led orchestration and construction of a "mobile, national family" (Desai 2007) or, through an excessive emphasis on their "backwardness" and alleged "unwillingness to reform," have not infrequently been portrayed as the very incarnation of the "immobile others" (Ataulla 2007). This in turn affects in a particular way the strongly essentialized depiction of Muslim women in India who, as before, are still perceived predominantly as "immobile" in every sense (social, physical, and with regard to mediated communication). A topical example that illustrates how deeply entwined and problematic the diverse forms and representations of (im)mobility are with regard to Muslims in India is the perceived "self-segregation" and "ghetto-building" of the Delhi Muslims during the last two decades. Increasing discrimination against Muslims in India coupled with anti-Muslim violence—culminating first in December 1992 in the razing of the Babri mosque in Ayodhya and then in the anti-Muslim massacres that shook the western state of Gujarat scarcely ten years later in the spring of 2002—led to the relocation of large numbers of Muslims to overwhelmingly Muslim-inhabited areas. In a large number of cases, they were and are even now unable to secure lodgings in those areas of Delhi that are not inhabited by a majority Muslim population, simply because of their Muslim names. When the English-language newspaper "The Hindu" carried out an investigative research in Delhi in the summer of 2012, they labelled the current situation an ongoing "housing apartheid" (Ashok and Ali 2012). This relocation in turn led to widespread criticism of the perceived "self-segregation" and "ghetto-building" of the Delhi Muslims. As Laurent Gayer accurately criticizes, the notion of immobile "insular existences" that accompanies these terms and media representations is particularly problematic and misleading because it overlooks the social realities of many Muslims in the Old City or Jamia Nagar who are in no way "cut off" from the media-communicative connectivity and from various interactions that arise

in the course of their actual working lives—and hence, spatial mobility—in completely different parts of the city every day (Gayer 2012, 236). Similarly, it can be observed that a highly essentialized and ahistorical representation of the "immobile" Muslim woman is often used to portray Islam and the Muslim minority in general as lacking the mobility that has come to symbolize contemporary "Indianness" and may thus be considered the current form of othering in post-liberalization India.

The responsible editor of the magazine *Islamic Voice* from Bangalore, Nigar Ataulla, speaks in this context of a "dangerous triangle." She argues, as soon as the conversation turns to a subject such as the status of Muslim women in the Indian context, the focal point of discussion is inevitably placed on three topics: the infamous out-of-court repudiation of a wife through the so-called "Triple Talaq," the matter of polygamy, and finally the "veiling" of the woman (Ataulla 2006). Also, opinion polls and studies reveal time and time again that the portrayal of the "veiled/secluded" woman, which was dominant in the Indian media for a long time, is not a realistic portrayal of Indian Muslim women, but that the majority of non-Muslims surveyed still attributed their low status, on the one hand, to the discriminatory treatment under the Muslim Personal Law valid in India, and on the other, to the religion itself. According to their convictions, Islam suppresses women to a greater extent than other religions do: Muslim women, compared to women of other religions, are "submissive," "reserved," "fragile," and, due to their social conditioning, unable to fight for their own rights (see Kidwai 2003, 104–128).

In sharp contrast to this, Muslim women in India have of course never been as quiet and passive as they are frequently portrayed, and there are many historical examples of women who have committed themselves in both public and private areas and staked their claims to their rights as full members of their communities. Historians like Gail Minault (1998), Barbara Metcalf (1990), Azra Asghar Ali (2000), Siobhan Lambert-Hurley (2007), and Margrit Pernau (2008)—to mention just these few—have shown that Muslim women and men alike have constantly strived for new or redefinitions of existing women's rights since the second half of the nineteenth century. With regard to the contemporary situation, however, Tahera Aftab argues in her ground-breaking "Inscribing South Asian Muslim Women" that studies on the situation of Muslim women in South Asia are generally scarce. According to Aftab, South Asian Muslim women are generally represented as "oppressed," "backward," and "victims of the double tyranny" of their religion and the specifically South Asian form of patriarchy grounded in the traditional Hindu view of femininity (Aftab 2008, xxxi). With specif-

ic reference to India, Nida Kirmani describes how a more recent scientific interest in research into the subject of "Muslim women" first crystallized in the 1970s, namely in the context of a generally increasing interest taken by Western feminists in "Third world women," in which the "Muslim women" were often assumed to be the most oppressed members of this group (Kirmani 2009a). At the same time, this construction and portrayal of the category of the "Muslim woman" in the field of academic research is also found in a wide range of scientific publications that attempt to explain the social realities faced by Muslim women in India from the perspective of their legal status under Muslim Personal Law and the gender-specific roles subscribed to them within the religious framework of Islam. It was only in the very recent past that this decontextualized and very strongly essentialized category of the "Indian Muslim Woman" has also been strongly called into question by the world of academic research itself, and the demand has been raised that the peculiarities of region, location, context, and social caste should be more strongly taken into account than has been the case thus far, and that the idea of a clearly definable, coherent group be questioned more strongly than in the past (see Searle-Chatterjee 2000).

A Watershed Moment for the Muslim Women's Movement in Postcolonial India: The Shah Bano Case and Its Aftermath

The fact that it was possible for such a deep-rooted perception and portrayal of Muslim women in India in both the media and the academic world as "immobile" relates to the very complicated discussion of Muslim Personal Law. Discussion of Muslim Personal Law, which has been going on for a number of decades, is heavily overloaded with political symbolism. It was, above all, Muslim Personal Law against which the agitation of the increasingly stronger Hindu nationalist organizations was primarily directed in the 1980s. They repeatedly attacked Muslim Personal Law as a symbol of both the Indian Muslim's "backwardness and unwillingness to reform" and the incarnation of the alleged "privileged treatment" afforded to the Muslim minority by the then ruling Congress Party. The aggressive agitation of the Hindu nationalists on one hand, and the resultant strong resistance on the part of influential Muslim organizations against a reform of Muslim Personal Law on the other, reached their peak in connection with the famous Shah Bano case in the mid-1980s.[10]

The origins of the Shah Bano case are to be found toward the end of the 1970s when a civil court ruled that lawyer M.A. Khan from Indore in

the Federal State of Madhya Pradesh should make monthly maintenance payments to his divorced wife Shah Bano. Khan refused to accept this and appealed to the Supreme Court in Delhi. His argument was that, under Muslim Personal Law, a Muslim woman would only be entitled to maintenance payments during the three-month waiting period after the divorce (*iddat*). When this appeal was rejected in 1985, this triggered bitter controversy between those in favor of the ruling and the Muslim spokesmen who felt their cultural rights as a minority were being violated. Their anger was strengthened by the clearly pejorative comments about Islam uttered by the presiding judge at the time, Chandrachud, in the reasons for the judgment.

The escalation in both the media and the real world—still in the run-up to the Hindu nationalistic mobilization in favor of the erection of a Ram-Temple in Ayodhya—made a very strong contribution toward the polarization of Indian society, and its after-effects are still being felt today. In this context, the portrayal in the media of the Muslim woman as a "suppressed victim" of the Islamic religion or of the male Indian Muslims reached a dramatic nadir (see Schneider 2005, 191–260).

At the same time—and this might appear paradoxical at first glance—it is possible, from today's point of view, to clearly state that the Shah Bano case marked the start of the newly emerging Muslim Women's Liberation movement in India. Thus, in the late 1980s, Muslim women's groups and organizations were founded in many places, for example, the Goa Muslim Women's Association and the Organization Awaaz-e-Niswan ("The Voice of the Women") in Bombay (see Vatuk 2008).[11] Despite the fact that these two and many other Muslim women's organizations have been in part very active in India for more than twenty years now, an increased interest on the part of the Indian media in Muslim women's organizations and networks can be observed only since the late 1990s.

Having said this, it should at least be mentioned that the Shah Bano case and the ongoing controversy over Muslim Personal Law (including the discussions about a reformed marriage contract, Nikahnama[12]) may not have had the same impact on the young generation of Muslim women—and men, of course—and thus not have the same rallying power they possessed for the generation of their mothers and fathers. In the words of Fathima Nizaruddin, the young documentary filmmaker from Kerala mentioned earlier, "the Shah Bano was the event which politicised my mother's generation, but my generation, we were politicized by the violence in Gujarat [in 2002]."[13] And it seems that some of the presently most active organizations and/or networks in India are currently beginning to think about agendas and topics that are likely to appeal more strongly to young Muslim women and girls in India.

With the support of Action Aid, the Bharatiya Muslim Mahila Andolan (BMMA),[14] for instance, recently conducted a survey on the aspirations of young Muslim women and girls in India for an upwardly social mobility and, above all, for a better education. In an interview with the Times of India, Zakia Soman, one of the three founding members of BMMA, explains:

> "We have felt for a long time that Muslim girls are neglected and their voices, opinions and needs overlooked. Their families give them least priority and the state acts as if they don't exist. Educated and empowered young women can play a key role in transforming the community. It is the most promising and the most deserving section of our society, which needs to be heard."[15]

Slow But Steady: A Diversification of Media Representations

Over the last ten years, Indian newspapers and magazines have in particular been reporting on Muslim women's activists and organizations that are not exclusively operating and arguing in a secular context, but also in a religious one. Topics are, among others, a reform of the valid Muslim Personal Law in favor of strengthening the rights of Muslim women, women's access to mosques, and the erection of mosques for women. Above all, these activists repeatedly point out that it is not Islam itself that discriminates or suppresses women, but the patriarchal system, which is based on a one-sided interpretation of the written documents, in particular of the Qur'an. The slow but nonetheless clearly identifiable emergence of self-confident Muslim women's rights activists in the Indian media world—and with that, an entirely new representation of their mobility—does indeed reflect an unexpected development that is not least of all to be attributed to the fact that women themselves are increasingly engaging in carefully targeted and continuous public relations activities.

And, once again, herein are revealed clear parallels to a discursive movement that can currently be observed worldwide and which, for a number of years now, has been known—and intensely debated—by the label "Islamic feminism" or "Gender Jihad." This Islam-based gender critique is founded on a historical-hermeneutic approach and new interpretations of the underlying texts from the perspective of equality of the sexes and legal equality (see Barlas 2002; Wadud 1992/1999). Even if Islamic feminism is still a long way from being front-page news, it may nevertheless already be observed that this discussion is on the one hand attracting an increasing

amount of interest worldwide, and on the other, is also being associated
with widely different ideas and reservations (see, for instance, Abou-Bakr
2001; Badran 2004; Mir-Hosseini 2006; Moghadam 2007; Moghissi 1999;
Gamper 2011).

Discourse and Praxis:
Islamic Feminism and Muslim Women's Activism in India

In a working definition that served as a basis for the four previous inter-
national conferences on the subject of Islamic feminism in Barcelona
and Madrid between 2005 and 2010, Islamic feminism is described as a
Qur'an-centered reform movement of Muslim women who have the required
linguistic and theological expertise to be able to call into question existing
patriarchal interpretations of the Qur'an and offer alternative interpretations
that can serve the purposes of gaining sexual equality as well as refuting
Western stereotypes and Islamic orthodoxy.[16] The criticism of Muslim femi-
nists as to the legal status of women and their subordinated social position
is being sparked in particular by the Muslim Personal or Family Law valid
in many countries with a majority Muslim population or in countries with
significant Muslim minorities, such as India. For Asma Barlas, the process
of learning how to read and interpret the Qur'an from the perspective of
gender justice and equality is deeply entwined with her personal narrative
and conceptualization of the "self." Barlas says, "If Muslims have always read
the Qur'an in existing patriarchies, is it any wonder readings have been
infused with male privilege?" So, for her, to become a text scholar involved
"both learning and un-learning and, if I were to put it simply, and perhaps
dramatically, I would say that it has allowed me to break out of the circle of
oppression created by conventional readings of the Qur'an."[17]

However, in her critical analysis of Islamic feminist discourse, Yasmin
Moll directs our attention to the problem that such engagements, in theo-
ry and practice, do not merely work to produce new understandings and
meanings of what Islam "says" on gender equality, women's roles, and so on,
but also of "how" the repertoires of reasoning called forth by Islamic femi-
nists involve radical reconceptualizations of the authoritative production and
transmission of religious knowledge (Moll 2009, 44; see also on the question
of authority Krämer and Schmidtke 2006). In particular due to the public
questioning of established religious authorities and their knowledge produc-
tion, both the discussion about Islamic feminism and the new Muslim-fem-
inist activists are encountering in India correspondingly energetic resistance

on the part of influential Ulama. A commonly heard critique is, accordingly, that "advocates of Islamic feminism have no independent world-view of their own" and that they "simply follow the dominant Western feminist discourse, which they seek to propagate in an Islamic guise."[18] And within Muslim society itself they are subject to strong criticism in that, owing to the problematic minority situation of Indian Muslims, they are being accused of a lack of loyalty toward their "community" (see Ataulla 2007). But Muslim women's rights activists, who argue within the framework of the Islamic religion, also encounter the distrust of many secular feminists, who have fundamental doubts concerning the compatibility of normative principles of Islam with the principle of gender justice. For these activists, Islamic feminism therefore represents right from the very start a "compromise with the patriarchy" (see Moghissi 1999, 32–48). In India this is compounded by the fact that the secular-national women's rights movements there see themselves fundamentally challenged in their claims to representation and in their convictions, in particular by the so-called revival of the religiously motivated mobilization of communities in the 1980s and 1990s (see Kumar 1993, 160ff.). As a consequence, they react more or less hesitatingly, by either reinforcing their own positions or at least partially rewording them (see Ahmed-Ghosh 2008). For a long time, secular women's rights organizations were of the conviction, with regard to religiously motivated women's rights in India, that only uniform, secular civil legislation for all would be able to guarantee the equal legal statuses of men and women and should therefore assume the former's place. Only very recently has the opinion been asserted that the necessity and possibility of reforms in the context of existing religious family laws could indeed be a feasible path toward achieving equal rights (see Schneider 2008).

Not least of all due to the active endeavors of Muslim activists to cooperate with secular organizations and to obtain recognition for the discussion of Islamic feminism, there are currently signs in India that they are, in the meantime, even coming to be regarded as pointing the way forward to the "national" women's rights movement in many parts of the country. As well as to the urban centers of Mumbai, Bangalore, and Hyderabad, this also applies to a number of less urbanized regions in the southern Indian Federal State of Tamil Nadu, where the increasing "politicization of Muslim women" in its various districts is even being regarded by secular feminists themselves as one of "the most exciting and tense developments in contemporary Tamil society" (Krishna 2007, 510). Without saying it explicitly, Sumi Krishna is most probably referring to Daud Sharifa Khanam's organization STEPS in the district of Pudukottai in Tamil Nadu, which was founded in 1987.[19]

In 2003, the organization announced its intention to establish a month-ly *jamaat* assembly for Muslim women in order to provide them with a public space for articulation and information about the patriarchal inter-pretation of Islamic principles by male religious authorities. In other words, by declaring their intention to found their own jamaat for Muslim women, STEPS activists fundamentally questioned the authority of the traditional Jamaat system in Pudukottai as well as the legitimacy of its claim to exert control over the Muslim community. What attracted, and still attracts, a remarkable amount of media attention in this context was the plan of these jamaat members to build a mosque exclusively for women. Besides the prayer room and a coordination office for questions related to education or job vacancies for women, the jamaat activists are also planning to set up a center for education and research on Islamic law and jurisprudence. Access to mosques for women, not only in the sense of a place for prayer but as a public space in which women are allowed to actively engage, remains a very controversial issue among Indian Muslims. Sharifa Khanam coordinates a large network of Muslim women in Tamil Nadu today, and it is interesting to note that, at an international level, she is increasingly perceived not only as a Muslim grassroots activist from South India but also as one of the most prominent Islamic feminists in India, a term she uses herself in interviews and in short portraits for various websites.[20] However, many other Mus-lim women's rights activists who draw on this discourse would not accept or even use the label "feminist" or "Islamic feminist" because it still has a negative, or at least ambiguous, connotation in non-Western contexts (see Ahmed 1992, 243–248). Yet one could argue that the discursive praxis and strategies of Islamic feminism is increasingly adapted by Muslim women's rights activists, who in many cases have already been associated with local, regional, or national women's organizations and also by actors within Islamic Movements such as the Jamaat-e-Islami Hind (see Ahmad 2008; Schneider 2009). So, quite naturally, it is adapted as a discursive strategy to very spe-cific and diverse contexts and may thus not necessarily lead to a singular organized movement with one common agenda.

The contemporary emergence of an organized, though very diverse, Muslim women's movement was first analyzed by Abida Samiuddin and Rashida Khanam in their three-volume study of Muslim-feminist forms of articulation and movements in southern Asia as the third and decisive histor-ical phase. In a first phase of Muslim feminism, according to their findings, it was above all individual writings and autobiographical testimonies, poems, short stories, novels, autobiographies, journal articles, essays, and scientific theses from which the early forms of gender awareness and feminist ideas

sprang in the twentieth century, which in turn sparked a debate and made an increasing degree of networking between women possible in the first place. The second phase of Muslim feminism in South Asia in the second half of the twentieth century was in its turn characterized by so-called "everyday activism," such as in the shape of individual innovations, the creation of social relief organizations, and educational initiatives, and also by the fact that Muslim women, at least from the middle and upper classes, gained access to public life and modern professions. It was only during the third phase, which Samiuddin and Khanam see first and foremost in the present day, that an organized movement grew out of this that was clearly visible and much more confrontational than previous forms of activism (Samiuddin and Khanam 2002).

While there are indeed clear signs of this at present, it is nevertheless possible that a unilinear conception of chronological phases of Muslim-feminist articulation could tend to trap one into only perceiving and portraying one aspect of current social dynamism at any given time. But focusing one's attention on the present day not only allows one to observe the already-mentioned politicization of Muslim women in India but also the simultaneous emergence of new and very diverse forms of articulation. In films, poems, novels, and journalistic formats, for example, these may describe new subjectivities of Muslim women in India that do not necessarily take place within a religious context or need to be justified by religion. They may also, however, take place on the level of "everyday activism" or contribute toward the organization of a social movement, which need not necessarily be located within a religious framework. It is precisely against the background of an increasing social differentiation in India that we need to understand in the "new forms of mobility" of Muslim women that they are in a position to develop their own strategies in order to be able to actively "set in motion" or interpret and reappropriate anew the category "Muslim woman."

Arguably the most informative example of this new representation and form of mobility is the Bharatiya Muslim Mahila Andolan (Indian Muslim Women's Movement, BMMA), which, according to Rafia Zaman is a "loose network of individuals and organizations working with the Muslim community, particularly women" all over India (Zaman 2013, 26):

> The network has increasingly used the language of "Islam" to promote its concerns, representing a concerted shift away from earlier positions. Formed at a time following the Gujarat pogrom in 2002, the highly publicized Imrana case and 9/11, the BMMA self-consciously promotes certain markers of identity around

which an emancipatory movement is organized. In this, the organization challenges the twin tropes of victim and ward that surround Muslim women. (Zaman 2013)

BMMA approaches the question of reform of the existing Muslim Personal Law by arguing for rights of women that are available in the Qur'an. But in spite of this appropriation and adaptation of the global discourse of "Islamic feminism," BMMA's approach also allows for a "conceptual shift away from the frame of religion," as the question of Muslim women's marginality and perceived immobility is also "located into social, economic and developmental spheres" (Zaman 2013, 42).

Conclusion

This essay looked specifically at the intersections of dynamics and connectivities between the discursive praxis and strategies of "Islamic feminism" and a newly emerging Muslim women's movement in India. It showcased Daud Sharifa Khanam as a paradigmatic example for the "citizens of the future" described by Saskia Sassen, who, in the course of the interplay between the de- and renationalization of cultural identities, do not necessarily feel they belong exclusively to one nation state or any other territorially defined community, but who may simultaneously see themselves as belonging to particular public spheres that are increasingly visible on a global level (Sassen 2008). In addition to this, Khanam's network forms an important link within the South Asian region to the globally oriented network Musawah, founded in 2007 and based in Kuala Lumpur. Musawah means "equality" in Arabic, and the work of Musawah is focused on the programmatic claim, "For Equality and Justice in the Muslim Family." It was brought into being by the well-known NGO Sisters in Islam (SIS), which has strived for a legal strengthening of women's rights within a religion-based framework. When Musawah was officially launched in Kuala Lumpur in 2009, activists, academics, lawyers, and decision makers from all over the world joined the event, among them a number of delegates from South Asia.[21] The network underlines the aspiration to become a global and a highly mobile, transregional and future-oriented movement of Muslim women in every respect. It remains to be seen if the Indian Muslim women's movement is generally more attuned to the discursive praxis of the Qur'anic women's rights discourse than to transnational advocacy networks and organizations, such as

Musawah, or if it will feel the need to become more visible in a global media sphere in order to be heard and be taken more seriously in the national public sphere in India too.

Notes

1. The state of emergency was declared by President Fakhruddin Ali Ahmed on 26 June 1975, upon advice by Prime Minister Indira Gandhi and lasted for twenty-one months, until 21 March 1977. To the present day, the Emergency is considered one of the most controversial times in the history of independent India. Arvind Rajagopal argues that the Emergency was a watershed in India's post-independence history, after which "culture and community became the categories that gained political salience in the period of economic liberalization." See Rajagopal 2011.

2. The Rajinder Sachar Committee was appointed in 2005 by Indian Prime Minister Manmohan Singh in order to compile a survey about the actual socioeconomic situation of Muslims in India. Former Chief Justice of the Delhi High Court, Rajinder Sachar, presided over the committee. Together with six other members, he compiled a report of more than four-hundred pages, which was presented in the Lower House (Lok Sabha) of the Indian parliament on 30 Nov. 2006.

3. The development of the personal law regime in India is described in Agnes 2001.

4. A blogger who attracts quite a bit of media interest in Germany right now is twenty-three-year old political science student Kübra Gümüsay, who has a blog titled "Ein Fremdwörterbuch," or "A dictionary of foreign words," and who writes a regular column for the German daily newspaper *Die Tageszeitung* titled "Das Tuch," or "The Cloth."According to Gümüsay's own statements in interviews, it seems very strange to her that she attracts such a lot of media attention simply because she might be the only woman wearing a hijab in the framework of a huge blogger conference and that she feels like a "token Muslim" indeed. At the same time, it is precisely this ambivalent attention that guarantees that her blogs and columns attract a growing interest and reaches her intended audience. See, for instance, http://ein-fremdwoerterbuch.blogspot.com/2011/04/ein-fremdwoerterbuch-unter-anderen.html.

5. See, for instance, Salma 2009.

6. See interview with Shahjahana in *Just Between Us—Women Speak About Their Writing* (Joseph, Menon, and Kannabiran 2004).

7. See Nishat 2008.

8. See, for instance, Christina Oesterheld (1994, 2004).

9. See also "The feminist poets of Mumbra," *Times of India* (March 4, 2012). Retrieved from http://articles.timesofindia.indiatimes.com/2012-03-04/mumbai/31120793_1_young-poets-poetry-poems (accessed June 16, 2012).

10. Innumerable volumes, articles, and comments have been published on the Shah Bano case, one of the most critical events in postcolonial India, which led to a renewed polarization of society, and the after-effects are still being felt today. For an introductory reading, see, for example, Engineer 1987; Baxi 1994; Hasan 1999; Mahmood 1993; and Mody 1987.

11. See also the website of AeN at http://www.niswaan.org/ (accessed Sept. 19, 2012).

12. See Suneetha 2011.

13. Personal interview with Fathima Nizaruddin, 13 July 2010.

14. BMMA was founded in 2007 and claims to be the first pan-Indian movement uniting Muslim women across various existing castes and classes in Muslim Indian society. See http://bmmaindia.blogspot.de/ (accessed Sept. 19, 2012) and also Kirmani 2009b, 75ff.

15. See Quraishi 2010.

16. "Islamic Feminism." Retrieved from http://feminismeislamic.org/2congres/participants/ (accessed Sept. 19, 2012).

17. See Barlas 2006.

18. "Islamic feminism and traditionalist ulema's stances on women—Interview with Waris Mazhari of India" (conducted by Yoginder Sikand). Retrieved from http://www.islamopediaonline.org/scholarly-analysis/islamic-feminism-and-traditionalist-ulemas-stance-women-interview-waris-mazhari (accessed Sept. 19, 2012).

19. See the website of STEPS at http://www.stepswomenjamaat.org/ (accessed Sept. 19, 2012).

20. See, for example, http://www.wisemuslimwomen.org/muslimwomen/bio/d._sharifa_khanam/ (accessed Sept. 19, 2012).

21. See, for example, "Muslim Women Demand End to Oppressive Laws," *Time*, Feb 17, 2009, retrieved from http://www.time.com/time/world/article/0,8599,1879864,00.html (accessed Aug. 22, 2011) and also the website of Musawah at http://www.musawah.org/ (accessed Sept. 19, 2012).

Bibliography

Abou-Bakr, Omaima. "Islamic Feminism: What's in a Name? Preliminary Reflections." *Middle East Women's Studies Review* 15 (2001): 4–16.

Aftab, Tahera. *Inscribing South Asian Muslim Women: An Annotated Bibliography & Research Guide.* Leiden, NL: Brill, 2008.

Agnes, Flavia. "Interrogating 'Consent' and 'Agency' Across the Complex Terrain of Family Laws in India." *Social Difference—Online. Special Issue on Women's Rights, Muslim Family Law, and the Politics of Consent* (2001): 1–16. Available at http://www.social-difference.org/events/womens-rights-muslim-family-law-and-politics-consent.

Ahmad, Irfan. "Cracks in the 'Mightiest Fortress': Jamaat-e-Islami's Changing Discourses on Women." *Modern Asian Studies: Islamic reformism in South Asia* 42, no. 2–3 (2008): 549–575. doi: 10.1017/S0026749X0700310.

Ahmed-Ghosh, Huma. "Dilemmas of Islamic and Secular Feminisms." *Journal of International Women's Studies* 9, no. 3 (2008): 9–116.

Ahmed, Leila. *Women and Gender in Islam.* New Haven, CT: Yale University Press, 1992.

Asghar Ali, Azra. *The Emergence of Feminism among Indian Muslim Women.* Pakistan: Oxford University Press, 2000.

Ashok, Sowmiya, and Mohammad Ali. "Housing Apartheid Flourishes in Delhi." *The Hindu.* July www.hindu.com/news/nationalarticle/361394.ece. Last modified July 16, 2012.

Ataulla, Nigar. "Muslim Women: The Dangerous Triangle." *Countercurrents.* 2006. http://www.countercurrents.org/ataulla050808.htm. Accessed June 16, 2012.

———. "Indian Muslims and the Media." *Countercurrents.* 2007. http://www.countercurrents.org/ataulla050607.htm. Accessed June 16, 2012.

Badran, Margot. "Islamic Feminism Means Justice to Women." *The Milli Gazette,* January 16–31, 2004.

Barlas, Asma. *Believing Women in Islam. Unreading Patriarchal interpretations of the Qur'an.* Austin: University of Texas Press, 2002.

———. "The Pleasure of Our Text: Re-reading the Qur'an." Interchurch conference on Women in Religion in the 21st Century. http://www.asmabarlas.com/papers.html. Last modified October 18, 2006. Also available at http://www.asmabarlas.com/PAPERS/Pleasure_of_our_text_Interchurch.pdf/.

Baxi, Upendra. "The Shah Bano Reversal: Coup Against the Constitution." In *Inhuman Wrongs, and Human Rights. Unconventional Essays,* edited by Upendra Baxi, 89–94. New Delhi: Har-Anand Publications, 1994.

Chakravarty, Rangan, and Nandini Gooptu. "Imagi-nation: The Media, Nation and Politics in Contemporary India." In *Cultural Encounters: Representing 'Otherness,'* edited by Elizabeth Hallam and Brian V. Street, 89–107. London & New York: Routledge, 2000.

Desai, R. Die Ausbürgerung Einheimischer und die Einbürgerung von Ausländern. Der Hindu-Nationalismus und das Revival des Hindi-Kinos in den 1990er Jahren. In *Themenschwerpunkt Film in Südasien,* edited by N.-C. Schneider, 2007. Available at http://www.suedasien.info/analysen/2223.

Engineer, Asghar Ali. *The Shah Bano Controversy.* Bombay: Stosius Inc./Advent Books Division, 1987.

Gamper, Markus. *Islamischer Feminismus in Deutschland Religiosität, Identität und Gender in muslimischen Frauenvereinen.* Bielefeld, DE: transcript, 2011.

Gayer, Laurent. "Safe and Sound. Searching for a 'Good Environment' in Abul Fazl Enclave, Delhi." In *Muslims in Indian Cities: Trajectories of Marginalisation,* edited by Gayer, Laurent, and Jaffrelot, 213–236. London: Hurst, 2012.

Hasan, Zoya. "Secularism, Legal Reform and Gender Justice in India." In *Dissociation and Appropriation: Responses to Globalization in Asia and Africa,* edited by K. Füllberg-Stolbergm, P. Heidrich, and E. Schöne, 137–150. Berlin: Arabische Buch, 1999.

Joseph, Ammu, Ritua Menon, and Kannabiran, V. Interview with Shahjahana. *Just Between Us—Women Speak About Their Writing.* New Delhi: Kali for Women/ Women Unlimited, 2004.

Kidwai, S. *Images of Muslim women: A Study on the Representation of Muslim Women in the Media, 1985–2001.* New Delhi: WISCOMP, 2003.

Kirmani, Nida. "Deconstructing and Reconstructing 'Muslim Women' through Women's Narratives." *Journal of Gender Studies* 18, no. 1 (2009a): 47–62. doi: 10.1080/09589230802584253.

———. "Claiming Their Space: Muslim Women-led Networks and the Women's Movement in India." *Journal of International Women's Studies* 11, no. 1 (2009b): 72–85. Available at http://vc.bridgew.edu/jiws/vol11/iss1/6.

Krämer, Gudrun, and Sabine Schmidtke. *Speaking for Islam. Religious Authorities in Muslim Societies,* Leiden, NL: Brill, 2006.

Krishna, S. "Feminist Perspectives and the Struggle to Transform the Disciplines: Report of the IAWS Southern Regional Workshop." *Indian Journal of Gender Studies* 14, no. 3 (2007): 499–515. doi: 10.1177/097152150701400307.

Kumar, Redha. *The History of Doing: An Illustrated Account of Movements for Women's Rights and Feminism in India, 1800–1990.* London: Verso, 1993.

Lambert-Hurley, Siobhan. *Muslim Women, Reform and Princely Patronage: Nawab Sultan Jahan Begam of Bhopal.* New York: Routledge, 2007.

Mahmood, Tahir. "Interaction of Islam and Public Law in Independent India." In *Religion and Law in Independent India,* edited by Robert Baird, 93–120. New Delhi: Manohar, 1993.

Metcalf, Barbara. *Perfecting Women: Maulana Ashraf Ali Thanawi's Bihishti Zewar: A Partial Translation With Commentary.* Berkeley: University of California Press, 1990.

Michaelsen, Marcus. "Linking Up for Change: The Internet and Social Movements in Iran." In *Social Dynamics 2.0: Researching Change in Times of Media Convergence. Case Studies from the Middle East and Asia,* edited by Nadja-Christina Schneider and Bettina Graef, 105–126. Berlin: Frank & Timme, 2011.

Minault, Gail. *Secluded Scholars: Women's Education and Muslim Social Reform in Colonial India.* Delhi & New York: OUP, 1998.

Mir-Hosseini, Ziba. "Muslim Women's Quest for Equality: Between Islamic Law and Feminism." *Critical Inquiry* 32, no. 4 (2006): 629–645. Available at http://www.jstor.org/stable/10.1086508085.

Mody, Nawaz. B. "The Press in India. The Shah Bano Judgment and its Aftermath." *Asian Survey* 27, no .8 (1987): 943–950. Available at http://www.jstor.org/stable/2644865.

Moghadam, V. M. "Qu'est-ce que le Féminisme Musulman? Pour la Promotion d'un Changement Culturel en Faveur de L'égalité des Genres." In *Existe-t-il un Féminisme Musulman?,* edited by Islam et laïcité, 43–48. Paris: L'Harmattan, 2007.

Moghissi, Haideh. *Feminism and Islamic Fundamentalism: The Limits of Postmodern Analysis.* London: Zed Press, 1999.

Moll, Yasmin. "'People Like Us' in Pursuit of God and Rights: Islamic Feminist Discourse and Sisters in Islam in Malaysia." *Journal of International Women's Studies* 11, no. 1 (2009): 40–55. Available at http://vc.bridgew.edu/jiws/vol11/iss1/4.

Nishat, Jamila. *My Life-Giving Ganges—Poems of Jamila Nishat,* translated by Hoshang Merchant. New Delhi: Sahitya Akademi, 2008.

Oesterheld, Christina. "Voices from the Inner Courtyard (On Early Women Poets of Urdu)." In *Tender Ironies (A Tribute to Lothar Lutze),* edited by Dilip Chitre and Lothar Lutze. New Delhi: Manohar, 1994.

———. 2004. "Urdu and Muslim Women." In *Islam in South Asia,* monograph number 1 of Oriente Modern, edited by Daniela Bredi (2004), 217–243.

Pernau, M. *Bürger mit Turban. Muslime in Delhi im 19. Jh.* Göttingen: Vandenhoeck & Ruprecht, 2008.

Power, Carla. "Muslim Women Demand End to Oppressive Laws." *Time.* Available at http://www.time.com/time/world/article/0,8599,1879864,00.html. Last modified February 17, 2009.

Quraishi, Humra. 2010. "Muslim Girls Want to be Allowed to Study, Work, Explore the World—Interview with Zakia Soman, a Founding Member of BMMA." *Times of India.* Available at http://articles.timesofindia.indiatimes.com/2010-09-01/interviews/28215648_1_muslim-women-bharatiya-muslim-mahilaan-dolan-personal-law. Last modified September 9, 2010.

Rajagopal, Arvind. "The Emergency as Prehistory of the New Indian Middle Class." *Modern Asian Studies* 45, no. 5 (2011): 1003–1049. doi: 10.1017/S0026749X10000314.

Salma. *The Hours Past Midnight.* Translated by Lakshmi Holmström. New Delhi: Zubaan Books, 2009.

Samiuddin, Abida, and R. Khanam. *Muslim Feminism and Feminist Movement: South Asia: India, Pakistan, Bangladesh & Sri Lanka.* 3 Volumes. Delhi: Global Vision Publishing House, 2002.

Sassen, S. "Migranten machen Geschichte." http://www.taz.de/nc/1/archiv/digitaz/artikel/ressort=ku&dig=2008%2F04%F22%2Fa0133&src=GI&cHash=1fbec-eb944. Last modified April 22, 2008.

Schneider, N. C. *Zur Darstellung von 'Kultur' und 'kultureller Differenz im Indischen Mediensystem: Die Indische Presse und die Repräsentation des Islams im Rahmen der Zivilrechtsdebatte, 1985–87 und 2003.* Berlin: Logos, 2005.

———. "Islamic Personal Law in India: Political Mobilisations along Religious Lines?" http://www.qantara.de/webcom/show_article.php/_c-478/_nr-552/i.html. Last modified 2008.

———. "Islamic Feminism and Muslim Women's Rights Activism in India: From Transnational Discourse to Local Movement—or Vice Versa?" *Journal of International Women's Studies* 11, no. 1 (2009): 56–71. Available at http://vc.bridgew.edu/jiws/vol11/iss1/5.

———. "Being Young and a 'Muslim Woman' in Post-liberalization India: Reflexive Documentary Films as Media Spaces for New Conversations." *ASIEN. Special*

Issue: *Islam, Youth and Gender in India and Pakistan: Current Research Perspectives* 126, no. 1 (2013): 85–103.

Searle-Chatterjee, Mary. "Women, Islam and Nationhood in Hyderabad." In *Postcolonial India. History, Politics and Culture,* edited by Vinita Damodaran and Maya Unnithan-Kumar, 145–162. Delhi: Manohar, 2000.

Sharify-Funk, Meena. *Encountering the Transnational: Women, Islam and the Politics of Reinterpretation.* Aldershot, UK: Ashgate, 2008.

Sheller, Mimi, and John Urry. "The New Mobilities Paradigm." *Environment and Planning* 8, no. 2 (2006): 207–226.

Sikand, Yoginder. *Islamic Feminism and Traditionalist Ulema's Stances on Women—Interview with Waris Mazhari of India.* http://www.islamopedeiaonline.org/scholarly-analysis/islamic-feminism-and-tranditionalist-ulemas-stance-women-en-interview-waris-mazhari. Last modified 2010.

Suneetha, A. "Indian Secularism and Muslim Personal Law: The Story of Model Nikahnama." *Social Difference—Online. Special Issue on Women's Rights, Muslim Family Law, and the Politics of Consent* 1, no. 1 (2011): 54–62.

Tasmuth. "Ein Fremdwörterbuch: Kübra Gümüsay über ihr Blog." http://netzdebatte. bpb.de/2011/04/14/ein-fremdworterbuch-kubra-gumusay-uber-ihr-blog.

Vatuk, Sylvia. "Islamic Feminism in India: Indian Muslim Women Activists and the Reform of Muslim Personal Law." *Modern Asian Studies: Islamic Reform in South* Asia 42, no. 2–3, (2008): 489–518. doi: 10.1017/S0026749X07003228.

von Braun, C., and Mathes, M. *Verschleierte Weiblichkeit: Die Frau, der Islam und der Westen.* Berlin: Aufbau-Verlag, 2007.

Wadud, Amina. *Qur'an and Woman: Rereading the Sacred Text from a Woman's Perspective.* New York: Oxford University Press, 1992/1999.

Wajihuddin, Mohammed. "The Feminist Poets of Mumbra." *Times of India.* Available at http://timesofindia.indiatimes.com/city/mumbai/The-feminist-poetsof-Mumrba/articleshow/12127842.cms?referral=PM. Last modified March 4, 2012.

Wenk, S. "Imperiale Inszenierungen? Visuelle Politik und Irak-Krieg." In *Imperiale Weltordnung—Trend des 21. Jahrhunderts?* Baden-Baden, edited by S. Jaberg and P. Schlotter, 63–93, 2005.

Zaman, Rafia. "(Re)Framing the Issues: Muslim Women's Activism in Contemporary India." *ASIEN. Special Issue: Islam, Youth and Gender in India and Pakistan: Current Research Perspectives* 126 (2013): 26–44.

Cited Websites

Automotive Industry Institute: www.ifa-info.de (accessed Sept. 19, 2012).

Awaaz-e-Niswan: http://www.niswaan.org (accessed Sept. 19, 2012).

Bharatiya Muslim Mahila Andolan (BMMA): http://bmmaindia.blogspot.de/ (accessed Sept. 19, 2012).

International Congress on Islamic Feminism: http://feminismeislamic.org/2congres/participants/ (accessed Sept. 19, 2012).

STEPS Women Jamaat: http://www.stepswomenjamaat.org/ (accessed Sept. 19, 2012).

Wise Muslim Women: http://www.wisemuslimwomen.org (accessed Sept. 19, 2012).

Musawah—For Equality in the Muslim Family: http://www.musawah.org (accessed Sept. 19, 2012).

Ein Fremdwörterbuch (weblog by Kübra Gümüsay): http://ein-fremdwoerterbuch.blogspot.de/ (accessed Sept. 19, 2012).

Chapter 7

Islamic Feminism between
Interpretive Freedom and Legal Codification

The Case of Sisters in Islam in Malaysia[1]

Yasmin Moll

Introduction

In this essay I explore several important aspects of "Islamic feminism," a discursive and increasingly political movement that has attracted much academic and media consideration in recent years. I do so through a case study of one prominent Islamic feminist nongovernmental organization, the Malaysian group Sisters in Islam (SIS). SIS began as a "study circle" led by American-Muslim scholar and influential Islamic feminist Amina Wadud in the late 1980s; by the mid-1990s, the group had developed into an internationally funded organization that regularly organizes conferences as well as publishes extensively on questions of women's rights and religion. SIS engages in a re-reading of the Qur'an and Prophetic corpus with the aim of developing a feminist fiqh, or jurisprudence, to replace the codified family laws, derived from Islamic law, of individual states in Malaysia.[2]

The growing public attention to Islamic feminism has been largely situated, at least post-9/11, within a policy context of looking for what is construed as a "moderate Muslim" voice, one that espouses understandings of key values such as equality, pluralism, and human rights that are compatible with their secular-liberal iterations.[3] On the part of the Muslim participants of this project, however, is a keen desire to show how such values, far from

being alien to Islam, are in fact the necessary implications of the religion "rightly understood" (see, for example, Sachedina 2001; Kamali 2002; Esack 1997; Abou El Fadl 2001, 2002, 2004). These and other Muslim intellectuals and activists have a deep normative commitment to the Islamic faith and its traditions of reasoning and argument, even as they seek to transform these traditions. As such, they should not be considered to be operating within the same conceptual and, indeed, political space as more (in)famous figures such as Ayaan Hirsi Ali and Irshad Manji, who enjoy much government and media accolades in the West.[4] By contrast, the intellectual genealogy of Islamic feminism can be traced back to early nineteenth-century Muslim reformers in the Middle East, reformers who have been given the moniker of "Islamic modernists" (see Kurzman 2002 for an overview).[5]

Scholarly discussions of these reformist trends and their most recent incarnations such as Islamic feminism invariably seek to locate such projects within a "multiple modernities" paradigm. They highlight how the struggle of Muslim women for their rights from within a religious framework works to "Islamize modernity," "modernize Islam" or, more often, both at once (see Badran 1995; Burgat 2003; Cooper 1998; Esposito 1996, 2001; Majid 1998; Moghadam 1993, 2005, 2007). These analyses rightly focus on how such struggles are at heart interpretive and epistemological—they call forth a re-engagement with the most important texts of the Islamic tradition with an eye toward uncovering their "true" meanings with regards to what constitutes justice, equality, or freedom from oppression.

This essay adds to such analyses a consideration of how such engage-ments do not merely work to produce new understandings and meanings of what Islam "says" (on women's roles, human rights, gender equality, and so on), but also how the repertoires of reasoning called forth by Islamic feminists involve radical reconceptualizations of the authoritative production and transmission of religious knowledge in addition to what constitutes such knowledge in the first instance as new conceptions of religious belief, rights, and texts are formed and articulated. Islamic feminists are participating in fundamentally different regimes and relations of knowledge and power than the male jurists and exegetes from the past they position themselves against. This underscores the ways in which "Islamizing modernity" or "modern-izing Islam" is never merely a question of taking a pre-given conceptual "container" (Islam, modernity) and "filling" it with novel content (-izing it), but rather of constituting new relations to texts and their contexts, and new normative imaginings of what these relations should consist of. In this essay, then, I depart from conventional modes of inquiry into Islamic feminism by thinking about not only what such feminists reason within an Islamic

paradigm, but furthermore how they reason, toward what ends, and with what implications.[6]

Indeed, at issue with Islamic feminists are not only what the canonical texts of Islam are/should be (the Qur'an is kept, but the Prophetic sayings expunged) and the authoritativeness of its (male) interpreters whose commentaries, usually considered an integral part of the canon, are now dismissed out of hand,[7] but also what styles of argumentation are involved. The traditional commentaries are rejected not only because of their substantive content, but precisely because they fail to adhere to what Islamic feminists believe is the correct way to reason and argue within an Islamic horizon (and this goes both ways, of course). For Islamic feminists, interpretive methodologies that do not adopt a critical historical approach to the text or seek to uncover the universal ethical message behind the contingent "historical" event are betraying the normative impulses of Islam. Thus, in many of their citationary practices Islamic feminists completely bypass established Islamic sources such as classic legal commentaries or exegeses, in the process discursively redefining what counts as an "Islamic tradition" and what should be excised.

This is a point that tends to be overlooked by participants in the Islamic feminist movement. Often, Islamic feminists point out that they are merely continuing a venerable Islamic tradition of dissent and debate—that the differences and diversity evidenced in Islamic history has been glossed over by jurists who seek to present it as a monolith of consensus. For example, Farid Esack (2002, 137), the author of several works on the "Islamic roots" of pluralism and democracy and a consistent supporter of Islamic feminist hermeneutics, argues that the historical presence of such jurisprudential and philosophical differences indicates that "no matter how committed to tradition a scholar may be, he or she still asks questions from that tradition and selects from it on the basis of his or her pre-understanding." But the conditions under which "questions" are asked and "selections" made are located within an epistemic framework that recognizes the authority of certain kinds of knowledge and discounts others. This does not mean that the knowledge produced will not be diverse or divergent, but only that it will be subject to certain evaluative criteria that will determine from the outset the parameters of that discourse. With Islamic feminism, these parameters are fundamentally reconfigured.

While contemporary Islamic feminists take as axiomatic the idea that a believer's access to the divine text and its meanings should be unmediated and immediate, traditional exegetes thought about their relations to the canonical texts in very different ways. This change in the "thinkable" is tied

to the emergence of the modern nation state and the creation of new inter-
pretive relations and objects of "religious knowledge" by this state. Islamic
feminist hermeneutics operates within a decidedly different episteme than
the Islamic interpretive tradition such feminists work to transform, even as
they seek to locate themselves in it. This discourse's differing assumptions
about what constitutes religious knowledge and who is allowed to partake in
its production engenders a concomitant textuality that departs in important
and radical ways with traditionally authoritative genres of religious knowl-
edge such as jurisprudential manuals, comprehensive Qur'anic commentar-
ies, or biographical histories. The "exegetical" works produced by Islamic
feminists are in the main academic books meant for a specialized scholarly
audience (whether Muslim or not) that are evaluated according to the secular
criteria of social scientific scholarship, as well as newspaper articles, press
releases, and photocopied booklets intended to reach a national audience of
citizens (who are not always addressed as "believers") and, increasingly, a
transnational audience of human rights activists, nongovernmental organiza-
tions, development funding agencies, think tanks, international governmen-
tal organizations such as the United Nations, and Western policymakers. At
the same time, Islamic feminism acquires its moral force for some Muslims
precisely because it does not situate itself as a distanced, third-space critique
of, or commentary on, the Islamic discursive tradition, but rather as a con-
stitutive (albeit contested by most) player within its epistemological field
even as the nature of that field is fundamentally reimagined. Nevertheless, I
argue that the emphasis on an individual believer's right to reason with the
text is undermined by the objectifying rationalities of the legal framework
Islamic feminist seek to work within.

In the sections that follow, I examine how one of the central premises
of academic articulations of Islamic feminism—the idea that each individual
believer has a right to interpret the Qur'anic text (Wadud 2006; Barlas 2002;
Mir-Hosseini 2003; Ali 2006; Abou-Bakr 2002)—is adapted to activist agen-
das on the ground by groups such as Sisters in Islam and what this can tell
us about the imbrications between discourses of gender equality as a social
goal, law, and religion in Malaysia.[8] In anthropologist Brinkley Messick's
(1993) terms, we have here evidence of a "discursive rupture" that cannot
be merely analyzed, I suggest, as an instance of "modernity Islamized" or
"Islam modernized" if we are to get at what is at stake in these ruptures,
in the relations of knowledge and power in which they are enmeshed in,
and in their conditions of possibility. Islamic feminism, whose genesis is
put by adherents as no earlier than three decades ago (Wadud 2006),[9] in

many ways suffers from a double marginality in its location on the fringes of both Islamic discourse as well as feminist discourse. Yet, it provides an exceptionally telling illustration of the constitution of new ways of knowing and new ways of doing in and through the discursive tradition that is Islam.

The Right to Reason

It is artificial to draw a rigid line between Islamic feminist activism and scholarship—participants usually see themselves as "scholar-activists" (see Webb 2000). At the same time, the battle of Islamic feminists, their "gender jihad" as the title of Amina Wadud's recent (2006) work puts it, has been waged in large part in the trenches of religious knowledge, especially that of Qur'anic hermeneutics (Badran 2009, 3). Indeed, a participant (Khan 2005) in this battle characterizes the target of the gender jihad as an "epistemological hijab" in the sense of a "barrier" erected between women and "Islamic sources" through their historic exclusion from Islamic interpretive communities. The title of a book by the late Egyptian scholar Gamal el-Banna, who advocates rebuilding Islamic jurisprudence from the ground up and is an active participant in Islamic feminist hermeneutics, captures this dynamic quite well: "The Muslim Woman: Between the Liberation of the Qur'an and the Fetters of the Jurists."

Ijtihad (independent intellectual reasoning) is thus a central issue for Islamic feminists—it structures both modes of relating to the canonical texts as well as reframes and redefines what it means to be a believer, a Muslim. In fact, their discourse is often translated into Arabic as al-islam al-ijtihadi. Not only is the intermediary role of "traditional" religious scholars rejected, but furthermore the personal links of relay structuring this role are rendered irrelevant. There is only one "author" of authority, God (Abou El Fadl in Wadud 2006, xiii), and between this divine author and any human interlocutors is no one. Omaima Abou-Bakr, a key participant in the Islamic feminist movement and a professor of comparative literature at Cairo University, locates such an interpretive regime within the "correct teaching" of religion, writing that "Islam teaches us that the true relationship to God is direct with no mediator or guardian between the reason of the believer and the Creator of the universe" (2002, 64). Asma Barlas, another academic and important figure for Islamic feminism, asserts in the postscript of her tafsir (interpretation, exegesis) of select Qur'anic passages (in itself a major departure from the historically established mode of tafsir of the entire Qur'an)[10]:

A mujtahid is thus, before all else, a believer imbued with a sense
of God-consciousness and a believer's right to interpret religion
derives not from social sanctions (permission from clergies or
interpretive communities), but from the depths of our own con-
viction and from the advice the Qur'an gives us to exercise our
intellect and knowledge in reading it (Barlas 2002, 210).[11]

There are two important discursive moves being made here by Abou-
Bakr and Barlas with regards to how religious authority is/should be consti-
tuted. First, there is a foregrounding of ijtihad as both a normative principle
and important instrument of struggle against patriarchy, invoking this cat-
egory while glossing over its contested historical trajectory. The Western
academic literature on Islamic law makes much of the jurisprudential claim
that the gates of ijtihad were closed in the tenth century—after this point,
jurists were more often than not muqalids (imitators) rather than mujtahids
(intellectual reasonor/jurist), leading to a pervasive "stagnation" of not only
intellectual contributions, but Islamic civilization more generally. The broad
outlines of this view of Islamic intellectual history is generally unchallenged
by most Islamic feminists, who see their project as operating in contradis-
tinction to this ossified past. However, critical scholars of Islamic law such as
Wael Hallaq (1984) have challenged this thesis, arguing that while the "gate"
may have been deemed "closed" in principle, in practice ijtihad continued
to be a dynamic force shaping jurisprudence, and the principle is in itself
an integral constituent of the Islamic interpretive tradition since its incep-
tion. The "commentaries on commentaries" were, of course, needed precisely
because there existed wide interpretive differences, multiple and contested
meanings of the canonical texts, and the inevitable arising of new problems
such texts had to be made to speak to. This underlines the fact that fiqh
was always regarded as human construction, "a necessarily flawed attempt
to understand and implement [divine] design" (Messick 1993, 17), even if
Islamic feminists sometimes write as if their point on this is unprecedented.

What is new and different, however, is the delineation of who can claim
a right to ijtihad and partake in the creation and mediation of new meanings
within Islamic discursive formations. This marks the second important move
by Islamic feminists, their definition of who can be a mujtahid. As the quote
from Barlas makes clear, the role of mujtahid is re-imagined (or "reclaimed,"
as they would put it) by Islamic feminists as one which could be filled by
any believer, thus bypassing, first, the need for specialized training, and,
second, the historic gatekeepers of such training. Mujtahids are largely self-
authorized.[12] This understanding of religious knowledge and its production

stands in radical opposition to the view of scholarly enterprise embedded in the traditional episteme of Islam; for example, the jurist Malik b. Anas, the eponymous founder of one of the four still extant madhabs (jurisprudential schools), reportedly said that he "did not issue fatwas until seventy individuals swore to me that I was qualified" (in Masud et al. 1996, 20).[13]

Anthropologist Dale Eickelman has written extensively on the "fragmentation of religious authority" this mode of knowledge production entails, a mode enabled in the first place, he writes, by the "massification" of education and rising literacy rates. In a widely cited article (Eickelman 1992), he argues that as modes of knowledge become more focused on questions of "how" and "why" with the institution of modern pedagogies on a mass scale, "religious imagination" becomes "objectified" in the sense that Islam becomes a distinct system examinable as such. Objectification is not so much about a shift from unreflective enactment to reflective deliberation on the part of individuals, but to the different kinds of public deliberation and reflection tied to modern institutions and their disciplinary modes. At the same time, this leads to the production of religious knowledge becoming framed as a question of "rights" for "ordinary people." For example, Zainah Anwar, then–executive director of Sisters in Islam (Anwar 2005, 240), argues for the right of "people like us to participate in matters of religion—people who did not go to that venerable university in Egypt for the study of Islam, al-Azhar, who cannot speak Arabic, and who are not covered up."[14] Below, I explore further this re-imagination of the problematique of knowledge production as a question of rights.

Contesting Patriarchy: Sisters in Islam

After gaining independence from British colonial rule in 1957, Malaysia enacted a constitution delineating Islam as the country's official religion. Malaysia is a multiethnic and religiously plural nation. It is also one where ethnicity and religion are neatly conflated—Malays (who comprise approximately half the country's population) are by legal definition also Muslims (Nagata 1997). Baker characterizes "Malaysian Islam" as "perhaps the most monolithic and the most state-regulated" across the Muslim world (Baker 2007, 82). Such state regulation, however, occurs in a context of codified plurality when it comes to Islamic family law, with each state comprising the Malaysian federation enacting its own shariah-derived personal status codes covering matters such as marriage, divorce, and inheritance (Siraj 1994). Indeed, the judicial system is a dual one, consisting of courts administrated federally and state-

level shariah courts. While the Department for the Advancement of Islam in Malaysia (JAKIM) can and does draft legislation pertaining to Islam, individual state assemblies have discretionary power in whether or not to enact such legislation (Martinez 2001). At the same time, to be valid, state laws cannot conflict with the federal code (Nagata 1997, 147).

Although political Islam has been part of the mainstream political scene in Malaysia since the colonial period (Baker 2007; Aziz and Shamsul 2004), the 1980s heralded the start of a nation-wide "Islamic resurgence," with both the beginning of state-led Islamization under Mahathir (Nasr 2001) and a vibrant, grassroots dakwah movement calling for greater adherence to Islamic norms on the part of ordinary Muslims (Frisk 2009). The nation's most powerful opposition group is PAS, or Islamic Party of Malaysia, which has as its declared aim the establishment of an "Islamic state" and the implementation of Islamic criminal law. While following the attacks of September 11 in the United States, Mahathir declared that "Malaysia already is an Islamic state" (Martinez 2001), his successor Ahmed Badawi has sought to promote what he calls islam hadari (civilizational Islam) as a counterweight, it seems, to the political Islam of both PAS and the government's UNMO party under Mahathir (Baker 2007).

Sisters in Islam has emerged over the past two decades as a vocal player in Malaysia's vibrant civil society scene (Ufen 2009), regularly weighing in on issues affecting Muslim women in the country (Mohamed 2004). Officially founded in 1993 as a Malaysian women's rights NGO, SIS began as a scriptural study circle in the 1980s led by Amina Wadud (considered by many a "Malaysian public figure" [Ong 1999, 361]) when she was studying at the Malaysian Islamic University. The hermeneutical approaches of Islamic modernists such as Fazlur Rahman, Abdullahi An-Naim, and Nasr Hamid Abu Zayd have had a formative impact on Wadud's thought, which has in turn influenced the discourse of Sisters in Islam (see Bowen 2003). There is a dearth of academic considerations of this group, despite its high media profile and connections with several prominent academics in the United States and England.[15] An exception to this is Aiwha Ong's (1999) detailed examination of SIS in an article titled "Muslim Feminism: Citizenship in the Shelter of Corporatist Islam." Ong (1999) ties the discourse of Islamic feminism in Malaysia to the political imperatives of a secular state seeking to regulate potentially contestatory Islamic nodes of authority by at once supporting groups like SIS—who fragment that authority by presenting an internal challenge to it—and by bringing Islamic law under the state's regulatory ambit (for a more recent discussion of the "Islamization of Malaysia" and "women's rights" see Tong and Turner 2008; Frisk 2009).[16]

At the time I was researching this essay (2006–2007), SIS maintained a weekly column on Islamic law and women's rights in Malaysia's largest circulating daily newspaper, *Utusan Malaysia*, and became a regular source of authoritative opinion—as representatives of the "progressive Islamic voice"—for journalists covering such issues. In addition, it conducted "study workshops" open to the general public at its office in Selangor on topics such as "Demystifying the Fiqh: an Approach Towards Understanding How Shariah Law is Constructed," "Islamic State—Fact or Fiction?," "Playing God: Who Speaks for Islam Today?," and "Religion, Traditional Interpretation & Critical Hermeneutics." These workshops feature not only Malaysian human rights activists and like-minded scholars, but also Muslim academics based in the West, American and British-Muslim journalists, and representatives from Western nongovernmental organizations concerned with women's rights and democratization. Members of the SIS board are also themselves invited to speak in the United States and Europe, often by Western academics who are interested in researching and promoting Islamic feminism as a corrective to what they see as the problematic enforcement of patriarchal interpretations of shariah-norms in Muslim societies, especially in the area of family law.[17] Indeed, family law is the most important site of activism for SIS, which provides free legal advice to Malaysians "dealing with Shariah & Civil Law problems" and worked on drafting a "Model Islamic Family Law" that is "based on the framework of equality and justice." A statement on the group's website said that the code would draw on four areas: "the Islamic framework, constitutional and national laws, international human rights principles and the realities of Muslim women's lives."[18] Malaysia's legal system, as with many Muslim countries, draws on shariah principles in its laws dealing with marriage, divorce, inheritance, and custody. In 2005, the federal government instituted a number of revisions to its family law bill (such as making the legal approval of a second marriage by an already-married man easier) that were met with loud opposition by Sisters in Islam as well as liberal civil society groups.

In addition to these lobbying initiatives aimed at changing the country's legal stipulations, SIS puts out a series of booklets distilling the "correct" interpretation of a number of Qur'anic verses held to be the most significant to gender relations and women's status, especially verses on polygamy, divorce, inheritance, and the veil. Innovating on the traditional fatwa genre, the booklets' titles take the form of questions—"Are Muslim Men Allowed to Beat Their Wives?," "Are Women & Men Equal Before Allah?," for example—followed by a lengthy answer that cites the relevant Qur'anic verse, the incorrect (patriarchal) interpretation of it, and the correct (feminist) one.[19] As Messick has shown in his analysis of "media muftis" in Yemen,

Whereas the old logocentric textual culture sought the legitimat-
ing immediacy of a human presence to secure the authoritative
transmission of knowledge, the new media intervene in a dis-
tancing and alienating manner. Instead of individualizing com-
munications, the new fatwas are broadcast messages for a mass
audience, the characteristic citizenry of a nation-state . . . the
personal matter has become public here (1996, 320).

This dynamic acquires particular saliency for groups like Sisters in
Islam, who are of course working within a framework informed by the femi-
nist axiom that the "personal is the political." Within this construction, the
modalities and qualities of relations between spouses or between spouses and
divine intent become legitimate objects of legal management and control by
the state as well as public discussion. This is, in fact, the common assumption
underwriting all of SIS's discursive and political work. A brief discussion of
an editorial entitled "Dress and Modesty in Islam" published by the group
in two newspapers (one of which is the English-language *The New Straits
Times*) illustrates this point more concretely.

The cause for the editorial was the arrest of three Muslim Miss Malaysia
beauty pageant contestants by Selangor's Islamic Affairs Department in 1997,
an action that sparked widespread public controversy and led a government
minister to call for the formulation of a definition of "indecent dressing and
behavior" with the intention of implementing it into a federal law. The edi-
torial writers began by questioning the very right of government/religious
authorities to draw up such guidelines, going on to say that if such guide-
lines must be imposed, they "must be carried out only within the widest
possible consultation (shura) of those who will be affected by these stan-
dards. . . . They cannot be made in isolation and by an exclusive group of
people who believe that no one else has a right to talk, discuss, or question
matters of religion." They go on to argue that state laws/fatwas (notice how
the two are collapsed) that affect "fundamental liberties" must be within the
purview of Parliament and be consistent with the constitution. In calling
upon the principle of "shura," the Islamic feminist activists are expanding the
definitional borders of a Qur'anic concept that was historically limited to the
religo-political elite (Moussalli 2001, 162) to subsume the idea of participato-
ry/representative government (Hourani 2002 (1962), 144)[20] where legitimacy
derives from popular, rather than 'ulamatic (religious-scholarly), consensus.

After establishing this as a first principle, the editorial then delved
into a lengthy exegesis of several Qur'anic verses dealing with modesty and
women's dress, concluding in the end that the Qur'an does not prescribe a

specific type of dress for Muslims. In reaching these conclusions, the writers resort to the Islamic modernist move of differentiating between the historical specificity of the Qur'anic message and its universal intent, employing (although not citing) An-Naim's (1990) distinction between universal Meccan surahs and context-bound Medinan ones[21] as well as Rahman's "double-movement" interpretive methodology.[22] In an appeal to reason, the writers argue that "the message of the Qur'an is not intended to cripple the human mind. . . . Are we to be a nation of muqallids (blind followers) which can only lead to further stagnation and intellectual paralysis . . . ?" They end the article by warning that "those in religious authority must begin to understand that they are operating within a democratic, multi-ethnic society whose citizens are not only increasingly better educated, but also better informed on Islam and its eternal commitment to justice, equality, freedom and virtue."

A second editorial, entitled "Differences of Opinions in Islam," similarly frames "the right to speak on Islam" as a fundamental right for citizens of a democratic state, while yet another editorial ("NO to JAKIM [Department of Islamic Development in Malaysia] Attempt to Silence Writers") argues that "When Islam in Malaysia is used as a source of law and public policy with widespread impact on the lives of the citizens of a democratic country, any attempt to limit writing about Islam to only those who supposedly have 'in-depth knowledge of Islam' is tantamount to rule of a theocratic dictatorship." In the discursive tradition of Islamic feminists, the politics of knowledge production are deeply imbricated with the politics of citizenship, rights, and public reasoning. I conclude by examining how the modern state's transformation of the shariah into a code of law has contributed to making this type of reasoning possible.

Legal Rationalities, Activist Potentialities

Messick (1993, 59) argues Ottoman reformers, influenced by European ideas of "progress" and legal rationality, began to see the shariah as cumbersome, obscure, and out of tune with the contemporary world. In the first and unprecedented attempt at the codification of the shariah, the Ottoman Majalla, "drafters took an important step toward silencing the open-ended argumentation of shariah jurisprudence. Once central to a vital intellectual culture, openness was now considered a drawback" (Messick 1993, 55). Codification places conscious restriction on the interpretive freedom of jurists and qadis (judges), transforming the shariah from an embodied (through memorization and human linkages in transmission) social discourse to an abstract

set of principles that exists within the neat, parallel lines of modern codes (Messick 1993, 205). Epistemologically these codes determine the "content" of the shariah as a set of univocal statutes (as opposed to heteroglossic lived texts) that could be applied uniformly by the state.

My point is that while Islamic feminism champions interpretive openness as the enabling condition for the insertion of women's voices into the privileged male domain of religious authority, they can only do so within the framework of a legal epistemology that itself demands a closure alien to Islamic orthodoxy, which allowed for a plurality of legal opinions, even if contradictory, to mutually exist. As Talal Asad argues (2003, 217), codification helped to create new conditions of possibility within Muslim countries, "new institutional and discursive spaces that make different kinds of knowledge, action and desire possible." This involves new ideas about both what the law is and what it can be made to do, in addition to a definition of what constitutes "genuine religion" and its "acceptable public face" (Asad 2002).

The uniform statutes of law (even if it varies from state to state) is also, of course, what makes the legal activism of groups such as SIS possible, allowing them to work through the power of the state to institute "real Islam" in contradistinction to what they view as the "corrupted Islam" of the traditional ulama. Indeed, while Islamic feminism has so far succeeded in carving a compelling (for some Muslims) space for itself mainly on the level of Qur'anic interpretation, its self-proclaimed goal is to change the legislation on family law in Muslim countries through articulating a "feminist fiqh" (Abou-Bakr 2002, 62, 70, 202). It does so through collapsing two categories considered distinct in traditional understandings of the law—qadi rulings (state, binding) and mufti opinions (individual, nonbinding) (Masud et al. 1996)—as well as rendering distinct two categories normally fused in the Islamic discursive tradition: the moral and the legal. For example, in an editorial titled "Morality policing by authorities the wrong way to go"(4 April 2008), SIS argues that a rumored proposal to extend the so-called khawlat law prohibiting sexual/intimate contact between unmarried Muslims to non-Muslims contravenes several Qur'anic verses that they interpret as upholding noninterference in the "private" realm of morality. Far from being merely liberal expressions of individual rights against a coercive state, such distinctions occur in the power-laden frameworks within which the codification of shariah took place. This involves the colonial separation of "law" from "morality" that then "enables the legal work of educating subjects into a new public morality" (Asad 2003, 231)[23]

This points to how it would be a mistake to view the "new Muslim public sphere" as the enabling condition for certain discourses or actions,

when in fact it is itself enabled by the shifts outlined above. Crucially, these shifts render possible a multiplicity of voices on Islam, not all of which are progressive or feminist.[24] Indeed, the feminist "gender jihad" of which the Sisters in Islam editorials are symptomatic is one being fought on a number of fronts: that of the traditional ulama which preceded the "freer market," but, more important, that of newer Islamic discourses that are enabled by the very same processes enabling Islamic feminism, and that share its same epistemological space. Islamic feminists are, of course, aware of this, with Zainah Anwar, the executive director of Sisters in Islam, noting that

> It is ironic that many of those who challenge and question the credentials of women's groups to speak on Islam themselves often do not speak Arabic and have not been traditionally educated in Islam. Many of those at the vanguard of the Islamic movement calling for the establishment of an Islamic state and the imposition of sharia rule are professionals, engineers, doctors, professors, and administrators without any formal religious training (2005, 243).

The anthropologist Mir-Hosseini goes even further, crediting what she calls the neotraditionalists for crystallizing the epistemic shifts that made a space for Islamic feminists. She argues that "by appealing to the believer's logic and reasoning, relying on arguments and sources outside religion, and imposing their vision of Islamic law through the machinery of a modern state, they have inadvertently paved the way for an egalitarian reading of the shari'a" (2003, 21). Thus, while Islamic feminists may frame speaking in the public sphere on matters of religion as a question of rights, other participants in the same sphere would deny them such rights even as they use them themselves. My point is that there appears to be an irreducible tension between, on the one hand, maintaining as Islamically normative a plurality of interpretive stances stemming from an individual "right" to reason with authoritative texts and, on the other, working toward codifying some of these interpretations as a matter of uniform law. Such enforced uniformity would inevitably clash with an individual's ongoing right to interpret the Qur'an, including its legal provisions.

Conclusion

The quest for gender justice within a religious frame is necessary and important—Islamic feminist groups have become significant actors in diverse

Muslim and non-Muslim states, whether in Malaysia or elsewhere, and have made important contributions to public discourses and policies on women's rights. Indeed, secular attempts to dismiss Islamic feminism as "apologetic" (Abu Khalil 1993; Karmi 1996; Moghadem 2002; Moghissi 1999) belies a lack of appreciation for the salient role diverse interpretations of the Qur'an have played (and continue to play) in Muslim societies. At the same time, it is important to situate Islamic feminism within changing relations of knowledge and power that work to create new conditions of possibility for both women's rights and religious belief, conditions that do not so much "reclaim" an "uncorrupted" Islamic tradition, but as this essay argues, redefine it in ways that are intimately tied to the legal rationalities of the modern nation state and the types of religious action it makes (im)possible. In the case of Islamic feminism as articulated by Sisters in Islam, these redefinitions work through an internal tension between interpretive freedom and legal codification.

Notes

1. I would like to thank Michael Gilsenan, Brinkley Messick, Vanessa Agard-Jones, and the two anonymous reviewers of *The Journal of International Women's Studies* for their thoughtful comments on various drafts of this essay. This essay is adapted from an article published in *JIWS*.

2. Another regional group with similar aims is the Indonesian Fiqhun Nisah, and in Iran there are many feminist NGOs and Islamic thinkers who regularly publish feminist re-interperations of certain verses of the Qur'an pertaining to women and the family, all the while pushing for modification of personal status law to reflect these new interpretations. Badran (2005) argues that historically the Iranian groups were the first to don the label "Isamic feminism." Such feminist exegetical circles—not to be confused with the more common and conventional mosque study circles for women such as those in Egypt profiled by Mahmood (2005)—have not caught on in the Arab world. There was one such group working out of Cairo University in the mid-1980s but it kept a very low profile and eventually disbanded (personal communication with Prof. Omaima Abou-Bakr, Cairo University, Department of Literature).

3. For a consideration of the politics surrounding the recuperation of a "moderate" Islamic agenda by the U.S. government as a strategy in the "war on terror," see Mahmood 2006.

4. Anthropologist Lila Abu-Lughod (2013) mounts a trenchant critique of the broader politics of such interventions to "save" Muslim women.

5. Margot Badran (2009, 308) has argued that the intellectual geneaology of both secular and Islamic feminist movements in the Middle East can be traced back to Islamic modernism.

6. In making my arguments, I critically draw on Talal Asad's (1986) highly influential conceptualization of Islam as a "discursive tradition." Asad's formulation invites us to see how ideas of authority and authoritative knowledge are historically and culturally constituted in the interactive space between people, texts, and practice that determines what is, or should be, "Islamic." At the heart of this idea of a discursive tradition is an anthropological interest not so much in a set of paradigmatic concepts continuous throughout Islamic history, but rather an interest in the traditions of reasoning and argumentation that are deployed around often hotly contested concepts. The Islamic discursive tradition is therefore not an unchanging or unitary formation, but admits diversity, debate, and difference. Nevertheless, for Asad the authority of a tradition rests in a degree of continuity that is not always open to the possibility of freely choosing certain elements and rejecting others out of hand—it is always located within certain "conditions of possibility" that discursively define what counts as "Islamic" and what positively cannot, at least from the point of view of power-laden orthodoxies. The interpretive value of such an understanding hinges, however, upon a recognition of the ever-present contingency of this discursive tradition, as new authoritative spokespersons are constituted, new "founding texts" introduced (or at least old founding texts re-imagined) into the canon, and new orthodoxies emerge through changing relations of power. How interpretive debates may be conducted, what modes of reasoning are deployed, and what epistemological assumptions these modes rest on can be qualitatively different from one Islamic actor to another.

7. Islamic feminists do not go as far as some of those calling for a "feminist theology" that rejects completely the Old and New Testament in favor of "writing new texts to express our new consciousness" (Ruether 1983, xii). This strategy follows from Audre Lorde's famous proclamation that "the master's tools won't destroy the master's house" (1984). In that essay, Lorde asks, "what does it mean when the tools of a racist patriarchy are used to examine the fruits of that same patriarchy?" (1984, 110), answering that such a mode of critique could never engender "genuine change." Islamic feminists, on the other hand, are choosing to challenge patriarchy on its own home turf—that of religious legitimation—by engaging in alternative readings of the canonical texts of Islam, texts that are authoritative references for the male elites as well.

8. The paradigm of Islamic feminism is not monolithic, but rather exhibits some important internal variations. However, common to all variant articulations is a set of basic premises (e.g., justice means gender equality) and a set of common questions (e.g., What does Islam have to say about gender equality?), although both premises and questions can be approached in divergent ways.

9. An argument can be made for a much longer historical geneology to Islamic feminism, however. For example, we have as early as 1928 Islamic feminist tracts such as the Lebanese Nazira Zayn Al-Din's *The Girl and the Shaykhs,* where she argues that "women are more worthy of interpreting verses that have to do with women's duties and rights than men, for they are the ones that are directly addressed" (cooke 2001, xiv).

10. This exegetical mode is the favored one among Islamic feminists, with participant Omaima Abou-Bakr, in her Arabic-language overview of the movement, highlighting how Islamic feminists are not concerned with undertaking a tafsir of the entire Qur'an, but rather only of several problematic verses dealing with women. Historically, there were women who did undertake holistic Qur'anic exegesis—in the twentieth century we have the Egyptian Aisha Abdelrahman's two-volume exegesis *Al-tafsir al-bayan li al-qur'an al-karim* (1962–1969), but such women are not considered by Islamic feminists to be within their geneaology since they do not make gender a salient category of analysis and they utilize a traditional exegetical methodology.

11. Questions of the material presentation, marketing, circulation, and use of this tafsir (the paratextual—see Genette 1997) are also interesting. It is published by a U.S. academic printing house and packaged as a text book for courses on gender studies or religion, and is indeed engaged with as such by students.

12. This is of course a particularly radical extension of the Islamic modernist project articulated by Abduh—he was more concerned with arguing that properly trained ulama can "once again" engage in ijtihad in light of modern exigenicies, not in displacing such ulama.

13. Such an understanding of the normative processes by which legitimate knowledge is produced is reflected in traditional classifications of Qur'anic exegesis: exegesis by transmission (bi il-riwaya) was commonly also referred to as exegesis by knowledge (tafsir bi 'il-ilm). Within this interpretive regime, Muslims engaging in tafsir not only are presumed to have mastered the requisite sciences, but also draw on a continuous chain of previous work making up the acceptable canon. This mode of tafsir, the most widely accepted, was contrasted with a tafsir bi il-ra'y or exegesis by opinion/reason, a marginal mode historically (Esack 2002). By contrast, Islamic feminists such as Barlas (see also Wadud 1999, 2006) recuperate in their project this exegetical mode, presenting it as the only truly "Islamic" one.

14. This is at odds with the Muslim women preachers Mahmood (2005) discusses in her ethnography of the Islamic Revival in Egypt. While for some of these women individual interpretive choice is important, the choices themselves are the ones arising from earlier juristic rulings and "as such, choice is understood not to be an expression of one's will but something that one exercises in following the prescribed path to becoming a better Muslim" (Mahmood 2005, 85). This is in contradistinction to the Islamic feminist position presented here, where the whole point is to contruct new choices sensitive to gender equality, in contradistinction to the juristic tradition.

15. But see Abu-Lughod 2013 for an extended and insightful discussion of this group, including its global initiative Musawah (Equality).

16. Ong is rather critical of the brand of feminism espoused by Sisters in Islam, saying that "they have not yet articulated women's most basic rights, that is, their rights over their own bodies . . . there has been no mention of women's right to sexual autonomy, even the right of women to premarital sex" (1999, 365). For a problematization of the rhetoric behind statements such as this, which present Western norms as "natural rights" desired by all women, see Mahmood 2005.

17. I attended one such lecture series at New York University (Fall 2006) with SIS's then–executive director Zaineh Anwar, who was invited to speak by Professor Ziba Mir-Hosseini, a noted legal anthropologist who has written prolifically on feminism and the law, especially in Iran, and is counted by some as an Islamic feminist herself.

18. Their website is www.sistersinislam.org.my.

19. In their introduction to the edited volume *Islamic Legal Interpretation,* Masud, Messick, and Powers (1996, 20) highlight how classical works in the adab al-mufti genre generally agree that muftis should defer on questions of Qur'anic exegesis to specialists in that area. Within modern relations of interpretations, this specialization is lost, with tafsir increasingly falling within the ambit of legal opinion, as can be seen by these SIS booklets.

20. Such redefinitions were often key to the "Islamic modernist" program, as Hourani notes. Another key traditional idea that was reinterperated as an Islamic rationale for democracy was ijma (consensus), understood by thinkers such as Rashid Rida as the "original conception of legislation in Islam" (Hourani 2002 [1962], 235), aligning it with contemporary pariliamentary legislative systems.

21. A quote by An-Naim is posted prominently on the welcome page of the organization's website: "My claim is not that we need to secularize the state in order to be modern. My claim is that we need a secular state to be better Muslims." This is the central claim of his book, *Islam and the Secular State* (2008).

22. Rahman's "double-movement" approach, heavily indebted to Muhammed Abduh's modernist understanding of Qur'anic language, is explicitly constructed by Rahman as a suitably modern reincarnation of the classical methodology of ijtihad. According to this approach, "first one must understand the import or meaning of a given statement [in the Qur'an] by studying the historical situation or problem to which it was the answer" (Rahman 1982, 6). Once this is understood, one has to look at what "general moral-social" principle was meant to be fulfilled by the specific Qur'anic injunction. One then takes this general principle and attempts to see how it can specifically be applied in the present.

23. Asad's (2003) sophisticated and complex argument here is against the common assumption that family law represented the last stronghold or bastion of the shariah as the modern state system was instituted in Muslim countries. Instead, he wants to show how the shariah was constructed as the law of personal status by the secular logic of the state that defined morality as a private affair, and hence in the domain of "religion," now also seen as a properly "private" matter.

24. Eickelman argues that the "fragmentation of religious authority" associated with the epistemic shift this paper has been problematizing creates a new Muslim public sphere marked by individual and group participation, a plurality of equally authorized voices and horizontal relations between producers and consumers of knowledge. He and others see "an irreversible trend toward a freer market in religious, political, and social ideas that fosters a pluralism often resisted and poorly understood by states and by religious authorities" (Eickelman and Andersen 2003, 34). The pluralism engendered by this freer market, the argument goes, may

ultimately function as a key underpinning for the emergence of a liberal democratic polity. At the same time, however, there is a key difference between a pluralism of religious voices and authorities, and voices and authorities for which pluralism is a key normative value, meaning where "different" (and differing) voices are welcomed as a matter of principle. The fragmentation of religious authorities, its plurality, does not necessarily entail a pluralism of the second kind.

Bibliography

Abou-Bakr, Omaima. *Al-mara'a wa-l-jindir: ilgha' al-tamyiz al-thaqafi wa-l-ijtima'i bayn al-jinsayn* (Women and Gender: Abolishing Cultural and Social Discrimination between the Two Sexes). Damascus: Dar Al Fikr, 2002.

Abou El Fadl, Khaled. *Speaking in God's Name: Islamic Law, Authority and Women.* Oxford: Oneworld, 2001.

———. *The Place of Tolerance in Islam,* edited by Joshua Cohen and Ian Iague for *Boston Review.* Boston: Beacon Press, 2002.

———. *Islam and the Challenge of Democracy: A Boston Review Book,* edited by Joshua Cohen and Deborah Chasmen. Princeton, NJ: Princeton University Press, 2004.

AbuKhalil, As'ad. "Toward the Study of Women and Politics in the Arab World: The Debate and the Reality." *Feminist Issues* 13, no. 1 (1993): 3–22.

Abu-Lughod, Lila. *Do Muslim Women Need Saving?* Cambridge, MA: Harvard University Press, 2013.

Ali, Kecia. *Sexual Ethics and Islam: Feminist Reflections on Qur'an, Hadith and Jurisprudence.* Oxford: Oneworld, 2006.

An-Naim, Abdullahi. *Toward an Islamic Reformation.* New York: Syracuse University Press, 1990.

Anwar, Zainah. "Sisters in Islam and the Struggle for Women's Rights." In *On Shifting Ground: Muslim Women in the Global Era,* edited by Fereshteh Nouraie-Simone. New York: The Feminist Press of the City University of New York, 2005.

Asad, Talal. "The Idea of an Anthropology of Islam." Occasional Paper Series, Center for Contemporary Arab Studies, 1986.

———. *Genealogies of Religion: Disciplines and Reasons of Power in Christianity and Islam.* Baltimore: John Hopkins University Press, 1993.

———. Q&A with Talal Asad. Asia Society. http://www.asiasource.org/news/special_reports/asad.cfm. Accessed July 15, 2002.

———. *Formations of the Secular: Christianity, Islam and Modernity.* Stanford, CA: Stanford University Press, 2003.

Aziz, Azmi, and Shamsul, A. B. "The Religious, the Plural, the Secular and the Modern: A Brief Critical Survey of Islam in Malaysia." *InterAsia Cultural Studies* 5, no. 3 (2004): 341–356. doi: 10.1080/1464937042000288651.

Badran, Margot. *Feminists, Islam, and Nation: Gender and the Making of Modern Egypt.* Princeton, NJ: Princeton University Press, 1995.

———. "Between Secular and Islamic Feminism/s: Reflections on the Middle East and Beyond." *Journal of Middle East Women's Studies* 1, no. 1 (2005): 6–28. Available at http://www.jstor.org/stable/40326847.

———. *Feminism in Islam: Secular and Religious Convergences.* Oxford: Oneworld Publishing, 2009.

Baker, Osman. "Malaysian Islam in the 21st century: The Promise of a Democratic Transformation?" In *Asian Islam in the 21st Century,* edited by John Esposito, John Voll, and Osman Baker, Oxford: Oxford University Press, 2007.

Barlas, Asma. *Believing Women in Islam: Unreading Patriarchial Interpretations of the Qur'an.* Austin: University of Texas Press, 2002.

Bowen, John. *Islam, Law and Equality in Indonesia: An Anthropology of Public Reasoning.* Cambridge: Cambridge University Press, 2003.

Burgat, Francois, and John Esposito. *Modernizing Islam: Religion and the Public Sphere in Europe and the Middle East.* New Brunswick, NJ: Rutgers University Press, 2003.

cooke, miriam. *Women Claim Islam: Creating Islamic Feminism through Literature.* London: Routledge, 2001.

Cooper, John, Ronald Netter, and Mohamad Mahmoud. *Islam and Modernity: Muslim Intellectuals Respond.* London: IB Tauris, 1998.

Eickelman, Dale. *Knowledge and Power in Morocco: The Education of a Twentieth-Century Notable.* Princeton, NJ: Princeton University Press, 1985.

———. "Mass Higher Education and the Religious Imagination in Contemporary Arab Societies." *American Ethnologist* 19, no. 4 (1992): 643–655. doi: 10.1525/ae.1992.19.4.02a00010.

Eickelman, Dale, and Jon Andersen. *New Media in the Muslim World: The Emerging Public Sphere.* 2nd ed. Bloomington: Indiana University Press, 2003.

Esack, Farid. *Qur'an Liberation and Pluralism.* Oxford: Oneworld, 1997.

———. *The Qur'an: A Short Introduction.* Oxford: Oneworld, 2002.

Esposito, John, and John Voll. *Islam and Democracy.* New York: Oxford University Press, 1996.

———. *Makers of Contemporary Islam.* New York: Oxford University Press, 2001.

Frisk, Sylva. *Submitting to God: Women and Islam in Urban Malaysia.* Copenhagen: Nias Press, 2009.

Genette, Gerard. *Paratexts: Thresholds of Interpretation.* Cambridge: Cambridge University Press, 1997.

Hallaq, Wael. "Was the Gate of Ijtihad Closed?" *International Journal of Middle East Studies* 16, no. 1 (1984): 3–41. Available at http://www.jstor.org/stable/162939.

Hourani, Albert. *Arabic Thought in the Liberal Age 1789–1939.* 11th edition. Cambridge: Cambridge University Press, 2002.

Kamali, Mohammad Hashim. *Freedom, Equality and Justice in Islam.* Cambridge: Islamic Texts Society, 2002.

Karmi, Ghada. "Women, Islam and Patriarchalism." In *Feminism and Islam: Legal and Literary Perspectives,* edited by Mai Yamani, Berkshire: Garnet Publishing, 1996.

Khan, Muqtedar. "Epistemological Hijab." http://www.ijtihad.org/Hijab.htm. Accessed December 1, 2006.

———. "The Role of Social Scientists in Muslim Societies." *IJTIHAD.* http://www.ijtihad.org/islamicsocialsciences.htm. Last modified May 21, 2004.

Kurzman, Charles. *Modernist Islam, 1840–1940: A Source-book.* Oxford: Oxford University Press, 2002.

Lorde, Audre. *Sister Outsider.* Freedom, CA: The Crossing Press, 1984.

Mahmood, Saba. *Politics of Piety: The Islamic Revival and the Feminist Subject.* Princeton, NJ: Princeton University Press, 2005.

———. "Secularism, Hermeneutics, and Empire: The Politics of Islamic Reformation." *Public Culture* 18, no. 2 (2006): 323–347. doi: 10.1215/08992363-2006-006.

Majid, Anouar. "The Politics of Feminism in Islam." *Signs* 23, no. 2 (1998): 321–361. Available at http://www.jstor.org/stable/3175093.

Martinez, Patricia. "The Islamic State or the State of Islam in Malaysia" *Contemporary South-East Asia* 23, no. 3 (2001): 474–503. Available at http://www.jstor.org/stable/25798563.

Masud, Khalid, Brinkley Messick, and David Powers. *Islamic Legal Interpretation: Muftis and their Fatwas.* Cambridge, MA: Harvard University Press, 1996.

Messick, Brinkley. *The Calligraphic State: Textual Domination and History in a Muslim Society.* Berkeley: University of California Press, 1993.

———. "Media Muftis: Radio Fatwas in Yemen." In *Islamic Legal Interpretation: Muftis and their Fatwas,* edited by Masud, Messick, and Powers. Cambridge, MA: Harvard University Press, 1996.

———. "Genealogies of Reading and Scholarly Cultures of Islam." In *Cultures of Scholarship,* edited by S. C. Humphreys. Ann Arbor: University of Michigan Press, 1997.

Mir-Hosseini, Ziba. "The Construction of Gender in Islamic Legal Thought and Strategies for Reform." *Hawwa* 1, no. 1 (2003): 1–28. doi: 10.1163/156920803100420252.

Moghadam, Valentine. *Modernizing Women: Gender and Social Change in the Middle East.* Boulder, CO: Lynne Rienner, 1993.

———. "Islamic Feminism and its Discontents: Toward a Resolution of the Debate." In *Gender Politics and Islam,* edited by Therese Saliba, Carolyn Allen, and Judith Howard, Chicago: University of Chicago Press, 2002.

———. *Globalizing Women: Transnational Feminist Networks.* Baltimore: Johns Hopkins University Press, 2005.

———. *From Patriarchy to Empowerment: Women's Participation, Movements and Rights in the Middle East, North Africa and South Asia.* Syracuse, NY: Syracuse University Press, 2007.

Moghissi, Haideh. *Feminism and Islamic Fundamentalism: The Limits of Postmodern Analysis.* London: Zed Books, 1999.

Mohamed, Maznah. "Women's Engagement with Political Islam in Malaysia." *Global Change, Peace and Security* 16, no. 2 (2004): 133–149. doi: 10.1080/0951274042000233350.

Moussalli, Ahmed. *The Islamic Quest for Democracy, Pluralism, and Human Rights.* Gainesville: University of Florida, 2001.

Nagata, Judith. "Ethnonationalism vs. religious transnationalism: nation-building and Islam in Malaysia" *The Muslim World* 17, no. 2 (1997): 129–150. doi:10.1111/j.1478-1913.1997.tb03290.x.

Nasr, S. Vali Reza. *The Islamic Leviathan: Islam and the Making of State Power.* Oxford: Oxford University Press, 2001.

Ong, Aiwah. "Muslim Feminism: Citizenship in the shelter of corporatist Islam." *Citizenship Studies* 3, no. 3 (1991): 355–371. doi: 10.1080/13621029908420720.

Rahman, Fazlur. *Islam and Modernity: The Transformation of an Intellectual Tradition.* Chicago: University of Chicago Press, 1982.

———. *Islam.* 2nd ed. Chicago: University of Chicago Press, 1979.

Rosenthal, Franz. *Knowledge Triumphant: The Conception of Knowledge in Medieval Islam.* Leiden, NL: Brill, 1970.

Ruether, Rosemary. *Sexism and God-Talk: Toward a Feminist Theology.* Boston: Beacon Press, 1983.

Sachedina, Abdulaziz. *The Islamic Roots of Democratic Pluralism.* New York: Oxford University Press, 2001.

Siraj, Mehrun. "Women and the Law: Significant Developments in Malaysia." *Law and Society Review* 28, no. 3 (1994): 561–572. Available at http://www.jstor.org/stable/3054075.

Tong, Joy Kooi-Chin, and Bryan Turner. "Women, Piety and Practice: A Study of Women and Religious Practice in Malaysia." *Contemporary Islam* 2, no. 1 (2008): 41–59. doi: 10.1007/s11562-007-0038-3.

Ufen, Andreas. "Mobilizing Political Islam: Indonesia and Malaysia Compared." *Commonweatlh and Comparative Politics* 47, no. 3(2009): 308–333. doi: 10.1080/14662040903073761.

Wadud, Amina. *Inside the Gender Jihad: Women's Reform in Islam.* Oxford: Oneworld Publications, 2006.

———. *Qur'an and Woman: Rereading the Sacred Text from a Woman's Perspective.* Oxford: Oxford University Press, 1999.

Webb, Gisela. *Windows of Faith: Muslim Women Scholar-Activists in North America.* Syracuse, NY: Syracuse University Press, 2000.

Chapter 8

Faith-based Challenges to the
Women's Movement in Pakistan

Afiya Shehrbano Zia

Enlightened Moderation

As a liberal dictator, one of the things Gen. Musharraf will undoubtedly be remembered for is the promotion of women's causes during his nine-year rule as President of Pakistan (1999–2008). Gen. Musharraf will also be remembered for his infamous accusation of rape survivor, Mukhtaran Mai, as a case in point that women cry "rape" every time they want to gain visa/asylum to Canada.[1] Under his leadership, women gained unprecedented rights in terms of political representation in Parliament; appointments in the federal cabinet; appointments in the armed forces and in public services, as well as patronage in the arts and cultural expression. Most important, we saw the reform of the discriminatory Zina Ordinance[2] against which the women's movement[3] had pitted a long-term struggle.

At the same time, it was during these years that women increasingly started observing the hejab, a form of scarving or veil not widely practiced in Pakistan before; piety movements gained momentum such that women preachers now had large followings and even set up private faith-based institutions and schools. For the first time in Pakistan, the Islamist parties won substantive seats in Parliament. Most important, we saw a split in the women's movement after twenty-five years, when the right-wing women's movement withdrew from the consensus that the discriminatory Zina Ordinance contravened the Quranic understanding of adultery. Instead, the right-wing women reversed their longstanding support from the campaign

to repeal this law. They actively organized protests and opposed, in Parliament, the efforts of the progressives to repeal or reform the controversial Zina laws.[4]

These contradictions and tensions make this period one of the most interesting and challenging for the women's movement. General Musharraf's very first speech assured the Pakistani people that his was not an obscurantist religious agenda. The reference was obvious—a distancing from the last military dictatorship of Gen. Zia ul Haq (1977–1988) whose Islamization agenda targeted women and minorities and institutionalized legal and social discrimination. Zia's regime had also instilled a spirit of militancy in the army, as well as strengthened the cause of bigoted religious politics in the country. The liberals were relieved not to have another faith-based moral crusader in uniform.

The Enlightened Moderation theme of Gen. Musharraf's rule become the raison d'etre for maneuvering his continuation at the helm of state affairs rather than calling for elections and reverting to total civilian governance. The reason there was no concerted serious protest movement against this was that liberals perceived him as a potential bulwark against the conservative ambitions of the previous government.[5] Unlike previous leaders, there was also a broad consensus that Gen. Musharraf was personally and materially incorruptible. The religious parties saw this as an opportunity to take advantage of swing votes, given the absence of leadership for the two leading parties, the liberal Pakistan People's Party (PPP) and the conservative Pakistan Muslim League (PML). They also had the very recent 9/11 attacks and the subsequent war on terror as rallying points around which they focused their campaign.

Democratic Opportunity for Islamists, Women, and Islamist Women

Fresh elections to legitimize the military takeover also provided an opportunity for the previously unsuccessful religious political parties to gain electoral success in 2002. In the four previous elections of 1988, 1990, 1993, and 1996, these parties never gained more than 3 percent of Parliamentary seats. This did not mean they did not exert influence on mainstream politics despite their lack of electoral strength. However, the atrophying of the main political parties, the PPP and the PML, was achieved when the leaders of both main parties went into exile after Gen. Musharraf's coup of 1999. This was to avoid the backlash expected from the military government's "account-

ability" process initiated soon after the 1999 coup. In 2001, the Mutahida Majlis e Amal (MMA-United Council for Action), was founded by the then amir[6] of the Jamaat e Islami,[7] Qazi Hussein Ahmed, who invited an alliance of six religious political parties. The MMA contested the elections called by General Musharraf to restore "controlled" democracy under his leadership.

The trajectory of Islamist politics in the country is not the central concern of this essay. However, the political context is important when we consider the social backlash that resulted when, for the first time, an Islamist alliance party gained substantial governmental power and was democratically instituted in Pakistan through the ballot box. The attendant alteration in the cultural landscape under the MMA has adversely affected Pakistan's political stability, politicized further the role of religion, and severely affected women in particular.

Women's organizations had for years been advocating for affirmative action to facilitate women's political representation in the political foray, and this seemed like a pipe-dream. Even under the liberal government of the late Benazir Bhutto, women's representation in Parliament was at a mere 1.4 percent, and her party pleaded lack of political support from the opposition to increase this quota.

However, the Legal Framework Order (2002)[8] under Gen. Musharraf made Constitutional changes that increased the number of overall seats in the legislature and increased the quota for reserved seats for women substantially. Apart from the (twelve) directly elected women, an unprecedented sixty seats for women were reserved for the 2002 elections. Women's organizations worked dynamically with women candidates to campaign for these seats. The MMA won an overall fifty-one seats in the National Assembly of which twelve had to be filled by its women members.

Although strongly opposed to a woman as head of an Islamic state and complicit in preventing women from contesting for public office, and even from exercising their right to vote, the MMA women readily accepted seats that were fielded by them on behalf of their male relatives. There is no better example of politics by proxy than this. Although, traditionally, women representatives from other political parties do not fare any better and also tend to operate as male proxies, the religious political parties make no apology for this trend. Theirs is a clear agenda—take any opportunity, including those attributed as progressive, modernist means, only to subvert them toward conservative ends. Thus, despite opposing the quota accorded to women on principle, the MMA women representatives actively participated in the legislative process between 2002 and 2007. One MMA Parliamentarian is reported to have said that women should have separate,

segregated assemblies to debate their issues and that the MMA would avail of the reserved seats only to ensure repeal of this provision once they had built the political power base that would enable them to do so.[9]

The record of the MMA provincial government formed in the North Western Frontier Province (NWFP, neighboring with Afghanistan) is a bleak trajectory that signals the political slide into uber conservatism as exemplified in the Hisba (Accountability) Act. This law originally proposed by the MMA in NWFP (now Khyber Pukhtunkhwa) in 2003, in violation of the Constitution, essentially attempted to legalize gender apartheid by awarding the Mohtasib (Arbiter) the duty to protect Islamic values and etiquette and act as vigilante. Under his watch, a culture police was to be appointed for the "Promotion of Virtue and Prevention of Vice" to monitor the social and personal relationships and activities of citizens. This was passed by the NWFP legislative assembly on the second attempt but, on a reference by Gen. Musharraf, was disallowed by the Supreme Court as contravention of the Constitution, in 2006.

Just like liberal and nationalist agendas are constructed across the body politic of women, the religious right, too, derives its moral authority from womanhood as a signifier of its ideological commitment to preserve male-defined, religiously ordained social order. Thus the MMA rule in NWFP based itself on a moral imperative to provide social order through vigilantism and remove all visible markers of womanhood from the public and relegate it to the private realm.

During the Musharraf years (1999–2008), on one hand we saw women being consciously inducted into public services, such as the first woman state bank governor, official female guards of Jinnah's[10] mausoleum, airline pilots, coast guards, and into the armed forces and senior positions in the bureaucracy. On the other hand, in the NWFP, a systematic drive was launched to remove any signs of womanhood in the public sphere. For example, women's shelters were attacked as Western-inspired initiatives that encouraged adultery and obscenity. In fact, a full-fledged, antiobscenity campaign was conducted by the youth wing of the MMA whereby billboards and hoardings of women in advertisements were blackened with paint and torn down. The most symbolic act was the order by the provincial government that all mannequins must be removed from shops as they represented the (disembodied) female form in public. All forms of femaleness were to be relegated to the private, domestic realm of the family. Women leaders and activists of the religious parties were at the forefront and complicit in such campaigns, as well as in efforts that actively prevented women from exercising their vote in local elections.[11]

These contradictions in the self-acclaimed liberal dispensation of General Musharraf's government peaked under his rule, which had accommodated Islamist politics for political expediency. Although this was not untrue of previous dictatorships in Pakistan, the result this time has influenced unprecedented social upheaval and an academic conflation of notions of what is liberal, secular, modern, and traditional. This period split the liberals and conservatives alike. In principle, liberals were supporting a military dictator who wasn't quite dictatorial, yet he had accommodated the religiopolitical parties who instituted the most radical conservative drives in the NWFP. At the same time, Gen. Musharraf played the buffer in resisting their attempt to impose religiosity over state and cultural discourse.

The liberal/conservative or modernist/traditional divide worked in synch and harmony since it did not directly challenge the interests of the liberal elite, who in turn supported a (politically conservative) military under a liberal leader. The military in turn was receiving moral and financial support for its frontline role in the war on terror and thus (ostensibly) breaking from its traditional support of jihadi militants.[12] The conservative religious parties who opposed this role as America's ally still stayed in government to gain credibility as a legitimate democratic entity. Through provincial governance they actively radicalized the sociocultural political environment by wedding religious codes with and furthering cultural conservatism.

My interest in exploring these contradictions is not speculative. Rather, I am interested to look through the lens of the women's movement to assess how these developments have reflected and affected the strategic positions and identity politics within the Pakistani women's movement itself. In other words, the inherent contradictions within the progressive women's movement of the 1980s onward, with regard to its strategic relationship with religion, is a mirror reflection of the interplay of overall religious and secular identity politics played out from 2002 to 2008. This has left the women's movement more polarized on the issue of whether it is still possible to reclaim the potential of religion to lobby for women's rights in the Muslim context, or if the only choice is now to remain wary of the religious idiom and stick to secular credentials and base its demands on a universal human rights discourse.[13]

Faith-Based Feminisms

The first generation of Islamic modernist feminists[14] believed in the participatory nature of religion, as well as the "psychological healing" and the

"solace and solidarity"[15] it may provide in the absence of alternatives, particularly for women from lower classes. This attribution of women's religious expressions as a placation or compensation for their social class is also not new. Linked to the critique of the urban-based, bourgeois women's movement has been the suggestion that one reason for the failure of mass mobilization of women across classes was that they chose to posit their politics outside of the religious framework.

Contemporary new scholarship challenges this limited attribution. Some academics studying contemporary Islamic movements advocate the viability of reinstituting alternative Islamic economic, legal, and political systems. They do not consider such projects to be simply reactions to Western colonialism and imperialism. With regard to the study of women activists of such Islamic political movements in Pakistan, this literature challenges the notion that right-wing women are pressurized to join Islamic political parties. It also challenges the idea that Islam or an Islamic state is oppressive for women as defined by Orientalist literature, or that women's resistance, agency, and autonomy must be the opposite of subordination.[16]

The Islamic feminists of the 1980s in Pakistan wished to sieve out the patriarchy from a male-defined Islam and saw religion as a pawn abused by an oppressive state. Their project became to reclaim feminist possibilities within a reformed Islam, and they were well supported by sympathetic international donors for such efforts. However, this strategy, despite some acclaim by Iranian Islamic feminists, has been criticized for paying a price whereby the feminism part of Islamic feminism gets subsumed and relegated as a lesser appendage to the more compelling and overarching Islamic phenomena. Islam as a political strategy is increasingly becoming a limited empowering tool for the Islamic feminist reformist project—instead it has become a legitimate mobilizing strategy almost exclusively for the radical right.[17]

The Islamic feminists clearly discredited the patriarchal Islamist project that aimed to inscribe religion onto the state and convert it from a secular entity into a sacred one.[18] The more recent scholarship from revivalists argues exactly the same but opposes the end analysis. Humeira Iqtidar suggests that yes, Islamists wish to inscribe religion onto the state, but by virtue of this imposition will be converting the sacred (agenda of religiosity) into a secular entity (state politics) rather than the other way around.[19] She upholds that since all secular states are essentially premised on religious faith, why can Islamic politics not be an equal contender for the secular label? What she doesn't specify is a repeated question asked by Pakistani secularists—what kind of a state does this project envision? What laws, economy, and processes

will it be governed by and what would the citizenship of women and minorities be based on? In other words, what is the political or, indeed, economic relevance of this proposition?

Meanwhile, various Western governments, propelled by their own political compulsions, seek to fund such introspection, research, and development by looking for alternative expressions of a "soft" Islam in Muslim countries. This is pandering to and resulting in apologia literature and diluted political insight into the dynamics of fundamentalist strategies. Worst of all, it is premised on essentialist notions that, in Muslim-majority countries, it is the religious identities that are foremost considerations when analyzing sociopolitical behavior.

Some contemporary Pakistani scholars[20] quote revivalist literature, stating that since there is no formal church or clergy in Islam, there is thus no possibility of calling for a separation of state and religion, or for secularization. The suggestion is that Islam is, by this definition, already secular. However, to the extent that there is de facto state power held by many a clergy in Muslim-majority states, or who hold the state hostage through competing religious idioms, this automatic secular theory is a myth.

In any case, the larger point is that dismantling the structures of political Islam will not challenge the increasing privatization of religion in Pakistan.[21] This private realm is the point of entry for faith-based activism and intervention and the point where Islamists are most successful. This private realm has become the site where both Islamic feminists and post-9/11 anthropologists base their analysis and hope for potentially liberating faith-based politics, particularly for women. Their differences come about in the understanding of politics.

While Islamic feminists consider religion a private spiritual, cultural, and social vehicle of empowerment, recent excavatory scholarship on Islamists invite the political expression of belief as a legitimate mode of women's agency and liberation. They also differ on the nature and role of the state, but recent scholarship, beyond its rejection of Western universalism, secular laws, and modernity as a colonial imposition, has not outlined an alternative vision as clearly. Some works in progress advocate the need for Islamic jurisprudence and authentic structures, such as Qazi courts (Islamic courts), to replace the postcolonial judicial systems in Islamic republics such as Pakistan.[22] However, these are already the demands of some Islamist parties, and even of the Taliban, in Pakistan. Thus such demands from these scholars and academics (mostly Western educated themselves) overlap within the realm of conservative politics. Also, such demands are deeply contested among Islamic scholars, including those within Pakistan.

Having said that, most Islamic feminists in Pakistan are clear about their demand for a secular or nontheocratic state and in their demand for the repeal of Islamic laws and separation of religion from state, business is a consistent one. By this token they can also continue to simultaneously work on feminizing women's relationship with religion within the private or social sector. However, scholarship that supports Islamist politics challenges this demarcation by illustrating the lived realities of women involved in piety and faith-based movements and insists that this should be seen as political and a valid instrument of empowerment, mobilization, and expression of women's attempts to cross the private/public divide.

This essay does not suggest that the shift in ideologies within the women's movements in Pakistan has come about through any conscious debate or consensus. Rather, this essay argues that competing theories on the role of religion in relation to women are shifting due to academic interests on the subject rather than out of a political engagement. The central argument in this paper challenges the temptation within this scholarship to promote the practices and activism of the right-wing women as indicative of a newly founded, liberationist alternative to Western feminism and universal rights.

Contesting for Primacy in the Private Realm

The challenge faced by Pakistan's feminists today is not simply from an overtly theocratic state that is pushing an Islamist agenda but more so from fragmented, organized faith-based (almost always gender-segregated) interest groups. They compete for legitimacy in routine politics and for relevance in the social fabric of the country. This growing piety movement includes many women religious leaders and home-based preachers, several of whom have successfully activated networks and mobilized communities to spread their word. Often, though not always, the women's theology groups are purported for the cause of women's rights in Islam. What used to be the strategies and vocabulary of the liberal and upper-class nongovernmental organizations' (NGO) women activists have been claimed by these, supposedly more "indigenous," Islamic women's rights activists.[23] These Islamist women may not be as overtly politicized yet, but they certainly are involved in (what is commonly known in NGO vocabulary as) "advocacy" toward this end.

Amina Jamal's (2005) work on Jamaat e Islami[24] (JI) women's political activism argues that the secular women's movement in Pakistan has refused to recognize the Jamaat women's agency and see this only in terms of a

passive submission to Jamaat men. Jamal warns of the danger of denying the autonomy and emancipatory self-definition of Jamaat women. Jamal suggests this denial allows some (secular) feminists to re-present the right-wing women as victims of false consciousness so that they may construct their own identities as feminists with a modernist agenda, particularly against Islamisation.[25] In contrast, Jamal's own work attempts to highlight the effectiveness of Jamaat women's autonomous attempts to appropriate modernity toward their own ends and their understanding of rights. These modern social and political rights, according to the Jamaat women that Jamal interviews, should enhance, not repress, Islamic values. She quotes from an interview of a woman activist of the Jamaat e Islami (JI) who explains that while Jamaat women are modern, they are not Westernized.[26]

Similarly, Humeira Iqtidar's (2011) work on women in the Jamaat e Islami (JI) and Jamaat ud Dawa (JuD),[27] also questions the notion that women are pressured or coerced to conform to piety movements or join Islamist parties.[28] Her theoretical perspective relies on scholarship that challenges the modernization framework and looks to include religion as a legitimate category of liberatory politics. She argues that the religious agency and belief of women activists of right-wing political parties in Pakistan is not blind, but rather is historically and culturally grounded and, therefore, substantive.

Iqtidar (2011) goes further than Jamal on two points that argue that women's agency can be mediated by religious belief and does not have to be consciously feminist. Her research finds that resistance to male domination may be incidental rather than purposeful in the activism of these right-wing women. Second, her analysis of these religious political parties suggests that by rejecting or failing at secular careers, women who join these Islamist parties find independent avenues, which afford them liberation. She also quotes scholarship that suggests that the status of women in postrevolutionary Iran or, indeed, under any Islamized regimes may have carried "certain advantages," and in any case should not be analyzed through any "de-contextualized categories."[29] Further, Iqtidar contends that by bringing religious belief into the public sphere and recognizing it as a motivating factor, this trend is secularizing Muslim societies.[30]

Where Jamal (2005) and Iqtidar (2011) stop short in their attribution of agency to women activists of Islamist parties is when they do not acknowledge the purpose of the agency and the conservative ends toward which it is used. The few examples that Jamal does quote in terms of Jamaat women emulating secular feminist strategies and methodology of politicking may be countered by the many instances in which they also support antiwomen legislation and policies.

Both scholars rely on Saba Mahmood's challenge to feminist theory, which assumes that agency must be substantive and informed by a feminist consciousness.[31] Instead, Mahmood argues that, in fact, piety movements prove that agency can be attributed even to passive, docile nonaction and preservation of the status quo and that feminist politics is not a natural desire. Humeira Iqtidar concludes through her dialogue with a woman member of Jamaat ud Dawa that Islamist parties can be oppressive for some but liberating sanctuaries for others.[32] The political experience in the Pakistani context, however, has shown that faith-based agency of women in religious parties is not often used just for nonfeminist ends but increasingly to actively support a patriarchal Islamic agenda.

Two different examples help to put this contention into context.[33] The first is an observation on the role and performance of right-wing women representatives and the political positions they took on women's issues in Parliament between 2002 and 2008. Apart from the overall conservative and antiwomen legislation and policies promoted in the NWFP (now, Khyber Pukhtunkhwa) discussed above, within the national Parliament too there were clear ideological divides on legislation regarding women's rights. When the opposition party, the PPP, proposed a bill on domestic violence, it was resisted by several male members from the ruling party (PML-Q) as well as by the religious party, the MMA. This led to a heated debate, and women Parliamentarians staged a protest in the Assembly when the (male) Parliamentary secretary opposed the bill on the grounds that a Muslim husband had the right to admonish and even beat his wife if she was disobedient.

In an impressive move of going against the party line, Samia R. Qazi, Member of Parliament representing the religious party, the MMA (daughter of the amir of the JI, Qazi Hussein Ahmed), defended the domestic violence bill by taking a stand against the Parliamentary secretary's interpretation of the Quranic verse. Admittedly, Samia Qazi's intervention was in support of protecting women from gratuitous marital violence as interpreted by male readings of religious verses. At the same time, her intervention record shows that she supported the larger understanding that a woman of a "certain character" and attitude may warrant light beatings but that this should not become an excuse for men to use wives as punching bags.[34] Such stances can be read as proof of agency of Islamist women, however this is not only nonfeminist but, indeed, it actively upholds a patriarchal coercive social order or contract with reference to "appropriate" matrimonial obedience or conduct.

The second exemplar with regard to Islamist women's agency is in connection with the Jamia Hafsa incident in 2007, which was simply a precursor

of the potential of the personal religious agency of women being converted in to political activism. The Jamia Hafsa women students belonged to a religious school or madrassa part of the Lal Masjid mosque in the capital city of Islamabad. They illegally occupied the premises adjoining the mosque land in protest against the government's threat to demolish and reclaim it as a suspected hotbed for terrorist indoctrination. The Jamia Hafsa women students conducted a vigilante puritanical drive against "unislamic" practices by demanding video and music shops to be shut down. They also kidnapped a woman from the neighborhood suspected of running a prostitution business and released her only once she had "repented." Eventually, a few months later, the seminary was stormed by state troops, which led to the death of many in the mosque, and while the government denies any women students were killed in the shootout, there has been no transparent inquiry or report on the action.

Women's rights and human rights groups in Pakistan protested against the vigilantism of the Jamia Hafsa women students. At the same time, they also disputed the need for such disproportionate use of state force when troops launched a military operation (Operation Silence, 10 July 2006) against the mosque where the clerics and students were lodged, armed, and refusing to vacate the state property. The visuals of these women students (which are also available on YouTube) show hundreds of women completely clad in black veils and holding bamboo sticks. However, other Islamist parties, including their women activists, have remained silent on this issue. They do not publicly support or condemn such action, nor do they express solidarity with the women of Jamia Hafsa as a political statement. The only exception was the Jamaat e Islami women's wing, which held a press conference in July 2008, one year after the incident and after losing the national elections in February 2008. Former MNA (Member of National Assembly/ Parliament) and representative of the JI, Saima Qazi, accused the former government (which included her!) as desecrating "Islamic principles such as burqa, veil and beard"[35] with reference to the Jamia Hafsa incident. She also demanded that an inquiry of the incident be held but made no comment as to the actions of the JH women themselves or to their politics or action.

The purpose of citing these examples is to demonstrate that religious affiliation and empowerment from within the religious discourse is consistently political rather than merely pietist, personal, and/or charitable. Also, such political positioning by Islamist women can work its faith-based politics or agency to liberate and oppress at the same time.[36] This is true for women and minority concerns alike.

Cultural Authenticity

The central anguish of many diasporic Muslim scholars, particularly in the Islamophobic environments of Western countries in the post-9/11 era, is over how Muslim countries have adopted wholesale modernist agendas of Western governments and ideologies of Western feminisms. This is not a new accusation, since conservatives and Islamists, including Gen. Zia ul Haq himself, repeatedly attempted to delegitimize women activists who challenged the state for equal rights, as being "Westernized." Yet, thirty years later, when the feminists of the second wave[37] have not only entrenched their politics but also gathered support at grassroots levels, this is a misplaced indictment that is rarely officially issued from Islamists in Pakistan, as it is from diasporic contexts.[38] Islamophobia has becomes pivotal in the consciences of diasporic Muslims, it seems, when analyzing secular resistance in Muslim countries. Diasporic analysis also tends to fetishize and romanticize Islamist movements, particularly its women activists.

The contradiction in placing premium on the "authentic believing" Muslim woman as opposed to the Westernized secular Muslim woman is clear in two perspectives on this issue. On one hand, Amina Jamal's analysis attempts to highlight that, in fact, the values, goals and efforts of Jamaat e Islami women are located in a modernist discourse and not some traditionalist one.[39] On the other hand, Humeira Iqtidar's work suggests that modernity is a construct that must be rejected, and that by redefining agency and liberation we can accept that these can be defined in religious terms, as well as nonfeminist terms, respectively.[40] According to both views, whether we accept or reject modernity as defined by the secularists' worldview, this allows an acknowledgment of Islamist women's agency as historically more relevant and culturally grounded.

However, both sets of analyses belong to what I term "political nunneries."[41] These are ethnographies that attribute agency as part of an anthropological effort to (re)construct an ideological framework for a political alternative to liberal notions of secular modernity. In the process, they stop short of contextualizing the political articulations of the agency that they recognize or ascribe to the Islamist women that they study. In other words, when this agency converts into political articulation, there is no discussion of the implications, outcome, or effects of such agency that has been, in the experience of Pakistan, both vociferously antiwomen at worst, and silent and hence complicit, at best.

Religious political parties claim to be true protectors of women as long as women adhere to their domestic domain, since the family is considered to be the locus of women's security. In a monograph that records the actions

and stances of the MMA between 2003 and 2005, Brohi lists a series of cases of violence against women in the NWFP during the leadership of the MMA government.[42] She notes the repeated silence on these cases that include violent rapes, forced marriages, and honour killings, against which MMA claims to be vehemently opposed. Even beyond the NWFP, on the publicized case of the jirga[43] ordered rape of Mukhtara Mai, which was condemned by activists across the ideological divide, women members of the MMA, at a seminar in Lahore, demanded a ban on NGOs, whom they held responsible for "harming the country by raising the Mukhtara Mai issue."[44] Brohi notes, "The MMA's strategy for preventing violence against women such as rape, gang rape and harassment is to reduce to minimum if not eliminate, their interaction with men."[45]

Against this backdrop, then, it is difficult to understand how these religious political parties can be understood to be potential reformists and ideologically liberating spaces, rather than politically radical and, indeed, conservative and detrimental to women's equal rights.

Some Proposals of Reconciliation

The temptation to conflate cultural purity with Islam as found in the pro-Islamist scholarship poses a practical challenge for the women's movement in Pakistan. This project overlaps with the Islamic feminist one that attempts to separate patriarchal cultural practices from "pure" religion. It is also the locale where secular feminists have struggled the most in their realization that women's sexuality is the site where both culture and religion collude to control and measure society's moral order. Thus the latter's concern is not so much on the interpretation of the law but over the fact that patriarchal culture and/or religion will dominate any translation of the social order. These feminists are not looking for bulwarks; rather, they are looking to uproot and transform gender relations to ensure that women's choices are neither divinely legally ordained nor sanctioned by a patriarchal culture.

Conventional Islamic punishment, such as stoning to death, which is practiced in Iran, Saudi Arabia, and Afghanistan, is not executed in Pakistan. Yet the informal, parallel legal structures institutionalize extra judicial practices based on the notion of retributive justice as culturally authentic and Islamically sanctioned. If the state continues to embed religious legality so as to reclaim and excavate an imagined "pure" Islamic culture, then necessarily some historical moments within patriarchal culture and religion will overlap and, logically, will condone stoning and honor killings.

When a woman minister for social welfare, Zille Huma, was shot at a public event by an "extremist" for not adequately veiling herself in 2007, does that fall under cultural norms or religious sanction? Flogging is widely understood as a prescribed religious punishment subject to circumstances, judicial process, and interpretation. In cases of adultery, blasphemy, willful marriages, and denying women their property rights by marrying them off to the holy book, cultural sanctions are often derived from or collude with existing religious laws. Thus, until the law was amended in 2006, the Zina law became a tool of controlling women's choice in marriage and her mobility, not so much about adultery. Even after the amendment, the basic premise of this law centers on the monitoring of women's sexuality as a threat to social order. Blasphemy, if proven, is punishable by death but, often, enraged Muslims take this law into their hands and use it as a moral justification to attack and even kill (usually) other Muslims. In most cases, the issue has nothing to do with blaspheming but is used to settle personal scores. Women's marital choice is subject to permission from her wali or guardian. At best, some women legislators have attempted to make the State the wali rather than a woman's male relative, which has been resisted by the right-wing women representatives. In either case, the concept of a wali for women and minors remains a discriminatory requirement. Retributive justice, as meted out in cases of murder under the Qisas and Diyat[46] law, sustain cultural norms of bartering compensation in return for a life taken, such as in (illegal) cultural practices like honor killings.[47]

Thus, some patriarchal cultural practices do not contravene the broader Islamic moral and social order, including attributing women lesser inheritance or minorities lesser status as citizens. Religion is not a logic that is going to be accepted as a piece of legislation, particularly if it challenges patriarchal norms. This piecemeal logic is also applied in other cases in which "progressive" interpretations of religion are appreciated as successful implantations of Islamic ethos. These always stop short of being equal for women, with the understanding that if such an attempt would be made such laws would be unsuccessful because they do not accommodate the expectations of normative religion nor the cultural environment as determined by patriarchy.

However, such arguments are more problematic when cultural practice and religious ethos do contravene each other. Then which will supersede, cultural authenticity or Islam? It is very much like the question: Which came first, the chicken or the egg? The argument that there is significant debate within Islamic tradition, and ijtehad (independent reasoning) and ijma (consensus) is the derivative method of legislating a religious law, is simply an attempt to justify another way of bringing (Western) rational-

ity and commonsense into the religious discourse. Gen. Musharraf's liberal intervention that led him to issue a reference against the proposed Hisba Bill of the religious right government in NWFP allowed the Supreme Court to strike down the bill. This is how the Council of Islamic Ideology operates, and courts in Pakistan too. By and large, they tend to respond to the political mood and leadership of the period.

Every time the Council makes a humanistic, progressive, or modernist interpretation (which coincides with the Universalist human rights discourse) of an Islamic law, this is hailed as proof of the progressive spirit of Islam. In other words, the standard against which progress is measured in Muslim countries is often when women's Islamic rights are compared favorably against Western or universal codes. Therefore, despite prescribing lesser status with regard to property, polygamy, law on adultery, child custody, evidence, blood money, and so on, these Quranic prescriptions are always justified as requiring "progressive" interpretation or rendered inapplicable if "taken out of context," and thereby need historical textual supporting evidence. This process is reductive rather than cumulative.

To presume that interpretations can be made in vacuum under some suspended historical period and under the pretense that we are no longer defined by modernist discourse is an unrealistic political expectation. Activism demands strategic alliances, as well as political positioning. When the opportunity came up to reform the Zina Ordinance in 2006 during Gen. Musharraf's government, women activists were not about to get caught up in a debate that had been circulating for twenty-seven years. Eventually, the adultery laws were not repealed, as the liberal women's movement had demanded, but were amended instead. The right-wing women, who clearly stood against the original Zina Ordinance from the 1980s, formally opposed the call for repeal or amending the law for the first time in twenty-five years. They had shifted from their earlier academic position that the law was interpreted incorrectly. They had also rejected the political imperative behind such a law passed by Gen. Zia ul Haq. Some twenty-five years later, the right-wing women shifted their strategic position on the law and followed the male dictate, which insisted that any change in this law would convert Pakistan into a "free sex zone."[48] This was an absolute rejection of modernizing a discriminatory law that targeted women and compounded rape with adultery. This rejection can be taken as evidence of the success of the agency of right-wing women as nonfeminist and nonmodernist, but of course is clearly not just political but very radical.

Certainly agency is not the monopoly of the vanguard and is, arguably, even better organized and used by the rearguard, too. However, there is a

critical blindness within these analyses that disregards how this agency is converted into political articulation and its impact. The suggestion that this agency helps women in their personal politics is fine, and coincides with the Islamic feminists' stance, but this cannot stop here. When this agency spills into an organized, antiwomen, antiminorities political agenda, then the responsibility for the consequences of the exercise of such agency must also be equally appreciated.

The pragmatic proposal of a coalition of Islamic, secular, and other feminisms in the form of "hybrid feminisms"[49] as submitted by Huma Ahmed-Ghosh is less problematic in theory but strategically has proven to be unwise in the Pakistani experience. The concept of "patriarchy trading," which allows women some agency by accepting patriarchy, is a dormant and tentative precipice to put women on. Repeatedly, the experience of feminist alliances has shown that right-wing politics manages to subsume and co-opt not just the tactics, vocabulary, and strategies of feminism but even manages to subvert these for the most patriarchal ends. At first, Islamic feminists rethought the concept of the veil as more polysemic than the Oriental and Western feminist understanding of it. Now, there is rethinking of polygamy, which is increasingly becoming a bargain that some (first wives) negotiate in order to gain domestic relief when second wives take over their duties.

Certainly there are debates and contestations within the religious political discourse, particularly between male and female ideologues on the issue and place of women's rights. However, such competitive struggles also tend to pit the perceived "good Muslim woman" who adheres to the more literal, conservative visions of the party against the challenging "bad Muslim woman." The hierarchies of these religious parties are severe, and women cannot head them or integrate into the mainstream decision-making process. Thus their intellectual agency is unlikely to contribute toward party policy unless they challenge the structures and roles for women members internally.

If rights are not informed or premised on the basis of universal rights, then these will be dependent on the limiting reformist agenda of patriarchal impulses within culture and Islam, as described above. If we start accepting nonfeminist agendas and lack of active resistance to male domination as acceptable agency by women activists of religious parties, then what hope is there of even challenging the patriarchal elements within religious discourse? This proposal by the recent scholarship that rehabilitates Islamist politics in Pakistan defeats the activism of both Islamic and secular feminists alike.

It is not just a political aversion that impedes liberal and Islamist women from coming together on women's issues. Rather, the discourse of women's rights has become a competitive one, whereby most contestants

on the ideological spectrum attempt to appropriate the woman question as the marker or sign-post of their claim to political relevance. At least, the feminist agenda has been successful in making women's rights central to the debate, but whether this is helping the realization or furtherance of their rights is questionable.

Jamal suggests we avoid the "re-inscribing [of] a simple framework of universalism-versus-cultural particularity and instead attempt to understand [Jamaat women's] religious agency in their own terms as an unfolding universality . . . of the modern."[50] This is consistent with the unwillingness of post-9/11 scholars to comment on the political support and silence that Islamist women observe when violations of women's rights take place and if victims are perceived to have transgressed prescribed modes of acceptable Islamic behavior. The political record does not support the fact that Jamaat women priorities women's rights in spite of the transgression. Thus, privatization of women's empowerment, modernist or not, is a useful proposition, except it does not corroborate with the politically articulated record of religious political parties. In fact, precisely because it is on "their own terms," the agency of Islamic activist women contradicts and restricts other women's empowerment if its expression does not fit the religiously prescribed mold.

There is also no mention or supporting evidence in the research by Jamal or Iqtidar of whether these women challenge structural patriarchy beyond attitudinal defiance within the religious discourse. While they may personally defy male wishes and question decisions, their political activism, on the contrary, has only demonstrated in the Pakistani context a resistance to women's independent legal or public status thus far.

The political performances and activism of women of religious parties in Pakistan in the last decade is contrary to the hope invested in a faith-based progress on women's rights. If, as the new scholarship advocates, docility and limited mobility in male-dominated religious outfits qualify as viable acts of women's rights, then perhaps we can claim that women's potential for progress is high in Pakistan. However, it is not possible to measure such progress without devising a new set of indicators and indices. Meanwhile, according to any commonsensical[51] indicators, there is no reason for such optimism and hope. Increased cases of stoning of women, floggings, and beheadings, as well as a backlash in cities where women are increasingly harassed by vigilante groups of men in the universities and streets demanding women to cover themselves or remain indoors, are not signs of progress, presumably, by any definition.

So far, stoning and flogging is only known to take place in Taliban territory (with sporadic incidents spilling over into other areas) and is committed

by their militants. However, the backlash in other parts of the country of harassment and violence preventing women from being in public spaces or exercising choice is loosely being termed as "Talibanization." Talibanization is simply the colloquialism being used to refer to the growth of intolerance advocated in the name of religion, and that is attempting to violently prevent women's mobility and education, as well as targeting shrines or other perceived 'unIslamic' practices such as shaving beards or listening to music. This policy emerges not from the state, nor is it advocated only by the Taliban media; in fact, it is part of and supported by the discourse of mainstream religio-political parties, as well as noninstitutional piety movements. They reject the Taliban ethos as extreme and "unIslamic" but imbibe and promote many of the same principles packaged in a less extreme or dramatic version. Such programs that promote Islamic etiquette are also found in upper-class clubs and theocratic societies and public and private universities. Religious discourse has subsumed all other forms of theory, philosophy, and currency.

Regardless of the nature of leadership—be it a liberal Gen. Musharraf, or the earlier despotic Gen. Zia ul Haq—women have served as the ideological identity markers of the liberal or regressive potential of a regime. In political reality, they continue to lose the larger struggle for equal rights. Now, a defeatist academic proposal that attempts to seam together secularism with Islam, as a culturally viable project, relies on the agency demonstrated by the religio-political parties. This challenges the minimum expectation that equal rights for women and minorities should be a nonnegotiable determinant of political activism and citizenry. In the process, feminist politics is a price such a project is willing to sacrifice if it does not fit the cultural, spiritual, or political requirements of an increasingly conservative and anti-women agenda of the religio-political forces in Pakistan.

Notes

1. http://english.aljazeera.net/archive/2005/09/2008410112050342208.html.

2. These laws were passed in 1979 as part of Gen. Zia ul Haq's Islamization policy. The Zina Ordinance made adultery a crime against the state punishable by death and blurred the line between rape and consensual intercourse. Many hundreds of women have been victimized and jailed under this law. It has since been amended in 2006 under the Protection of Women Act.

3. In this essay, I refer to the women's movement through a more inclusive definition, which recognizes women activists across the board regardless of their ideological location on the political spectrum. In general, the activists with a consciously feminist orientation and involved in human rights–based work are referred

to (by the media, analysts, and in development literature) as "progressives" and "liberals," while the more right-wing women activists, usually associated with religious political parties, are perceived as "radical" and "conservative." Gen. Musharraf and his supporters positioned his rule as a "moderate" wedge between these two ends of the political spectrum.

4. Some of these debates are recorded in "A Five Year Report on Performance of Women Parliamentarians in the 12th National Assembly (2002–2007)," Naeem Mirza and Wasim Wagha, Aurat Foundation Publication, 2009.

5. This was the Pakistan Muslim League government under Nawaz Sharif (1996–1999).

6. Religious mentor/ leader.

7. The Jamaat e Islami was a reformist movement for Indian Muslims formed in 1941 that later went on to become a right-wing Islamic political party in Pakistan. Its mass base includes an educated middle class, and despite its ideologue for a gradual Islamization, the party never did well in any national election. For the 2002 elections, they allied with five other religio-political parties to form the MMA and, subsequently, formed part of the government.

8. Legal Framework Order (LFO) of 2002 indemnified Gen. Musharraf's coup and gave him an extension of five years as president among other constitutional changes.

9. Quoted in Nazish Brohi, "The MMA Offensive: Three Years in Power, 2003–2005," monograph by Action Aid, Pakistan, 2006, p. 58.

10. Mohammed Ali Jinnah (1876–1948) was the first Governor General and the Quaid or founder of Pakistan.

11. Afiya Shehrbano, "The Invisible Woman," *The News,* Karachi, April 21, 2005, http://thenews.com.pk.

12. Ahmed Rashid describes jihadi militants in Afghanistan as those who wage militancy so as to impose a new Islamic order by adopting the shariah or Islamic order not for the purpose of pursuing justice or any social benefits but as a means to regulate personal behavior, and a regime that sustains itself through punitive rule. Rashid describes this as a perversion of the original meaning of *jihad,* which during Prophet Muhammad's time was understood as the struggle to improve the self and/ or transform a corrupt society. The Pakistani secret service, military, and intelligence agencies invoke the notion of jihad as a holy war and use this as a training ethos and have historically relied on it as a metaphor for the struggle for the liberation of Indian-held Kashmir and against the communist occupation of Afghanistan. See Ahmed Rashid, *Jihad: The Rise of Militant Islam in Central Asia,* Penguin 2003, England.

13. The emergence of all these identity conflicts cannot be read in a historical vacuum. Many of the sociopolitical crises came to a head during this period but were in continuation of growing violence and conservatism that predate 9/11. The contention here is that during the Musharraf regime, the conservative elements and faith-based religious parties sought to expand their brand with renewed zeal in the wake of 9/11 and in an effort to reclaim and articulate all symbols and policies based purely on an imagined Islamic identity.

14. Feminists concerned with empowerment of their gender within a "rethought Islam" and involved in reinterpreting and re-examining a masculinist reading of the Quran (divine Holy Book of Muslims) and Shariah (Islamic law derived from the Quran) and compiled sayings of the Prophet of Islam, Prophet Muhammad. Riffat Hasan and Asma Barlas are well-known academics residing in the United States who fall into this category. In Pakistan, Islamic feminist scholarship is most often associated with Farida Shaheed heading the NGO, Shirkat Gah, and is a south Asian contact for the Women Living Under Muslim Laws network.

15. Farida Shaheed, "Women's Experiences of Identity, Religion and Activism in Pakistan" in *The Post-Colonial State and Social Transformation in India and Pakistan,* S. M. Naseem and Khalid Nadvi (Eds), Oxford University Press, 2002, p. 367.

16. With reference to women and Pakistan this literature includes my readings of Humeira Iqtidar, *Secularizing Islamists? Jamaat-i-Islami and Jama`at-ud-Da`wa in Urban Pakistan,* Chicago University Press, 2011, and Faiza Mushtaq, "A Controversial Role Model for Pakistani Women," *South Asia Multidisciplinary Academic Journal,* Thematic Issue Nb. 4: "Modern Achievers: Role Models in South Asia," http://samaj. revues.org/index3030.html. Others would include Sadaf Aziz, *Beyond Petition and Redress: Mixed Legality and Consent in Marriage for Women in Pakistan,* and Moeen Cheema and Abdul Rahman, "From Hudood Ordinances to the Women's Protection Act," papers presented at the 3rd Social Sciences Annual Conference at the Lahore University of Management Sciences, December 2007, which look to tackle the woman question from a new perspective located entirely within Islamic jurisprudence. Amina Jamal's work and doctoral thesis, similarly, explore the potential of a "balanced modernity" among right-wing women activists inspired by modern Islamic revivalism (see the bibliography for a list of her work).

17. For detailed critique on Islamic feminism in Pakistan, see Afiya S Zia, "The Reinvention of Feminism in Pakistan," *Feminist Review,* 91, South Asian Feminisms; *Negotiating New Terrains,* edited by Firdous Azim, Nivedita Menon, and Dina M Siddiqi, Palgrave Macmillan, London, 2009.

18. Farida Shaheed, *Gender, Religion and the Quest for Justice in Pakistan, Report for United Nations Research Institute for Social Development* (UNRISD) & Heinrich Boll Stiftung project on Religion, Politics and Gender Equality, Geneva, 2009, p. 37.

19. Humeira Iqtidar, cited in note 17.

20. See note 18.

21. By privatization of religion I do not imply that religious expression has therefore dissipated from the public. Instead, social conservatism has increased precisely because personal expressions of religion are influencing public articulations to the exclusion of other forms of sociability. This includes language, dress, and a general conflation of Islam with everything that has to do with "Arab-ized" culture as a conscious effort to counter south Asian (Indian) influences.

22. Discussion at a seminar, The 3rd Social Sciences Annual Conference at the Lahore University of Management Sciences, December 2007, Lahore, Pakistan. Qazi

courts would be presided by Islamist jurists or "qazis." Currently, Pakistan's judiciary runs on a secular model inherited from colonial India.

23. Amina Jamal, "Feminist 'Selves' and Feminism's 'Others': Feminist Representations of Jamaat-e-Islami Women in Pakistan, *Feminist Review*, 81, 2005, p. 19, www.feminist-review.com.

24. See note 7.

25. Jamal 2005, p. 17.

26. Ibid, p. 20.

27. Humeira Iqtidar, *Secularizing Islamists? Jamaat-i-Islami and Jama`at-ud-Da`wa in urban Pakistan,* Chicago University Press, 2011.

28. Iqtidar, cited above.

29. Ibid, p. 170.

30. Ibid, p. 163.

31. Saba Mahmood, *Politics of Piety; The Islamic Revival and the Feminist Subject,* Princeton University Press, 2005.

32. Iqtidar, cited above, p. 174.

33. Although there are plenty of cases in which the women members of religious parties such as the JI/MMA have taken outright antiwomen stands, the examples quoted here are deliberately chosen to acknowledge the agency of these women as claimed in the new scholarship. However, the point here is to highlight that even when this agency is seemingly neutral, it in fact supports and bolsters a patriarchal, discriminatory social, political, and economic order.

34. "A Five Year Report on Performance of Women Parliamentarians in the 12th National Assembly (2002–2007)," Naeem Mirza and Wasim Wagha, Aurat Foundation Publication, Pakistan, pp. 142–150.

35. "JI for Commission to Probe Jamia Hafsa Tragedy," 28 July 2008, *The News International,* http://www.thenews.com.pk/print1.asp?id=123312.

36. This is different from Humeira Iqtidar's suggestion that it is only a matter of "perception" that Islamist parties may be oppressive for some because others may feel liberated by joining them. The point here is that the agenda of such an ideology is to allow liberation only if the "freed agent" accepts an overall discriminatory or unequal framework. Quite different from the criticism that claims willing members are victims of "false consciousness," my point is that these members do accept the limited and unequal status of women and minorities by consciously justifying and rationalizing them within the modernist discourse.

37. The second wave of the women's movement in the 1980s and 1990s pivoted around a dynamic and sustained struggle against the military dictatorship of Gen. Zia ul Haq (1977–1988), who made women direct targets of a misogynist state under his purported Islamization project. The women's movement is acknowledged as perhaps the strongest challenger of this very politically and socially oppressive historical period.

38. Observation by renowned human rights activist and lawyer, Asma Jahangir, who is often at the receiving end of criticism and threats for exposing human rights

abuses, both those committed in the name of religion as well as by the state. She notes the wave of such accusations against her personally and against women activists who identify with a liberal politics within Pakistan has reduced considerably. Private conversation, March 2009, Lahore.

39. Amina Jamal, "Gendered Islam and Modernity in the Nation-Spaces: Women's Modernism in the Jamaat-e-Islami of Pakistan," *Feminist Review*, 91, 2009, Palgrave Macmillan, London, www.feminist-review.com.

40. Humeira Iqtidar, *Secularizing Islamists? Jamaat-i-Islami and Jama`at-ud-Da`wa in Urban Pakistan*, Chicago University Press, 2011.

41. Afiya S. Zia, "Challenges to Secular Feminism in Pakistan: A Critique of Islamic Feminism and Revivalism," Centre of South Asian Studies, University of Cambridge, UK, Occasional Paper No. 29, ISNN: 1476–7511, p. 14.

42. Nazish Brohi, *The MMA Offensive: Three Years in Power 2003–2005*, monograph by Action Aid, Pakistan, 2006, pp. 62–66.

43. A tribal assembly of male elders that resolves disputes through consensus. Jirgas are outlawed by the state but function effectively as a parallel legal system in tribal and rural areas and, increasingly, in urban pockets of Pakistan.

44. "State of Human Rights, 2005, Annual Report," Human Rights Commission of Pakistan, Lahore, Pakistan, Maktaba Jadeed Press, 2006.

45. Brohi 2006, p. 67.

46. Those sections of the Pakistan Penal Code that relate to offenses of murder and manslaughter were replaced in 1990 by the Qisas and Diyat Ordinance, which redefines the offense and its punishment in Islamic terms. *Qisas* is equal punishment for the crime committed; *diyat* is compensation payable to the victims or their legal heirs.

47. Crimes of honor are understood to flag a type of violence against women in its various manifestations from assault, confinement, and murder characterized by motivation rather than by perpetrator. Most often, women are victims of such crimes and are punished for violating or "shaming" a male relative's "honor" by exercising their agency through choice of marriage or perceived to transgress moral boundaries of gender relations as defined by male cultural norms.

48. http://www.thenews.com.pk/top_story_detail.asp?Id=4686. Also see a response to the debate on this issue by Afiya Shehrbano, "A State of Suspended Disbelief," in *Economic and Political Weekly*, 43 (23), June 2008, www.epw.org.in.

49. Huma Ahmed-Ghosh, "Dilemmas of Islamic and Secular Feminists and Feminisms," *Journal of International Women's Studies*, 9 (3), May 2008, www.bridgew. edu/SOAS/jiws/May08/Huma.pdf.

50. Amina Jamal, 2009, "Gendered Islam and Modernity in the Nation-Spaces: Women's Modernism in the Jamaat-e-Islami of Pakistan," *Feminist Review*, 91, Palgrave Macmillan, London, 2009, p. 26.

51. I refer here to Nivedita Menon's discussion on the particular and the universal. She problematizes the notion of what she calls "the myth of free will" and calls for the need of a "radical politics" that are "long term struggles to reclaim meaning at the level of common sense . . . to challenge local structures of power . . . the

family and other hegemonising institutions." She also points out the limitations of the law in dealing with "free will" and its "unfreedom," though she maintains that in democratic politics the notion of free will should be preserved for the right to proselytize and convert. Nivedita Menon, "Recovering Subversion: Feminist Politics Beyond the Law," Permanent Black, 2004, India, p. 216.

Bibliography

Ahmed-Ghosh, Huma. "Dilemmas of Islamic and Secular Feminisms." *Journal of International Women's Studies* 9, no. 3 (2008): 9–116.

Barlas, Asma. *Believing Women in Islam; Unreading Patriarchal Interpretations of the Quran.* Austin: University of Texas Press, 2002.

Brohi, Nazish. *The MMA Offensive: Three Years in Power, 2003–2005.* A monograph. Pakistan: Action Aid, 2006.

Iqtidar, Humeira. *Secularizing Islamists? Jamaat-i-Islami and Jama`at-ud-Da`wa in urban Pakistan.* Chicago: Chicago University Press, 2011.

Jahangir, Asma, and Jillani, Hina. *The Hudood Ordinances: A Divine Sanction?* Lahore: Rohtas Books, 1990.

Jamal, Amina. "Gendered Islam and Modernity in the Nation-Spaces: Women's Modernism in the Jamaat-e-Islami of Pakistan." *Feminist Review* 91, no. 1 (2009): 9–28. doi: 10.1057/fr.2008.43.

———. "Feminist 'Selves' and Feminism's 'Others': Feminist Representations of Jamaat-e-Islami Women in Pakistan." *Feminist Review* 81 (2005): 52–73. Available at http://www.jstor.org/stable/3874341.

Mahmood, Saba. *Politics of Piety: The Islamic Revival and the Feminist Subject.* Princeton, NJ: Princeton University Press, 2005.

Menon, Nivedita. *Recovering Subversion: Feminist Politics Beyond the Law.* India: Permanent Black, 2004.

Nadvi, Khalid, and Naseem, S. M. *The Post-Colonial State and Social Transformation in India and Pakistan.* Oxford: Oxford University Press, 2002.

Rashid, Ahmed. *Taliban: Islam, Oil and the New Great Game in Central Asia.* London: I. B. Tauris, 2000.

———. *Jihad: The Rise of Militant Islam in Central Asia.* London: Penguin Press, 2003.

Rashid, Tahmina. *Contested Representation: Punjabi Women in Feminist Debate in Pakistan.* Oxford: Oxford University Press, 2006.

Zia, Afiya Shehrbano. *Sex Crime in the Islamic Context; Rape, Class and Gender in Pakistan.* Lahore: ASH, 1994.

———. "Challenges to Secular Feminism in Pakistan: A Critique of Islamic feminism and revivalism." *Occasional Paper No. 29.* Centre of South Asian Studies, University of Cambridge, 2009.

———. "The Reinvention of Feminism in Pakistan." *Feminist Review* 91, no. 1 (2009): 29–46. doi:10.1057/fr.2008.48.

Periodicals and Newspapers

Dawn, Dawn Group of Newspapers, Abbas Nasir (ed.), Karachi, Pakistan, http://
 Dawn.com.
Economic and Political Weekly, http://epw.in/epw/user/userindex.jsp.
Feminist Review, Palgrave Macmillan, UK.
Journal of International Women's Studies, http://www.bridgew.edu/SoAS/JIWS/.
Newsline, monthly periodical, Rehana Hakim (ed.), Karachi, Pakistan, http://www.
 newsline.com.pk/.
The News International, Jang Group of Publishers, Mir Shakil ur Rahman (ed.),
 Karachi, http://thenews.com.pk).

Reports and Unpublished Papers

"The State of Human Rights in 2005, 2006, 2007." *Annual Reports by Human Rights
 Commission of Pakistan.* Lahore, Pakistan: Maktaba Jadeed Press.
"A Five Year Report on Performance of Women Parliamentarians in the 12th National
 Assembly (2002–2007)," Naeem Mirza and Wasim Wagha, Aurat Foundation
 Publication, Pakistan, 2009.
Cheema, Moeen, and Rahman, Abdul, "From Hudood Ordinances to the Women's
 Protection Act," papers presented at the 3rd Social Sciences Annual Conference
 at the Lahore University of Management Sciences, December 2007.
Hasan, Riffat Dr., "Islam and Human Rights in Pakistan; A Critical Analysis of the
 Positions of Three Contemporary Women," unpublished paper, 2002, http://
 www.mediamonitor.net/riffathassan1.html.
Mushtaq, Faiza. "Al-Huda: New Forms of Islamic Education." Paper presented at
 Miskeen Study Group, Karachi, Pakistan, 2007.
Shaheed, Farida, "Gender, Religion and the Quest for Justice in Pakistan." Report
 for United Nations Research Institute for Social Development (UNRISD)
 & Heinrich Boll Stiftung project on Religion, Politics and Gender Equality,
 Geneva, 2009.

Part III

Transnational Feminisms

Locating Muslim Women at the Crossroads

Chapter 9

From Dhaka to Cincinnati

Charting Transnational Narratives of Trauma, Victimization and Survival

Elora Halim Chowdhury

Introduction

This essay is part of a larger project in which I trace women's mobilization of the anti-acid violence campaign in Bangladesh. Elsewhere I have written about the story of Bina Akhter, a prominent survivor-activist of the campaign who was splashed with acid by a young man, Dano, in 1997. Naripokkho, a women's group in Bangladesh that works on gender violence and pioneered the anti-acid violence campaign there, provided assistance to Bina and her family, and Bina gradually came to join the campaign. Eventually, Bina came to the United States for medical treatment and reconstructive surgery. Her trip was sponsored by a U.S.-based NGO, Healing the Children, as well as Bangladeshi expatriates living in the United States. Naripokkho activists negotiated with the United States State Department, who agreed to sponsor 20 victims of acid attacks to come to the United States for reconstructive surgery on the premise that these women would return to Bangladesh upon the completion of their treatment and not apply for immigration to the United States. Bina, however, for various reasons, chose to apply for gender-based asylum and in the process lost support of both Naripokkho activists as well as their United States counterpart Healing the Children. Thus her status shifted from the recipient of humanitarian aid (read "good victim") to that of betrayer of the cause (subsequently, the eighteen other acid violence

survivors were not allowed to come to the United States for reconstructive surgery) and nation (the activists in Bangladesh saw Bina's actions as a national humiliation to their transnational feminist networking).

Bina's story allows for a discussion of the multiple dimensions one must attend to when designing programs that are meant to "aid" "third-world beneficiaries." These dimensions include global inequality, power relations between the North and the South, the control of agendas of humanitarian projects, and the limits of global feminism. Bina navigates the tricky waters of multiple and shifting subjectivities of victim, survivor, and activist, which are seen as mutually exclusive categories in international humanitarian aid discourses.

In this essay I want to draw attention to the importance of stories or testimonials in human rights campaigns, the construction of narratives in presenting experiential truths as well as in strategic mobilizing, and the ways in which human rights narratives contribute to both assisting and impeding transnational movement building. I draw on oral history narratives of Bina, which I documented over a span of ten years. I also use interviews with Naripokkho activists who worked closely with her in the campaign, as well as television and print media reports representing her story. The use of these narratives is an attempt to further discussions on transnational feminist praxis with regards to gender violence. It is not my intention to present any one narrative as "truer" or more authentic than the other, but rather to bring attention to the processes of narrative construction, interpretation, circulation, and reception and to demonstrate how all of these registers are imbued in power relations. Recognition of the multiplicity of interpretations of knowledge in itself does not change reality, but it can disrupt given analytic categories to open up new possibilities for political thinking and action. Furthermore, I deploy a transnational feminist analysis, which illuminates the far-reaching relations of domination and resistance in these everyday narratives.

Bina's Story

Bina has been alternatively spoken of as "victim," "survivor," "activist," and "angel of mercy" by various actors over the course of the anti-acid violence campaign. She has been praised as the "star of the campaign," admired and appreciated as a skillful leader, yet also referred to as "selfish" and deceitful by the same organizers. My purpose here is to explore the shifting contexts of her ever-evolving subject positions and how these defy categorical rep-

resentations. Her varying positionalities emphasize the need for a broader framework within transnational organizing to speak of victimized women's experiences and choices.

Speaking to the linguistic limits of "telling a woman's story of violence," Tami Spry makes the observation that terminology such as "victim" and "survivor" are inadequate and curtail the agency of women to make meaning of their complex experiences. These linguistic constructs govern the ways women can structure their own stories and hold women hostage to hegemonic categories of reference regarding violence—that is, "she is victim to it or survivor of it" (Spry 1995, 27). It denies women the capacity to define their experience in a more fluid way with "narrative agency" (Spry, 1995, 27). She urges feminists to move toward a more "liberatory epistemology" to talk about violence, one that will not freeze them in these given categories, which are perceived to be mutually exclusive. Such dualistic framings of women's experience of violence actually pit them as either "losers" or "winners," "weak" or "strong," and disallow tellings, which show women negotiating in their own terms the various constraints and opportunities to make meaning of their struggles. Using Judith Butler's theory of gender construction through performance, Spry urges feminists to conceptualize women's experience as constituted through shifts, multidirectional movements, and in dialogue with herself (Spry 1995, 32). Liberatory epistemologies, with all their contradictions and conflicts, can offer "narratives of knowledge" in our quest for decolonizing and creating oppositional knowledges.

In 2000, during the first year of her stay with her American host family, Bina applied for asylum status in the United States, thus defying the terms of her contract with Healing the Children. When a letter from the lawyer's office with the details of Bina's immigration application reached HTC, the sponsoring parties were upset. The expatriate Bangladeshis who had helped organize the sponsorship, HTC, and Naripokkho members tried to persuade Bina to rethink her decision. Naripokkho activists in particular even tried to persuade Bina to try other options for staying in America, such as applying for academic scholarships. Bina's relationship with both organizations became very contentious. One HTC staff member moved Bina and Jharna Akhter (the second survivor who accompanied Bina to the United States for reconstructive surgery, and who also applied for immigration) into her own house with the intention of sending them back to Bangladesh. According to Bina, they were not allowed to leave the house or talk on the phone. Both girls' passports were taken away by HTC staff. Bina described one difficult conversation:

They [HTC] asked me, 'why did you apply for immigration?' I said, 'I need security in my life. Here in the U.S. I can study, get a job and help my family. I love my life, and I want to be safe.' They said, Naripokkho informed them that I had lied about my situation in Bangladesh. That my family was not in any real danger. I said, 'I am not interested to hear what Naripokkho and others said about me. I don't want to hear about it.' I am sorry that because of what I have done, other girls cannot come to America for medical treatment. Because, our contract with HTC specified that we cannot stay here. I am sorry other people will be hurt because of what I did. But, I decided that I would not think about HTC, about Naripokkho, or other acid burnt girls. I did this for myself. When I filed for immigration, HTC informed Naripokkho. These two organizations had a lot of problems because the promise was broken, the understanding was broken. I did this for myself—I did not think of them. The contract was between the two organizations. I don't believe that I should be blamed for the terms of the contract and what happened to the other girls. I think they [the sponsoring organizations] did the *beymaani* [betrayal]. Thousands of people are coming to this country in various ways. What had I done that they had to prevent all the other girls from coming here for treatment? Why blame me? 'Whoever comes here will stay back,' they said! That's not true. Not everybody wants to stay here. I stayed because I had my own issues. HTC punished us by punishing all these other girls. Why should that be my responsibility? Naripokkho was angry with me because their campaign suffered. Everybody was doing business with me, using me. I am not a thing to do business with. Go everywhere and do interviews! I am not a toy. So, I stopped doing interviews.

The organizers of the anti-acid campaign believed that by staying back in the United States, Bina would (a) jeopardize chances of any other acid survivor to come to the United States for medical treatment; (b) be responsible for Naripokkho's loss of face in the national and international advocacy communities; and (c) betray the trust of the international community, which had come forth with assistance. Furthermore, in Bina's absence, a trial could not be held to prosecute her attacker, which activists of Naripokkho believed to be a serious setback in the acid campaign. Because Bina's story had received media coverage nationally and internationally, this trial would have been particularly significant for the larger campaign.

The Faces of Hope Story

One direct consequence of internationalizing the anti-acid violence campaign was the U.S.-based ABC network television report, "Faces of Hope" (1999), featuring the story of Bina Akhter's "arrival" in the United States. Connie Chung, a reporter, and Teri Whitcraft, a producer of ABC's "20/20," had traveled to Bangladesh to research a one-hour segment on acid violence. Various Western publications such as *Ms.* (1999) and *Marie Claire* (1998) and TV networks and programs such as CNN (1999), BBC (1999), and "The Oprah Winfrey Show" (1999) had already reported on acid violence in Bangladesh. Thus, although not the first program but influential nonetheless, "Faces of Hope" held the promise of generating further attention from the international community. Yet it is also crucial to remember that the use of personal narratives of suffering in mass media venues can both bolster and impede human rights campaigns by emphasizing certain aspects—for instance, sensationalizing "distant suffering" and implying that such suffering is a consequence of other inferior and foreign cultures—while obscuring others, such as the agency of local actors and contributions to "local" suffering made by global relations of power. A transnational feminist analysis of trauma narratives presented by such mass media venues therefore gives us important insight into the contradictory roles such narratives can play in human rights organizing.

In predictable ways, "Faces of Hope" deployed a victim-savior-savage prototype narrative in explaining men's acid throwing against women in Bangladesh. Moreover, by evoking images of burqa-clad women, the use of azan (the Islamic call to prayer) in the background, the presentation of the male perpetrators in prison as unrepenting yet diminished men, and the authoritative interviews with Western aid workers, the producers (even if unwittingly) make use of Orientalist rescue narratives concerning the Muslim woman as the ultimate victim subject, the Muslim man as the aggressor yet feminized, and Western humanitarian aid workers as the saviors.

The program presents Bina in America as finally "free" from the repression of her past. She is now ready to face anything. "As long as I'm here for the treatment, I'll be safe," she says. "If I were still in Bangladesh, I might have been kidnapped or killed by now." Chung's voiceover says, "For the first time in a long time, she wasn't afraid." We watch "Windy"—Bina's nickname among friends in Bangladesh for her athletic talents—running in slow motion on screen, and her voiceover of hope saying, "America is a big country. If we all work together and stand as one, we can conquer the world" ("Faces of Hope," November 1, 1999).

"Faces of Hope," then, imagined Bina as a grateful recipient of aid, and therefore a "good" victim. It indicated an inability to understand the lived reality of her situation or to see her as a complex subject who actually participated in the negotiations that brought her to Cincinnati. The program gave wide exposure to a critical human rights campaign, while simultaneously reproducing colonial images of victimized third-world women being rescued by benevolent first-world institutions. This narrative did nothing, of course, to challenge the historically asymmetrical relations of power and authority that usually frame such representations by Western media of the "third world," but instead re-inscribed such power dynamics. Bina's own role in shaping her future was obscured, as was the role of the advocacy work done by Naripokkho members.

Interviews with Bina reveal that she had declined an earlier offer of going to Spain for medical treatment because she had not felt ready. The decision to accept Shriner's Hospital's invitation was, thus, well thought out. By Bina's own admission it was the result of two years of work, mainly by Naripokkho activists, and not a sudden stroke of sheer luck. Bina chose to come to America, primarily for treatment for her damaged eye—and not to acquire "a new face," as the "20/20" report repeatedly emphasized. Surgery to restore the victim's "original face" seems to be the miracle cure offered by the West for which the victim has to physically leave the place of suffering and travel to the place of freedom. Other more pressing needs and wants that are prioritized by the survivors, such as employment and educational opportunities, are not mentioned at all in this report. The terms of Bina's "arrival," stay, and treatment, were also carefully dictated by the sponsors, and the hosts and were not altogether "rosy" as confidently predicted by the televised story. The fiery Bina Akhter, who spoke out against women's oppression, demanded justice from the government, and delivered impassioned speeches at women's rallies, was reduced to a childlike figure dazzled by America. At the end of the report, we hear Bina using the imperial language of "conquest"—"we can conquer the world"—as if to make her transfer and transformation to the "free world" complete.

In 2002, I had the opportunity to interview Teri Whitcraft, the producer of the ABC "20/20" segment, who explained some of the narrative choices for the segment:

> I was doing an Internet search one night on violence and social justice issues when I stumbled upon an article on acid violence against women in Bangladesh in *Ms.* magazine. I knew then that we had to do this story. Fortunately for us, we entered at a

moment when Bina was poised to leave for Ohio. Thus, we were able to film her arrival. This has been quite a journey for us and one that hasn't yet ended. We have continued to film various events in Bina's life. For instance, I sent a team for one of the first surgeries. We have so much footage. And, we plan to be there when Bina gets her citizenship. That's going to be the end. You see, a story such as this needs a proper ending. People want to know what happens to her, and we're going to be there till the end. (Teri Whitcraft, personal interview, November 23, 2002)

The producer's focus on Bina's citizenship as the "proper ending" to her story serves to draw the narrative focus of the anti-acid violence campaign away from the activism in Bangladesh and elsewhere to United States citizenship as the ultimate solution. It implies that Bina's story, like all good immigrant stories, ends with citizenship. The irony here is, of course, that the road to that citizenship is paved with many contestations, not the least of which is the United States' granting of a limited visa to victims of violence, and taking away that victim's right to treatment if she transgressed the strict codes governing the contours of her stay in America.

Scholars such as Schaffer and Smith (2004) and Wendy Hesford (2004) have developed definitions of life narratives that can help to contextualize the ways in which the international media contributes to spectacularizing "third-world violence," often in the service of generating public response, yet at the same time reinscribing problematic and simplistic generalizations. Schaffer and Smith (2004) define life narrative as a broad term encompassing a range of personal storytelling based on the experiential (p.7). Wendy Hesford (2004) locates the deployment of the genre of life narratives, or "testimonio," specifically within the transnational human rights movement. These testimonials, often by victims of gender violence in third-world contexts, play a key role in advancing an international human rights agenda by mobilizing diverse publics into action, even as they further romanticize spectacularized renditions of the speaking subject. Hesford (2004) cautions that scholars and practitioners must account for the "ungovernability of trauma and the methodological and ethical crises posed by its representation" (106). This means recognizing that documentations, interpretations, circulations, receptions, and representations of trauma narratives cannot be contained, and are always incommensurable. Hesford (2004) terms this instability of narrative genre a crisis of reference to mean "the inability of representation to capture, as in fix or make static, the truth," leading to difficulty in using these narratives within human rights campaigns to persuade legal and social

action (107). The mediated nature of life narratives or the intersubjectivity of them has pushed transnational feminist studies to consider not only the social location of the writer, or the "speaking subject," but also the circumstances in which the text is produced. The critical negotiation involved in the struggle within which trauma narratives are told, listened to, and interpreted occur within "available cultural and national scripts and truth-telling conventions" (Hesford 2004, 108). The discursive subjectivity and agency of the narrator, and the ethical responses the narratives evoke from diverse actors, are shaped within such rhetorical conventions.

While reports such as the "20/20" segment presented certainly catalyzed social and legal action (outpouring of support on behalf of Bina and Jharna; the endorsement of ABC journalists for Bina's asylum case in the United States), these are incommensurable narratives that are primarily about rescue and salvation. One might ask at what cost are these narratives publicly re-inscribed? Is there room to talk about internal struggles such as the ones that unfolded between HTC and Bina, or Naripokkho activists and Bina, in such narratives, and more generally within human rights narratives that so categorically imagine its victims and saviors? Even as such colonialist narratives are deployed by Western media with the effect of obscuring the power dynamics shaping transnational relationships, how might these same ungovernable narratives also open up space for transgressions?

Furthermore, the individual emphasis in human rights narratives in the Western context is also connected to the rise of global capitalism, which champions individual rights and uniqueness. For instance, sensationalized stories of individuals triumphing over their sufferings, such as the one furthered by the ABC "story of arrival" and later plans to culminate a report with the "proper ending" of Bina's American citizenship, have been endlessly popular in media circuits. These frames have been harnessed by transnational actors, including human rights NGOs, to package their own campaigns and agendas.

Of particular interest to this discussion are the ways in which "distant" narratives of trauma and suffering are mediated within international human rights regimes, as are the strategies and methodologies that render intelligible the experiences of "foreign subjects" in local and transnational sites. Pointing to the success of linking local campaigns of gender violence to transnational movements of human rights, Schaffer and Smith (2004) remind us that, "In these instances, transits between the local and global and within pockets of modernity involve complex negotiations of traditional and modernist discourses and practices. In other instances, stories may be framed within traditional, communal, religious, or philosophic frameworks different from,

but arguably consonant with, modernist aspirations for human dignity and social justice" (17). In other words, trauma narratives located at the intersection of local and global spaces might rely on "common sense" scripts but also throw into crisis existing paradigms of cross-border communications.

These narratives, then, hint at the paradox of representation for human rights activists, what Wendy Hesford (2004) calls the dilemma of speaking or staying silent, given the mixture of empowering and voyeuristic elements of these actions. One has to recognize the role reports such as "Faces of Hope" serve in raising awareness and generating support for campaigns against gender violence, and even providing opportunities for victims and activists to state or overstate their own particular angle in order to further just one aspect of transnational campaigns, which are inevitably multifaceted. This positive dimension is achieved, even as the overall narrative of such Western media representations tends to reinforce reductive Orientalist categories. Weaving together the multiple narratives of Bina, Naripokkho, and the Western media's versions of the anti-acid campaign can offer such a necessary disruption that does not claim any one as more true but points to the complex rhetorical and negotiation processes entailed in the telling and remembering of events/lives.

I do not mean to overstate the importance of the "20/20" report, nor deny that audience readings of it can be multiple. The "20/20" report appeared among a host of news reports in the United States following Bina's "coming to America" story, all of which came at it from similar angles. For instance, the *Cincinnati Enquirer* credited Healing the Children as "an international charity that seeks high-tech care for children from developing nations" (Bonfield 1999). The *Honolulu Star Bulletin* described it as "hard to look at Bina," the "subject of a fascinating story" who had acid thrown at her while "asleep one night in [her family's] Bangladesh hut" (Chang 1999). The *Cincinnati Post* quotes Bina from the ABC news program as saying, "From the moment I arrived in Cincinnati, I felt like I had stepped into a dream world," and notes that the "women are already gaining a sense of hope from just being in the United States" (Conte 1999). The article goes on to explain, "In Bangladesh, women generally survive through the support of husbands, and these women are typically doomed to a life of extreme poverty." Stories of acid victims have continued to appear in the American press with titles such as "Victims of acid attacks find new life in the West," and "Fort Myers surgeon lends skills to repair Third World Horrors" (Wu 2002).

While it may be true that coming to the United States offered Bina certain opportunities, it is also true, as I learned from Bina's story over the years, that such an "arrival" is riddled with contradictions of loss as well as

gain. Lost in this portrayal of the grateful Bina are her day-to-day negotia-
tions of adjusting to a new life that on one hand promised a recovery but on
the other expected obedience to cultural traditions that were not her own.
For instance, the young women were not allowed to cook Bengali foods in
the house, nor go to the local mosque where they wanted to connect with
other Bengali Muslims. Again, Bina's own story suggests that obedience is
often a result of fear and desperation because survivors have nowhere else
to turn in a foreign country. For instance, Bina admitted that she had no
choice in attending church services and enrolling in Christian education
classes because her medical treatment depended on adhering to HTC, and by
association her host family's, rules. Because Healing the Children espoused
Christian values, they placed the survivors in the homes of a family who
expected boarders to abide by those same standards. At one point, this family
was even pressuring Bina and Jharna to convert to Christianity. When Bina's
actions turned her in to a "bad victim," she was in a manner of speaking
"kidnapped" from her so-called place of safety (home of the host family) and
held in the home of the HTC staff member who tried illegally and against
Bina's will to return her to Bangladesh, which would have ended her medical
treatment. This is different from the story of benevolence, which does not
fit neatly into the paradigmatic representations of survivors and their advo-
cates, particularly ones that come from the other side of the global divide.
Indeed, as Hesford (2004) has explained, this version of the story is what is
lost in the crisis of reference and the crisis of witnessing in such narratives
as spun by the "20/20" report. Also neglected throughout the course of the
campaign was Bina's own agency and shifting sense of self.

Naripokkho's Story

Naripokkho's work related to the acid campaign saw significant shifts in
the years following Bina Akhter's departure for the United States and the
establishment of the Acid Survivors Foundation. Paying close attention to
its narrative allows us to further complicate an understanding of transna-
tional human rights movement dynamics, and to observe the effects "back
home" of the process that Friedman (1999) has called "transnationalism
reversed." This section weaves together the at-times dissonant voices of dif-
ferent activists involved in the campaign, and thereby continues to point to
the partial, contingent, and constructed nature of narratives this essay wishes
to illuminate. Simultaneously, it offers a critique of some of the organiza-
tion's strategies and vision deployed with regard to empowering survivors

of acid violence. One of the key organizers of the campaign explained the fallout surrounding Bina's decision to apply for gender-based violence as follows:

> A very important part of the agreement with HTC however was that none of the girls could stay back in the U.S. If they did, it would terminate the program there and then. This was an agreement with the U.S. State Department for acquiring the requisite visas for the survivors. The expatriate Bangladeshi sponsors had put their own names on the agreement, they had given their personal assurances to the sponsoring agency. This [some survivors staying back in the U.S.] had always been a concern—however, I just didn't expect it to be the first two! In fact, when the Bangladeshi expatriate sponsors were trying to enlist others from the larger Bangladeshi community, some people said, 'how do you know that people will not throw acid on themselves just to have the opportunity to come to America? How do you prove a case is genuine?' But the sponsors disregarded those concerns. (Khan, personal interview, April 14, 2003).

Ms. Khan had been in a particularly tricky position, being the key liaison among all the actors: the expatriate Bangladeshi community that mobilized sponsors in the United States, the attendant organizations that sponsored the acid victims for treatment, Naripokkho organizers, and the survivors. The fallout occurring among all of these parties left her understandably frustrated and angry. Her comments above, however, are revealing for us as we come to see the various power structures that were navigated in this campaign: for instance, it was the United States State Department that laid out the terms of the contract, and we might also critique the class-based assumptions of the Bangladeshi community that people in Bangladesh would be willing to self-inflict acid injuries just for an opportunity to immigrate there. It should also be acknowledged that Naripokkho's subsequent virtual withdrawal from the work that it initiated is not unprecedented in studies of intra-organizational dynamics in women's advocacy groups. For instance, Honor Ford-Smith (1997), a member of the Sistren Collective, an organization in Jamaica that worked with women both culturally and politically, describes the crossroads that members of well-intentioned women's groups often encounter. Despite goals to work in the interest of social justice, women's groups can operate within, or reenact themselves through, historically determined power relations in new forms. As she has argued, colonial

narratives often work to regulate the production of the unwitting "development worker" in the image of the missionary (Ford-Smith 1997).

Later Ms. Khan relayed the following story:

> When I heard about Bina's plan to seek asylum, I called her. She gave me all sorts of excuses. She did the same to her host family, telling them that her family was in danger in Bangladesh. What danger? If her family was in danger, how come Mukti [Bina's cousin who had been the target of the acid attack that left Bina burnt, and who now worked at ASF] was going to work every day? If you come to think about it, nobody is "safe" in Bangladesh. There is so much crime here. Bina's family is in no more danger than the next person. I just said one thing to Bina: that she would be responsible for stopping the treatment of 18 girls. The next day, her host family called and accused me of shouting at Bina. They said she was very upset. I told them I had not shouted at her. "Is she lying to us then?" they asked me. I told them, "We are the people who sent her." They were yelling at me! My son was in the next room, and when he saw how upset I was he asked, "Why are you still talking to them? You have done enough for these girls." (Khan, personal interview, April 14, 2003)

Having access and connections to the medical community in the United States, Ms. Khan was able to mobilize a sizable expatriate initiative to help Bangladeshi survivors of acid attacks. This, as she points out, had been a risky initiative with the ever-present possibility of someone along the way defecting and thus jeopardizing the entire program with the possible humiliation of the organizers among an international community. When precisely that happened, the organizing group dissolved, turning accusatory eyes on those who needed their assistance. Ms. Khan and her fellow organizers spoke from a position of economic and social privilege when they speculated that the girls need not have applied for asylum because there was no real danger facing them in Bangladesh, or when they debated whether poor Bangladeshis were desperate enough to douse themselves with acid in order to avail themselves of opportunities to go to America. Having "done enough for these girls," in the formulation of Ms. Khan's son, they were able to withdraw from the acid violence work altogether. It was hard for them to accept Bina's disobedience to the rules of the agreement, not unlike the response of HTC.

This turn of events illuminates both the inter- and intra-national cultural differences within women's organizing. In a conversation with Jenny Sharpe (2003), Gayatri Spivak shows how international civil society crosses borders in the name of "woman," and prescribes policy on development and human rights, which they profess to be for the benefit of the lowest strata of those living in the developing world. The reality on the ground, however, is quite different. In this instance, the international collaboration resting upon a United Nations mandate (the acid campaign in Bangladesh was supported by UNICEF as part of their work to carry out the mandates of the Beijing Platform for Action, 1995) for helping victims of violence enabled Naripokkho members to organize a pipeline of twenty acid survivors to go for medical treatment to America. When the pipeline fell through, the euphoria and enthusiasm of the activists dissipated along with their interest in supporting the "lowest strata," in this case the survivors of violence, because of a failure, I would argue, to understand the realities of the survivors' lives on the ground. It is not my intention here to pass judgment on Bina's or other Naripokkho members' actions and decisions. However, at the end of the day, it is she (and the eighteen survivors who were not able to go to the United States for treatment) who bore the most painful consequences of the inter-national and intra-national negotiations.

This hierarchical scenario is recognizable in the "dissolution" of Naripokkho's involvement in acid work, which I contend occurred not simply because of the emergence of the better resourced Acid Survivors Foundation funded by international donors, but rather, as a result of other interconnected events as well. Bina Akhter, the so-called "grassroots" beneficiary and activist, had provided currency to the organization and helped bring unprecedented national and international support. When she had ceased to be "grassroots," she also lost the nurturing relationships with both her sponsor, Healing the Children (and by association ASF, CIDA, and UNICEF), who had found the measurable product of their work in Bina, and with her mentors at Naripokkho, who had found in her the star of their campaign.

At different points in the campaign, then, we have seen the various participants use a particular subjective narrative to bolster and/or subdue certain goals, whether for the greater good of the individual or the group as a whole. The disagreements between Bina, Western NGOs, and Naripokkho activists are certainly cases in point. It is important to recognize the different parties' diverse understandings of their choices, in order to illuminate the multilocational complexities of gender violence as revealed in the contesting narratives of this campaign. It is this dissonance—the tension, ambivalences,

and outright conflicts—that are so important in stories of transnational femi-
nist praxis. They are stories often not told, or analyzed, within feminist schol-
arship, but doing so leads us to a more realistic understanding of feminist
organizing.

The differences in Bina's, ABC Network's, and Khan's versions of the
story show how human rights narratives in the service of mobilizing cam-
paigns are subject to multiple renditions and contingent on the prevailing
discourses of the locations in which they circulate. For instance, the "local"
discourse of Naripokkho activists revolves around the losses that the cam-
paign as well as individual activists suffered, and the organizational in-strug-
gles. On the other hand, the circulation of Bina's story among the media
and NGOs in the United States has concentrated on the potential dangers to
Bina's family, and the need for medical services, which the United States can
provide. These became contesting narratives of the transnational campaign.

Furthermore, stories of the survivors' experiences were to be central
in both local and global actors' development of strategies to respond to
gender violence. This was reflected in the way each group, particularly Nari-
pokkho, aspired for the survivors' experiences to unfold in the spectrum of
victim-survivor-activist roles. Specific value was attached to women's—and,
in this case, victims of violence—ability to speak and act for themselves as
a symbol of personal transformation and empowerment. On the other hand,
the international media representations offered a rescue narrative, in which
victims also became agents capable of action and speech, but only once they
were extricated from local oppression through Western intervention (we saw
this in the manner in which Bina's travel to the United States was cast as a
"story of arrival" by various Western media reports). The act of speech by
the (victimized) woman, then, is crucial to both the local and global visions
of empowerment. In complicated ways, both these logics share a material
and symbolic economy of patronage—a transactional system in which the
woman rescued is always a client—never co/eval in these efforts of "empow-
erment." To illustrate with an example, I highlight a conversation with Bristi
Chowdhury, an activist from Naripokkho, regarding the "transformation"
that was key to Naripokkho's vision for acid survivors. She explained:

> I think becoming a survivor is a process. You travel a long road.
> A person goes through stages of denial, depression, of not know-
> ing if they want to live or die. One doesn't immediately become
> a "survivor" the day of the event. The second time I saw Bina at
> DMCH she was sitting up on the bed and smiling. The bones on
> her forehead were visible, but she was smiling. This is a survivor.

Becoming a survivor involves a complicated emotional process. She was no longer a victim. She didn't kill herself, or lie down and die. Of course, she required help as most of the girls do. It is possible for them to slip into depression but they get over it. There was a day when I visited Bina at DMCH when she threw herself on the bed and wept, she wanted to die. But she didn't. The fact that you decide to get up everyday and get on with it means that you are a survivor. That you choose to believe that there is still meaning to your life whether or not you have a perfect face. A victim on the other hand lies down and says, "My life is over. I will never live. There is no point to my being." Something terrible happened to the girls. What the guys did to them is vile but the girls refuse to be victims. We have to acknowledge that refusal. Look at Nurun Nahar [referring to a survivor turned activist of anti-acid violence campaign]. It is not in her nature to be a victim. If you ask her, she'll say "I went to school, got a job, got a counseling diploma—so what makes me a victim?"

Chowdhury's comments illustrate her organization's view of the ways in which survivors go through their own internal emotional shift from victim to survivor. However, this view—not unlike the Western rescue narrative, but minus the travel westward—is still mired in a linear understanding of the transformation that victims of violence experience, and a certain assumption that victimized women are able to exert agency merely through the act of speech. Indeed, the same logic inheres in the use of individual narratives of suffering in activist circuits as alluded to earlier in the discussion of the deployment of stories of trauma in mobilizing human rights campaigns. It is Bina's arrival to the United States and the perceived "freedom" she acquired by doing so that was emphasized in the various global media reports. In their essay "Survivor Discourse: Transgression or Recuperation," Linda Alcoff and Laura Gray (1993) draw upon a Foucaldian analysis to demonstrate that while speech can be seen as a locus of power in movements of social change, it also stands the risk of submission by being inscribed into hegemonic structures. Therefore speech that aims to resist and transform existing power relations cannot automatically be read as liberatory. What then, we might ask, are the implications for survivor discourse, particularly within transnational circuits? At the very least, recognition that human rights life narratives can be both recuperative and transgressive of hegemonic norms, and an admission of that which is "stateble" and not necessarily that which is the "truth." Alcoff and Gray

(1993) conclude that "arrangements of speaking" need to be transformed such that spaces are available for women to be "witness and experts, both reporters of experience and theorists of experience. Such transformations will alter existing subjectivities as well as structures of domination and relations of power" (282). Rigid categorizations of victim and survivor, the movement of individuals from one category to another, such as the victim turned survivor, or the survivor turned activist, cannot do justice to the multilayered, overlapping, and shifting positionalities of women who were part of the transnational anti-acid campaign. In light of Alcoff and Gray's analysis, it seems more appropriate to read Bina as witness—as both experiencing and interpreting her life events, and not as linearly progressing from a victimized state to that of a survivor or activist. Similarly, this analysis calls for the language for women to better express their capacity to transgress the fixed roles of the good and obedient victim/survivor to influence more nuanced understandings of their experiences of violence and agency. This might also free Bina from being interpreted alternatively as the "good" and "bad" victim/activist by campaign members on both sides of the geographic divide, and potentially recognize that her (Bina, as well as other women survivors/activists of violence) actions and subject positions are contingent on various shifting circumstances.

Furthermore, as Marnia Lazreg (2002) has argued, speech serves as the privilege signifier of empowerment within development discourse (and global feminism, I would add), through which primarily "third-world" women are brought into "modernity," "action," and "agency," often by the already modern, active, first-world agents. Thus, structurally, these progress narratives are positioned such that they transmit powerful values of Western-dependent development and global feminism. As part of civil society, these narratives have enforced the shift from viewing women as beneficiaries to participants in development. The subject status of "Other" woman participants in global feminist schemes is governed by a powerful script of confessional narrative modes. Transforming women's lives into discourse, these stories assign to their speech the sign of "empowerment" and describe women's survival stories as linear processes of victimhood to empowerment. These primarily individualistic and heroic narratives are recognizable in global feminist discourse as interchangeable across geographic locations. Gayatri Spivak, for instance, in an interview with Lyons and Franklin (2004) adds a cautionary note regarding the use of testimony/institutionalized truth telling within human rights praxis, calling it "a literalization of a Christian model" (206). Alcoff and Gray (1993), and Hesford (2004) in turn suggest that we recognize that the confessional mode implies an "objective" listener being confessed to—in the case

of feminist transnational work of the kind we are talking about here, this is often the "savior" entity—the elite activist, or the Northern based researcher whose own subjectivities in reinterpreting the "confession" gets obscured in the equation. Instead of the "confessional mode," these scholars encourage us to think of survivors as witnesses, or subjects who experience and interpret their life experience in acts of self-and-knowledge creation.

It is the absence of this concept of role fluidity and a level of unacknowledged privilege among some Naripokkho activists that contributed to positioning the survivors and the activists of Naripokkho in a patron–client relationship, contrary to their egalitarian vision. For example, when Bina ceased to be the "good victim" by breaking the sponsoring organizations' rules, she was not treated as an agent who made the choice that she deemed as best for her. Rather, HTC, the American partner organization of the acid campaign, withdrew their support of the broader campaign and wanted to immediately send Bina and Jharna back to Bangladesh. And Naripokkho activist Ms. Khan's response was territorial when she said to Bina's host family, "We are the people who sent her." Similarly, Bristi Chowdhury's response was to suggest that Bina had not been properly groomed to be an activist, and that she was selfish and childlike. Neither Khan nor Chowdhury interrogate their differential positions that may lead them to come to different decisions and priorities in life and instead dismiss Bina's concerns about her and her family's long-term security in Bangladesh. Nor do they reflect on their own infantilization of Bina—attributing her choices to a childlike selfishness.

The trouble with the dualistic framing of women's experience of recovery from violence in terms of victim/survivor or survivor/activist is that it assumes a linear progression from one to another, often signified by the culminating achievement of agency, when victims speak for themselves. This does not allow for complex narratives to emerge, in which a woman can be all of these things at the same time, or to shift from one subject position to another while negotiating her own terms. This is why it is important to hear the more complex stories of the individuals involved.

In comparing the multiple narratives of the anti-acid campaign, we see how Bina's and Naripokkho's more complex and ambiguous stories were transformed by the Western media to a heroic "rescue narrative," in which Bangladeshi women activists are aided by Western benefactors in their struggle for gender justice, and victims of gender violence acquire "freedom" by arriving in the United States. In addition, we also see that Naripokkho activists, including Bina, strategically used the dominant rescue narratives in furthering both their own campaign and members' own individual agendas.

The use of these narratives at times bolsters the mobilization of transnational forces, and at other times impedes the autonomy and agency of local actors. By disrupting the victim/survivor, victim/activist, Western benefactor/third-world victim, researcher/researched binaries, we move closer to a different kind of (self-) knowledge about women's experiences of violence and the ways in which we come to learn about them in diverse contexts.

Bina's role as the "self-serving" survivor had defied the sociocultural perceptions of a "good" victim that are often perpetuated through transnational feminist organizing. Powerful assumptions of womanhood and class-based directives of "appropriate" female behavior governed the movement actors' understandings and expectations of how a "good victim" should act. Naripokkho campaign leaders' indignant responses to Bina were also reflective of their disapproval of her disobedience as well as of the fact that her action jeopardized other survivors' medical treatment. In the process, Bina's complex agency, including both complicity and resistance, were undermined. Also missing in these responses by NGOs and activists alike is an understanding that women who form alliances in transnational movements are differentiated not only by the North–South global divide but also by the South–South class divide.

Bibliography

Alcoff, Linda, and Laura Gray. "Survivor discourse: Transgression or Recuperation?" *Signs* 18, no. 2 (1993): 260–290. doi: 10.1086/494793.

Bonfield, Tim. "Women Burned in Acid Attacks to Get Care Here." *The Cincinnati Enquirer.*http://www.enquirer.com/editions/1999/08/15/loc_women_burned_in_acid.html. Last modified August 15, 1999.

Chang, Diane Yukihiro. "One Woman's Lesson on True Beauty." *Honolulu Star-Bulletin.* http://archives.starbulletin.com/1999/06/21/editorial/chang.html. Last modified June 21, 1999.

Chowdhury, Bristi. Personal Interview. March 9, 2003.

Conte, A. "Shriners to Treat Acid-Attack Victims." *The Cincinnati Post.* http://www.cincypost.com/news/1999/acid102999.html. Accessed August 3, 2005.

Ford-Smith, Honor. "Ring Ding in a Tight Corner: Sistren, Collective Democracy, and the Organization of Cultural Production." In *Feminist Genealogies, Colonial Legacies, Democratic Futures,* edited by M. Jacquie Alexander and Chandra Talpade Mohanty, 213–258. New York: Routledge, 1997.

Friedman, Elisabeth. "The Effects of 'Transnationalism Reversed' in Venezuela: Assessing the Impact of UN Global Conferences on the Women's Movement." *International Feminist Journal of Politics* 1, no. 3 (1999): 357–381.

Hesford Wendy. "Documenting Violations: Rhetorical Witnessing and the Spectacle of Distant Suffering." *Biography* 27, no. 1 (2004): 104–144. doi: 10.1353/bio.2004.0034.

Khan. 2003. Personal Interview, April 14.

Lal, Jayati. "Situating Locations: The Politics of Self, Identity, and 'Other' in Living and Writing the Text." In *Feminist Dilemmas in Fieldwork,* edited by Diane L. Wolf, 185–214. Boulder, CO: Westview Press, 1996.

Lawless, Elaine. *Women Escaping Violence: Empowerment through Narrative.* Columbia, MO: University of Missouri, 2001.

Lazreg, Marnia. "Development: Feminist Theory's Cul-de-Sac." In *Feminist Post-Development Thought: Rethinking Modernity, Post-Colonialism, and Represen-tation,* edited by Kriemild Saunders, 123–145. London: Zed Press: 2002.

Lyons, Laura, and Cynthia Franklin, C. "'On the Cusp of the Personal and the Impersonal': An interview with Gayatri Chakravorty Spivak." *Biography* 27, no. 1 (2004): 203–221. doi: 10.1353/bio.2004.0038.

Nahar, K. 2003. Personal Interview. April 11.

"Queen Elizabeth Honours Director of Acid Survivors Foundation in Bangladesh." *The Daily Star.* http://www.dailystarnews.com/200206/18/n2061808.htm. Accessed June 10, 2002.

Razack, Sherene. *Casting Out: The Eviction of Muslims from Western Law and Politics.* Buffalo, NY: University of Toronto Press, 2008.

Schaffer, Kay, and Sidonie Smith. *Human Rights and Narrated Lives: The Ethics of Recognition.* New York: Palgrave Macmillan, 2004.

Sharpe, Jenny. "A Conversation with Gayatri Chakravorty Spivak: Politics and the Imagination." *Signs* 28, no. 2 (2003): 609–627, http://www.jstor.org/stable/10.1086/342588.

Spry, Tami. "In the Absence of Word and Body: Hegemonic Implications of 'Victim' and 'Survivor' in Women's Narratives of Sexual Violence." *Women and Language* 22, no. 2 (1995): 27–32.

Stiles, Kendall. *Civil Society by Design: Donors, NGOs, and the Intermestic Development Circle in Bangladesh.* London: Praeger, 2002.

Stone-Mediatore, Shari. *Reading Across Borders: Storytelling and the Knowledges of Resistance.* New York: Palgrave Macmillan, 2003.

Welch, L. "Uppity Women." *Ms. Magazine Online.* http://www.msmagazine.com/jun99/uppitywomen-jun.asp. Last modified June 1999.

Whitcraft, Teri., Connie. Chung, and J. Ford, J. "Faces of Hope." ABC News "20/20" television broadcast, November 1, 1999. New York: American Broadcasting Company.

Whitcraft, Teri. Personal Interview. November 23, 2002.

Wu, Elizabeth. "Splash of Death: Victims of Acid Attacks Find New Life in the West." *CityBeat* 8, no. 22 (April 11–17, 2002).

Chapter 10

Governance Feminism's Imperial Misadventure

Progress, International Law, and the Security of Afghan Women

Cyra Akila Choudhury

Abstract

After the September 11, 2001, attacks and the subsequent U.S. engagements in Afghanistan and Iraq, the question of how to "help" Muslim women progress toward greater liberty and rights has become a near obsession. The plight of Muslim women as victims of their religion and their hyper-patriarchal menfolk has become such common knowledge that it can barely be refuted. There are many obvious reasons why Americans have become so intimately familiar with the Orientalist stereotypes, the burka, and Islamic punishments. Liberal feminists in legal academia and practice, particularly governance feminists, have not been silent in this discussion, nor have they necessarily drawn a nuanced picture about the situation of women in the "War on Terror." In Afghanistan, the construction of women as abject victims has yielded positive results in both garnering international funding and foreign policy responses. In this essay, I examine from a theoretical perspective, the liberal feminists who consider religion and culture as obstacles to achieving women's equality and rights. I explore the linkages between Liberalism's troubled history with Universalism, rights, and progress with governance feminism. Second, I examine the problems that result from this theoretical position: the reliance on victim subjects that have resulted in fractured transnational alliances and governance feminism's support for international intervention that ignores the victimization of men and its effects on women's security.

As the United States prepares to leave Afghanistan after over a decade of military intervention, the question of how the withdrawal will impact Afghan women is on the minds of a great many. In particular, those groups that have worked on Afghan women's rights stand to see their gains evaporate if the Taliban return to power. While at the onset of the war, a multitude of voices joined the throng of "experts" on Islam, including conservative Islamophobes, liberal feminists, and elite, Western-trained Muslim women themselves relying on their identities to provide credibility to their claims,[1] only the ardent few remain in the arena. By now, the cynical use by the Bush administration of women's rights as a justification for the war has been thoroughly interrogated and rejected. Indeed, hindsight allows for a modicum of reflection on the feminist theoretical armature, the instrumental uses of feminism, and the reality of Afghan women's lives in this conflict.

This essay looks back on the experience of transnational feminist advocacy for Afghan women and critically assesses some of the difficulties with the legal governance feminists[2] approaches to women's rights in the country. I argue that governance feminism partakes of Liberalism's troubled theoretical aporia with regards to imperialism and universal rights. Because of this weakness, with a linear view of progress and adding its own notion of male dominance, governance feminism is unable to fully appreciate the dark sides to its women's rights projects.

To lay the groundwork for my critique, I briefly examine the liberal philosophical underpinnings of these scholarly and activist projects in Part I. The aim here is to reveal how Liberalism and governance feminism advances a particular idea of human flourishing that seeks to ultimately "reform" out of existence those life forms (including traditional Islam) that do not comport with it. I underscore the fatal flaw in Liberal ideas of history and progress and examine how Liberalism's justification for colonialism has become sublimated in governance feminism, which subconsciously continues traditional liberal political theory's judgments about the "East." I suggest that most governance feminists also have a specific idea of women's flourishing that prevents them from fully comprehending Muslim women who choose to adhere to Islam, which is, in their view, a hopelessly patriarchal and gender-oppressive religion—as they all are.[3]

In Part II of the essay, I offer examples of Muslim women's visions of flourishing that show that although they overlap with liberal values they also diverge in significant ways. I propose that when Muslim women articulate the importance of adherence to religion it ought to be accepted as legitimate expressions of their priorities and desires even if we, as Western feminists, are skeptical about the freedom of their choice to not conform to the Liberal order. I urge feminists on both the left and the right who

have continued to be extremely incredulous about Muslim women's choices to live according to Islam, to re-evaluate and see these women as exerting power and agency in their own lives.[4] Nevertheless, it is a reality that in Muslim-majority countries women are facing an uphill struggle for gender justice, and transnational efforts on their behalf may be of help. The question is how best to go about assisting these projects. After more than two decades of transnational activism, it is worth examining the dark side of the strategies used by activists.

Both women's organizations in the Muslim world and Western organizations strategically deploy victimization to gain support from resource-rich first-world organizations and to mobilize their constituents. There are costs to reducing women to their subordinations, even as there are benefits. One cost is the broken alliances that result from misrepresentation, and another is the looming threat of armed intervention justified by violation of women's rights. In Part III, I assess these costs. First, I examine the split between organizations from the Global North and South at the Beijing Women's Conference to show how women's agendas originating from the South can be decentered by more powerful Northern interests. I then discuss the interactions between the Revolutionary Afghan Women's Association ("RAWA") and the Feminist Majority Foundation ("FMF") and highlight the ways in which transnational feminist activism is based on the victim subject to underscore how this results in estrangement between otherwise natural partners. Second, I examine the governance feminist arguments for the use of international law to address Muslim women's issues. I argue that the use of international law to legitimize various interventions has partaken of the narratives of powerlessness and exacerbates that very powerlessness that its proponents seek to remedy. I suggest that such armed interventions should be treated with skepticism at the least and should more thoroughly interrogated and, if possible, eschewed for more peaceful alternatives. Finally, I conclude with some thoughts about the use of the state as a tool for achieving feminist goals. I argue that the calls for continued state intervention to secure women's legal rights is problematic because of the limits of rights as well as the overreliance on the punitive structures of the state rather than its redistributive ones.

Liberalism's Daughter: Governance Feminism and the Narrative of Progress[5]

Third-world, critical-race, postcolonial feminists as well as other strands of "outsider" feminists have critiqued mainstream, middle-class Western

feminists for their imperialism. It is not my intention here to restate that critique. Rather, I want to draw some linkages between governance feminism and Liberal theory to suggest that we treat the narratives of progress and history contained in both with skepticism. However, it is important to clarify the terms I use and what and whom they describe. When I refer to dominance feminism and governance feminists, I am referring primarily to second-wave legal feminists who share Liberalism's political agenda of individual autonomy, equal rights, and a commitment to liberal democracy as well as a particular view of human flourishing and progress more fully explored below. Dominance feminism in the legal field refers to that strain of feminism that ascribes women's subordinated status to a patriarchy that always operates to keep women in second place to men. Governance feminism has a very particular provenance; it is a term coined by Janet Halley and refers to feminists who are willing to engage the state, increasingly the punitive structures of law and order, and the military elements of the state to effectuate their agenda.[6] As Halley describes it:

> GF is, I think, an underrecognized but important fact of governance more generally in the early twenty-first century. I mean the term to refer to the incremental but by now quite noticeable installation of feminists and feminist ideas in actual legal-institutional power. It takes many forms, and some parts of feminism participate more effectively than others; some are not players at all. Feminists by no means have won everything they want—far from it—but neither are they helpless outsiders. Rather, as feminist legal activism comes of age, it accedes to a newly mature engagement with power.[7]

These two theoretical and activist strains, then, are a subset of liberal feminism that also contains those who are critical of reliance on the state. To some extent, the definition is broad enough to capture elements of the third wave, but for the most part I am speaking of the second wave. Further, I am not constraining this definition to women located in the "West" but to all women who share this particular agenda. Second, "Muslim women" is a rather broad category, and the use of the term could be taken as a reduction or essentialism born of identity politics. However, I use the term more for simplicity than out of a belief that all Muslim women share some essential characteristic. In my discussion of Muslim women's groups, I include secularist groups such as the Revolutionary Afghan Women's Association (RAWA) as well as the religious pietist women because what I am trying to get at is

a worldview that exists outside of Western Liberalism. Even though secularism itself is a product of Liberal thought and the Enlightenment, Muslim women's secularist groups live in contexts in which secularism coexists and is shaped by culture and religion in ways that, to some extent, place them outside of Western Liberalism. Finally, when I refer to International Human Rights (IHR), I am referring to the universal norms that underlie IHR law and the pressure to reform local norms to reflect them. However, I do not mean to suggest that there is no overlap or that the human rights conventions do not reflect the aims of women in the third world. What I will suggest is that what is understood by inequality or discrimination, and the rights that are struggled for, is heavily mediated by local considerations, including culture and religion, neither of which is essential or monolithic. I would suggest that because culture is not monolithic, claims that certain cultures clash with human rights because of some essential incompatibility ought to be examined very critically.[8]

Building on the insight that Liberalism contains both ideas of universal rights and equality as well as justifications for empire, I want to return to the task of this section and consider whether liberal feminism and its legal governance feminist offspring can overcome the dark side of imperialism.

In his work, *Liberalism and Empire,* Uday Singh Mehta raises the question: What happened when a political thought, self-consciously universal in its scope, was confronted with the unfamiliarity of the life forms in the British Empire?[9] A summary answer to this question, at the risk of oversimplifying a complex historical interaction and process, is that Liberalism understood the unfamiliar as the underdeveloped or the infantile. Putting all the cultures on a single evolutionary trajectory, Liberalism in its colonial period understood the colonized to be progressing toward civilization defined by Europe. One responsibility of the conscientious imperialist, then, was to advance that progress, although it seems unlikely that any of the colonized societies would ever progress enough to reach the point of civilization that would allow them self-rule.[10] In any event, while the telos was a liberal society with the necessary social arrangements, the technique that was then used to achieve it was both social and legal reform. In India, during British rule, this led to the codification of the laws and to the import of British liberal legal norms and laws to replace the domestic systems that were in effect. British law was more efficient and more just in the eyes of the colonial administrators, while native laws were hopelessly arbitrary and confusing. Certainly the view was that the imported laws were more progressive for many minorities and women, despite the fact that these improvements were resisted by a large number of Indians.[11] As Mehta notes:

History and progress are an unremitting preoccupation of nine-
teenth-century British Liberalism. Yet the political vision that
governed that liberalism was, as it were, already firmly universal.
Philosophically there is a dilemma here. Either the validity of that
political vision could not be swayed by historical considerations
or the liberal agenda was in some central way directed at the
"reform" and modification of the various histories it encountered,
so as to make them conform to the universalistic vision. Because
if the particularities and trajectories of the histories and lives
to which the empire exposed liberals did not somehow already
align themselves with that vision, then either that vision had to
be acknowledged as limited in its reach or those recalcitrant and
deviant histories had to be realigned to comport with it. Liber-
als consistently opted for the latter—that is to say, "reform" was
indeed central to the liberal agenda and mind-set. To that end
they deployed a particular conception of what really constituted
history along with a particular conception of what counted as
progress.[12]

To what extent, then, is this also the account of governance feminism
with regard to women in the Global South? Are the women's rights activists
who seek to rearrange the "deviant histories" of Asian, African, and Islamic
peoples engaged in the same project as the liberal scholars who provided
the philosophical justifications for colonial empires? After all, is not the
end to which liberal feminism aspires a society that resembles and has all
the hallmarks of equality between the sexes? This is a laudable goal that is
imagined to be shared by women all over the world.[13] But in order for that
goal to be reached, progress must be made by reconfiguring not just the
relationship between men and women and between women and the state but
to reform culture or religion in a way that comports with liberal notions of
history and progress. For most governance feminists whose view of women's
lives in the Global South as thoroughly interwoven with violence justified by
culture, this is an unmitigated good. Judged from the Archimedean point of
liberal feminism, how can change toward Liberalism be anything but good
when women are merely subjects of a patriarchal religion or culture and live
in abject misery? The following quote illustrates the point:

It is by no means clear, then from a feminist point of view, that
minority group rights are part of the solution. They may well
exacerbate the problem. In the case of a more patriarchal minor-

ity culture in the context of a less patriarchal majority culture, no argument can be made on the basis of self-respect or freedom that the female members of the culture have a clear interest in its preservation. Indeed, they might be much better off if the culture into which they were born were either to become extinct . . . or, preferably, to be encouraged to alter itself so as to reinforce the equality of women—at least to the degree to which this value is upheld in the majority culture.[14]

Although the author's sentiment is expressed in the context of minority cultures in a liberal majority society, the assimilationist view—and indeed the very explicit comfort with the alteration or extinction of another culture that, in her judgment, does not measure up—is an example of the kind of imperative to progress Mehta interrogates. Here the yardstick used to judge the relative value of "other" cultures is both liberal and feminist (in a total-izing and essentialist way). Governance feminists certainly share the liberal worldview, but in addition they are willing to use the state's military power. For instance, Jean Bethke Elshtain, the University of Chicago ethicist, has gone a long way toward providing the justifications for the intervention in Afghanistan as a "just war." She fully supported the invasion, and indeed links it to the women's rights cause.[15] In this aspect, governance feminists are different from more progressive legal feminists who have no problem with using the state to redistribute resources—even while being skeptical about the state itself as a primarily male-dominated, often racist and classist, institution—but are against the use of state violence. Further, governance feminists' view of the dominance of males over females leads to analyzing women's actions through the lens of victimization. In other words, they tend to focus on the "fact" that women are victims of male domination and, therefore, any behavior that looks like acquiescence to subordination is a result of false consciousness, severely constrained choice, or male force. This view—not a healthy skepticism of women's choices but a structural explana-tion for them—makes governance feminism ill-equipped to deal with women who do not accept the liberal ideals of progress out of religion and culture.

Alternatives Visions of Flourishing: Islam and Women's Lives

In the post-9/11 United States, images of oppressed Muslim women are a commonplace. It would not be an overstatement to say that Muslim women are considered some of the most oppressed women in the world. Typically,

references to the veil, female circumcision, honor killings, gang rape, and restrictions on movement all bear the hallmarks of a singular "Islamic culture." Religion, rather than liberating women, or helping them actualize themselves, is used to justify such subordination and compounds their oppression at the hands of Muslim men. In general, neither culture nor religion is seen as internally heterogeneous, contested and fluid.[16] Interestingly, this view of religion (and culture) as being largely unchanging is shared by both highly traditional Muslims who argue that no part of Islamic law is contingent on interpretation and location as well as traditional liberal feminists who construe religions as unchangingly patriarchal—both views essentialize some part of religion to make their arguments for or against it.[17]

In her article, "Piercing the Veil," Madhavi Sunder argues that the problem with this construction of religion is not with religion itself but with liberalism, which places religion in the private sphere and prefers to leave it alone rather than engaging it, as have many Muslims.[18] By not engaging in the internal debates about religion in liberal societies and ignoring the debates in nonliberal societies, liberals maintain the fiction that the interiority of religion is a fixed landscape. By not sufficiently accounting for the changes in religion that would become apparent through such engagement and by casting the debates as being about civil liberty issues such as freedom of religion or separation issues—that is, the separation of religion from the public/state—the fiction that religion's place is in the private, or indeed that it keeps to such a private sphere, is similarly maintained. I agree with Sunder that limiting one's view in this manner prevents one from understanding the importance of religion in the everyday public life of those living in nonliberal societies.[19]

Liberalism as it is currently configured in feminist thought cannot do the work of explaining why women value what it deems patriarchal religion except through judgments about these women as being either ignorant, suffering from false consciousness, or coerced.[20] None of these begin to explain the entire reality of women's experiences from the point of view of many Muslim women. After centuries of interaction with the "West" and the ongoing attempts to reform "developing" societies into liberal ones, the tenacity of religion must be quite a puzzle. I suggest that in order to fully understand why women value religion one must set aside liberal judgments. Muslim women's priorities and their commitments to religion ought to be considered seriously and not simply as a premodern remnant that will eventually fall away or be relegated to a private sphere. This is important because the reality of women's lives in Islamic societies indicates that no such development is

occurring, and in fact a rise in religiosity, as Olivier Roy argues, is a result of modernity and not at all a vestige of premodernity.[21]

Roy's point is underscored by a survey of Muslim women done in 2005 by The Gallup Organization. The survey revealed that Muslim women did not view themselves as particularly oppressed, that they did not feel conditioned to accept second-class status evidenced by the belief that they ought to have an unfettered right to vote, to work outside the home, and to serve in the highest levels of government.[22] Yet, they also did not share typically liberal feminist concerns about gender arrangements; they did not see sex issues as a priority and placed violent extremism, economic and political corruption, and lack of unity among Muslim nations over concerns about the hijab, which was never even mentioned by the respondents.[23] When asked to identify the best aspect of their own societies, an overwhelming majority of women cited attachment to their spiritual and moral values.[24] What is remarkable about this data is that women clearly articulate the desire for certain (liberal?) rights while valuing their own (nonliberal) religions and cultures.

Examples of this very "modern" hybrid sensibility can be found among even rural women. In an interview published in *Islamica* magazine, Mukhtar Mai, the now famous Pakistani survivor of a tribally sanctioned gang rape, repeatedly asserts the value of her religion and its role in providing the strength to stand up for justice.[25] She challenges the view that Islam supported the violence done to her. At the same time, she levels a class critique of her treatment at the hands of the state, and it is clear that she considers herself to have the right to redress.[26] Indeed, Islam is being contested but also lived in ways that are more fluid and controversial than we see in most representations or expectations.[27] For instance, Muslim women in Egypt are divided in their support for secularism and their adherence to Islamic norms. The mosque movement in Egypt and the increasing number of women who are attempting to learn about Islam and live its norms faithfully are challenging and are challenged by domestic secular feminisms.[28] Yet Islamic women's activism has taken root and is gaining ground, as Margot Badran claims:

> It is important to note that Islamic feminism is the creation of women and men for whom religion is important in their daily lives and who are troubled by inequalities and injustices perpetrated in the name of religion. Islamic feminism continues to spread because it is relevant. It is engaged and enlightened. It is also controversial and unsettling.[29]

The fact that women continue to value religion and culture cannot be reductively explained as a product of ignorance or brainwashing.[30] These examples do not signify a simple story of oppression and resistance or blind adherence to religion, but a complex reality in which religion plays a much more multifaceted role, where it coexists with the demand for rights that overlap with Liberalism but may not come from a liberal understanding of self or society. To acknowledge this alternative view is not to say that Muslim women do not live in systemic patriarchy (though certainly not as seamless a patriarchy as envisioned by dominance/governance feminists), that Islam is not patriarchal, and that gender subordination sometimes reflected in "traditional" arrangements ought not to be challenged. Rather, it is to say that opinions about how these sites of subordination are challenged, by whom, and what priorities are established can legitimately differ among women and are mediated by local contexts. It is also to acknowledge that Islam is not fixed and can be interpreted in a number of ways, and that religion must be engaged by feminists if they seriously seek to support the full liberation and flourishing of women in the Muslim world.[31]

The Costs of Representing Muslim Women as Victims: Fractured Alliances, Imperiled Lives, and the Weak "Rights"

In this section, I want to explore the costs of governance feminism's approach to helping Afghan women. First, there is a cost to the overemphasis of the dominance framework by representing Afghan women as helpless victims. It undercuts the agency of Afghan women's groups and has resulted in fractured alliances. Second, governance feminism's willingness to punish Muslim men (again the dominance framing) via the use of international intervention and military power diminishes the capacity to see men as victims of the War on Terror and whitewashes the crimes committed against both Afghan men and women by their so-called saviors.

Fractured Alliances

The co-presence of the seemingly conflicting commitments to religion and to rights may tempt some scholars to reconcile them through liberal notions of progress toward modernity. Certainly, that has been the dominant interpretation. However, to do so misapprehends the project of women's groups in Islamic communities, which do not necessarily follow such a linear temporal progression from religion to the privatization of religion or "liberty from

religion." Muslim women who want both the vote and the hijab do not see a conflict between the two or the desire for the latter as less "evolved."[32] However, otherwise well-intentioned women's groups in the West treat this double consciousness as naïveté. Further, most Western donors are unlikely to fund projects that promote an illiberal agenda without the requisite regard for an absolutist secularism.[33] Thus, if women's groups want funding, they must perform the script expected of them. It behooves them to highlight their victimization and downplay their agency.

Yet, many women in the South have not silently accepted the unidimensional construction of a subject meant to represent them. Nor have they silently acquiesced to the framing of their agendas. Resistance to Northern feminists' hegemony was much in evidence at the Fourth World Conference on Women held in Beijing in 1995. As Vandana Shiva noted,

> Human rights emerged as a major theme at the Women's Conference, with speaker after speaker insisting that women's rights are inseparable from human rights. . . .
>
> The right to meet basic needs does not figure in the US discourse on human rights even though in the Third World, the denial of basic needs is the real issue of violation of human rights. This will also increasingly become the central human right that will be violated in the North as globalisation leaves larger numbers unemployed, homeless and without economic security.[34]

Hegemonic agenda-setting undertaken by Western women's organizations tend to silence and disempower nonelite women in the Global South, making solidarity across the lines difficult. A singular case that illustrates the pitfalls of such coalitional work based on the "victimhood" of Muslim women would be RAWA's experience with the FMF. Because by now this has been well covered in the literature, I want to merely point to the controversy and underscore the particular problems that emerged.

RAWA has become very well known, particularly after September 11, for bringing attention to the plight of women under various factions in the internal conflict in Afghanistan. During the 1980s, RAWA's main strategy to gain global support for its projects was disseminating visual representations of the oppression of Afghan women.[35] These images were exported to the world, printed in newspapers and shown on television, as part of a campaign to raise awareness and get monetary support. While it is clear that Afghan women were indeed living under terrible conditions, these representations standing alone deeply reinscribed the prevailing stereotype of powerlessness

and victimization that the world had come to accept about most Muslim women. The strategy yielded results because it shocked most viewers and gave first-world feminists a transnational cause with a palpable urgency to support.

While RAWA exported an account of oppression externally, its internal strategy was markedly different. Their newsletter "Payam-e-Zan" contained editorials and commentary and inspirational materials encouraging women to redress their own problems. RAWA built schools and hospitals and instituted social programs combating fundamentalism even as they were pushed to the borders of Pakistan during a decade of increasing violence. Thus, on one hand, RAWA was attempting to help Afghan women through reinforcing a self-perception of empowerment and self-help, a self-perception that RAWA shared as an organization. On the other hand, the external image that brought them crucial material support from the West was one of abject powerlessness and brutal oppression.[36]

In 1997, RAWA partnered with the FMF in its Campaign to End Gender Apartheid. This was seen as a positive development by RAWA.[37] As media made stories and images of the abuses faced by Afghan women readily available, FMF quickly mobilized on their behalf. Unfortunately, FMF's own representations of Afghan women soon put them at odds with RAWA. FMF used the same strategy of showing powerlessness and oppression to gain public support but without adequately recognizing or acknowledging RAWA's long and hard-fought struggle on the front line.[38] Moreover, the focus on the burqa and FMF's simplistic interpretation of the veil as a sign of abject oppression and its lack of nuance annoyed many Muslims:

> This swatch of mesh represents the obstructed view of the world for an entire nation of women who were once free. Wear it in remembrance—so that we do not forget the women and girls of Afghanistan until their right to work, freedom of movement, education and health care are restored and they are free once again.[39]

At the time, RAWA sent an open letter to FMF to protest the way in which FMF had assumed leadership in the struggle for Afghan women and charged it as a hegemonic corporatist feminist organization.[40] Yet RAWA itself was not entirely blameless. Indeed, it was RAWA's representations that were used to mobilize women in the United States. It was perhaps not that unforeseen that FMF's advocacy and rhetoric would provide the Bush administration a ready source of material to justify intervention in Afghanistan. After all, in retrospect, FMF is a prime example of governance feminist

advocacy. FMF's willing collaboration with the administration, its misguided attempts to shape foreign policy in the region, and its continuing willingness to use military force to secure women's rights have made it difficult to forge wider alliances among all those who are interested in Afghan women's well-being. Also troubling is the silence of governance feminists, and FMF is again an example, surrounding the torture and abuse of Afghan men and the population in general at the hands of coalition troops.

Imperiled Lives: The Use of International Law and Force

Another consequence that merits consideration is the way in which the situation of Afghan women was used to justify violent intervention in Afghanistan. Careful analysis of the strategic deployment of women's rights has much to teach us about its future role in legitimating such intervention. I have already considered governance feminism's use of the victim subject above. Here I want to probe the crudely constructed, correlating subject of men as the victimizer. Such formations neatly allocate power and vulnerability along gender lines. While this may seem entirely natural to some feminists, I want to interrogate the easy symmetry of this construction and suggest that such oversimplifications occlude men as victims and aid the validation of violence that affects everyone in Afghanistan. Second, I want to question the ease with which some liberal legal feminists have accepted the benefits of humanitarian intervention to save women without weighing the consequences of such intervention on subject populations. And I also suggest that we reconsider the use of law as a legitimating force in furthering these interventions. Both these strategies work to sanitize uses of violence against Muslim communities and often affect women themselves adversely.

Women do not live in vacuums. Their lives are inextricably bound up with those of men. And it is stating the obvious to say that, in some cases, the men nearest to them can pose the greatest threat. However, it is equally important to underscore that not all Muslim men are the violent monsters that fill the pages of newspapers. Quite often, in times of violence, women's interdependence with men is heightened. And it is the shelter of the family and community that offers security that cannot be found through any other means.[41] So, in a context like Afghanistan, riven with violence from competing factions, and violence from both internal and external actors, what does it mean to promote women's rights without regard to women's relationships with men?

Women's ability to fend for themselves in Afghanistan has been quite thoroughly examined over the last decade. What has become clear is the

inability of the state or its foreign allies to protect women. There are little to no social services available, and the police and armed forces are vulnerable to corruption.[42] The economic prospects for women are dismal. In a majority of the country, tribal mores prevail over formal laws. In this context, protection of men is a critical element for women's security and well-being. As a result, characterizing men as the oppressors of women only partially tells the story of gender relations in the country.[43]

For a more complete account, a more nuanced understanding of gender relations is imperative. The unrelenting focus on women as victims relieves governance feminists from having to interrogate their positions regarding Muslim men. Moreover, it relieves them of having to acknowledge the role of military violence in exacerbating the situation of women by targeting their main means of support. For instance, what do liberal feminist hawks make of the following narrative?

Although Dilawar was only a small, frail man, he was regarded as noncompliant when he apparently spat in the face of a soldier, who gave him a couple of peroneal strikes [a debilitating blow below the knee] that made him cry out, "Allah!" The soldier explained, "Everybody heard him cry out and thought it was funny. It became a kind of running joke, and people kept showing up to give this detainee a common peroneal strike just to hear him scream out "Allah!" It went on over a 24-hour period, and I would think that it was over 100 strikes." Over the next two days, Dilawar was subjected to brutal interrogations, in which few words were actually spoken. Unable to assume a stress position in the first session, because his legs were so damaged, he was repeatedly thrown against the wall, and, according to the interpreter, a violent female interrogator stamped on his bare foot with her boot, and kicked him in the groin. The following day, after being chained to the ceiling once more, he was unable to kneel and kept falling asleep. After asking for a drink of water and being sprayed with water until he gagged, he was returned to his cell and chained up once more, and by the following morning he was dead.[44]

As I noted about this case in a prior article, Dilawar was a taxi driver who was wholly innocent. Two coroners later said of his injuries that his legs had "basically been pulpified" and that the injuries resembled those who had been run over by a bus.[45] We are all too familiar now with soldiers like Lynndie England of Abu Ghraib infamy. But she is not the anomaly that the U.S. government claims. Dilawar was interrogated and tortured by women who were then later sent to Iraq. As *The New York Times* reported, many of the Bagram interrogators, led by the same operations officer, Capt. Carolyn

A. Wood, were redeployed to Iraq and in July 2003 took charge of interroga-
tions at the Abu Ghraib prison. According to a high-level Army inquiry last
year, Captain Wood applied techniques there that were "remarkably similar"
to those used at Bagram.[46]

If men are the victimizers of women and the perpetrators of terror,
can they also be victims? In the discourses that have dominated governance
feminist activism in the wars, the answer appears to foreclose that possibility,
or at the very least glosses over it. Thus, governance feminists are able to
turn a blind eye to violence done to men because the discourse of gender
oppression validates it and legitimizes it as a necessary corollary of protect-
ing women.[47]

On this backdrop of the women/victim–men/perpetrator paradigm,
governance feminists have sought to marshal the use of international law
to protect women's rights. After the systematic use of rape as a tool of war
in the Bosnian conflict, and the continuing use of rape in the Congo, it is
difficult to argue that international law should not be used to protect the
rights of women.[48] That is certainly not my argument here, although I am
increasingly skeptical about military intervention. Rather, my aim is to raise
concern about the use of human rights law as a mode of legitimating political
decisions to intervene in countries where violations are taking place.

Increasingly, calls for intervention have blurred the lines between two
doctrinally distinct areas: human rights law and humanitarian law. Human
rights was primarily the province of states until the recent enactment of
the Optional Protocol to the Convention on the Elimination of All Forms
of Discrimination Against Women.[49] States were required to report on their
progress toward a gender-equal society, and very little could be done by indi-
viduals to challenge their own states. The Optional Protocol gives individuals
standing to bring complaints directly to CEDAW without the intermediary
of the state. The Optional Protocol's enactment was a result of increasing
awareness that leaving governments to redress abuses was ineffective. After
all, states themselves were often the authors of the alleged crimes. Allow-
ing individuals to raise concerns directly at the international level increased
accountability. However, this too has been a partial remedy given that it takes
resources and skill to craft the kind of legal complaint that the CEDAW
committee typically hears. As a result, the poorest and most vulnerable are
left to seek intermediaries within their home countries to represent them.
And the problems of representation, as I have been arguing, are manifold.

Even if the human rights apparatus at the international level takes
note of and requests action from states for its abuses or failure to act to

prevent abuses, there is no international police force that can impose order. As human rights law has moved in a direction allowing for greater individual standing, thereby eroding states' ability to hide behind sovereignty, humanitarian law has similarly moved toward legalizing the heretofore political practice of individual states' or coalitions' armed intervention in times of humanitarian crisis.[50] As Jose Alvarez points out, the United Nations adoption of the "Responsibility to Protect" (R2P) turns political rhetoric into a legal norm. In other words, states had on occasion intervened to prevent or stem gross violations of human rights or genocide. However, those interventions had never been sanctioned by international law; they were exceptions to the laws on the use of force. Now, we have a doctrine that is definitionally malleable and can be used to "legalize" a variety of reasons for and modes of intervention.[51]

Humanitarian intervention to protect women has been supported by governance feminists who question why such intervention has not come sooner. Indeed, humanitarian armed intervention is increasingly seen as a necessity and not a last measure for preventing violence toward women and children. According to the 2001 Responsibility to Protect document, the grounds for intervention are large-scale loss of life and large-scale ethnic cleansing (including rape). The inclusion of rape, a common war crime, was a result of the Bosnian experience. Governance feminists, reacting to the mass rapes in that conflict, sought to create a closer legal nexus between genocide and rape. Some even conflated the two into "genocidal rape" and used it to justify humanitarian intervention.[52] It is beyond the scope of this essay to fully explore the legal dimensions of this elision. However, it is worth pointing out that the call for intervention focusing on the violence being perpetrated tends to obscure the devastating violence of intervention itself.[53] While we might want to argue that peacekeepers can hardly be equated with an invading army, there are increasing reports of the sexual exploitation and abuse of women and children perpetrated by peacekeepers deployed to war-torn areas.[54] And, indeed, if peacekeepers are not above committing abuses, neither are regular military personnel who are often deployed in allied interventions. Indeed, over the last decade, we have had a steady stream of reports about the atrocities and torture committed by U.S. and coalition troops in Afghanistan.[55] Moreover, as the War on Terror moves into a more mechanistic and automated phase, the use of drones to kill militants has led to numerous civilian casualties as well. Humanitarian intervention never was as simple as it seemed to governance feminists, and it has only become more complex both legally and on the ground.

Conclusion: Weak Rights/Weak States
and the Limits of the Law

As part of the justification for the intervention in Afghanistan, the Bush administration deployed a discourse about women's rights abuses. Despite the fact that it was not explicitly couched in humanitarian terms, it is nevertheless troubling that the plight of women being abused by terroristic, Muslim men lent a humanitarian/human rights flavor to the war. Governance feminists failed to interrogate the appropriation of women's rights rhetoric to this end. Indeed, having set up the dynamic in which they had to be "for women" and against the men doing the abusing, they then faced difficulty when confronted with the increased abuse of Muslim men in camps, detention sites, and prisons. The only way to justify the torture and killing of Muslim men is if they are reduced to culpable, terrorist perpetrators deserving of the harshest treatment.[56] The idea of sending in troops to save women from their men folk becomes fantastical when the result is the devastation of the victims' homes and the indiscriminate killing of their families and communities by drone attacks, and guided missiles in increasingly impersonal combat. Legal sanction for such intervention does little to whitewash the reality or absolve feminists of their complicity. Given the costs of acontextually using the Muslim-woman-victim narrative, it is important to think carefully before we undertake representation of these victims and activism on their behalf.

Zillah Eisenstein observes, "[m]any Afghan women activists wonder why U.S. women, even progressive ones . . . are more interested in 'why Afghan men treat women like dirt' rather than why Western male-dominated governments foster 'misogynist religious extremism at the expense of women's rights.'"[57] It has been over ten years since the incursion into Afghanistan. In that time, it has become quite clear that women's rights are not a priority for the U.S. administration, particularly as they prepare to leave Afghanistan in the hands of a faltering state and as they begin talks with the Taliban in Doha.[58] Yet instead of questioning the ongoing war and its many failures, most U.S. liberal feminists have continued to remain silent about the violence done by the United States even while purporting to work for Afghan women. Having tasted the victory of including rape as a ground for intervention, they have failed to critique the very premise that intervention is necessary and its results positive. In fact, the FMF continues to call for troops to stay in Afghanistan to protect women.

The question arises, Why is this the case? The answer, I have suggested in this essay, lies in the conception of Muslims, in general, and the

liberal, dominance framework that pits Muslim men and women against each other, in particular. If Islam is not a mere backward mindset that can be evolved out of, and Muslim men are not the terrorists acting with impunity against their women, and if Muslim women are not merely faceless victims, then the use of violence for the cause of women's rights cannot be supported. Governance feminism suffers from a deep-seated and, perhaps, sublimated, theoretical prejudice that prevents true solidarity with women who differ. The judgment that Liberal arrangements in society, polity, and family is superior to other arrangements, and reducing illiberal alternatives to vestiges of backwardness, results in difficulties in understanding choices that go against the grain. Women who choose to veil, who find value and comfort in a seemingly oppressive religion yet have a sense of their desires, rights, and future, are inscrutable. Their choices can only be understood as false choices made as a result of false consciousness. Consequently, they must be educated out of their desires and helped to progress. Increasingly, liberal feminists have been willing to countenance the use of armed force to save women and bring about this progress into a gender just world.

For women of the Global South, these developments are worrisome. They are, after all, the people who stand to lose their lives, and those of their children, along with those of their brothers and sisters, their mothers and fathers, and their husbands, in armed interventions for largely illusory rights—rights that must be guaranteed by a functioning state and that must have the force of law. The focus on women's rights as defined by governance feminists draws the focus away from the distributional problems that are at the heart of these conflicts and prevents us from shifting the terrain of the struggle. Rights are only as strong as the state that guarantees them and enforces them. What does it mean to say that girls have a right to education, if the state is incapable of providing schools and the protection to attend? What does it mean to assert that women have a right to work outside the home in a state that suffers from military devastation, high unemployment, and lack of opportunity? If the state cannot guarantee basic subsistence and security, can the passage of laws solve the problem? And is gender equality the top priority in such a state? International intervention has clearly failed to achieve many of its high-minded aims. Moreover, it is also clear that the Afghan state is ambivalent with regard to women's "rights" and its willingness to expend political capital in reshaping the current societal distributions of resources and protections. The continued use of the language of rights with its default legalism suggests that what is needed is legislation—formal laws and then proper enforcement. Such a state-centric approach stunts the ability to think creatively about how to solve the societal problems that the Afghan people face.

In this struggle, first-world women have been naïve or willing collaborators with the very "patriarchy" that they claim to be oppressed by, partnering with a violent international coalition, relying on a weak but equally violent Afghan state, deploying their weapons while decrying the cooptation of women's rights rhetoric. While these inconsistencies persist, solidarity between progressive women's groups and governance feminists in the North and South will be problematic.

Governance feminists need to move away from the home turf of their philosophy and venture out into different terrain. At the very least, if they wish to build strong relationships of solidarity, abandoning their judgments, provincializing their values and goals, and allowing women from the Global South to represent themselves and their agendas would be a good start. Being willing to relinquish their tutelary posture with regards to theorizing what is "good" for women, and appreciating their position of privilege and their complicity with global distributions of power, would be a necessary predicate for living up to feminism's promise of gender justice. It is no longer possible to undertake transnational feminism without a proper regard for the global landscape. As I have argued, it is not enough for feminists to embrace international law and put it in the service of women; they must remain skeptical of the force and validity of legal enactments and legitimations. In the last decade, International Law has been used to sanitize violence undertaken for political ends, and women's rights have been similarly used. The difference between world condemnation of violence and acquiescence depends on its legality. And as we have witnessed, "legality" can be a political decision rather than a legal one. As we move forward, similar justifications and any invocation of state power in a punitive, violent mode should be met with strong resistance and vociferous objection rather than silent acquiescence, let alone enthusiasm.

Notes

1. See generally, Ayaan Hirsi Ali, *Infidel* (2008); Irshad Manji, *The Trouble with Islam: A Muslim's Call for Reform in Her Faith* (2005).

2. A more complete discussion of governance feminism follows later in the essay.

3. See Halley et al. 2006.

4. Indeed, we ought to be skeptical about the freedom of our own choices despite the fact that we "feel" free. Skepticism about Muslim women's choices, particularly when they choose modes of being that seem to constrain freedom, prevents us from a relativist extreme that makes all choices of equal value. On the other hand, skepticism about our own choices and modes of being prevents us from mistaking

our position as objective or somehow inherently superior. Resolving the dilemma between agency and victimization is no easy task, and this essay does not explore it in depth. See West 2005.

5. Parts of this section of the essay were published in a prior article—see Choudhury 2009.

6. See Halley et al. 2006.

7. Id., at 340. Some prominent governance feminists are Jean Bethke Elshtain, Catherine A. MacKinnon, Andrea Dworkin, and Hillary Clinton (and perhaps Bill Clinton).

8. I should also make clear that I do not subscribe to the notion of a discreet East/West or North/South. It is clear that the West contains a large population that could be considered "Eastern" and that the Global South is no longer "people over there" but often people who live side by side with their affluent "Northern" neighbors in urban ghettos and banlieues. As such, my references to third-world women, women of the Global South, and women in the East should be read not geographically but politically and economically.

9. See Mehta 1999.

10. See id.

11. See Choudhury 2009.

12. Mehta, supra note 5, at 77.

13. See, for example, Okin 1999.

14. Id. at 22–23 (emphasis added).

15. Jean Bethke Elshtain, "The Ethics of Promoting Democracy," in Christianity Today, Sept. 8, 2010, available at http://www.christianitytoday.com/ct/2010/september/15.72.html (last visited January 13, 2015).

16. See, for example, Okin 2000. In her article Okin seems not to appreciate that the women in the third world who are the subjects of her concern are also participants in culture and religion, not just victims of it. She notes that there are feminists who are working on oppression, but they are rarely internal to the society; when they are, their work is seen only as resistance to, but never participation in, culture or religion. See id. at 40-41.

17. See, for example, supra note 7.

18. Sunder 2003.

19. Id. at 1402–1404.

20. See generally Mehta, supra note 5.

21. See Roy 2004.

22. Mogahed 2006.

23. Id. at 3.

24. Id. at 2.

25. Khan 2006.

26. See id.

27. See id.

28. See Mahmood, *Politics of Piety: The Islamic Revival and the Feminist Subject,* 2–6, 15–16 (2005).

29. Margot Badran, "Islamic Feminism Revisited," Countercurrents.org, Feb. 10, 2006, http://www.countercurrents.org/gen-badran100206.htm. While I would be wary of collapsing all Muslim women's activism under the rubric of "feminism," which has historical and philosophical particularities that may not translate to certain Muslim women's activism, this quote can be read broadly to apply to all women's gender activism except perhaps those that simply reinforce the dominant patriarchal norms. See also Elizabeth Warnock Fernea, "Islamic Feminism Finds a Different Voice: The Muslim Women's Movement is Discovering its Roots in Islam, Not in Imitating Western Feminists," 77 *Foreign Service Journal* 24, 29–31 (2000) (arguing that by women giving Qur'anic texts new interpretations they are gaining greater gender justice). But also see Val Moghadam, "Islamic Feminism and Its Discontents: Notes on a Debate," *Middle East Forum,* available at http://www.iran-bulletin.org/women/ Islamic_feminism_IB.html (last visited Mar. 5, 2008). Moghadam argues that what has been achieved through the interpretation of Islamic texts is limited in content and consequence, because interpretation of the texts is ultimately left to the ruling religious elites, which may dismiss feminist interpretations.

30. See Mahmood, supra note 24, at 1–2.

31. See Sunder, supra note 14, at 1433–3434, 1456–1457, 1463.

32. See supra notes 5–13 and accompanying text.

33. There are a number of different forms of secularism. The kind of neutral secularism enshrined in the First Amendment requires that the state remain neutral among religions in the public sphere and refrain from establishing a state religion. However, many states that have come to be regarded as secular have an official state church, such as the Church of England. It is curious, then, to regard "Islamic Secularism" as an impossibility even in the face of these examples. For an excellent discussion of secularism, see, for example, Talal Asad, *Formations of the Secular* (2003).

34. See Shiva 1995.

35. See Farrell and McDermott 2005.

36. See id. at 39–40.

37. Undoubtedly, it benefited FMF and the women's movement in the United States; some scholars have suggested that such a project reinvigorated the lagging support for feminist organizations by domestic women. Part of the reason for that decrease in domestic support is the achievement of substantial legal and social victories for feminists leading to greater access to education and the workplace and, therefore, greater economic freedom.

38. See Eisens 2004.

39. Val Moghadam 2003.

40. See Farrell and McDermott, supra note 31 at 43.

41. See Choudhury supra note 7 for a discussion of Muslim women in India whose safety depends on the shelter of the family and community when faced with communal violence that the state fails to protect against if not actively promotes.

42. See, for example, Koeble 2005; Mashal, 2010.

43. See World Bank 2005.

44. Worthington 2007.

45. Golden 2005.

46. Id.

47. See Van Schaack 2011.

48. Id.

49. See, for example, United Nations 1999.

50. See Jose Alvarez, "The Schizophrenia of R2P." Panel Presentation at the 2007 Hague Joint Conference on Contemporary Issues of International Law: Criminal Jurisdiction 100 Years After the 1907 Hague Peace Conference June 30, 2007. Available at www.asil.org/pdfs/r2pPanel.pdf (accessed March 31, 2011).

51. Id.

52. Id.

53. My argument here is indebted to Karen Engle's critique of feminism and humanitarian intervention. See Engle 2007. See also Kennedy 2004.

54. See "Peacekeepers Abusing Children," BBC, May 27, 2008, http://news.bbc.co.uk/2/hi/ 7420798.stm; Peacekeepers Sell Arms to Somalis, BBC, May 23, 2008, available at http://news.bbc.co.uk/ 2/hi/africa/7417435.stm (accessed March 31, 2011).

55. See Hoffman 2000; Bales 2013.

56. See Choudhury 2007.

57. See Eisenstein, supra note 34, at 166.

58. de Young 2013.

Bibliography

Ali, Ayaan Hirsi. *Infidel.* New York: Atria, 2008.

Bales, Robert. "Soldier who Killed 16 Civilians in Afghanistan Pleads Guilty." *The Guardian.* http://www.guardian.co.uk/world/2013/jun/06/soldier-killed-afghans-pleads-guilty. Last modified June 6, 2013.

Choudhury, Cyra Akila. "Empowerment or Estrangement?: Liberal Feminism's Visions of the 'Progress' of Muslim Women." *University of Baltimore Law Forum* 39, no. 2 (2009): 153–173. Available at http://law.ubalt.edu/downloads/law_downloads/UBLawForum39.2.pdf.

―――. "Comprehending 'Our' Violence: Reflections on the Liberal Universalist Tradition, National Identity and the War on Iraq." *Muslim World Journal of Human Rights* 3, no. 1 (2007). doi: 10.2202/1554-4419.1076.

―――. "(Mis)Appropriated Liberty: Identity, Gender Justice, and Muslim Personal Law Reform in India." *Columbia Journal of Gender & Law* 17, no. 1 (2006).

de Young, Karen. "US to launch formal peace talks with Taliban." *Washington Post.* http://www.washingtonpost.com/world/national-security/us-to-relaunch-peace-talks-with-taliban/2013/06/18/bd8c7f38-d81e-11e2-a016-92547bf094cc_story.html?hpid=z2. Last modified June 18, 2013.

Eisenstein, Zillah. *Against Empire: Feminisms, Racism, and 'the' West.* London: Zed Books, 2004.

Elhstain, Jean Bethke. "The Ethics of Promoting Democracy." *Christianity Today*. http://www.christianitytoday.com/ct/2010/september/15.72.html. Last modified September 8, 2010.

Engle, Karen. "'Calling in the Troops': The Uneasy Relationship Among Women's Human Rights, Human Rights, and Humanitarian Intervention." *Harvard Human Rights Journal* 20 (2007): 189–226.

Farrell, Amy, and Patrice McDermott. "Claiming Afghan Women: The Challenge of Human Rights Discourse for Transnational Feminism." In *Just Advocacy? Women's Human Rights, Transnational Feminisms, and the Politics of Representation*, edited by Wendy S. Hesford & Wendy Kozol. New Brunswick, NJ: Rutgers University Press, 2005.

Golden, Tim. "In U.S. Report, Brutal Details of 2 Afghan Inmates' Deaths." *The New York Times*. http://www.nytimes.com/2005/05/20/international/asia/20abuse.html?pagewanted=all. Last modified May 20, 2005.

Halley, Janet, Prabha Kotiswaran, Hila Shamir, and Chantal Thomas. "From the International to the Local in Feminist Legal Responses to Rape, Prostitution/Sex Work, and Sex Trafficking: Four Studies in Contemporary Governance Feminism." *Harvard Journal of Law & Gender* 29, (2006): 336–423. Available at www.law.harvard.edu/students/orgs/jlg/.../halley.pdf.

Hesford, Wendy, and Wendy Kozol. *Just Advocacy? Women's Human Rights, Transnational Feminisms, and the Politics of Representation*, New Jersey: Rutgers University Press, 2005.

Hoffman, Michael. "Peace-Enforcement Actions and Humanitarian Law: Emerging Rules for 'Interventional Armed Conflict.'" *International Review of the Red Cross* 837 (2000). Available at http://www.icrc.org/web/eng/siteeng0.nsf/html/57JQCY.

Kennedy, David. *The Dark Side of Virtue: Reassessing International Humanitarianism*. Princeton, NJ: Princeton University Press, 2004.

Khan, Fareeha. "Interview with Mukhtaran Mai." *Islamic Magazine*. 2006. http://www.is'lamicamagazine.com/issue-15/interview-with-mukhtaran-mai.html.

Koeble, Susanne. "Corruption in Afghanistan: US Cuts Aid After Millions Siphoned Off to Dubai." *Spiegel Online*. http://www.spiegel.de/international/world/0,1518,704665,00.html. Last modified July 5, 2005.

MacKinnon, Catharine A. *Are Women Human? And Other International Dialogues*. Cambridge: Belknap Press, 2006.

Mahmood, *Politics of Piety: The Islamic Revival and the Feminist Subject*. Princeton, NJ: Princeton University Press, 2005.

Manji, Irshad. *The Trouble with Islam: A Muslim's Call for Reform in her Faith*. New York: St. Martin's Press, 2004.

Mashal, Mujjib. "Poll Shows Afghan's Frustration with Corruption at War." *The New York Times*. http://atwar.blogs.nytimes.com/2010/07/12/poll-shows-afgans-frustration-with-corruption/. Last modified July 12, 2010.

Mehta, Uday Singh. *Liberalism and Empire: A Study in Nineteenth Century British Liberal Thought*. Chicago: University of Chicago Press, 1999.

Mogahed, Dalia. "Perspectives of Women in the Muslim World." *Gallup World Poll Special Report: The Muslim World.* http://media.gallup.com/WorldPoll/PDF/ GALLUP+MUSLIM+STUDIES_Perspectives+of+Women_11.10.06_FINAL. pdf. Last modified November 10, 2006.

Moghadam, Val. *Globalizing the Local: Transnational Feminism and Afghan Women's Rights.* http://www.peuplesmonde.com/spip.php?article20. Last modified December 26, 2003.

Okin, Susan Moller. *Is Multiculturalism Bad for Women?* Princeton, NJ: Princeton University Press, 1999.

———. "Feminism, Women's Human Rights and Cultural Difference." In *Decentering the Center: Philosophy for a Multicultural, Postcolonial, and Feminist World,* edited by Uma Narayan and Sandra Harding, 27–47. Bloomington: Indiana University Press, 2000.

Roy, Olivier. *Globalized Islam: The Search for a New Ummah.* New York: Columbia University Press, 2004.

Shiva, Vandana. Beijing Conference: "Gender Justice and Global Apartheid. Third World Network," 1995. http://www.twnside.org.sg/title/just-cn.htm.

Sunder, Madhavi. "Piercing the Veil." *Yale Law Journal* 112 (2003): 1399–1405.

Van Schaack, Beth. "The Crime of Aggression and Humanitarian Intervention on Behalf of Women." *International Criminal Review* 11, no. 3 (2011).

United Nations. Optional Protocol to the Convention on the Elimination of All Forms of Discrimination Against Women, G.A. Res. 54/4, art. 2, U.N. Doc. A/RES/54/4, October 15, 1999.

West, Robin. "Law's Nobility." *Yale Journal of Law and Feminism* 385, no. 17 (2005): 392–458. Available at http://scholarship.law.georgetown.edu/facpub/487.

World Bank. "Afghanistan: National Reconstruction and Poverty Reduction—the Role of Women in Afghanistan's Future." http://siteresources.worldbank.org/ AFGHANISTANEXTN/Resources/AfghanistanGenderReport.pdf. Last modified March 2005.

Worthington, Andy. *The Guantanamo Files: The Stories of the 774 Detainees in America's Illegal Prison.* London: Pluto Press, 2007.

Chapter 11

Islam, Feminism, and Agency in Germany Today

Beverly M. Weber

If we speak of Islam in Europe, we must also speak fundamentally about Europe's self-conception. The demanded recognition of the "culture of Islam" is about freedom, secularism and human rights. Can we, as Tariq Ramadan demands, leave it to the Muslims to "decide for themselves" how they wish to define integration?

—Necla Kelek (2007)[1]

But not until there is a loyal stance of Muslims vis-à-vis society and the recognition of the principal of individual freedom, when they are ready to stop denying their own problems and to grapple with them, only then will they do justice to their responsibility as citizens.

—Necla Kelek (2011)[2]

I open with these quotes to illustrate the pervasiveness of interconnected tropes of freedom, secularism, and human rights in discussions about Islam in Europe today. These tropes in turn are often expressed as connected to the emancipation of Muslim women—freedom as Muslim women's freedom from intimate and family violence; secularism as a rejection of symbols of Islam, often women's dress, in public space; and the importance of women's rights as human rights. Prominent European Muslim women like Ayaan Hirsi Ali, Fadela Amara, and Necla Kelek—women of Muslim heritage who argue for either rejection or reform of Islam today—take part in a larger

251

public discussion that identifies women's rights as the legitimization for a form of secularization that prohibits the presence of Islam in public space, and thus the presence of openly Muslim women in the public sphere. The relationship of Muslim women to feminism in Europe, as elsewhere, is thus deeply bound up in notions of agency and the liberal democratic subject.

These notions have, of course, also been central to the impact of other forms of feminism in Europe. The German case, however, also presents a unique set of paradoxes. Even though many feminist discussions regarding the role of Islam in Germany today rely heavily on the valorization of the autonomous liberal democratic subject, liberalism historically has not played as an important role in German feminisms as elsewhere. Indeed, in the German case, a prominent West German feminist discourse of gender difference led to widespread acceptance or even celebration of women's unique role in the private sphere, a form of feminism that was dominant for decades.[3] Today, a new reliance on the subject of liberalism has led to a shift in the representation of the state on the part of some feminists, in which state patronage is viewed as necessary in order to protect the rights of Muslim women.[4] The reliance on state protection for women's rights creates a "governance feminism" that often obscures both the history of feminist criticism of state regulation of women's bodies as well as the current ways in which federal policy produces structural disadvantages for Muslim groups. In other words, in a dramatic shift in feminist strategies among many mainstream white feminists as well as a small group of Muslim feminists, state protection is now seen as necessary to enable the agency of individual Muslim women.

Saba Mahmood has eloquently elaborated the importance of a particular understanding of liberal agency to feminist engagements with Islam, an understanding rooted in a notion of the political and moral autonomy of the subject. Mahmood points out that the emphasis on forms of agency rooted in the ability of the autonomous subject to resist existing societal structures prohibits recognition of other forms of agency claimed by Muslim women. Although Mahmood focuses particularly on those involved in piety and mosque movements in Egypt, her work has provided an important impetus for rethinking feminist intellectual inquiry that takes Islam as its focus in a range of locations. Yet, Muslim women and women of Muslim heritage who have active roles in the European public sphere present a different intellectual problem for feminist thinking about agency and Islam. On one hand, women such as Kelek and Ateş in Germany, and, to some extent, Hirsi Ali in the Netherlands, have actively distanced themselves from Islam and from communal affiliations with immigrant communities—precisely in

order to articulate their claims to political and moral autonomy as a form of arrival to a European time (the present) and space.[5] In France, Fadela Amara and the activist group Ni putes ni soumises actively critique their Muslim communities using the language of an autonomous subject they define as fundamentally European, calling for state intervention through means such as a headscarf ban to emancipate Muslim women.[6] Though accused of Islamophobia, Amara, Hirsi Ali, and the members of Ni putes ni soumises retain an overtly expressed positionality as Muslim women. Still others, often lesser known, frame their public, visible affiliation with or experience of Islam as itself one aspect of their participation in a democratic European community.

Engaging with the presence of women in the public sphere in Europe thus presents a rather thorny problem. How is one to challenge the popular, essentializing narrative that contrasts a democratic, enlightened Europe to a patriarchal, violent Islam incapable of democratic change—while also recognizing that many Muslim women strategically make claims to a European democratic tradition in order to participate in the public sphere? While a rejection of European discourses may be partially located in anticolonial movements in many parts of the world, a claim to European discourses in Europe itself becomes a necessary strategy in the face of racialized forms of exclusion from the public sphere. In this essay I sketch a range of claims to agency present in European Muslim feminisms, using examples drawn from Germany. I highlight the strategies of claiming democratic and emancipatory traditions that Muslim women construct as specifically European in order to show the emphasis on claiming participation in the European democratic public. This will allow me to theorize further implications for feminist theory and notions of agency. I thus intend this essay to be a theoretical dialogue with Mahmood's work that allows us to consider the parameters for understanding Muslim women's claims to agency in the European context.

Theorizing Agency

It would be a gross oversimplification to suggest that there is "one" form of agency in Western feminist discourse; Mahmood argues no such thing. Rather, her argument reveals a trajectory of Western feminism and leftist thought that emphasizes autonomy as necessary for self-realization, and then opposes resistance to oppression, locating agency in resistance. While I do not have the space to extensively revisit this history of theorizing agency here, I would like to emphasize a few points. Following Lila Abu-Lughod, Mahmood points out that leftist and feminist theorists have tended to romanticize resistance.

She argues that instead one must recognize resistance as part of complex and shifting strategies, produced by complex, shifting relations to multiple, historically specific structures of power.[7] Mahmood further draws on post-structuralist models of power, in particular to challenge a fundamental tenet of liberalism as well to question a resulting binary.[8] Liberalism and liberal notions of the transcendental subject depend on the inextricable linking of free will and self-realization. Reliance on this linkage can produce models of power that are limited to a binary of repression and resistance. Michel Foucault and Judith Butler created more complex models of power with an insistence that the subject does not precede relations of power, but is partially produced by them. Butler imagines performativity, for example, as a repetitive performance of norms that enables their subversion—in their repetition, they may fail. Nevertheless, poststructuralist discussions of agency, including Butler's sophisticated consideration of agency and performativity, continue to "conceptualize agency in terms of subversion or resignification of social norms, to locate agency within those operations that resist the dominating and subjectivation modes of power," leading to a "scholarship [that] elides dimensions of human action whose ethical and political status does not map onto the logic of repression and resistance."[9] Instead, Mahmood wants to conceptualize "the variety of ways in which norms are lived and inhabited, aspired to, reached for, and consummated."[10]

Muslim women in Europe move from subject positions produced by a radically different context. Mahmood's call to rethink our notions of agency nevertheless allows us to pose a number of important questions: How do Muslim women inhabit competing sets of norms in German society today? What forms of public sphere participation are enabled and foreclosed by such norms? How might feminist theory interested in radical democracy conceptualize these forms of participation?

Although a mapping of agency onto a simplified logic of repression and resistance may belie the complexities of agency, many of the people to whom I make reference in this essay frame their interventions into the public sphere quite explicitly in terms of repression and resistance. Furthermore, their claims to the public sphere quite often explicitly link European norms, autonomy, freedom, and democracy. This occurs, however, in a range of contradictory moves, including the rejection of public expressions of Islam as presumably antithetical to democratic and human rights concerns; the description of Islam as always already in line with European ideals; or a desire to exclude discussions of Islam from public discussions as unnecessary to or distracting from experiences of racism and xenophobia.

These efforts take place in the context of the increasing importance of governance feminism in Germany, which, as Gökçe Yurdakul points out,

seeks to propagate feminist tenets through the invitation to governmental regulation of gender relations based on exclusively Western notions of equality. Often the emphasis on governance feminism has served to support Islamophobic discourses.[11] Such notions are rooted in assumptions that Muslim women are unable to participate in progressive change, particularly in activism against violence. Mahmood suggests a few considerations to approaching notions of agency in relation to Western Muslim feminists. First, her analysis shows that we must recognize that women's agency exists in ways that do not necessarily promote gender justice. Second, we must recognize that strategies for gender justice may look very different in different contexts, and of course that we cannot consider gender justice outside the context of struggles against racism, homophobia, or Islamophobia. Third, in the context of Europe, where women are often expected to choose between affinities with "Europe" and feminism, or affinities with an immigrant or Muslim community, the location of resistance is deeply fraught. In the case of Germany, Muslim feminists largely claim positions as Muslim and feminist, rather than as espousing anything akin to an Islamic feminism rooted in religious values, though proponents of a specifically Islamic feminism also exist.

Immigrants, Feminism, and Agency

Scholarship on Muslim feminist agency faces an intellectual tradition that addressed women of immigrant heritage from a perspective that rarely considered agency, focusing instead on victimhood and difference.[12] A number of important works have shifted this trend. Umut Erel, for example, looks at the performance of Turkish skilled immigrant women's citizenship practices through life stories as a form of agency, examining how these life stories negotiate sets of power relations around gender, race, nation, ethnicity, and sexuality in German and British society.[13] Encarnación Gutiérrez Rodríguez has considered migrant women as migrant organic intellectuals, examining the ways in which subjectivities are negotiated among regimes of gender, race, and sexuality.[14] Both of these works, and others, consider the production of subjectivities and the forms of agency enabled by these regimes. Scholars who engage with minority women in Germany as agents and active subjects, rather than as silent victims of Islam, have nevertheless largely remained reluctant to specifically address women as Muslim—that is to say, while studies on immigrant women may largely be addressing Muslim women, given the dominance of Turkish labor migration in postwar migration to Germany, such studies are hesitant to consider religion as a category for analysis or in relation to the women's agency.

One way German studies scholars have cautiously begun to address this is by critically reconsidering representations of Islam in media, literature, and film with attention to the agency employed by Muslim women characters. I'm thinking particularly here of Yasemin Yıldız's work showing the importance of representations of Muslim women as victims for shifting the production of Otherness from an ethnonational to a religious one,[15] Margaret Littler's examination of the generally ignored presence of Islam in Emine Sevgi Özdamar's work,[16] and my own work on differing possibilities for conceptualizing subjectivity and freedom in autobiographies by activist women.[17] Yet I do not think that we have really begun to approach the possibilities that might be opened by bringing German and European discussions into dialogue with Mahmood's work. I think we find that through this dialogue we may discover that by posing Mahmood's questions we get at something that wasn't as important to Mahmood's own work on Egypt—namely, what is the potential for Muslim agency in the service of work for progressive social change? How might we approach understanding the role of Muslim feminisms in the European feminist landscape today? This emphasis on progressive activism and resistance may seem to counter Mahmood's project, but I argue that the opposite is the case. By questioning agency from a poststructuralist perspective that does not reside in a subversion/repression dichotomy, we will see that women may inhabit a range of subject positions (and multiple subject positions at once) in relation to work toward more democratic public spheres.

My reflections here have been partly inspired by questions I've been considering while writing on the constructions of violence in Europe today via an examination of German cultural products. In one chapter of my book, I argue that women such as Kelek and Ateş, who often argue that Islam is inherently antimodern and antiwoman, actually foreclose Muslim participation in the public sphere in their memoirs. That is, their essentialist portrayals of Islam, and their desire to promote a state-implemented feminism that prohibits representations of Islam in public space, actually prevent the reader from imagining democratic public feminist participation.[18] I offered as alternative narratives of self the lighthearted autobiographical narratives of women such as Hilal Sezgin, Hatice Akyün, and Dilek Zaptcıoğlu because they resisted these dominant discourses by providing other representations of violence capable of addressing racist as well as sexist violence. I summarize this project at length here because, as you can see from this rather deliberately simplified schematic, I have also had difficulty going beyond the subversion/repression binary. What might the consequences be? I've been wondering if we can consider more carefully the ways in which the sub-

ject positions taken by Kelek, Sezgin, and Zaptcıoğlu are similarly produced by the discursive conditions under which they live and work, despite the radically different conclusions they reach about the presence of Islam in Europe today. This essay doesn't seek to make a singular argument about what Muslim feminism in Europe today looks like, or to provide a comprehensive overview of Muslim feminists in Germany today, but rather to begin a reflective process in response to that question.

Mahmood's theoretical contributions to such a discussion are useful not merely in re-examining questions of agency on the part of religious women, but also in reconsidering the potential for feminist agency and alliances. Even if resistance has been romanticized by feminist research thus far, and has become a factor in obscuring how pious (or for that matter conservative) women live and act in the world, I am not interested in giving up the notion of resistance altogether. Rather, I would like to consider what the conditions of possibility for resistance—in particular, antiracist feminist resistance—are in Europe today. I am thus at least partially bound by the restrictions Mahmood points out: the dual nature of feminist inquiry as both an intellectual and activist project. Rather than reject that productive tension, however, I wish to continue to assume that such a tension is useful and productive.

Secular and Religious Feminisms

It is already clear from my comments thus far that examinations of claims to agency by Muslim women in European public spheres cannot be adequately apprehended within a juxtaposition of secular and religious feminisms. In much of the Middle East and South Asia, one can suggest that:

> Islamic feminists use religion as a framework to define gender roles, structure of the family and community, and ultimately, its inclusion in the formation of the nation state in which the individual is subsumed. Secular feminists, on the other hand, base their rationale for women's rights on a human rights discourse to enable and empower the individual in a secular democracy to create a civil society.[19]

And as Madhavi Sunder elaborates, there are many women who don't necessarily identify as feminists who "Rather than accepting the binary framework of religion (on traditional leaders' terms) or rights (without normative

community) . . . [they] are developing strategies and new human rights theory that enable women to claim freedom and equality within the context of normative community."[20] In Europe, however, many women find themselves comfortably occupying positions as both secular and religious feminists, locating themselves more as "Muslim and feminist" than as "Islamic feminist." Public religious identity is considered the expression of a fundamental human right, while religious rights are seen as fundamental aspects of a secular democracy.

In a society in which a religious Islamic identity is constantly ascribed to any immigrants with roots in countries that are largely Muslim, claiming an identity outside of Islam becomes a difficult and hard-fought battle. Given these discursive conditions, it is perhaps not surprising that more religiously grounded forms of feminism have not gained extensive attention. Indeed, overviews of feminist representations of Islam,[21] as well as of women of color critiques of German feminism,[22] often do not address Muslim feminism, focusing instead on the more comfortable triad of gender, race, and class inflected by the postcolonial. Additionally, given the significant number of people who moved to Germany not only for economic reasons, but also to obtain political freedoms denied to them elsewhere, it is perhaps not surprising that articulating feminist goals within a European rights framework is paramount.

Feminist Activist Agents, European Space

Not Religious and of Muslim Heritage

The mode of inhabiting European public space that is most visible in the public media and the political arena in Germany today is exemplified by Kelek. Kelek's public presence has been examined as contributing to Islamophobic discourse via her emphasis on governance feminism,[23] as participating in a shift in forms of otherness from ethnonational to religious,[24] and as prohibiting Muslim women's entry into the public sphere by promoting a public discourse in which a very specific form of secularism—that in which Muslim symbols are removed from public space—is presumed to be the necessary path to nonviolence.[25] Fatima el-Tayeb locates Kelek among other European feminists, such as Ayaan Hirsi Ali and Fadela Amara, who write memoirs in which their lives are viewed as journeys from a Muslim past to a Western future. These are old colonialist tropes. What has shifted, however, is that these journeys physically move their characters into European

spaces as part of contemporary immigration flows—suggesting that Europe is now forced to confront a problem it had previously solved.[26] However, in considering the importance of this public figure, it has been far too easy to create a dichotomy in which Kelek has merely internalized German racisms, while others resist them. Instead, we might consider how anti-Islam discourses produce the norms within which a broad range of feminist engagements take place. As is clear from the quotations with which I opened this essay, Kelek uses a discourse of European rights and individual autonomy to articulate her position. Her word choice in these citations also unmistakably sets her apart from Muslims. Kelek thus is representative of a direction that claims Europeanness by rejecting Islam in public as necessarily antithetical to democracy. While I have addressed this more extensively elsewhere,[27] Kelek takes a number of positions that frame this opposition between Europe and Islam in terms of Muslim women's positioning in German society. For example, she sees women's head-covering as a "flag for Islamism,"[28] and argues that multiculturalism's "false tolerance" is responsible for a trivialization of honor killings and forced marriages.[29] Her claims are similar to those of the Central Council of Ex-Muslims, which comprises members who were never Muslim or have rejected Islam but nevertheless claim to speak for religious Muslims because of recent family immigration from a largely Muslim country. Like Kelek, the Ex-Muslims argue that the headscarf is a marker of Muslim patriarchy, and call for "the implementation of universal human rights as incontestable individual rights of the individual."[30]

Kelek's status was sanctioned by the state when she was chosen to represent Muslims at the German Islam Conference, a shifting set of working groups consisting of politicians, scholars, religious representatives, and "everyday Muslims" whose goal is to articulate new directions for integration and the normalization of Islam in Germany today. Another member of the conference, the fiction writer Feridun Zaimoglu, caused some controversy when he offered to give up his place to a Muslim woman who wears the headscarf, as none were represented at that time in the conference; Kelek and other women members of the conference protested Zaimoglu's offer.[31] While many articles in popular news media have criticized Kelek's viewpoints, Kelek has been dominant in German and international media as an expert on Muslim women's issues in Germany today. The position represented by Kelek as an explicit feminist, and shared by people like the members of the Central Council of Ex-Muslims, prioritizes forced marriages, honor killings, and violence against women as issues for action. These crimes in turn are seen as specifically Muslim manifestations best addressed by championing European secularism and individual freedoms over and against

Muslim religious identity. Among these groups, the problems facing Muslims in Germany today are seen largely as the consequence of Islam and Muslim patriarchy, and they articulate their activism accordingly.

Muslim and Feminist

There are a range of ways in which Muslim feminists express a positioning as Muslim and feminist while calling attention to the ways in which Muslim women are structurally disadvantaged in Germany today. Many of these positions would not, however, be considered Islamic feminisms by many definitions. They occupy a different, specifically European space in which women locate themselves as activists for democracy and women's rights as part of their insistence on rights as European citizens. They are often explicitly Muslim and feminist, without necessarily even considering anything like a "Muslim feminism" possible.[32]

Journalist and writer Mely Kiyak, for example, identifies as a feminist while criticizing feminists for sidelining issues relevant to Muslim women under the heading of "integration problems."[33] A recent discussion about "new feminisms" in the pages of the German newspapers largely centered on the concerns of middle-class Christian white women. While white feminists debated the questions of whether or not to work or stay at home with children, or how to reconcile the demands of marriage, children, and feminist ideals, they ignored the growing number of women who can't even consider such a decision—because they are unable to get positions that suit their educational and skill levels.[34] Kiyak draws largely on notions of equal access and equal rights to intervene into this discussion:

> Of course it would be interesting to discuss why so many Turkish heritage women do not really challenge the model of "marriage plus children." Even more interesting would be to look at why these married women with an immigrant background cannot get jobs suitable for their qualifications (this is especially true for journalists). Meanwhile, the white middle class women have walled themselves in [sich einbetoniert] and dominate feminist discourse. Within these walls they tear themselves apart and fight to maintain a position of superiority. And outside the door, the other sisters smile gently and sigh, "We wish we had your problems!"[35]

Journalist and writer Hilal Sezgin also criticizes the limited perspectives of many white German feminists. She openly identifies as Muslim, while challenging the ways in which Muslims are reduced to a caricature, even as atheists and political refugees are "made Muslim." Sezgin cites the discourse of human rights when she insists, "[R]eligious freedom means that each has the right to practice his own faith. Secondly, each has the right to believe in no religion. Perhaps it is time to defend a third right: the right to remain silent about one's own religion. Not to be constantly addressed as a member of a religion. To decide for oneself when and in which context one's religious belonging is relevant or not."[36] In other words, given a context in which affiliation with Islam is constantly ascribed to those of Turkish heritage, and when a perceived Muslim identity becomes a legitimation used to exclude members of a group from social access and rights, a claim to a lack of public religious identity serves as an important strategy to negotiate the European social context.

One could potentially also locate the Liberal Islamic Federation (Liberal islamischer Bund e.V.) similarly. While not an explicitly feminist organization, the LIB understands itself as both Muslim and in support of women's rights: "The self-evident core prerequisites for the representation of liberal Muslims in Germany are a commitment to the free democratic fundamental order and the equality in rights and dignity of men and women. Political participation is further based on combating racism, anti-Islamic sentiment, and anti-Semitism. It also follows from the commitment to pluralism that no exclusive claim to truth may be asserted against other religions."[37] The LIB has, however, come under criticism by some Muslims, who are disturbed that only people who do not belong to any other Muslim organization can participate in the LIB. They thus, somewhat awkwardly, negotiate the popular positioning of Islam as antidemocratic and anti–women's rights, and the LIB's own conviction that commitment to Islam and women's rights is possible. Even as they promote religious pluralism, they occasionally seem to imply that it is impossible to belong to other Muslim organizations and support LIB principles.

Feminists who are also Muslim, as can be seen from these examples, tend to articulate positionalities in which Muslim affiliation and feminist goals—particularly ending gender violence, women's democratic participation, and access to the workforce—coexist comfortably. At the same time, these feminists tend not to see their religious belonging and their feminist goals as necessarily explicitly related. While they clearly move in a context in which their positions as Muslim women are created by mutually constitutive

forms of race, religious understandings, and gender, these feminists generally respond to these complex interactions by simultaneously acknowledging their relationship to Islam while insisting that it is and should be irrelevant to their public lives.

Islamic Feminist

Feminist communication scholar Saliha Kubilay, alternatively, understands herself as part of an Islamic feminist movement. In a guest column in the women's magazine *Gazelle,* which was founded with the explicit goal of encouraging a common space for all women in Germany, Kubilay has expressed frustration:

> Isn't it somewhat presumptuous to speak of the rights of Muslim women without even giving them the right to speak? And I do not mean the individuals who project their own experiences onto an entire social group, or self-proclaimed feminists like Necla Kelek, who have chosen the course of Islam critique for purely populist reasons. There is a Muslim women's movement in German-speaking countries that is not to be underestimated, though it hardly earns attention in mainstream media.[38]

Kubilay not only relies on the constitutionally guaranteed freedoms of opinion and expression, but further points to the problems of assuming those rights are necessarily European. She particularly points out that the right to vote was legally granted to women much earlier in many so-called Muslim countries, even ones particularly prohibitive of women's rights, than in European countries. By considering that even certain goals associated with liberalism and liberal feminism are not necessarily more fully achieved or achieved earlier in more "secular" or more European countries, Kubilay points to human rights goals that are produced via multiple spaces and histories.

Kubilay points to a number of public figures and organizations as important examples of this Muslim women's movement. One is the recently founded Aktionsbündnis muslimischer Frauen e.V. (Coalition of Muslim Women; from here on, AMF). This group has set the priority of identifying and strategizing the most urgent problems facing Muslim women, particularly with an emphasis on protecting the constitutionally guaranteed rights to human dignity, physical integrity, and freedoms of religion and opinion.[39]

Both Kubilay and the AMF see themselves as grounding their priorities in the "Basic Law [Germany's constitution], human rights; as well as the principles grounded on Islam of human dignity, responsible action before God and men, as well as the shared lives of all people in freedom and justice."[40] Somewhat differently than Sezgin and Kiyak (although Kubilay also points to Sezgin as a model), Kubilay and the AMF thus express explicit interest in finding connections between Islamic religious principles and principles of democracy and universal human rights.[41]

There are a number of white German converts to Islam who also articulate similar positions, deliberately seeking to find a place for Muslim feminism in German society. Nina Mühe, Silvia Horsch, and Kathrin Klausing, for example, have established the organization and website Nafisa. They seek to promote dialogue, both between Muslims and non-Muslims, as well as among Muslims, on the relation between Islam and gender roles. Rabeye Müller (who also works with the LiB) and Luise Becker, together with the ZIF (Zentrum für islamische Frauenforschung und Frauenförderung; Center for Islamic Women's Research and Women's Advancement)[42] in Cologne, have focused on creating new interpretations of Muslim teachings in the interest of gender justice. One might note here that their approach bears similarities to forms of feminist theology in Germany that similarly sought to create new Biblical interpretations in the interest of creating a gender-just Christianity.

Perhaps the most visible attempt to articulate a Muslim feminism has been expressed in the activist blogging of Kübra Gümüsay, who writes in German, English, and Turkish, and has been living between Oxford and Berlin. In a regular online column for the Berlin daily *die tageszeitung*, frequent appearances in other major dailies, and on her blog entitled Ein Fremdwörterbuch (A Dictionary of Foreign Words), Gümüsay focuses on Islam, feminism, racism, and activism. She works together with other young feminists through the collective Mädchenmannschaft, and has cofounded several organizations for Muslim professionals. She proudly claims the title of the first "hijabi columnist" for a major German newspaper, but also that of an "Islamic feminist."[43] Her work also immediately reveals the limitations of the schematic I've suggested here—although she is most explicitly, consciously, and vocally an "Islamic feminist," and although she insists on the right to declare her religious affiliation visibly and publicly, she does not found her notions of feminism exclusively on Islam. Indeed, we might suggest that her work has much in common with other intersectional approaches to feminism, insisting that gender be understood as mutually constituted by race, religion, nation, and sexuality.

Consider, for example, Gümüsay's response to the group femen and their protests in Germany. In 2013 femen instigated several naked protests in which they called for the liberation of Muslim women's bodies. This sparked counterprotest by many Muslim women, who were further appalled when a femen activist responded by declaring that "slaves have never recognized that they are slaves."[44] In an interview sparked by Gümüsay's criticism of femen, Gümüsay argues that feminism cannot be about regulating clothing choices, but rather that it "is about working out the social network in which women live, and the hurdles with which they are confronted on an everyday basis."[45] Gümüsay often uses the language of self-determination and personal choice, but clearly embeds these notions of the autonomous subject in a context, and understands a subject position constructed by relationship to race, class, and sexuality. When she worked to promote the hashtag "#schauhin" (look over there) as a strategy for creating a Twitter archive documenting experiences of everyday racism, she sparked broad reflections on the difficulties of articulating racism in contemporary Germany. She thus inhabits an intersectional feminist positioning that insists on attending to a broad range of issues confronting Muslims in Germany today.

One notes, then, that the difference between Muslim and feminist or Muslim feminist is a small one, more a matter of degree to which affiliation with Islam is deliberately lived as part of public presence, than to which Islam itself is understood as underpinning feminist ideals. In a context in which Islam has become a factor in societal exclusion, women often inhabit their feminist positionalities via claims to space in a European public and expression of support for human rights and women's right to self-determination. Equally interesting, despite the intensified transnational connections in Muslim feminist communities, where recent immigration backgrounds are dominant, any transnational feminist community is articulated primarily as a European one, not as part of or related to global feminist Muslim movements.

Implications for Democratic Subjectivities

In the German case—and, I would argue, this holds for much of Europe, though there are certainly national and regional differences—the perceived relationship of gender to Islam is constantly reframed as a key problem facing democracy. Furthermore, a desire exists to search for and find the repressed informant of the "Other" culture, and yet frequently the only accepted voices are those that speak in the name of "governance feminism," a form of feminism that until now has tended to prohibit the visibility of Islam in public

space. A notion of agency underlies the acceptable voice—the woman who is autonomous enough to reject Islam entirely is viewed as the most reliable "native informant." Alternatively, those who overtly express an affiliation with Islam are more likely to be viewed with suspicion, particularly if they wear Muslim dress in some form. Privileging a particular kind of "native informant" inflects the forms of agency imagined for Muslim women in Germany. While those imaginations, as in other feminist contexts, may tend to privilege resistance, it is a particular kind of resistance that is validated in these cases, namely resistance to a perceived repression attributed solely to Muslim culture.

Attending to the range of possible subject positions produced vis-à-vis Islam and feminism in contemporary Europe has a number of possible impacts. I caution against the temptation to revert to a schematic of resistances, merely enlarging the spectrum to include a range of possible forms of resistance. By bringing together these contradictory forms of feminism we might be able to instead better consider the ways in which this historical moment produces this particular configuration of feminisms, responding to norms that would exclude Muslim women from public participation, inhabiting and refiguring human rights norms to address their complex experiences. Feminist debates over Islam in Europe today are equally contentions over what strategies can best achieve gender justice, even as they are quickly instrumentalized in the interest of agendas that would limit immigration and deny the existence of racism, including racism in its Islamophobic forms, in Europe. Nevertheless, as Judith Butler has said, "I am quite sure that feminism should not resign in the face of such instrumentalization." Yet, "There can be no feminism within the contemporary global situation that does not actively contest the kind of nationalist violence that pervades immigration policy in Europe right now."[46] Such contestations include challenges to representational violence that would ignore the range of potential feminist Muslim positionings. However, they also will include acknowledgment of the need for and difficulty of doing the hard work to build and rebuild feminist alliances, and insistence on engaging the question, as the AMF phrases it: "How do we achieve gender justice?"[47]

Notes

1. Kelek, "Integration der Muslime."
2. Kelek, "Migrationsforschung."
3. Rottmann and Ferree, "Citizenship and Intersectionality," 486–488.
4. Ibid. 502–504.

5. El-Tayeb, *European Others*, 98–110.

6. Amara and Zappi, *Breaking the Silence*, 98–100.

7. Abu-Lughod, "The Romance of Resistance," 52–53.

8. Mahmood, *Politics of Piety*, 10–14.

9. Ibid. 14.

10. Ibid.

11. Yurdakul, "Governance Feminism," 113.

12. The slippage here from "Muslim" to immigrant is intentional. In much scholarship on postwar migration, Otherness was defined primarily in terms of national, class, and metropolitan/rural difference; Islam played a much more minor role in definitions of difference until the 1990s; this is also often true in popular culture. Weber, *Violence*, 99–102.

13. Erel, *Migrant Women Transforming Citizenship*.

14. Rodríguez, *Intellektuelle*.

15. Yıldız, "Turkish Girls, Allah's Daughters, and the Contemporary German Subject."

16. Littler, "Intimacies Both Sacred and Profane."

17. Weber, "Freedom from Violence"; Weber, "Beyond the Culture Trap."

18. I first explored these ideas in my article "Freedom from Violence."

19. Ahmed-Ghosh, "Dilemmas of Islamic and Secular Feminists and Feminisms," 106.

20. Sunder, "Piercing the Veil," 1405–1406.

21. Chin, "Turkish Women, West German Feminists, and the Gendered Discourse on Muslim Cultural Difference."

22. Weber, "Beyond the Culture Trap"; Steyerl and Gutiérrez Rodríguez, *Spricht die Subalterne Deutsch? Migration und postkoloniale Kritik*; Rodríguez, "Fallstricke."

23. Yurdakul, "Governance Feminism."

24. Yıldız, "Turkish Girls, Allah's Daughters, and the Contemporary German Subject."

25. Weber, "Freedom from Violence."

26. El-Tayeb, European Others, 100–103.

27. Weber, "Freedom from Violence."

28. Kelek, *Die fremde Braut*, 246; Kelek, "Frauen werden zu Unruhestifterinnen stigmatisiert."

29. Kelek, "Eure Toleranz."

30. Zentralrat der Ex-Muslime, "Wir haben abgeschworen."

31. Wolff, "Zank über Islam-Konferenz verstummt nicht."

32. Markus Gamper has undertaken research on three Muslim women's organizations, the currently inactive HUDA; the ZIF (Zentrum für islamische Frauenforschung und Frauenförderung e.V.—Center for Islamic Women's Research and Women's Advancement), a Cologne organization founded by women theologians and educators with a broad focus, including reinterpretations of the Qur'an; and Iman, a locally focused center for Muslim women located in Darmstadt. He found that only a small percentage of participants identified with feminism. However, I have

significant concerns with the framing of feminism in his survey, which provided the following question and choices, which Gamper viewed as a hierarchal list from most to least committed to feminism: "The organization of which you are a member is a Muslim woman's organization. Would you thus identify yourself as a feminist?" (1) Without question, for one has to do something about the dominance of men. (2) I want more rights for women, but I don't have anything against men. (3) No, but I believe in equal rights between men and women, as well as among all people. (4) No, I find that feminists exaggerate. It is good the way it is." Given that choice number 3—a "no" to feminism—may well be one of the most common definitions of feminism, it is difficult to assess these results. Gamper, *Islamischer Feminismus in Deutschland,* 276.

33. Kiyak, "Und was ist mit uns?"

34. Ibid.

35. Ibid.

36. Sezgin, "Deutschland schafft mich ab."

37. Liberal-Islamischer Bund e.V., "Statement of Principles."

38. Kubilay, "Wo sind die muslimischen Feministinnen?!"

39. Aktionsbündnis muslimischer Frauen e.V., "Wie erreichen."

40. Aktionsbündnis muslimischer Frauen e.V., "Über uns." Note that the AMF does not explicitly label itself feminist, though some members do.

41. While I do not have space to address this extensively here, there are a number of converts who have expressed an even more explicit desire to articulate a Muslim-based feminism. For an example, see the blog at Nafisa.de.

42. See fn. 32.

43. Gümüsay, "Femen und die muslimische Frau."

44. Ibid.

45. Hausblicher, "Kübra Gümüşay."

46. Butler, "Feminism Should Not Resign in the Face of Such Instrumentalization."

47. Aktionsbündnis muslimischer Frauen e.V., "Wie erreichen."

Bibliography

Abu-Lughod, Lila. "The Romance of Resistance: Tracing Transformations of Power through Bedouin Women." *American Ethnologist* 17, no. 1 (1990): 41–55, http://www.jstor.org/stable/645251.

Ahmed-Ghosh, Huma. "Dilemmas of Islamic and Secular Feminists and Feminisms." *Journal of International Women's Studies* 9, no. 3 (2008): 99–116.

Aktionsbündnis muslimischer Frauen e.V. "Über uns." Aktionsbündnis muslimischer Frauen e. V. http://www.muslimische-frauen.de/uber-uns/. Accessed August 30, 2011.

———. "Wie erreichen wir Geschlechtergerechtigkeit?" Aktionsbündnis muslimischer Frauen e.V., June 15, 2011. http://www.muslimische-frauen.de/2011/06/amf-tagung-am-2-und-3-7-2011-wie-erreichen-wir-geschlechtergerechtigkeit/.

Amara, Fadela, and Sylvia Zappi. *Breaking the Silence*. Translated by Helen Harden Chenut. Berkeley: University of California Press, 2006.

Butler, Judith. "Feminism Should Not Resign in the Face of Such Instrumentalization." *IABLIS: Jahrbuch für europäische Prozesse* 5 (2006). Available at http://www.iablis.de/iablis_t/2006/butler06.html.

Chin, Rita. "Turkish Women, West German Feminists, and the Gendered Discourse on Muslim Cultural Difference." *Public Culture* 22, no. 3 (October 1, 2010): 557–581. doi: 10.1215/08992363-2010-009.

El-Tayeb, Fatima. *European Others: Queering Ethnicity in Postnational Europe*. Minneapolis: University of Minnesota Press, 2011.

Erel, Umut. *Migrant Women Transforming Citizenship: Life Stories from Britain and Germany*. Surrey, UK:Ashgate, 2009.

Gamper, Markus. *Islamischer Feminismus in Deutschland*. Bielefeld, Germany: Transcript Verlag, 2011.

Gümüsay, Kübra. "Femen und die muslimische Frau: Gut gemeint." *die tageszeitung*, 04 2013, sec. Alltag. http://taz.de/Femen-und-die-muslimische-Frau/!114255.

Hausblicher, Beate. "Kübra Gümüşay: 'Nur ein Tamtam machen ist zu wenig.'" diestandard.at, April 28, 2013. http://diestandard.at/1363709425894/Kuebra-Guemuesay-Nur-ein-Tamtam-machen-ist-zu-wenig.

Kelek, Necla. *Die fremde Braut: Ein Bericht aus dem Inneren des türkischen Lebens in Deutschland*. Köln: Kiepenheuer & Witsch, 2008.

———. "Eure Toleranz bringt uns in Gefahr." *Die Welt*, February 26, 2005.

———. "Frauen werden zu Unruhestifterinnen stigmatisiert." *Spiegel Online*, May 7, 2006. http://www.spiegel.de/politik/deutschland/0,1518,424999,00.html.

———. "Integration der Muslime: Bist du nicht von uns, dann bist du des Teufels." *Frankfurter Allgemeine Zeitung*, April 25, 2007, sec. Feuilleton.

———"Migrationsforschung: Professor Bade gibt den Anti-Sarrazin." FAZ.NET, May 9, 2011. http://www.faz.net/artikel/C30864/migrationsforschung-professor-bade-gibt-den-anti-sarrazin-30336389.html.

Kiyak, Mely. "Und was ist mit uns?" *Die Zeit*, July 3, 2008. http://www.zeit.de/2008/28/Feminismus.

Kubilay, Saliha. "Wo sind die muslimischen Feministinnen?!" *Gazelle*, July 7, 2011. http://www.gazelle-magazin.com/?p=587.

Liberal-Islamischer Bund e.V. "Statement of Principles." Liberal-Islamischer Bund e.V. http://www.lib-ev.de/index.php?c=13. Accessed August 21, 2011.

Littler, Margaret. "Intimacies Both Sacred and Profane." In *Encounters with Islam in German Literature and Culture*, edited by James Hodkinson and Jeffrey Morrison, 221–235. New York: Camden House, 2009.

Mahmood, Saba. *Politics of Piety: The Islamic Revival and the Feminist Subject*. Princeton, NJ: Princeton University Press, 2005.

Rodríguez, Encarnación Gutiérrez. "Fallstricke des Feminismus: Das Denken 'kritischer Differenzen' ohne geopolitische Kontextualisierung. Einige Überlegungen zur Rezeption antirassistischer und postkolonialer Kritik." *Polylog*, no. 4 (1999).

————. *Intellektuelle Migrantinnen: Subjektivitäten im Zeitalter von Globalisierung.* Opladen, DE: Leske + Budrich, 1999.

Rottmann, Susan B., and Myra Marx Ferree. "Citizenship and Intersectionality: German Feminist Debates About Headscarf and Antidiscrimination Laws." *Social Politics: International Studies in Gender, State & Society 15*, no. 4 (2008): 481–513. doi: 10.1093/sp/jxn017.

Sezgin, Hilal. "Deutschland schafft mich ab." *Die Zeit,* September 2, 2010. http://www.zeit.de/2010/36/Muslimifizierung/komplettansicht.

Steyerl, Hito, and Encarnación Gutiérrez Rodríguez, eds. *Spricht die Subalterne Deutsch? Migration und postkoloniale Kritik.* Münster: UNRAST-Verlag, 2003.

Sunder, Madhavi. "Piercing the Veil." *Yale Law Journal* 112 (2003): 1399–1472.

Weber, Beverly M. "Beyond the Culture Trap: Immigrant Women in Germany, Planet-Talk, and a Politics of Listening." In *Women in German Yearbook: Feminist Studies in German Literature & Culture,* edited by Helga Kraft and Marjorie Gelus, 21: 16–38, 2005.

————. "Freedom from Violence, Freedom to Make the World: Muslim Women's Memoirs, Gendered Violence, and Voices for Change in Germany." In *Women in German Yearbook,* edited by Patricia Simpson, 25: 199–222. Lincoln: University of Nebraska Press, 2009.

————. *Violence and Gender in the "New" Europe.* New York: Palgrave Macmillan, 2013.

Wolff, Johanna. "Zank über Islam-Konferenz verstummt nicht." *Frankfurter Rundschau,* May 2, 2007, sec. Themen des Tages.

Yıldız, Yasemin. "Turkish Girls, Allah's Daughters, and the Contemporary German Subject: Itinerary of a Figure." *German Life and Letters* 62, no. 4 (2009): 465–481. doi: 10.1111/j.1468-0483.2009.01475.x.

Yurdakul, Gökce. "Governance Feminism und Rassismus: Wie führende Vertreterinnen von Immigranten die antimuslimische Diskussion in Westeuropa und Nordamerika befördern." In *Staatsbürgerschaft, Migration und Minderheiten,* edited by Y. Michal Bodemann and Gökce Yurdakul, 111–126. Wiesbaden, DE: VS Verlag für Sozialwissenschaften, 2010. Available at http://www.springerlink.com/content/m262285165080587.

Zentralrat der Ex-Muslime. "Wir haben abgeschworen." Zentralrat der Ex-Muslime e.V. http://www.ex-muslime.de. Accessed August 29, 2011.

Contributors

Huma Ahmed-Ghosh is a Professor in the Department of Women Studies and on the Advisory Boards of the Center for Islamic and Arabic Studies and the Center for Asian and Pacific Studies at San Diego State University. She has published extensively on women in Afghanistan and in the U.S. diaspora; Islam and feminism; Ahmadi women in the United States; Indian women and aging; beauty pageants; and domestic violence in India. Her recent book, *Walking the Tightrope: Asian Muslim Women and their Lived Realities,* was also published by SUNY Press. She is currently finalizing a manuscript, *Asian Muslim Women: Globalization and Local Realities,* based on the life stories of women peacemakers at the grassroots level. ghosh@mail.sdsu.edu

Zeynep Akbulut is a lecturer at the University of San Diego, Department of Theology and Religious Studies. She received her PhD from the University of Washington in Near and Middle Eastern Studies. She also has a Master's degree in Islamic Studies, with a focus on Christian-Muslim Relations from Hartford Seminary, and a Law degree from Ankara University in Turkey. Currently she is working on a book manuscript based on her dissertation, which examines Muslim women's experiences with the headscarf ban in Turkey. zeynep@sandiego.edu

Dr. Birte Brecht-Drouart is a German expert on Gender and Islam in the Southern Philippines. She was employed for several years as a research assistant at the University of Passau at the Department of Southeast Asian Studies. For her PhD she received two grants in support of her studies. The Universität Bayern e.V. granted her a scholarship for postgraduates under the Bayerischen Eliteförderungsgesetzt (BayFEG). The Cluster of Excellence, "The Formation of Normative Orders," at Frankfurt University included her in its financially supported postgraduate project, "Kulturelle und politische

Transformationen in der islamischen Welt." In January 2012 she earned her PhD, magna cum laude, at the Goethe-University in Frankfurt am Main. brecht5@yahoo.com

Cyra Akila Choudhury is Associate Professor of Law at Florida International University, College of Law, Miami's only public law school. She obtained her J.D. from Georgetown University Law Center and earned graduate degrees in political science and law from Columbia University and Georgetown. Prior to joining the academy, she practiced corporate finance at Freshfields Brukhaus Deringer. Her publications focus on legal subjectivities, feminist and queer legal theory, and postcolonial theory, focusing on South Asia. She also writes on the sociolegal effects of the War on Terror. She is admitted as a court expert in matters of transnational and Islamic family law and human rights, and has been interviewed and cited in the media on family law, Islamic law, and Islamophobia. choudhuc@fiu.edu

Elora Halim Chowdhury is Associate Professor of Women's & Gender Studies, and affiliated faculty of Asian Studies and Asian American Studies at the University of Massachusetts, Boston. Her research and teaching interests include critical development studies, transnational feminism, gender violence, and human rights advocacy, with an emphasis on South Asia. She has published in numerous anthologies and journals, including *Meridians; Feminism, Race, Transnationalism; International Feminist Journal of Politics; Women's Studies International Forum;* and *Gender, Place and Culture.* She is the author of the book, *Transnationalism Reversed: Women Organizing Against Gendered Violence in Bangladesh* (SUNY Press, 2011). Her book was awarded the Gloria E. Anzaldua Book Prize by the National Women's Studies Association (NWSA) in 2012. Elora.chowdhury@umb.edu

Maris Boyd Gillette is a sociocultural anthropologist and filmmaker who has done ethnographic research on Muslims in northwest China and porcelain workers and entrepreneurs in southeast China. Her publications on Muslims include *Between Mecca and Beijing: Modernization and Consumption Among Urban Chinese Muslims* (Stanford University Press), "Violence, the State, and a Chinese Muslim Ritual Remembrance" (*Journal of Asian Studies*), and "Muslim Foodways" (*Handbook of Food and Anthropology, Bloomsbury*). She was also co-director of the community history and media project Muslim Voices of Philadelphia, and worked as a facilitator on "The Sun Rises in Philadelphia," about the founding and history of the Ahmadiyya community in Philadelphia. She is E. Desmond Lee Professor of Museum Studies and

Community History at the University of Missouri–St. Louis. gillettema@umsl.edu

Alexander Horstmann is Associate Professor in Southeast Asian Studies at the Department of Cross-Cultural Studies, University of Copenhagen. He is also a Senior Research Partner of Peter van der Veer at the Max Planck Institute for the Study of Ethnic and Religious Diversity, Göttingen, Germany. He has published five books and over forty journal articles on different aspects of multicultural studies, rights, violence, and religion. He has published various articles on the Tablighi Jama'at between South and Southeast Asia in journals such as *SOJOURN, Studia Islamica,* and *Comparative Studies of South Asia, Africa and the Middle East.* fnt592@hum.ku.dk

Yasmin Moll is a Visiting Assistant Professor of Anthropology at the University of Michigan and a Postdoctoral Fellow at the Michigan Society of Fellows. Her current book project, based on long-term ethnographic fieldwork in Cairo with Islamic media producers, focuses on the intersections of religion, television, and revolutionary politics in contemporary Egypt. She has published widely on questions of mediation and cultural politics in contemporary Muslim contexts as well as produced documentary films on these themes. ymoll@umich.edu

Svetlana Peshkova is an Assistant Professor at the Department of Anthropology, University of New Hampshire, in Durham. She is a sociocultural anthropologist whose interdisciplinary teaching and scholarship focus on societal gender dynamics and individual moral projects in post-Soviet space. Svetlana has published articles about social movements, reproductive health, cultural models, spatial dynamics of Islamic renewal, non-liberatory desires, and Muslim women's leadership. Her book about Muslim women religious teachers and leaders in Uzbekistan (2014, Syracuse University Press) engages questions of individual identity, gender, religious education, and history. S.peshkova@unh.edu

Nadja-Christina Schneider is a Junior Professor for Mediality and Intermediality in Asian and African Societies at Humboldt University Berlin. Her areas of research include media and society and debates on Islam and Gender. Her recent publications include an edited special issue of ASIEN in *The German Journal on Contemporary Asia,* titled "Islam, Youth and Gender in India and Pakistan: Current Research Perspectives." Her forthcoming publications include two edited volumes, *Studying Youth, Media and Gender*

in Post-Liberalization India (with Fritzi-Marie Titzmann) and *New Media Configurations—Changing Societies?* (with Carola Richter). nadja-christina. schneider@asa.hu-berlin.de

Beverly M. Weber is associate professor of German at the University of Colorado at Boulder. Her publications include *Violence and Gender in the "New Europe": Islam in German Culture* (Palgrave, 2013), and articles on gender, race, and Islam in Europe in *German Studies Review; Comparative Studies of Asia, Africa, and the Middle East; Women in German Yearbook;* and *German Life and Letters.* beverly.weber@Colorado.edu

Afiya Shehrbano Zia is a feminist researcher and activist based in Karachi, Pakistan. She has a Master's degree in Women's Studies from the University of York, UK. She is author of *Sex Crime in the Islamic Context* (1994) and *Watching Them Watching Us* (2000), and has edited a series of books, authored several essays in recent publications and contributed to scholarly journals. She is currently completing a manuscript for publication titled *Faith and Feminism in Pakistan.* She is also pursuing research for her PhD from the University of Toronto. She is an active member of Women's Action Forum—a secular women's rights organization in Pakistan—and an advisory board member for the Centre for Secular Space (UK).

Index